Ove Arup

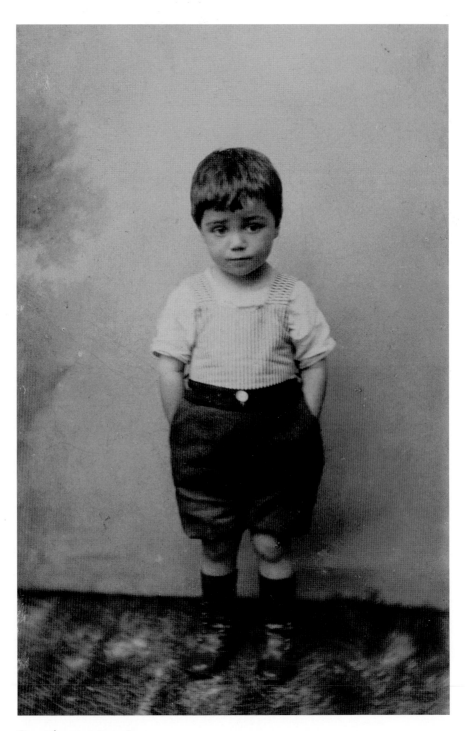

Ove at the age ot two, 1897.

OVE ARUP

MASTERBUILDER OF THE TWENTIETH CENTURY

Peter Jones

Yale University Press • New Haven and London

Designed by Emily Lees

Printed in China

Library of Congress Cataloging-in-Publication Data

Jones, Peter, 1935 Dec. 18-
Ove Arup : masterbuilder of the twentieth century / Peter Jones.
p. cm.
Includes bibliographical references and index.
ISBN 0-300-11296-3 (cl : alk. paper)
1. Arup, O. N. (Ove Nyquist), 1895- 2. Architects–Great Britain–
Biography. I. Title.
NA997.A84J56 2006
720.92–dc22 [B]
2006010203

A catalogue record for this book is available from
The British Library

Contents

Acknowledgements

All biographers owe debts. Mine are extensive. First of all to the Arup family, who made available all the papers, public and private in their possession, together with vast quantities of memorabilia; secondly to the Trustees of the Arup Foundation and the Directors of Arup Group Ltd, for making available all papers in their charge, and also placing at my disposal library and support services; thirdly, to the director and staff of the Churchill Archives Centre, Cambridge, for access to the Arup Archive in their charge, and for helpful assistance on my every visit.

The formal debts, however, are as nothing compared with personal debts. The welcome extended to me by members of the Arup family, in the first place, by close friends and colleagues of Ove Arup in the second place, and by staff of Arup offices in London and Australia has been extraordinary, and cannot be adequately conveyed. Some individuals simply must be named, beginning, of course, with the family: Anja and Keld Liengaard generously answered intrusive questions about the past; Jens and Sheila Arup welcomed me most warmly and tolerated endless speculations; and Karin and Brian Perry put up with me, fed me superbly, and suffered my garage-rummaging on more occasions than I care to count.

Of Ove's oldest friends, Jack Zunz was my mentor, patiently putting me right, tactfully suggesting directions, and tolerantly accepting my aberrant interpretations; Philip Dowson memorably conveyed something of his vast experience of Arup Associates, aiming to keep me on track; Duncan Michael and Bob Emmerson, as former chairmen respectively of Ove Arup Partnership and Ove Arup Partnership Ltd, benignly encouraged and tolerated my eccentric enquiries and interests. Julian Diamond and Vic Curran made space available in their busy offices with the utmost courtesy, and Andrea Beddard in library services was fantastic; Pauline Shirley, the doyen of everything photographic, was a mine of information and advice, and contributed significantly to this book: her technical wizard, Justin Perks, deserves special thanks. These members of the firm uphold with distinction the Arup 'philosophy' and on every occasion impress outsiders with its ethos. I have enjoyed fascinating and indispensable conversations with other colleagues associated with Ove in various capacities: Peter Ahrends, John Allan, Michael Baume, Ralph Bott, Peter Campbell, Trevor Dannatt, Olivia Gadd, Richard Hough, Emory Kemp, Joanna Kennedy, Patrick Morreau, John Nutt, Michael Somers, William Southwood, Derek Sugden, Marit Tronslin, Diane Veness, Francis Walley, Anne Watson, Jonathan Winawer and Kenneth Woolley. Åsa Söderman and Knud Haakonssen, as always, offered golden advice on things Danish.

The *lares et penates* of a biography should always be honoured: Ilona and Nicholas Parsons come first, for enabling me to research and write much of the book opposite Ove's first significant building – Highpoint; Mary Mortimer and Donald Denoon, Janet and Donald McDonald, and Brigid Ballard and John Clanchy for luxurious succour and laughter during my sojourns in Australia; the staff of the Australian Club; and during my early researches Martin Fitzpatrick for many hilarious hours of Baroque music and the best of wines. To Hilary Rubinstein I owe debts for advice of all kinds, and especially editorial comments. And to my family I am indebted for enthusiastic interest and toleration of long absences. Gillian Malpass at Yale University Press has been a source of great encouragement throughout the project. Special thanks are due to Ruth Thackeray, my copy editor, for masterly scrutiny of my text and inspired advice for its improvement. To staff in the State Library of New South Wales, Sydney; the Western Sydney Records Centre, Kingswood; the Sydney Opera House Trust; and the Royal Commission on the Ancient and Historic Monuments of Scotland I am also indebted for help and endless courtesies. I am very conscious that I was unable to meet many people with whom I corresponded, and that there are others with whom I

failed to make contact at all: from all of these individuals I would have learned a great deal, and I offer my apologies to them.

There are debts that go back a long way. Kyffin Williams first encouraged me to look hard at Highpoint in 1949, and forty years later Philip Dowson guided me as Chairman of the Client Committee through ten tortuous years of building the Museum of Scotland. From the late 1950s onwards Ian Ferguson, Frank Clark and Michael McMordie indulged me in endless debate about architecture, which spilled over into the philosophy classes I gave for fifth-year architectural students.

For omission of someone's favourite story, key decision, significant event, or crucial individual, I accept full responsibility and can offer only Dr Johnson's irreproachable explanation: ignorance.

Author's note

Since 2000 the firm has used the singular name 'Arup', and since October 2001 has been trading as Arup Group Ltd. However, during his own lifetime, both Ove Arup himself, and many of his colleagues and correspondents, referred to the firm as 'Arups' or 'Arup's' and the founder himself as 'Arup'. It should be clear from the context whether the man or the firm is being referred to. Key points in the history of the Partnership are listed in the Chronology.

Copies of Ove Arup's original documents exist in several versions. Among minor amendments to the quoted extracts are 'silent corrections' to eccentric spellings, punctuation and capitalisation. Translations from the Danish are mostly by Jens Arup and Knud Haakonssen. Ellipses in square brackets generally indicate the omission of a word, phrase or sentence; other smatterings of dots can be taken to be as in the original.

All measurements, whether imperial or metric, are cited as in the documents, very few of which state equivalents. The United Kingdom adopted partial metrication in 1971. Sums of money here are therefore in £ s. d. Decimal currency was gradually introduced in Australia while the Sydney Opera House was being designed and constructed, hence the references to both Australian pounds and dollars. The abbreviation 'DKK' refers to Danish krone.

The orthography of Scandinavian proper names has suffered numerous barbarities at the hands of outsiders. Every effort has been made to use the spellings adopted within the Arup family itself.

Photograph credits

With the exception of the images listed below, all photographs belong to Arup or to private family collections and are reproduced by permission of Arup and the Arup family:

Getty Images: 15, 16, 36–8, 40–47, 55; Giraudon/ The Bridgeman Art Library: 23; Imperial War Museum (D1570): 39; RIBA © 1999–2002: 59, 60, 69, 73, 74, 101, 102; John Holden: 63; Photo © Wm. J. Toomey: 65; Photo © de Burgh Galwey: 66, 87; Drake & Lasdun: 67; Photo © Sydney Morning Herald: 68; Jørn Utzon: 70; Max Dupain: 75, 79, 86; Henk Snoek: 81; Photo © W. Brindle: 83; Yuzo Mikami: 84; Royal Commission on the Ancient and Historical Monuments of Scotland: 88; John Laing and Son Ltd.: 89, 90; Behr Photography: 100; Andrew Holmes: 103; Central Photography: 115; Graham Gaunt: 116

Graphs drawn by Martin Hall for Arup

Introduction

He carried a pair of extra-long chopsticks in his top pocket, to poach enticing dishes from his neighbour's plate; on one occasion he asked the King of Denmark what his name was, on another why his guest was important: and with inspired improvisation he addressed Lord Primrose as Mr Daffodil. This endlessly doodling, whimsically rhyming, cigar-waving, beret-wearing, accordion squeezing, ceaselessly smiling, foreign sounding, irresistibly charming, mumbling giant: Ove Arup, who changed the assumptions of architects and engineers throughout the world. At the age of fifty-one, and with a capital of £10,000, he founded what became the most influential structural engineering consultancy in the United Kingdom. In its first year, 1946, Ove N. Arup, Consulting Engineers, achieved a turnover of just over £3300: in the year of the founder's death, 1988, the turnover of Ove Arup Partnership exceeded £100 million. Today, the turnover of the global Arup Group Ltd is approximately five times that figure.

Ove was born in 1895 in Newcastle upon Tyne, of a Danish father and Norwegian mother. Educated in Germany and Denmark before and during the First World War, he took his first degree in philosophy and mathematics, his second in engineering. He returned to England in 1923: and stayed for

life. He sensed that broad-based engineering consultancy might be the cata-
lyst to unite architecture, art and philosophy, in each of which he feared he
might not be uniquely distinguished. He soon came to know most of the avant-
garde architects and designers in Europe, many of whom were refugees from
Nazi Germany, such as Walter Gropius and Berthold Lubetkin, who influ-
enced him greatly. He initially worked for two Danish firms, but then set up
with a cousin, and later on his own, as an engineering consultant. During
World War II, when he designed shelters and worked on Mulberry Harbour,
he came to know leading scientists and engineers, and took part with them in
discussions on the application of science for the betterment of man.

The reputation of his firm grew slowly, but the event that propelled the
name of Arup onto the global stage was the long-drawn-out construction of
Sydney Opera House. The saga has been told many times, but two chapters
are here devoted to this event, using previously unavailable documents,
because it embodied Ove's ambitions. If successful, it would demonstrate the
perfect harmony of architecture and engineering; it would prove that complex
problems can be solved only by teamwork, since no individual knows enough
to encompass all necessary expertise; and it would demonstrate, for those with
eyes to see, that the character of a highly complex product could be wrought
and judged only by an understanding of the processes which leave no other
trace.

By 1964 the firm was achieving an annual turnover of £1 million. Ambitious
clients and architects wanted – or even needed – Arup to be their engineers:
many architectural dreams could not otherwise be realised, whether by Denys
Lasdun, Basil Spence, Richard Rogers, Norman Foster or younger designers.
Notable buildings were literally underpinned and structurally secured by
Arup, although the general public is often ignorant of the fact: the Centre
Pompidou, the Hong Kong and Shanghai Bank, the Lloyds of London build-
ing, university libraries, residences and laboratories, airports in Hong Kong,
and Japan, railway stations, the Channel Tunnel, bridges throughout the
world, villages and stadia for the Olympics in Beijing and London. The sta-
bilising of York Minster in the 1960s and the Millennium Bridge in London
are among the firm's few projects within the public consciousness, although
proposals to secure the Leaning Tower of Pisa and to encase Abu Simbel in
glass could have attracted equal attention.

Ove Arup's fame rests on his success as a consulting engineer, and the inspi-
ration he established in and through the work of his firm. But the key to his
life are the philosophical ideas that permeated and underpinned everything he
proposed: they are explored in this book. In form and content his ideas were

far in advance of his time. Even in his lifetime, he succeeded to a degree that few would have initially predicted: by his own example, and with his own firm, he showed both what could be achieved and how to achieve it. The clue was in the people chosen – initially by him, of course – people whose core values motivated them to open-minded co-operation. But that goal presupposed an even wider aspiration: that barriers to mutual understanding, wherever they exist, be broken.

Ove's aim was to secure complete integration between the work of an architect and his engineering consultants from the inception of any large-scale project: 'Total Design is the key to what is built.' To fulfil their role, engineers must be inspired and motivated by several key ideas: a primary concern for staff and clients alike, relentless pursuit of excellence, and financial security to keep the show on the road. Architects, too, would have to be educated about the need and benefits of co-operation to fill lacunae in their knowledge, too often disguised by hunches and lunches. To some cynical observers all this sounded like no more than a device to satisfy socialist ideals, or commercial expediency: it was not. Ove's beliefs were grounded in views about the nature of knowledge and its acquisition, and about the nature of human relationships: such ideas were much more difficult to inculcate and sustain, because he needed first to create a receptive audience.

Ove's legacy is Arup Group Ltd, one of the most respected multidisciplinary engineering consultancies in the world: it employs over seven thousand full-time staff in over fifty countries. Its much admired ethos distinguishes it from almost all its rivals, and the main ideas of that ethos can be very simply stated. They are, he insisted, 'just common sense' – although they are still not universally accepted.

Of course, the criteria for satisfying his firm's ethos would change over time, and in different contexts: this meant that no eternal methods could be formalised, and effective communication would always be necessary to help colleagues remain alert. If each member of the team were not only trusted, but motivated by fearless open-mindedness, the rewards of success were virtually without limit.

This is a story of relationships to be built and barriers to be breached: only by such means could Ove's lifelong search for 'truth' be undertaken. In contrast to the dramatic schemes with which the firm was increasingly involved, however, the impact of his writings was harder to gauge, especially in the proudly anti-intellectual sectors of British society in which he often worked. Few of his colleagues at the time – barely a dozen remain – and none of his successors knew that for over seventy years he had ceaselessly scribbled down

his reflections: the remaining archives of diaries, letters and lectures exceed three million words. During his lifetime the band of his devoted followers was small in relation to the revolution he was promoting. As usual, actions not words attracted more converts, and the success of the firm increasingly forced outsiders to consider how it had been achieved. How his ideas emerged and evolved in the social and political context of the day are themes of this book. In 1960 the distinguished engineer Sir Alan Harris wrote to thank Ove for attending his lecture at the Royal Institute of British Architects. He concluded:

> Those engineers who work with good architects in a spirit of harmony and common aims are really a new race, created by, and creating, a new sort of architecture and, thank God, a new sort of architect. The whole situation is almost the invention of one man, yourself.

This book is a biography: it is not a history of engineering or of architecture, or of a firm and its evolution. It is the story of a patriarch and friend who was much loved, whose idiosyncrasies were treasured, and who inspired others to remarkable feats of loyalty and achievement. He was devoted to his family at home and in Scandinavia; his firm, in its early days, was to him but another family, enlivened by argument, hilarious parties and controllable anarchy. To some, he appeared as an irrepressible bohemian intellectual, belonging more to the world of architects than to his fellow engineers. And the many honours which came his way, from the Gold Medals of the Royal Institute of British Architects and the Institution of Structural Engineers, to his CBE and knighthood, did not entirely detach him from his much-prized role of 'outsider'. That, after all, gave him added freedom to think the unthinkable, and sustained his enthusiasm to practise 'the art of the impossible'.

'Si jeunesse savait . . .'

Newcastle 16 April 1895

Dear – on behalf of our little son I may now write <u>Grandparents</u> – for a couple of hours ago Mathilde brought into the world a strong boy, and let me say immediately: Mother and boy seem to be "all right." It was a surprise, and, as it has turned out, a happy one. For it was good deal earlier than expected. [. . .] at 11 (a bit after) we had the boy, a strong little chap with long dark hair – in all appearance, a true Nyquist. [. . .]

Mathilde's love to all at home from
Your faithful
Johannes Arup[1]

Jens Simon Johannes Arup and his second wife, Mathilde Bolette Nyquist,[2] lived at 16 Jesmond Vale Terrace. Johannes himself, born in Roskilde on 21 March 1844, was the son of a printer and farmer, and the eldest of four brothers. He trained as a veterinary surgeon, travelling on board mule transports to South America and the West Indies in the 1860s. After service as a district vet in Otting, Salling, he moved to Newcastle in 1889 as a government con-

sultant, supervising the health of beef cattle. Many Danes were looking to England at the time, for a life exempt from the enforced Germanisation of citizens in Holstein and elsewhere, and the explicit ambitions of Bismarck. In 1879 Johannes had married Johanne Kirstine Cathrine Munk, daughter of a watchmaker, but having borne three daughters to him, Astrid, Ingeborg and Ellen, she died suddenly in Denmark in 1890, before she could travel to England.

For at least a year before Johanne died a young Norwegian girl, who had earlier studied English as an au-pair in Ireland, had been serving as a housekeeper-governess to the girls, to whom she became devoted. In due course, after securing the consent of his in-laws, and to the absolute delight of his daughters, on 19 October 1893 Johannes married Mathilde Nyquist in Grimstad, Norway. It was to her parents that he addressed the letter. Norway was still a decade from dissolving its union with Sweden, a union that had been established by Denmark ninety years earlier after the Napoleonic wars.

Political events immediately affected the future of the child. No sooner had the baby arrived than Britain banned the import of live cattle, and the newly enlarged Arup family sailed for Hamburg, where a similar consular post had become vacant. They rented a large apartment in a middle-class suburb, ten minutes' walk from the Alster. A second son, Henning, was born three years after they arrived. The two boys, in due course, went to a superior day school run, as Ove later described it, 'on rather Prussian, strictly Lutheran lines' – 'if you did not believe in Father, Son and Holy Ghost, we would all go to Hell'.[3] Except at home and among their large family in Denmark and Norway, German became their first language and to Norwegians, at least, Ove's Danish always betrayed a detectable German intonation. He later recalled that even in the proudly independent Hanseatic cities of Hamburg, Lübeck and Bremen, governed by merchant oligarchies, German imperialism was being proclaimed with increasing stridency. Such an emphasis at school turned Ove and his brother into Danish patriots, not least because Germany had been proclaimed as the enemy of Denmark ever since attacking Schleswig Holstein in 1864. For the two brothers the highpoints of every year were the long summer holidays with cousins and Matilda's parents in central Norway, or with stepgrandparents at Åbenrå in Schleswig. Henning told their beloved half-sister Ingeborg that the only criticism made by the Hamburg headmaster of the star pupil, Ove, was that 'he was not paying attention in English'.

Johannes Arup planned to retire from Hamburg to Denmark, and in advance of moving, Ove was sent off to a boarding school, some seventy kilometres south-west of Copenhagen, where he stayed from August 1907 until

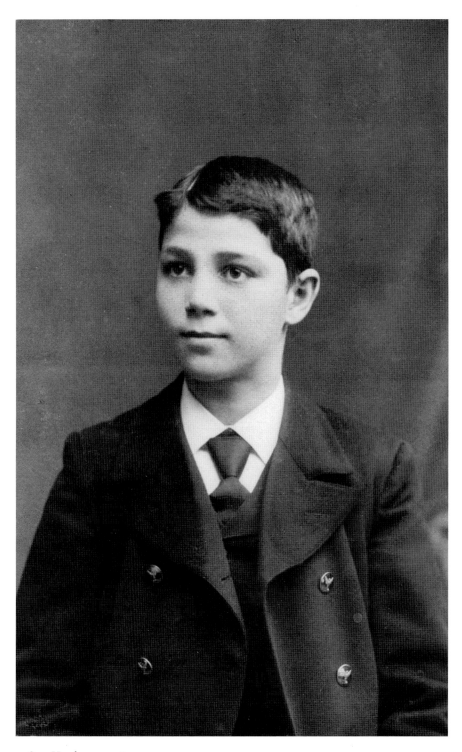

1. Ove, Hamburg, 1906.

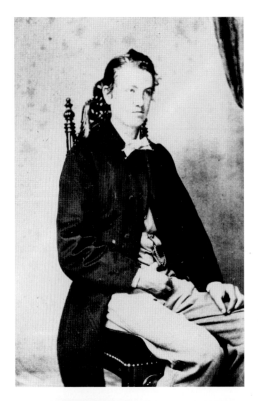

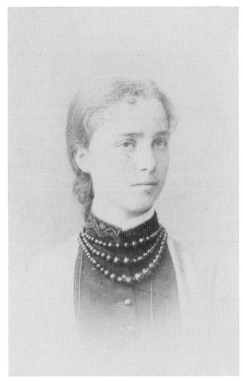

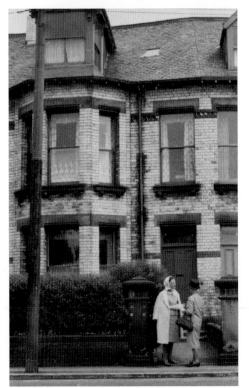

above left 2. Ove's father, Jens Simon Johannes Arup, 1860s.

above right 3. Ove's mother, Mathilde Bolette Nyquist, 1880s.

left 4. The family house at 16 Jesmond Vale Terrace, Newcastle upon Tyne, where Ove was born. His wife Li and sister Ingeborg are standing outside, 1967.

5. Johannes Arup, on the occasion of his second marriage, 1893, with his brothers and their wives (from the left): Peter, with Malvina behind; William and Elise; Frederik and Petrine; Johannes and Mathilde standing.

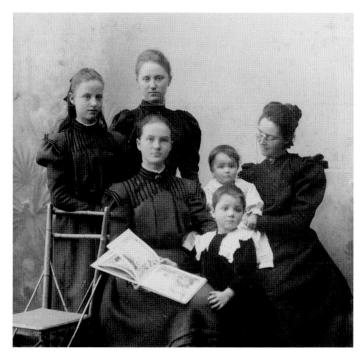

6. Ove (standing) with his siblings and his mother (far right), 1898.

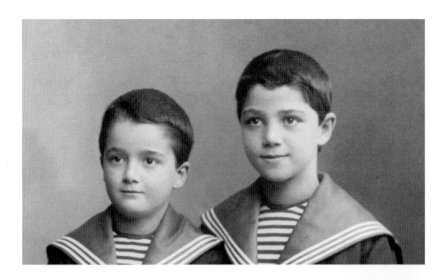

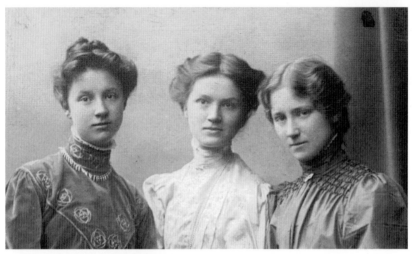

top 7. Ove and his brother Henning, Hamburg, 1903.

middle 8. Ove's three sisters, Ellen, Ingeborg and Astrid, Hamburg, 1906.

left 9. Ingeborg, 1906.

facing page top 10. Molbechs House, Sorø Academy, 1912: one of three original boarding house pavilions, named after the first housemasters.

facing page middle 11. Sorø Academy Library, where Ove 'came across Darwin'.

facing page bottom 12. Sorø Academy orchestra, Ove standing on far right, next to portrait, 1913.

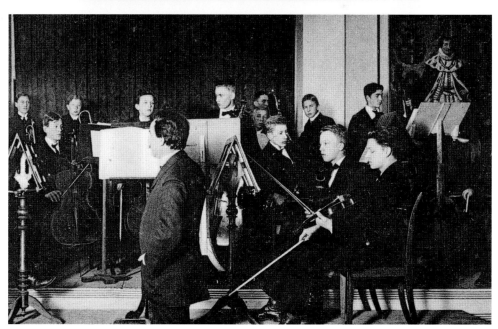

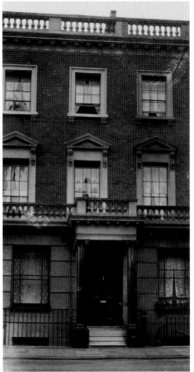

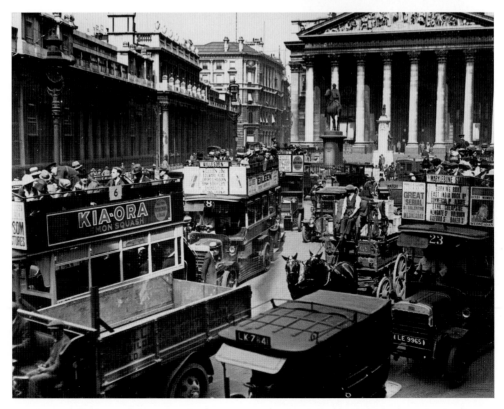

above 16. In retrospect, fogs typified Ove's moods and the London of his early days, when he walked across the Thames to work, 1931.

facing page top left 13. Ove as a philosophy student, Copenhagen, 1916.

facing page top right 14. Ove's first London lodging, 22 Cambridge Street, Pimlico, December 1923.

facing page bottom 15. Traffic at the Bank of England, 1922. Ove walked miles through the city at weekends.

17. Esther and Ruth Sørensen, 1916.

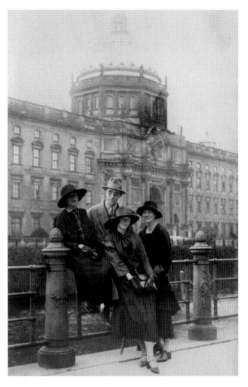

18. Ove with Ruth (Li) Sørensen and her sister Esther, who were 'au-pairing', and their mother Dagmar Hahn (left), 1924.

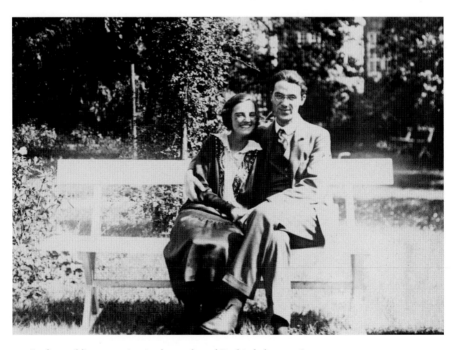

19. At the wedding reception in the garden of Ruth's father, 13 August 1925.

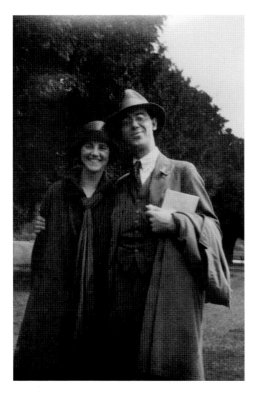

20. Li and Ove, 1925.

21. Ove in London, 1927.

22. Li at Albert Bridge Road, London, 1925.

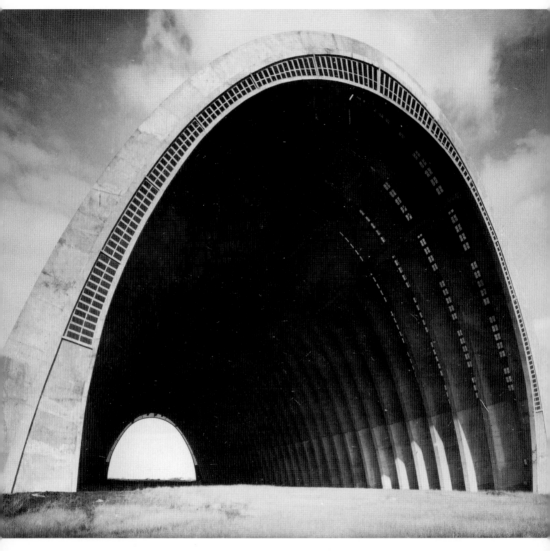

23. Two vast airship hangars were constructed in pre-stressed concrete by Eugène Freyssinet between 1921 and 1923 at Orly, France. Each was 175 metres long, 91 metres wide and 60 metres high. The form, scale and construction of the hangars attracted considerable attention among engineers and avant-garde architects.

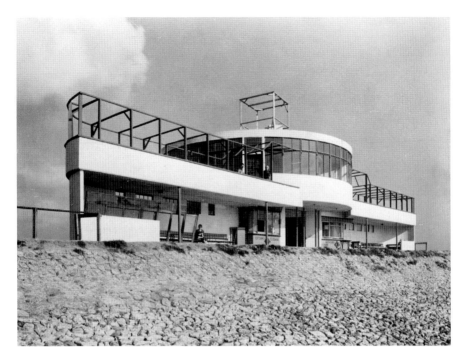

24. Ove worked on this café and shelter at Canvey Island, Essex, for Christiani & Nielsen in 1932–3.

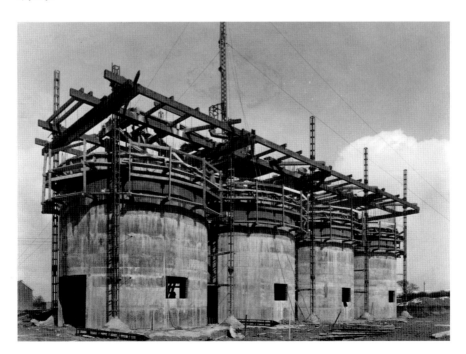

25. Ove adapted marine techniques of sliding shuttering for land use: he constructed these silos at Barking, Essex, 1933.

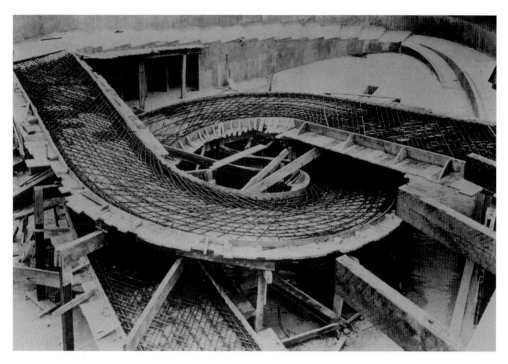

26. The Penguin Pool at the London Zoo, on which Ove collaborated with Berthold Lubetkin, 1933–4. Its structure involved complex mathematical calculations, which were completed by Felix Samuely.

27. Ove, 1934: painters are adding finishing touches. After enjoying alternative accommodation during renovation of the pool in 1986–7, the penguins 'refused' to return.

28. Model of Highpoint I, 1933–5.

29. The sliding formwork for Highpoint I was supported by yokes which were raised by hydraulic jacks.

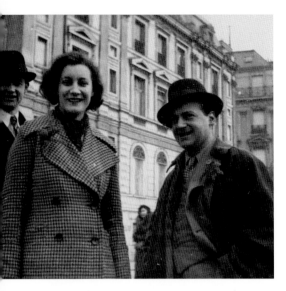

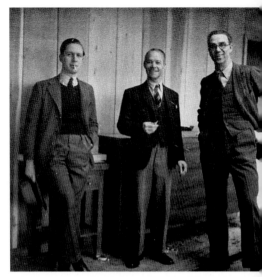

30. Lubetkin and his future wife Margaret in Paris, celebrating the prizes for the shuttering at Highpoint and designs for working-class flats, March 1935.

31. Cyril Mardall (Sjøstrøm) and Henry Crowe (Krog-Meyer) celebrate with Ove the opening of Arup & Arup Ltd, Civil Engineers and Contractors, April 1938.

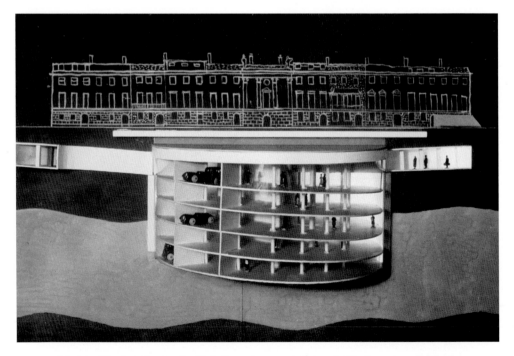

32. Model of Ove's design for double-helix underground shelters in Finsbury, intended for later use as car-parks, 1938.

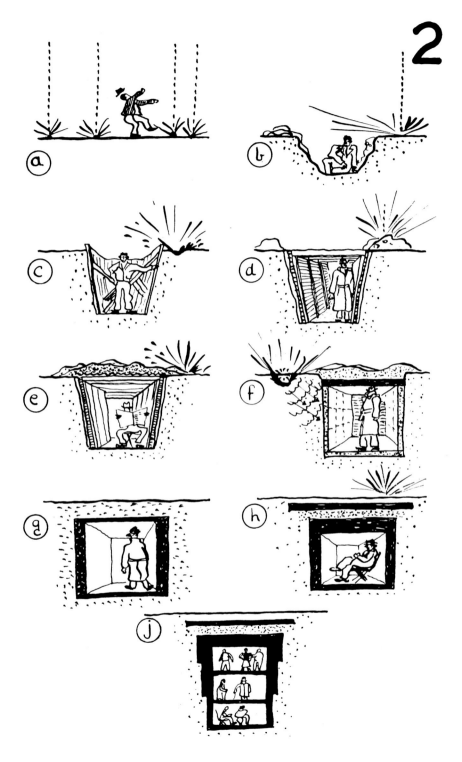

33. Gordon Cullen (1914–94) designed witty diagrams for the Tecton-Arup report on deep shelters, to illustrate the dangers of bomb-blasts.

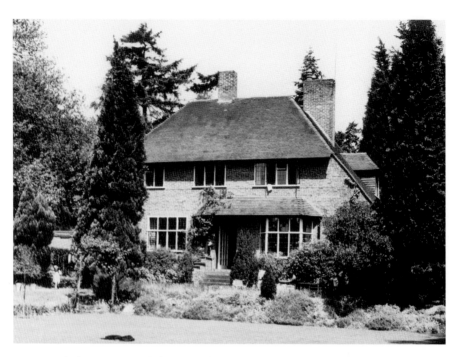

34. Dana, the house in Surrey belonging to his cousin Arne, to which Ove evacuated his family from North London in 1939.

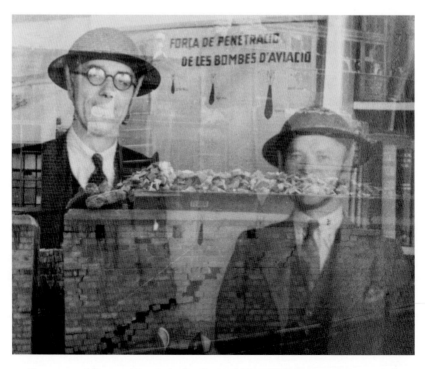

35. Four years of fire-watching duties for Ove and his colleagues were anxious occasions for them and their families at home: 1940. A poster from the Barcelona shelters is in the background.

July 1913. There had been a school associated with the abbey at Sorø since at least 1562, but Sorø Academy had been re-established, with a royal charter, in 1623, on a large estate of woods and lakes.[4] Although it had suffered managerial misfortunes, it thrived again during the nineteenth century, and by 1900 the school had adopted many of Dr Thomas Arnold's principles and practices from Rugby School, in England. Ove encountered precisely the challenges and discomforts of an essentially English public school education. Initially handicapped by imperfect Danish and increasingly introspective, Ove nevertheless was a good scholar and especially valued his piano lessons, which had begun in Hamburg. The school aimed to make pupils think for themselves and to open their eyes literally and metaphorically to the world around them. Ove thrived in these conditions, although the sporting side did not appeal at all, nor the relaxed social and moral attitudes of his wealthy peers.

In the December school plays of 1909, 1910 and 1911, by Holberg, Molière and Johan Herman Wessel, the names of his lifelong friends Henry Krog-Meyer (who, in Britain, changed his surname to Crowe) and Aage Bugge appear: the accompanying music, played by the school orchestra, included works by Bach and Gluck, as well as by Boccherini and Sacchini, two late eighteenth-century composers whose extensive chamber works were then little played in Britain.

After the first year in school, regulation dress was a blue jacket with two rows of phoenix buttons, a blue waistcoat with one row of phoenix buttons, and for everyday wear blue or dark grey trousers. A white summer outfit was allowed only when a formal notice had been issued. Side pockets in trousers were not permitted.

Ove treasured his schooldays, and he kept a mass of memorabilia: letters, school reports, calendars and magazines, student messages and japes, caricatures and sketches. Affectionate thank-you letters to his half-sister Ingeborg list his birthday and Christmas presents: handkerchiefs from mother, a photo album, money, gloves, books, postcards from Henning (still in Hamburg), a watch from father – and later a fine fishing rod. In February 1911 Henning wrote to Ingeborg in halting English – his brother was nearly sixteen: 'last Saturday here was a big, end-of-season ball at my Dance school. I was not there but Ove was. It did not amuse him very much, so I am glad that I was not there.'[5]

Krog-Meyer, one year ahead of Ove, later recalled the years 1909–11:

School classes began at 8.00 a.m. and lasted 40 minutes: an afternoon break for sports or free study between 12.10 and 3.40 was followed by two more classes, the last of the day ending at 5.10. Dinner was at 7.30 p.m. bedtime

was 10.30 p.m. We lived on the first floor of the headmaster's house. [. . .] There were six single rooms which were awarded to the best [. . .] students; you chose a room according to how many points you had, and it was most enjoyable to be able to move into a single room with two cupboards instead of one. Inside the cupboard there was a long list with the names of previous occupants, and you proudly added your own – the last name in a line of great predecessors.[6]

Most of the students were right wing in their politics and, in spite of boisterous debates with more liberal students, only conservative newspapers appeared. Ove contributed both to the school magazine *Minerva* and to the student society called 'Baldur', which met every Wednesday during the winter; members of that society were permitted to smoke, which they did energetically. Because a favourite author among the less superior Sorø students was John Coryell, who wrote innumerable novels about Nick Carter, members of the Baldur Society formed an 'Anti-Nick-Carter Society'.[7] The student committee always found it difficult to think of entertaining meetings, although there were irregular visits by outside speakers: typically they drew lots, and the losing student had to produce a lecture himself. Of course, Ove occasionally drew the short straw. 'On hospitality and entertaining' was one result:

What then, is entertaining? Well, this is more complicated. Here, everything works according to set rules and regulations, and adhering to these is considered part of good manners. [. . .] It is important that you gather as grand a party as possible so that anyone may see that you socialise with persons of rank. The house has to look its very best; if necessary you rent flowers, paintings, perhaps even furniture for this one night. Of course you must attend wearing a certain kind of clothing, stick to certain formalities, dance with the daughters of the house if you are attending a ball, praise the food, etc. What you actually do is eat several fine dishes. Make conversation, eat again, perhaps listen to some boring pianist, smoke, drink wine, eat fruit and dessert until at last it is acceptable that you leave. Of course you have had a splendid time, and you are looking forward to receiving the host and hostess in your home on another occasion. To put it briefly, then, it is all a matter of appearances rather than reality, you say a whole lot of things which you really do not mean, etc.

Here, at the age of fifteen or sixteen, Ove reveals several characteristics that defined him to his friends and family, particularly a combination of ironic detachment and a clear intention to enjoy himself. After he settled in England, a decade later, he had to devise strategies to ensure such enjoyment, while suf-

ficiently conforming to the often stifling social etiquette of the day. Ove's school lecture book contains slighter pieces, but after discovering both philosophical and scientific books in the school library, his writing became more ambitious. A critique of Lutheran orthodoxy struck Ove, in old age, as quite impressive, but the author who most captured his imagination was Darwin. An equally good essay on evolutionism is not dated, but since he signed the school library slip to borrow *The Origin of Species* on 19 September 1911, it probably belongs to that period of study. When he was seventy, he recalled that at the age of fifteen he wanted to study science rather than classical languages:

> At that time I came across Darwin, I read *The Origin of Species* and *The Descent of Man* and that set me thinking of a lot of things. I liked his sober, methodical, scientific approach, and it seemed to me that he had established without doubt, that all species, including man, had evolved from lower forms, by whatever mechanism this was achieved.[8]

In another school essay, on 'The benefits and dangers of wealth', he wrote:

> For most people, wealth is not a beneficial thing. [. . .] Only when you spend your wealth on some great cause to the benefit of mankind, or to reach scientific results that you work hard to attain, or to help some of those thousands of people suffering in the world, only then do you benefit from wealth. Wealth will damage all those people who can't resist its dangers, and it won't benefit the rest particularly.

We should not dismiss this as either priggish or naively idealistic: later on, Ove helped a considerable number of people financially with gifts and loans, although he rarely had to forego the comforts of life himself – a champagne socialist, as one friend anachronistically described him.

During and after class boys scribbled notes to each other on tiny pieces of paper or the flaps of envelopes. Ove's collection includes rules for the farting box, arrangements for fights, the geography master's routine jokes, invitations to play cricket and to go rowing, remarks about a blonde Brunnhilde Ove met in Hamburg, and a complaint from his friend Aage Bugge: 'Stop hitting me, you act as if you are in the class above, but you aren't. I don't mind fighting for fun, but if it gets serious you had better watch out.' There is a challenge to a duel from another friend, August Baumann, who insisted: 'As I am smallest, I shall decide which way we shall fight. [. . .] I only fight with seconds.' By June 1912 Baumann was an active member of the Copenhagen Rifle Corps, and was working on navy boats. He sent a prescient warning to Ove about rearmament throughout Europe: 'You'll probably notice all this

yourself when you join the University Rifles', adding that one should speak with caution about such matters. A few months later, in reply to Ove's questions, Baumann insisted that they should all be on the conservative side, mainly because both socialists and anarchists were currently rejecting all efforts at defence.[9]

In July 1913, before setting off for Greenland, in order to revise peacefully for examinations, Aage Bugge expressed concern that Ove was so uncertain about a career:

> I can only wish that you'll pull yourself together and become a <u>man</u>, you're too young to despair yet; don't circle around too many of the plans you were harbouring in Sorø. [...] Thanks for our years in Sorø, I do believe after all that that we have sometimes meant something to each other, at least you have to me.[10]

From their first enrolment Sorø students were expected to undertake holiday studies. Among half a dozen essays dating from 1909 are descriptive pieces on the school day, family gatherings in Norway, and visits of his parents to the school. In an essay headed 'What I want to do when I grow up, and why', Ove wrote:

> when I was just five or six years old, I wanted to be a master builder, but later on, I felt more like being a farmer, or a forester. Now I think I would like to be a forester. This is partly because I would then be living in the country and near the forest, and I do not care very much about living in the city. Also, I am very interested in natural history, and this would give me plenty of opportunities to study animals and plants.

Among the many books with which pupils were provided, all of Ove's containing his signature on the flyleaf, are a history of the school and a songbook, in which the romantic songs, commonplace for the day, include allusions to the Norse mythology that played a vital role in school life. Yearly reading lists were issued to pupils, together with the School Library Catalogue, originally printed in 1898, and which Ove marked up: all the editions are in Danish. He underlined: in the literary sections, numerous works by Carit Etlar, some by James Fenimore Cooper, and very prominently those by Frederick Marryat – including *Peter Simple* and *Mr Midshipman Easy*. In the French section all the works are again in Danish editions, with the exception of classical authors: but only works by Jules Verne are underlined, and in the scientific section only works by Darwin (translated by J. P. Jakobsen) and Nansen. More than fifty years later he recalled:

I read other books, the German Haeckel, whose brazen materialism I found very shallow, Spencer and various others, but also Kierkegaard, whose savage attacks on the hypocrisy of official Christianity I could not but approve of. And I admired his wit and irony, and the intellectual honesty of his 'credo quia absurdum'. I also got a vague idea of Indian philosophy, and read Høffding's psychology – and for that matter Thomas Hardy and Bernard Shaw's 'Plays Pleasant and Unpleasant' and Danish and German literature, and Ibsen, of course. Not that I was a bookworm exactly, I did many other things, and enjoyed the last years of my school-days. I was actually very sorry when I had to leave. But all this had left me rather bewildered, there were so many problems to solve; How did life evolve from matter? How to square free will with determinism, Western science with Eastern mysticism? The nature of truth, the foundation of ethical beliefs and behaviour – all that and more. Obviously I had to find out before I could think of a profession. It seemed rather absurd to me that the object of life should be to earn a living. So I decided to study philosophy.[11]

One feature of Sorø, evident also in the best British schools of the time, was the independence pupils enjoyed, risky though it could be: at its extreme, some boys were free almost all day, because the responsibility for self-discipline had to be learned. Moreover, as end-of-year photographs reveal, the sets in the upper forms were small – usually no more than six pupils. But his school reports, endorsed by his mother's signature, curtly state in November 1908: 'often fails to pay attention'; in September 1909, in English, 'Cannot maintain a 6 unless he starts paying more attention in class', and in geography 'does far too little work'; in April 1911, 'not prepared for English translation', and in French, 'absent minded'; in January 1912, having secured the top grade 6 in most other subjects, in French also 'by perseverance he should be able to attain the mark of 6'. Like most clever children, he was easily bored by unchallenging studies.[12]

In his senior years at Sorø and at university Ove kept a private diary into which he poured his soul. On 11 October 1911 he recorded that the previous weekend their mother had asked Henning and him to come home from school where they also found their half-sisters Astrid and Ingeborg. Their father was suffering from cancer: 'He himself believes that he will die soon, and looks forward to going to Sorø. I wish he would get well.' They returned to school, where he had to rehearse three pieces of Schumann for the Baldur Club. On Thursday 19 October he reported:

Father dead. 'Remember my son, that first of all, you have to have good thoughts with which to chase away bad ones. That is most difficult, especially when one is among young people. That is what my father did in his time.' Those were the last words Father said to me last Sunday. I hope I will always remember and abide by them.

After the death of Johannes, Ove's mother sold the house and moved back to Copenhagen: Ove lived at home in his first terms at university, like most other students. He matriculated on 4 October 1913, and from his first weeks of study launched into lectures by Professor Harald Høffding on religious philosophy, as well as courses on the history of philosophy from the Renaissance, and a specialist course on Kierkegaard. He took to the subject, and after two weeks dramatically inscribed a new notebook on philosophy 'Op.1.No.1': and dated it 24-11-1913 – which confirms that it was not, in fact, his first set of notes. Nevertheless, the notebook covers a course on Bergson, Descartes, Locke and Guyau, and long passages in English are transcribed from Locke.

The first-year reading list included recent works by Lucien Lévy-Bruhl (*La Morale et la science des moeurs*, in its fourth revised edition, 1910) as well as substantial late eighteenth-century commentaries on Kant.[13] Ove was also required to be acquainted with one of the leading English works of the period, Henry Sidgwick's *The Methods of Ethics*, 1874. Among English works to be studied in the course on European literature were novels by Bulwer-Lytton, Dickens, Thackeray and George Eliot. Some seventy years later Ove declared that when he came to Kant's *Critique of Practical Reason*, he 'simply couldn't take it: especially the idea that the really good man was he who hated doing it but forced himself from duty to do so. [. . .] Only the intention to do good could be good. That's when I said "No, Sir. There must be something wrong here." '[14]

In old age Ove recalled only times of intense emotional turmoil as a student. At the age of ninety he claimed that 'early on, I never got to know about sex – my mother talked about bees and flowers'.[15] There were endless philosophical discussions, but there were plays and concerts at least twice a week. The concert programmes reflect Danish cultural life as it gingerly faced the twentieth century. Ove's musical preference was for piano, violin and song recitals. These embraced works from Bach to the Romantic composers – especially Chopin and Brahms – and included pieces by César Franck, Saint-Saëns, Grieg and Dvořák. The symphonic repertoire was limited to Tchaikovsky and Beethoven, usually his Ninth Symphony – with an occasional work by Mozart or Haydn. Looking back, he admitted that, as a student, he had found Mozart rather 'lightweight', although he later changed his mind.[16] He was keen to

hear Sibelius, whose fiftieth-birthday concert he attended in 1915; and he frequently attended concerts and operas conducted by Carl Nielsen, then at the Royal Danish Music Conservatoire in Copenhagen, the first performance of whose Fourth Symphony he attended in 1916. In later life he recalled with special pleasure the Bach organ recitals of Karl Straube in 1914.[17] He attended the annual students' concerts, particularly if a friend was performing. Ove scribbled comments on his programmes: 'good voice', 'weak', 'very impressive, strong'. Among notable musicians, he heard Arthur Nikisch direct the Berlin Philharmonic in Berlin,[18] and Richard Strauss conduct a performance of *Der Rosenkavalier*, with Melchior in the baritone role of Faninal.[19] To underline his own commitments, Ove inscribed his own music scores: his copy of the Peters edition of Chopin's polonaises is dated 10/8/15, and the Universal edition, containing the three posthumous polonaises, is dated 1/12/15. The diary over those months mentions nothing of the war: the failure of the Allied offensive in the spring, Gallipoli, or the carnage that had become global. His copy of Chopin's waltzes is signed but not dated, and many individual pieces are marked; the Peters edition of Beethoven's sonatas and Book II of Schubert's are undated, while Book I of Haydn's is dated April 1916. Ove's scores of Scarlatti, Schubert and some violin sonatas also exist. None of these works is elementary, and his admiring private audience frequently alluded to his playing in their affectionate letters. He was still regarded as a good pianist by professionals up to the early 1930s, but thereafter he played seriously only for himself; on returning from the office he invariably went straight to the piano, where he enjoyed improvising, and tackling short pieces by Poulenc. His children recall with the utmost pleasure falling asleep to the strains of music from downstairs. In his last years, he mostly improvised, in minor keys, or played entirely from memory.

But Ove's later recollections of his student days were not primarily of either philosophical or musical engagement because, during his first term, aged eighteen, charming, elegant, slim and over six feet tall, he met Olga Kaae. Whenever daily meetings were interrupted, letters flew between them – sometimes three a week. Philosophical conversation and music were the common threads in all of Ove's early attachments, together with a great deal of introspection as relationships evolved in unwanted directions. Deep down, perhaps, both Ove and Olga yearned for something closer, but that did not occur: Olga's letters mention that the two of them never get a proper chance to meet, although she was perhaps less keen on the idea than Ove.[20] She assiduously observed the conventions of the time, although Ove was clearly trying to bypass them. She used the formal 'De' and also addressed him as 'Kære student

Arup', 'Kære hr. Arup' or 'Kære Arup'. On one occasion she indignantly asked, 'Why do you always address me as O.K. rather than writing my full name?' A pressed flower is still enclosed in an otherwise formal note from 'O.K.'.

Denmark, inevitably nervous about its southern neighbour, did not engage in World War I: silence about it, however, was impossible. Throughout the summer of 1914 Ove went on long bicycle rides with Henning or by himself. The rains of that summer, as they trundled through desolate villages where boarding houses had been closed and evacuated, only deepened his despair. Diary entries for that period are stark.

2/8/14

By the way World War is brewing. The Situation has been tense for some time. Austria and Serbia are at War and now this morning I heard that Germany has declared war on Russia. So now it's on . . . People everywhere are talking about the War. Soldiers are being conscripted etc. I don't care. I am rather pleased by it all, because it is at least exciting. We may lose all our money: but so what. Anything can happen.

7/8/14

The War is in full flow. Germany has declared war on France, England, Belgium also. And rumours abound everywhere. Many people are anxious about it, but I don't care in the least. If Denmark gets involved in the War I think I will join the Academic Corps and make sure that I get shot as soon as possible.

8/8/14

It sounds as if Germany is being beaten.

13/8/14

I sincerely wish that Denmark would get involved in the War. I would then volunteer and get shot. Hurrah for Denmark. In Belgium, people are being slaughtered in their thousands.

Telegrams posted on village notice boards reported claims to victory in both Berlin and Paris. It seemed sensible to get a ferry back home to the mainland, but that turned out not to be a casual matter:

17/8/14

All the straits are mined. Weather has been beautiful these two days. . . . There is no proper news of the war, there are victory jubilations in both

Berlin and Paris. However, it seems that the Frenchmen are in the better position thanks to the Belgians' defence of Liège. Well, peace be with them. – Now nearly everybody has left the bed and breakfast. On Wednesday, Astrid and Ingeborg will be the only ones left. – How damned grim my fate is!!

To promote its neutrality Denmark had mined its own waters. This had been done with German support, but the gesture was soon regretted because naval flexibility was hampered. But the ferry did not sink, Ove was not conscripted, and he was not shot. Nevertheless, the introspective gloom of his later years had its roots in the febrile contexts in which his identity was formed.

Professor Høffding's course on philosophy of religion in 1913 heightened, if it did not exactly focus, Ove's doubts. On 1 September 1914 he recorded in his diary: 'Today I have been to Pastor Rode's to get the form for leaving' the Lutheran state church, into which he had been confirmed at school. After such a crucial decision, he needed time to warn his mother: even at the age of ninety he still resented the treatment he had received as a youth at the hands of grown-ups who 'did not really believe'. Whenever he asked a question 'they would only talk baby talk to me or tell me to wait until I grew up', and he smarted under the title of 'Der Kleine Herr Professor'. And as for God's behaviour towards Abraham: 'that was an outrageous way to behave. I told him: "That is not the way I expect God to behave – you are sacked!" '[21]

But how was he going to tell his mother? As he poured out his soul on to sheets of yellow paper, there occurs the first recorded thought of studying engineering, which his cousin Leif had casually suggested while out sailing. First, however, he needed someone, a guardian perhaps, in whom to confide. But there were objections to each of the four most obvious candidates:

1) The ideal friend. 2) Høffding. 3) A doctor. 4) Mother.

1) . . . the ideal friend does not exist in the real world. . . .
2) . . . A nice man. But that is almost asking too much of him. After all, it is mad to go to a stranger about such things. Would he be interested? Would I be able to go to him and say it? – no. What right would I have to do so?
3) . . . it's his job, after all. It would be a business deal. But a <u>total</u> stranger? . . . And would a doctor be able to heal my soul? It is bad.
4) Mother. This would seem the most natural solution. But there's mother's religious view of life to consider. She doesn't understand me. She would drag religion into it. And then I'm deeply ashamed of myself.

There were certain facts to be faced:

<u>That for the moment there isn't a single thing you can do other than become an engineer.</u>

True enough, you could shoot yourself in the autumn, if this doesn't work out, but you might as well try to do it this term, since you won't be any happier if you give up on it immediately.

Secondly, when all is said and done, it wouldn't be the worst thing to happen, to become an engineer. The joy of the work, the results, travel, books, music, people. The respect of your fellow human beings, officially you're managing, etc. A little love here and there – or perhaps "for ever" – on ne sais pas [sic] what may happen. Irrigation plants in Mesopotamia, India etc. A room, wine, a book, an armchair, a pipe.

You have the wretched skills – in any case enough to pass the exam, and burdening yourself with doubt about your practical skills before you know them, letting such doubts influence your exam results, is not exactly clever.

What ought you to do about this?

<u>Do something</u>. Go to lectures. <u>Do the sums</u>. Most of all, <u>show your friends that you're independent</u>. [. . .] Never fool yourself that you're hopelessly in love. [. . .] Get used to deciding on something, and then doing it.

Be good to other people, to mother.

After all this, he decided to write his mother a careful letter, and to go into town for dinner, leaving it for her to read and ponder:

Dear Mother, I have been in the most despairing situation and was close to giving up on everything. I did not have the necessary energy. But now I'll try once more. It's a question of developing one's will, I have to help myself, because I do not believe and will never end up believing in any god. Do not talk to me about this any more, because it is no use. But you'll have to help me, too. I have always wanted to say this to you, but I couldn't. I would rather die, I thought. But it is good that you know this. If in the future I should be overcome, I will tell you, and my fear of doing so, the shame of it, will help me. And I do not want any other help. And I would rather if you didn't talk to me about this, or about Christianity, because it only hurts me. I have to help myself. And if things don't work out this time, then I'll have to shoot myself sooner or later. It is not my bad conscience, as you think, it's just that if I cannot get over this, then I cannot live, because then I don't have enough energy, not enough will to do other things, either. And I promise you now that I'll do everything I can. And it will be a help to me that you know this, that you watch my struggle, because I will do anything

I can not to make you sorry. But I don't have any energy just now, and things might be slow. And I'll do what I can to help you, too, but I hardly know how to, since I don't have your faith.
Ove

He continued to record his introspection: the ironic tone and style of Kierkegaard, whose works he had studied and much admired, periodically colour the episode. In November he noted that

> At my place we talked about the war; at Jørgen's I talked about myself and to some extent poured out my heart to him. In a way he understands, sort of. – Hitherto I have been lazy; now I ought to start working. Not think, just act. One has to pretend that there is some meaning in things, close one's eyes to the fact that everything that one does is meaningless. Resignation. And then by and by, will. If one hasn't gone to the dogs in the meantime.

This was Jørgen Jørgensen, who later became Professor of Philosophy at Copenhagen: they were friends and rivals, and Ove was deeply disappointed not to secure the vacant lectureship offered to Jørgensen, after they graduated, even though he had not applied himself so diligently to his studies.

Letters from Olga poured in, were logged, and analysed in the diary.

15-11-1914

Dear Mr. Arup,
If only I understood why on my birthday you let me know that I existed in your memory, if it wasn't because you wanted to be in touch again like in the old days. [. . .] I have never wished to appear as anything special to you, but made great efforts to take things as they came and went.

21-11-1914

Dear Arup.
Thank you for your letter. [. . .] I really thought at that moment, thank god that you are not sentimental. When I reached the bit "I love you" I said to myself, "Nonsense", out loud, and thankfully you yourself say something similar right after that. All in all, it is all nonsense, but I am pleased about one thing – that I wrote to you, because now I feel that after all we can see an end to things. I must say, I have always cared about you an awful lot, too, but for that very reason I have been bothered as well by the imbalance in our relationship.

He saturated his notebooks, conversations and letters with his inner musings. On 1 December 1914, for example, he wrote to Olga:

> I really do not have anything to write about, and in a way the most sensible thing to do would be not to write at all, but I still do feel like writing to you, and that's why I do. Yet I have to write about something, and therefore I am going to write about myself; unfortunately this is what seems most natural to me. [. . .] But you only get to know yourself through interaction with the world around you, by taking on those tasks that are at hand, and not by becoming deeply absorbed in reflections about yourself. By doing so, you only tear yourself apart, you dream instead of acting, and in the end you take away your own ability to act. [. . .] I am unable to focus my attention on anything at all. I sit for hours staring at a book without reading a single line; the smallest of sounds, the smallest of influences from the outside or the inside are enough to distract my attention away from the book [. . .] losing my self-confidence. And at the same time I lost the faith of my childhood, and more than that, my faith in anything at all. It did not matter to me before, but now I need to believe in something, to have something to lean against, something to fight for. For this, not believing in anything, not having an ideal, an aim, that is total hopelessness.

Ove was worried that he thought too highly of himself, believing himself to be capable of great things, but not tackling even the simplest of tasks that might prove it. He would confess to ambition only if allowed to distinguish two types: the 'good' kind, which fuels a search for one's identity and proper ideals, and the 'evil' kind, which is governed by the judgment and ideals of others. Hope resides in pursuing the 'good' kind, refusing to compromise with true ideals. But he assigned his inability to act to the lack of an ideal, as well as to lack of will. The latter resulted from the impossibility of reconciling beliefs and emotions, so that he found himself repeating the questions: 'Why? What for? What do you really want?' Of course, a complex psychological state cannot be adequately conveyed in words, so even what he had written was incomplete, misleading, distorted: 'Thus, it is most likely that what I say is completely wrong; in any case it is a one-sided abstraction, and I can only say that sometimes this is the way I believe things are. If I had to describe my condition with a single word, it would have to be "chaos".' It is not clear whether Olga had received this last letter when she wrote:

> we have never really had the time to talk about me when we have been together. [. . .]

First of all, I am very much afraid that you think far too highly of me. I am by no means a steady support in life, even if at times I may have appeared so, when we talked to each other. When I have been defending religion, I have done so less because of experience than because you appeared in the attacking part. Yet I believe that our doubts on this matter are based on completely different things. As far as I understand, you doubt if this and that may be proven or pointed to as a genuine historical fact, whereas I to a much greater extent, or almost entirely, doubt I myself am able to receive a part of the personal relationship with God. [. . .]

I fear, too, that you think that I am much wiser than I actually am.[22]

Olga reprimanded him for mooning around reading novels and playing chess. She worried that 'perhaps another time you won't be able to fall in love with another young girl because you have dedicated too many unnecessary thoughts to me and I to you.' Two years his senior, she felt acutely more mature. Introspection and self-torture over their relationship drove him to write and re-write what he wanted to say: one letter in May 1915 survives in the form of seven drafts, some of them a foolscap page long. Penned over three days, they were all addressed to 'Miss Kaae'. He was deeply upset about her suggestion to write less often. No doubt he feared a likely outcome. One draft:

every day I think of you, long to hear from you, see you, talk to you. I know that I shouldn't bother you with this, and for a long time I have restrained myself, but I cannot stand it any longer; I know that it is foolish of me to write, I know that I will achieve nothing by doing so, I don't even know what I wish to achieve by it. [. . .] I know only too well that you cannot help me, and yet I write to you, just to do something, just to talk to another person, just so that you may write something back to me. What on earth should I do, I love you so, Olga Kaae.

By June of that year, Olga found herself apologising for her recent tone, and for her suggestion that they write less often:

We're only moving from one extreme to the other. [. . .] it is entirely a matter of chance whether we'll see more of each other or not, and I feel that both of us deserve better than to be depending on chance. [. . .]

I agree to decide on an end when the two of us decide on this together, but I dare not take the <u>sole</u> responsibility for putting the final stop to it all. The thing is, you see, I care for you more than I wish to admit to myself, and when I have continued to hold back on letters etc., it is only because I

know that the very people who feel the strongest sympathy are able to hurt each other much more severely than those who never cared for each other at all – and this is where the danger lies.[23]

By the autumn of 1915 things had cooled, her letters now no more than studiously polite, with suggestions of a walk or piano playing. But a year later she sent Ove a locket that used to belong to one of her uncles:

I wish that I could give you this present without your having to speculate any further about where it came from, but of course, I cannot be in control of your thoughts. However, I can tell you that generally I have a passion for giving presents to people that I have been in touch with, who are having hard times in one way or another, and now you just happen to be one of them. I have left my grandfather's picture in the locket.[24]

Ove had, of course, read the signs.

For much of Europe, the morning of 11 November 1918 was supposed to signal an end to ghastly slaughter and meaningless distress: the geography and structure of the continent had been re-shaped. On that very day Ove received the letter he dreaded – ironically, Olga was writing from 'Peace Street':

Fredensvej 22 Charlottenlund

Dear Arup,
This is my second attempt to write to you. Perhaps on this occasion I will manage to tell you what I think. Only time will tell.

The last time we spoke on the telephone about meeting up somewhere, but I haven't really been able to feel at ease with this. It was right once, but that time is past now. The reason that I contact you at all now is the letter that you sent to me the other day, in which you say that you would like to see me again. I did believe that the last time we met I had made it perfectly clear to you that I had taken another view of life, which quite naturally cannot be of any interest to you. Obviously, I am able to speak only on such assumptions as I have at the moment, but it is my experience that non-Christian people inevitably must look down on Christians as a kind of lower race.[25]

Olga felt that they could not enjoy conversations together without touching on the subject of religion: it would be best, therefore, to avoid them altogether. Towards the end of her letter, however, she recommended a church worth visiting, should Ove ever feel inclined to do so. And if she also happened to be in church that day, Ove would be welcome to visit her after the service: 'I am

sure we would be able to pass the time somehow. With kind regards. Olga Kaae.' The day after Olga's letter he confided in his notebook: 'is it only possible to either love or hate a supposed spiritual master? Is there no other possibility?'

With distinctly modified rapture Ove started his engineering course at the Polytechnic Institute in Copenhagen. But he threw himself into music, and social life – with more girls. His conversations with friends gave them the clear impression, notwithstanding the fashionable hyperbole of the day, that he had recently been, was again, or was about to be, in love with quite a number of the women of their 'group'. But there was other news to darken his gloom. His youngest half-sister Ellen Grønning died on 28 February 1919 as a result of the Spanish influenza pandemic, then at its height: a mere statistic in the hundred million lives it is estimated to have claimed in the two years up to 1920.

Fifty years later Ove admitted that at university he had 'got rather into a muddle': 'a lack of control over one's personal problems, feelings and behaviour – altogether taking oneself far too seriously'. Most of his friends were artists, who easily tempted him away from Kant or Schopenhauer to attend a party or go sailing, and he somewhat neglected his studies. 'Truth with a capital T' eluded him, and he 'abandoned philosophy'.

> Closer acquaintance had made me realise that it consisted of a series of specialised disciplines, Theory of Knowledge, Ethics, Psychology and so on, all involving a lifetime immersed in books, and none of them answering the questions I had set out to solve. In fact in philosophy there seemed to be no answers, only more and more subtle questions. Science, or any logical reasoning, cannot solve the human predicament: What is the whole thing about? What are we? Where are we? What are we supposed to do? What is good or evil? Can we, or should we teach the tiger not to eat meat? The greatest happiness of the greatest number? And what is happiness, and Truth, and Beauty? I revolted against ideologies, philosophical systems, moral codes, on Kant's insistence on rectitude in preference to kindness.[26]

There is a measure of rationalisation in this account of his youth. His philosophical ambitions, albeit largely unformulated, had been rudely shaken by Jørgensen's appointment to the lectureship: officialdom had not acknowledged his own unproven superiority, and a turn towards engineering would be an appropriately condescending rejection of everything 'they' stood for. On the other hand, Ove was correct that his basic philosophical stance had barely changed since adolescence, when he had aligned himself with the empirical

philosophy of modern scientific method: it was epistemologically sceptical, and in the moral domain often promoted social benevolence. Ove had rejected the rational idealism, and abstract universal prescriptions associated with Kant, and the dogmas, duties and dreariness he had experienced in Lutheranism. Years later he recalled: 'I realised that human relations are important, that art is important; listening to a fantasia and fugue by Bach I felt that here was something that was good in itself no matter whether the mysteries of this world were solved or not.' Moreover, he could, perhaps, 'be an artist on small matters', because creating something good of its kind would give satisfaction. He was not sure that he had 'enough artistic ability to become a really good architect', but he was good at mathematics, so engineering might be a solution. There was nevertheless a *caveat* – and a vital clue: 'I cannot say that I felt wildly enthusiastic about it, I disliked the idea of specialising, and felt that I was perhaps giving up too easily.'[27] Giving *what* up too easily?

In his later years at university he had several discussions with his respected philosophy professor Høffding, against whom he maintained that suspension of belief was rationally and morally justifiable, in contrast to meaningless commitment to unintelligible ideas. He also argued that it was both intelligible and realistic to acknowledge that someone may well choose the wrong road in full knowledge of the right. In August 1917, by then half-heartedly enrolled on his engineering courses, he was still obsessed with the conflict between thought and action:

> If thought provokes doubt, is this doubt then not 'justified', is it not necessary for the sake of intellectual decency? Is not 'intellectual decency' an ideal that should be highly esteemed? Or could it be that I happen to be made in such a way that my very self-esteem demands intellectual decency from me, demands that I do not chase away doubt? Choosing not to think, is that not indolence? Is that not escaping from the demands of your own personality, neglecting to use your skills? In this way, can I possibly satisfy my 'conscience', my real self? Besides, the security which I am supposed to reach through acting, is that not a precondition of being able to act? [...] Surely you ought to think as well as act; the question is an individual one, for the moment I ought to emphasise the latter. If only one does not get completely stuck in narrow-mindedness.

Such thoughts were the foundation of his lifelong hostility to abstract ideologies, on the grounds that they tend to detach their adherents from reality. He accepted the ancient insight that the demands of thought are unending:

'choosing not to think' is the ultimate immoral act. Only by acknowledging that fundamental duty could the ludicrous and often fatal intellectual, moral, social and political barriers between human beings ever be dissolved.

To a reader a century after the event, therefore, Ove's abandonment of philosophy for engineering may still appear unduly petulant. But the uniquely favourable Danish context, little known in Britain, provided strong rational grounds for the gamble: the key concept is what the Romans, by the third century BC, were calling *opus caementicium* – concrete.

2

'. . . to be a masterbuilder'

Ove almost never referred to ancient writings on architecture, even those by the Roman author Marcus Vitruvius Pollio or the Renaissance scholar Leon Battista Alberti. And yet their practical and philosophical reflections constituted the backcloth against which his own training, experience and ideas evolved.

Vitruvius wrote and published his *Ten Books on Architecture* around 30 BC; he derived his vocabulary from Cicero's works of twenty years earlier, and the terminology reverberated across the centuries. Vitruvius himself probably came from the Bay of Naples, and it was in that region that volcanic silica dust from Mount Vesuvius, mixed with lime and fired rubble, was found to set even harder under water: it became known as Pozzolana. Vitruvius was writing as a practical man, and had no need of tracing historical origins, even if he had known of them.[1] In his discussions of the material he described experiments to make concrete more weatherproof by using other materials, such as tiles, as facing for cornices, and efforts to strengthen it even more with embedded stone. The chemistry of concrete was of course unknown to the Romans, but they did know that small variations in the mixture altered its strength. A major discovery was that, when properly moulded, concrete was

strong enough to stand alone: this greatly reduced reliance on formwork which, because of the scarcity of wood, hampered both design and construction.

Pozzolana was well known to Renaissance French architects, who recommended it for foundations in water or marshy soil, and pozzolanic substitutes ('trass' or 'tarass' or 'terras') were commonly used in northern Europe from the seventeenth century onwards. But the most rapid developments took place during the nineteenth century, after the publication in 1791 of Smeaton's research since the late 1750s into mortars.[2] The manufacture of artificial cements by burning materials at higher temperatures, from the 1820s, accelerated the development of modern concrete; the best known of these was 'Portland cement', invented in 1824, which soon became the basis of cement and concrete mixes.

François Hennebique is normally credited with introducing reinforced concrete (*béton armé*) as an exclusively structural material for above-ground buildings. In 1892 he secured his first patent, in Brussels, which covered more than a decade of experiments, and set up in that year his engineering consultancy, moving to Paris in 1897. Hennebique's radical business techniques, including staff training, monthly newsletters, focused and aggressive marketing, quality control, celebratory banquets and prestigious head office ensured worldwide success that had no serious competitors. Within a decade, a young Danish visitor to the company, at that time more familiar with recent German reinforced concrete structures which had followed Joseph Monier's much earlier patent of 1867, conceived the idea of starting his own business.

Publications about these new developments appeared with increasing frequency at the end of the century. From 1893 *The Builder* had regular articles on reinforced concrete, and by the turn of the century many French and American magazines on cement appeared. *Concrete and Constructional Engineering* began in 1909. There was little doubt that reinforced concrete combined the compressive and tensile strength of steel, and that concrete could provide fire and rust protection by enclosing the thin steel reinforcement rods, which typically range between 8 and 32 mm in thickness. Nevertheless, sceptical engineers feared that reinforcement did rust, promoting fissures in the concrete itself. How could quality control be assured when the preparation of both the concrete and the accurate placing of the reinforcing metal were undertaken by the construction workers themselves – not offsite, under expert supervision? In the first decade of the twentieth century, Germany, France, the UK and the United States all established regulations for the use of reinforced concrete, with the Americans introducing a more liquid mix which could be

mechanically distributed by chutes and tubes, and also avoided the honey-combing which resulted from inadequately compressed dry-mix. By 1918 it was realised that one critical factor in determining strength was the water-cement ratio. During the twentieth century, of course, the technology of concrete advanced considerably, and many unforeseen elements in its nature and performance have been discovered.

In 1903 August Perret reduced the vertical elements of a house he was designing in Paris to a few columns, enabling floors to be freely partitioned: this was the first step towards open floor-plans which Le Corbusier, who worked in Perret's office, claimed as an essential ingredient in his own aesthetic philosophy. But another development was about to take place in Germany, distantly echoing ancient Roman achievements: the concrete shell. Probably the most dramatic example of the time was the ribbed dome roof, topped by a shell, of the Centennial Hall in Breslau, of 1911–12. During and after World War I the French government revived an earlier proposal for concrete hangars, and Eugène Freyssinet built two vast structures for airships at Orly between 1921 and 1923. By 1927 the construction of thin shell structures had been further refined, enabling the Market Hall at Frankfurt to be spanned by barrel vaults less than four inches thick.[3]

But why were these technological developments specifically relevant to Ove? The answer lies in the precise historical and social context of Denmark at the time.[4]

In 1813, as a result of the Napoleonic wars, Denmark faced, and formally declared national bankruptcy. The king, Frederik VI, together with the State Council, pursued two paths of reconstruction, both of them echoing recent Enlightenment ideas. In the short term, they encouraged new industries and promoted trades that were already prosperous; in the longer term, however, they invested in scientific education. H. C. Ørsted was commissioned to promote scientific discoveries, and the distinguished geologist J. G. Forchhammer was commissioned to identify mineral resources.[5] He found plentiful clay and chalk, enabling six factories for the production of 'Roman cement' to be established by the mid-1850s. By the 1870s, the Technical University of Copenhagen, of which Forchhammer had been director at the time of his death, had inaugurated both research and courses in structural engineering. By then, also, a series of groynes had been constructed on the west coast of Jutland, and reinforced concrete was being used in Copenhagen Free Harbour. The crucial features of progress were extensive personal interaction and co-operation between civil, mechanical and chemical engineers, including close collaboration between the civil and private sectors. Moreover, agencies

responsible for development had political backing, the requisite raw materials were readily available, and research was carried out in the design and construction offices themselves.

In 1902 a new graduate from the Technical University, Rudolf Christiani, was recommended to visit the firm of Hennebique in Paris. He stayed two years, and on his return, with Aage Nielsen, established the firm of Christiani & Nielsen, specialising in reinforced concrete design and construction. The firm quickly established a reputation for underwater work, although they also constructed a reinforced concrete dome of 40 metres diameter, for the circus building in Copenhagen. Following the deep recession after World War I, politically alert young architects – and that meant liberals or socialists – turned to concrete as a material for addressing housing problems. Reinforced concrete enabled them to invent new systems of columns, walls and slabs to construct low-cost buildings with an unskilled workforce.

In Denmark, public investment in coastal protection and harbour construction required not only coastal engineers, but quality control of the new materials being used: if concrete could be made well, it could also be made badly, especially by unskilled labour. Quality control itself rested on scientific research into chemical reactions, and into tensile and compressive strength. But production supervision had to be matched by site surveillance, and in the post-war economic depression, a marked decline in both activities generated hostility to concrete in conservative quarters. Nevertheless, and with very few rivals, Christiani & Nielsen had established their expertise before the war, and by ensuring that they always and immediately recruited the best graduates from the polytechnic, exercised considerable influence on the course of marine engineering up to World War II. Once Ove had enrolled on his courses, and performed well in them, an offer from Christiani & Nielsen was almost guaranteed. He applied, and was immediately accepted. He was posted to Hamburg in 1922: the city of his childhood, the country of his first language, and the nation that harboured some of the most avant-garde engineers and designers.

During his studies two names had captured his attention, and their work profoundly influenced his ideas. In 1922, just as Ove was completing his engineering courses, Charles Edouard Jeanneret – Le Corbusier – issued a collection of previously published papers: *Vers une architecture*.[6] He proclaimed that genuine architecture of the day was to be found only among the work of engineers, because only they followed the laws of nature, necessarily, and only they pursued the goal of utility. Two things interested Ove. First, of course, was the celebration of engineering; second was Le Corbusier's explicit homage

to monumental architecture of the past, on the grounds that one can transcend the past only by honouring one's debts to it. Le Corbusier justified what seemed to be new, by reference to a familiar past. This witty rhetorical gesture appealed to Ove, although he quickly discovered that such intellectual gymnastics held no attraction in the dour offices of Victoria Street, London, the headquarters of the main engineering firms.

The second person to excite Ove's intellectual engagement was Walter Gropius.[7] He founded the Bauhaus School in Weimar in 1919, with the aim of bringing together craftsmen, artists and architects to pursue a new, utopian vision for a democratic world after the miseries of war. The initial idea was to educate artistic consultants for industry, crafts and commerce. In explicit homage to the medieval guilds responsible for constructing cathedrals, the aim was to fuse art and technology, theory and practice. Such an unconventional agenda was repudiated by conservatives in Germany as anti-academic, subversive and politically suspect, and the Bauhaus always faced strident opposition. Although the movement was distinctively German in many respects, it echoed ideas that were prevalent elsewhere in Europe: such ideas as an essential unity of human goals and aspirations, the inter-connectedness of all things, appealed widely to all who deplored the adverse consequences of increasingly specialised, fragmentary and isolated enquiry. In 1923 Gropius realigned the focus of the Bauhaus with technology, rather than craft, proclaiming: 'art and technology – a new unity', but it was still committed to a communal intellectual core, sympathetic to Spengler's cultural pessimism, and to Bergson's insistence that man is not an exclusively rational animal. Ove had been attracted to some of Bergson's writings when studying with Høffding, but his own inclination was to reject all metaphysical or ideological claims. His response was: cut out the theory, let's see what you can do.

Gropius's goal of unity, and Le Corbusier's celebration of engineering, provided the core and foundation of everything for which Ove subsequently campaigned.

Meanwhile, however, a second courtship, with correspondence even more passionate than that with Olga, had begun a year or so after he had parted from her. Else Lorenz was three years younger than Ove. They met almost daily throughout 1920, and corresponded energetically until he left for Hamburg. Ove and Else shared interests in piano playing, concerts and the theatre: he visited her at home, although she had a strained relationship with her divorced parents, and they also invented a preposterous story about a cycling holiday, in order to spend more time together: but her neurotic mother opened her letters and discovered the plot. Else declared her feelings directly

and with intensity, constantly reassured Ove of her affection, complained he did not write enough, and clearly wished to be engaged. Her diary entries for the summer of 1920 convey her moods:

5/5/20

One thing is for sure, if Ove should let me down, I'll never let him go; whatever it takes I want to win his heart, even if I have to change myself completely, if only he is able to conquer his weakness. . . . He lacks one thing only – will. . . . I <u>do</u> want to live my life with Ove.

21/6/20

Was lying on the couch almost the entire time that we were at home. Had to take morphine. [. . .] He went out to do the shopping for lunch, which he later prepared, too. We had macaroni, frankfurters and fried eggs. Ove brought a bottle of white Bourgogne and the glasses from Berlin. We had an absolutely wonderful time and I was quite overjoyed, but of course the morphine was partly to blame for that. But I was happy, too, because I could tell that Ove thought it would be hard to be away from me for such a long time. [. . .] We went together to see Mamma in hospital at 2 o'clock. She was feeling fine. Ove then had to leave shortly afterwards. I kissed him so that Mamma saw it when he left.

Else's highly strung mother, then living in Berlin, had reported on 21 March 1922 that

the situation is getting worse and worse everywhere around here, and people are so nervous and depressed and worried about the future that things are getting more and more unbearable. It has become much worse during the last few months, and I have just heard that Hamburg is supposed to be just as bad as here.

She was theatrically offended to learn that Else's father had helped Ove secure the job in Hamburg. But the economic, social and political unrest in that city was becoming extremely uncomfortable; pilfering from the docks reached unprecedented levels, and inflation appeared to be uncontrollable. To many younger Germans, violence began to seem both a natural and a rational response to the distress and disorder around them. Ove later recalled that there was 'a lot of political upheaval, with fighting and barricades in the streets' because the mark had collapsed – 'it ended up by being one thousand billion marks to a shilling'. On Fridays he had to take his salary directly to the baker because its value would drop by the next day. In the artistic world

'there was turmoil' at the Münchener Kammerspiele, which had transferred to Hamburg, with new Expressionist plays by Ernst Toller and Fritz von Unruh: 'my favourite authors were Hermann Hesse and Thomas Mann, both well established before the war.'[8] He subscribed to progressive papers such as *Neue Rundschau* and Wasmuth's *Monatshefte*, the latter dedicated to modern architecture.[9]

To most people very large numbers are incomprehensible. Official reports after 1918 were hard to stomach: over ten million people had been killed during the war, another twenty million wounded, and five times as many died of Spanish influenza. And now, within a few months, prices in Germany were about to reach a billion times their pre-war level.

During the war the value of the paper mark had halved, sinking to 8 marks to the US dollar; by the end of 1919 it had sunk to 47, and two years later to 263. Things now spiralled out of control. Between July and December 1922 the rate rose from 493 marks to 7000. Nationalistic outrage at Allied demands for German repayment in 1921 fuelled a series of murders and assassinations – four hundred in the three-year period from 1919.[10] Some professional people temporarily quit their posts and residences for safer havens: anti-semitism was on the rise. Assuming that Germany intended to renege on reparation, France and Belgium occupied the Ruhr in January 1923. Meanwhile hyper-inflation took hold, as Ove himself witnessed. During January 1923 the cost of the dollar rose from 7000 to 17,000 marks, passing 24,000 in April, 353,000 in July, 4,621,000 in August and in September reaching 98,860,000. Absurdity did not cease: in November the figures reached 2,193,600,000,000; and in December 4,200,000,000,000. The correct nomenclature for such figures was disputed, but no one was amused. The staple diet of rye bread cost 163 marks per kilo on 3 January 1923, 78 billion marks by 5 November and 233 billion marks two weeks later.

Postage stamps could not be printed fast enough to keep up with price rises, so letters were mailed with banknotes pinned to the envelope. On 29 July 1923 the German correspondent of the *Daily Mail* reported:

> In the shops the prices are typewritten and posted hourly. For instance, a gramophone at 10 a.m. was 5,000,000 marks but at 3 p.m. it was 12,000,000 marks. A copy of the *Daily Mail* purchased on the street yesterday cost 35,000 marks, but today it cost 60,000 marks.[11]

A national state of emergency was declared in September, but at the beginning of November Adolf Hitler, inspired by Benito Mussolini, attempted a putsch in Munich. His aim was to unite various nationalist groups under his

leadership, and to stage a march on Berlin. The attempt failed after barely twenty-four hours. Hitler was arrested and sentenced to five years' imprisonment – of which he served only nine months. His name, however, had emerged. In prison he wrote *Mein Kampf* which, like millions of other Europeans, Ove read with horror.[12] Meanwhile, however, a new government – one of sixteen in the ten years up to 1930 – stabilised the currency in November 1923 by introducing a new Rentenmark, soon renamed the Reichsmark. One Rentenmark was equivalent to one trillion inflation marks.

In that same November, Ove pressed hard for a transfer from Hamburg to Paris: exotic, vibrant and surely full of opportunities to match his memories of it. Ove asked his English-educated cousin Arne, in London, to draft a letter in the correct form: he proposed to say that 'any man who has even the slightest chance of getting out of the country will try his very best to make the most of such a chance'. The result was that he was suddenly appointed to London, in the first week of December. Ironically, by then, friends were complimenting him on his vivid reports from Germany. He could not know how fortunate he was to get out. London, however, seemed to be frozen fifty years in the past.

Ove, nevertheless, was once again in a muddle. Another girlfriend had appeared on the scene, in succession to Else Lorenz. Her name was Elsebeth Juncker. In the days immediately before he set sail from Hamburg, he confided in his notebook:

Why do people write diaries? Isn't it always like declaring yourself bankrupt? And for whom do you write a diary? When I write my diary, I always have a slight feeling that I'm writing to an audience, I feel a bit like an actor. Then I end up being annoyed about it, when I realise that I'm only writing for 'myself', and that the only thing I can demand from what I write is total honesty. But it's so difficult to know when you're completely honest. [. . .]

To 'show one's backbone', isn't that a purely formal quality? A mark of concentration and willpower? What is the difference between showing one's backbone and being strong-willed? 'Backbone' has something to do with 'dignity' and 'decorum', it inspires respect.

His reflections so closely resemble those of six years before because of his new obsession, Elsebeth:

14-XI-23

I didn't get any further about 'backbone'. I wonder if that shows lack of backbone?

My chest hurts, it feels like shortness of breath and palpitations, a strange heaviness of heart. I wonder if this is what they call 'a broken heart'?

I feel so terribly sad that Elsebeth is not fond of me. Because she isn't, it's no use imagining anything different. And most likely that won't change, either. Of course, I'm constantly hoping, I just can't help it. But it sure is foolish. After all, she doesn't need me. [. . .]

Actually, I'm feeling very sorry for myself. I believe that's a bad thing. So, this is where 'backbone' is required.

21-XI-23

I hear nothing from E. I suppose there is no doubt that I do not matter much to her. Que faire?

First of all, I have to look the facts straight in the eye and admit: E. does not 'love' me. That I cannot change, or at least not directly. [. . .]

I can either declare that life isn't worth living – and shoot myself. Highly consistent, no objections. But I won't do that, after all. Why, I hardly know myself, whether it's cowardice or considerations for my fellow beings or something else altogether. I suppose it's because it's quite impossible for me to make such an irrevocable decision . . . Or I may declare: life isn't worth living – and then go on living. That is to say, what I do declare is unimportant for the moment, but still: go on living . . .

Of course, I could consider the situation from a different angle . . . it was a precondition for living with E. in any case that I would get my act together. It would have been easier to do so if E. had been fully interested in the matter and helped me along, but even now, this is the only thing I can do in order to improve my relationship with E., as I do not have any means to make her fond of me. Persuasion, cunning, all sorts of half-measures, 'friendship' etc., they are all nonsense. [. . .]

At the same time, I want to bring to light a certain desire or inclination of mine to put on an air of martyrdom, i.e. to wish that E. would realise that she has destroyed my life, to deliberately go to the dogs just to show E. what she has brought about. Somehow, I don't really like it if E., provided that I do get my act together and pretend nothing has happened, will end up thinking, 'Oh, well, things probably weren't that bad after all'. . . .

I must admit that the whole matter may have been presented here in a more simple way than it really is. . . . Perhaps this 'great' love isn't really all that important at first. Still, the fact is: I don't know any of this for sure. Things could work out the wrong way. Tactics may work against the original intentions. The other means – inward control – never goes wrong, and

it has the added advantage of being an end in itself, and a very important end at that. Actually much more important than happiness and E. and everything.

22-XI-23

Every morning, I walk to the office hoping that there will be a letter from E. waiting for me; I've almost got palpitations when I arrive, but every morning my hopes are dashed – there is no letter. . . .

It is quite clear: If E. isn't in love with me, she doesn't need my friend-ship either – all that is just nice words. After all, I ought to know this from the case of Else.

24-XI-23

When I think of Paris . . . of our 'wedding dinner' at the Glacis Café, of the collegium, then I'm tormented.

Three weeks after arriving in London, and still without satisfactory lodgings, he received the letter from Elsebeth that he had most feared:

I have been so nasty towards you that it beats everything I've suspected was bad in me. Why have I not been writing to you? I don't know, Ove. Cow-ardice. I have no excuses . . . my dearest, surely you must know that every-thing of the kind is over between us and that I wasn't the one to rekindle our relationship here in Paris. [. . .] Ove, it's no good at all if you come to Paris this Christmas. I am deeply in love with someone else. I spend a lot of time with this person. I don't think you would like him . . . There, I've said it . . .[13]

That was enough: they had to meet. Two days later, Ove was in Paris:

23-XII-23 Paris, Hôtel du Quai Voltaire

At last, the matter is finally concluded. The reason why E. didn't write was a kind of cowardice, she didn't dare tell me that she was living with someone else. Now we are through.

He met his old Sorø friend Solomon Rosenblum in Paris, and after Christmas he returned to London, bought himself a teapot and 'put up the relief print of E. It is my household god.' But he could not stop brooding:

5-I-24

I'm lonely and have nowhere to put all that tenderness etc. that I would like to put somewhere. Any connection between E. and myself has now been

completely broken off . . . I really have ended up as a square peg in a round hole, seeing that I'm actually not a hands-on engineer, damn it, and all in all I'm dissatisfied with this big city drudgery. People sure do make life a misery for each other!

However: from the point of view of an energetic man, I may be envied. I have been appointed to take care of the Southampton job – i.e. I have a specific field where I can show what I'm worth and which I can take an interest in. [. . .]

I need to restore myself in the opinion of others after receiving those blows from my two wives [*sic*].

By February he was still pensively wandering the deserted London streets at weekends, convinced that life could not be worth living without Elsebeth. His mother and most of his friends were horrified to hear about his emotional disasters, and he tried to clear his mind by drafting an analysis of the situation for her a month later:

When I hadn't heard from E. for two months I couldn't stand it any longer, so I travelled to Paris for Christmas as I had some days off. I then had a conversation with Elsebeth during which it became clear to me that everything was finished between us. Although she had prepared me for this, I had been constantly hoping that things could be sorted out; but Elsebeth assured me most definitely that she would never be able to care about me again, and as time goes by, I suppose I have to start believing this. Elsebeth says that she can't really care about anybody – and perhaps this is so – although I find it hard to believe, and in that case it is a great shame for her.

He added that 'if Elsebeth and I had been able to spend more time together, I believe that this would never have happened.' He continued:

If you allow me, I would like to ask you that you leave Elsebeth alone as much as possible now that she returns home, not putting her under any pressure by asking questions or making suggestions. [. . .] I suppose she would be better off forgetting about me and occupying herself with something else.

To expunge such very recent and painful memories, Ove decided to organise another trip back to Paris for Easter 1924, for old university friends, mostly female. All his women friends bombarded him with letters: he had paraded his soul and six, seven, eight sought to cheer him, boost his morale, cajole him. One, for example, frequently told both Ove and others that she was in love with him: 'it is so awful that I love you so much.'

In old age Ove inclined to sentimentalise his arrival in London, referring to himself in the third person and claiming to have found the city full of exciting things:

He arrived in mid-winter in the early 'twenties in a real old-fashioned pea-souper, policemen in white nightgowns armed with flares or white sheets walking carefully in front of whole rows of red double-decker buses. There were coal fires in stations, even in drawing offices, cosy and dirty, roasting on one side freezing the other. Surveying in gumboots on the mudbanks of the Solent, staying at a little pub, darts, warm beer, kippers, joint and two veg; a hot humid December, tea with crumpets, lovely old Christmas carols – he was enchanted with it all. I don't suppose he was actually asked whether he thought our London policemen were wonderful – but of course that's what he did think.[14]

Frederik and Petrine Arup, the parents of his cousin Arne, had been in London for forty years – the uncle managed the Royal Copenhagen Porcelain showroom in Bond Street. Ove stayed with them in Kew for two weeks until he found a bedsitter advertised in *Dalton's Weekly* by Mrs Singleton, at 22 Cambridge Street, Pimlico, within walking distance of 92–4 Victoria Street. He stayed at Mrs Singleton's eighteen months, until he got married. Mr Singleton 'was a real butler, complete with side-whiskers; he and his wife had served in a number of big houses, their thoughts seemed to be entirely focused on the doings of the great, and he could hardly talk about anything else.' At first he had 'felt rather lost': he did not speak the language well, 'mixed a lot with foreigners', but 'had no access to any set which might have shared' his interests. In particular, the young seemed naïve, 'not a bit interested in intellectual gamesmanship, having never heard about Nietzsche, Oswald Spengler, or even their own Bertrand Russell'[15] – years later he vehemently deleted Lord Esher's misreading of this in his draft biography, which stated that Ove was *attracted* to Nietzsche and Spengler. Ove himself put it neatly: 'I did not happen to land in a circle where social, aesthetic or moral problems were being discussed.'[16]

Ove was always keen to honour the 'inspired engineer' Herluf Forchhammer under whom he worked in London; he was the grandson of the great nineteenth-century director of the polytechnic. The firm's main means of securing contracts was emphasis on good design, and Forchhammer had established a system that Ove readily adopted twenty years later in his own firm, 'of circulating technical reports on interesting jobs, special difficulties encountered and overcome, new methods of calculation, and so on to all

branches, so that you really benefited from the firm's experience everywhere'. Looking back on those days he recalled:

> it has been my – I almost said bitter – but at any rate frustrating experience, that the paramount importance of getting the right design is hardly understood by laymen, including clients, is rarely grasped by building authorities and the legal profession concerned with building, often not by architects who leave the costing of jobs to quantity surveyors and therefore lose touch with the method of building, or by consulting engineers, who concern themselves exclusively with structural stability, but leave matters of construction to the contractor.[17]

Throughout 1923–4 Ove's mother conveyed family and local news from Copenhagen. In the April elections, although Henning intended to vote for the socialists, like Ove's old friend Jørgen Jørgensen, she intended to vote for

> the conservatives, in spite of the fact that I probably really belong to those who have shared interests with the socialists. Since my assets are not taxable. Still, I have no trust in people who break down all sense of responsibility and appeal to egoism only – and what will happen to foreign exchange, for instance?[18]

Her current worry was embarrassment at a very public affair of Henning's, although he had at least escaped intact from previous close 'friendships'. She persuaded a young cousin to confront Henning about his behaviour, but this only prompted the reply that at the age of twenty-six he was quite capable of making his own decisions. She could not help asking if Ove planned to visit Elsebeth in Paris over Easter: 'much depends on whether two people suit each other, and I do believe that it is necessary to decide whether there is anything else to found a relationship on apart from this erotic thing . . . !'[19]

The letter concludes with a rebuke. Whereas she had confessed all her worries about the family, Ove had made not a single comment in reply. This turned out not to be the case: he had written at length and forcibly to his brother who generously showed the letter to their mother. By May 1924 Mrs Arup had lost her maid, and could barely afford to keep the five rooms of her apartment, or provide all Henning's meals and requirements. Henning suggested that she move in with Ingeborg, but this was not greeted with enthusiasm, and she retaliated by proposing his own exit. Always late for meal times, Henning arrived in a cloud of smells – 'the whole house was scented with Miss J's perfume'.[20]

Meanwhile, throughout the first half of 1924, Ove continued to ask all his old friends about Elsebeth Juncker: and news of Else Lorenz also arrived from time to time. Most of his female correspondents unburdened themselves to him, as he did to them: misunderstandings typically resulted. One friend, who was about to move from Berlin to Moscow, having sold all her communist books, decided to stop writing him soul-bearing letters.

A new crisis arose in June 1924, between Mrs Arup and Henning. She confessed that at her marriage in 1893, Johannes had insisted that his three daughters address the new young wife as 'Mother'.[21] Mr Arup had even offered to send Astrid to live for a period with his own brother, because as a sensitive and reserved child she had been deeply upset by her father's remarriage. Now, some thirty years later, Mrs Arup suggested, as she had first done after Johannes's death in 1911, that her children address her by her first name. On the verge of her sixtieth birthday, Mrs Arup wrote to her thirty-year-old son about family relationships and the sexual escapades of the family. These letters would have struck many British people of the same generation and class as unnervingly frank, albeit Henning was noisily coupling in her own house:

> I must say I'm relieved not having to listen to or watch H's Treiben with Miss J. – I suppose I am being like the ostrich that hides its head under its wing, but still! . . . No, this modern mistress-nonsense is demoralising, no matter what [. . .] others say – is being a slave of your own desires any sort of position for somebody who wants to call himself a man![22]

Anxieties in her own household fuelled her concerns about Ove in London: he was dismayed at the class snobberies, but she was worried about his relative penury, his search for satisfactory lodgings, the noise from the underground, and how he got his laundry done. Since, for reasons of space and cash flow, he had been forced to sell his piano, perhaps she should ship across his bicycle, which was stored beside the mangle? Even if this proposal did not obviously follow, he must eat properly, especially porridge.[23] Happily, he received a wage rise in June at the very moment that many employees were being laid off.

Meanwhile, Ingeborg, who was a voracious reader, and had taken up shortwave radio as a hobby, continued to recommend books to Ove, including works by Anatole France and Lafcadio Hearn.[24] By the summer of 1924 Ove had joined the Danish Club and the Engineer's Society in London, and there was talk of his sharing a flat with a 'Chinese chap'. And soon afterwards his emotional friend Grete Backe, who was studying the piano in Berlin, reckoned that she was as lonely, cold and depressed as he. Ove and Elsebeth

Juncker did not stop writing to each other. He learned that she had passed her examinations, and this naturally called for a letter, to which she duly replied:

> Of course you are entirely right in everything that you wrote, and I feel very low about it every time I consider things properly. I have behaved really badly. Much worse than you think. I might as well confess right away: I have left your Arts thesis behind in Paris and I keep putting off writing for it to be sent here.[25]

But although Ove continued to hear about both Else and Elsebeth, it was Grete Backe who besieged him with letters during the autumn of 1924: 'It would be very bad for me if for instance you suddenly ran off to India for a long time. Wouldn't it be bad for you too, [. . .] now that you no longer have a wife.' She suggested that he should get a transfer to Paris, where he could have piano lessons from Christiansen, from whom she herself was about to receive tuition. She also challenged him to decide whether he really wanted to continue as an engineer, or switch to architecture, about which he had talked to her in Copenhagen.[26]

There are no references to architecture in general or to any individual buildings, ancient or modern, in Ove's papers of the period. But he had discovered that engineers were not expected to tender any architectural advice, and that he had little opportunity to design anything at all: he needed something that would keep in tension, as well as satisfy, the twin cravings of his deep aesthetic sensibilities and his absolute commitment to rational thinking and practice. He half-heartedly decided that whereas he possessed the mathematical skills necessary for the latter, he lacked creative skills sufficient for the former: so he stuck with engineering – but with a proviso. He did what only a philosopher or a politician would think of doing: he *redefined* his terms, so that all manmade structures were to be classified as 'architecture'. A week later Grete enclosed an architectural journal and declared that 'it's almost brutal and certainly not right that people in their own homes are forced to live in specific surroundings'[27] – she was referring to fitted furniture in mass housing developments, which was being expounded by proponents of the 'modern' movement in Germany, France and Scandinavia. Could she entice him to Berlin, or to Paris, or should she just turn up in London?[28]

But then he suddenly sent news to which Grete simply had to reply, at length:

> Now, Ove, I don't understand you and your self-torture at all! You're telling me that you have met a girl whom you like and who likes you, too. And

you're also saying that you have got yourself a piano. I should think these were two happy events. [. . .]

Surely in situations like this – unless they are under age – people know what they want, and if they end up unhappy afterwards they don't want to be pitied, anyway. Talking of pity, this sometimes has quite a practical effect. I remember once that, from something you'd written, I got the impression that you were pitying me somewhat, because I was unhappy; I thought that was so annoying, that my feelings for you immediately cooled quite drastically. Well, anyway of course that didn't last all that long.

It's a shame that you're not doing any better. And it's a shame that this Danish girl can't stay and comfort you. I think she ought to do that. And it may even be that – if you parted in the future – she would do quite well, just as in my case.

P.S. I've just read your letter once more. But I constantly have to shake my head in wonder! Dear Lord, what's the matter with you? What sort of strange person are you! No, I think, you're a terrible coward! Of course I know that when it's really needed, you do not lack courage. But when it comes to all those so-called 'small things' in everyday life, why don't you dare to take any risks? I suppose this is all due to 'the goodness of your heart', and also a certain amount of indolence. But you end up destroying so much for yourself through this, why do you carry on in this way?[29]

Such remarks had become a mantra among Ove's young women, most of whom knew each other, and none of whom seemed unduly discouraged by his own self-analyses: but for the rest of his life he used Grete's precise phrases to confess his failings.

As if all this had not been enough, in a foggy, damp, miserable London, two weeks later Ove received a full blast from his mother:

If only Henning had been engaged to a young girl from a good home – surely it is strange that he always ends up with widows' daughters. It seems almost as if both you and Henning are afraid of having to take on responsibilities and therefore you seek the company of those who are unattached and 'free' – are your own impressions of our and other homes so negative that you absolutely must seek out this more or less bohemian lifestyle? After all, this really isn't something which comes naturally to either you or Henning – I am sure both of you would find it difficult to give up domestic life and security, things which may indeed only be found where there is solid ground to build on, metaphorically and literally – trust, order and cleanliness. [. . .] Would it not be possible to be sensible and modest enough

to admit that socialising with adult, clever, and 'respected' men might be beneficial? I am quite sure that both you and Henning would have made it much better through these years in Copenhagen if father had been alive and able to support and guide you – because Father was not like William [his brother, and father of Ove's cousin Leif], for instance – he was not afraid of speaking his mind and standing by his opinions when it came to the crunch. And I know that he would not have thought twice about stepping in where he could see that things were turning into something risqué and unclean, in one way or another. [. . .]

So you've been to a ball where you met Faber but didn't dance with the daughter! . . . who was that Danish lady you went there with? And even more importantly – who is the English lady whom you have been to visit 'a couple of times' – surely you're not taking English classes? Yes, as you know, I immediately start to worry where ladies are concerned – do you always have to take an interest in these 'free' independent characters?[30]

The situation in Germany and his despair about British practices encouraged Ove to search around and contact friends overseas. He received regular reports from the United States about prospects there, and in May 1923 learned of a building boom. The best opportunities seemed to be in steel framework, especially for bridges and skyscrapers in the New York area. Fluent English would be necessary. Although Danish engineers were highly esteemed, 'Americans want to see the man himself', so that jobs could not be arranged at a distance. His old Sorø friend Knud Rübner-Petersen wrote from New York a year later, however, to counsel against Ove's moving across the Atlantic: not least because there were signs of an increasing American imperialism which echoed pre-war Germany. He asked whether Ove was still exploring ideas of going to India.

Overall, the Americans don't believe that European qualifications or European experience are any good; they hardly believe in American qualifications, as there is a lot of bluff over here. [. . .] The cost of living is approximately $100 a month; you can rent a room at $7 a week, perhaps not as good as the one you have in London but including heating and lighting costs, and you can live on $1–$1.25 a day, if you're a bit careful with your money, that is. Any leisurely activities are extremely expensive, going out for dinner may easily cost $6–$8 per head. I believe my monthly budget is around $80–$85, but then I'm being very careful with my money [. . .] living in America. That's almost the worst thing, that you have to live here, for sure I would prefer being in England. Well, of course you know

as much about the perils of America as I do. The most obvious is the hypocritical and capitalist religiosity.[31]

A couple of months later, another Sorø friend, Bengt, renewed his reprimand of two years earlier. He was sorry to hear 'about the troubles you're encountering in the case of Elsebeth Juncker, but unfortunately I have to say that I think you're partly to blame yourself'. The new rebuke took a form to which Ove was becoming accustomed:

> You tell me that Elsebeth Juncker doesn't love you any more, or rather that already a year ago she didn't love you any more, and you made some bitter remarks that you will forever remain an amateur etc etc. I do not agree that you are entitled to feel such depression. Apart from an unknown number of amorous affairs you have experienced two more serious relationships, the first of which I do not believe qualifies for any comment. This was one of the excesses of your youth, and it's a good thing that she was married into the Finnish cavalry. As for E Juncker, without knowing the lady personally, I dare to suggest the following working hypothesis: First of all, as far as your personality goes, I'm sure you'll admit that elderly people in particular, as well as those who are not exactly about to burst due to internal brain pressure, often get the wrong impression from that 'fart-in-a-trance' behaviour with which you prefer to disguise your undoubted intelligence and your likewise undoubted practical approach to life. They consider you a confused creature with whom only a lunatic would entrust their most precious belongings, these being respectively their daughter, virginity, etc. while at the bottom of your heart, as often pointed out by L Arup, pocket philosopher, is a great Norwegian power, the most unpleasant manifestation of which is getting up early and eating porridge. This purely external feature I believe is what most women object to. [. . .] I believe I have observed that what you search for in a woman is 'das ewig weibliche' rather than true enlightenment: therefore I should perhaps recommend that you put on a bit more of a 'copper mask' and do not – on the surface at least – show your no doubt justified doubts.
>
> The same goes for what is of course due to an abundance of knowledge, education and brain matter, your inability to act. I understand very well that pondering and searching souls have to distance themselves from something which is as unworthy and, due to its unpredictable consequences, as dangerous as action . . .
>
> Of course, it is impossible to eliminate this lack of energy since it is part of your nature. [. . .] Any woman with so much as a tiny bit of the female

animal in her demands of the man who shall win her something extraordi-
nary. E Juncker would have followed you to the ends of the earth if you
hadn't headed for immediate advantages but instead, in a brooding and
inscrutable manner, travelled to the lands of the future.[32]

Attitudes in Denmark to rearmament and national defence changed after
World War I, fostered in part by the alarming social and financial instability
of their southern neighbour. By the mid-1920s Ove's family and friends were
becoming anxious about doing military service: several failed the medical tests,
as did Henning, who was found to have a heart murmur. But in London there
had been a development. In early 1925 Grete was excitedly broadcasting a
sworn secret: Ove had become extremely fond of a Danish girl in London.

3

Becoming a 'double outsider'

Ove had met Ruth Sørensen at a tea-dance at the Anglo-Danish Society. She had been sent over to London by the Rockefeller Foundation, to teach domestic science at some women's institutes. He was thirty and she was nearly twenty-three. She was the younger daughter of Poul Sørensen and of his half-Jewish wife, Dagmar M. Samuel.[1] He was a civil engineer and director of Copenhagen's water supply, and in later life became a much respected industrial arbitrator; she was a music teacher, singer and stenographer, a forceful character of whom her daughters were terrified. Ruth's elder sister Esther was married to an American painter, Gerald Davis, and lived in France. Their parents had separated when they were still schoolgirls, and Ruth developed a lifelong horror of the destructive effects of divorce, which she forcefully drilled into her own children. From their early meetings Ove called Ruth by the affectionate diminutive 'Li'; much later, one of her grandchildren called her 'Mussi', likening her to the sound of velvet on the skin, and others of that generation adopted the name. By the middle of March Li had told her grandparents her news, and Ove's mother enthusiastically reported that Miss Sørensen had paid

a visit and won her over. She also remembered to ask a crucial question about former attachments:

> Dearest Ove! I must say, that was some surprise – little wonder, then, that you have been able to stand it, being on your own across there. God give that this may turn out well and that you may be able to trust her! . . . [later] Miss S has been to visit – great success! I do feel that I can safely say that she has won all three of us over – certainly Marie and Me – and Henning likes her too, I'm sure. [. . .] Miss S said that her mother would like me to come and visit one day – but not until they had finished cleaning in a couple of weeks time. [. . .] I really wanted to see her sooner rather than later. Yet, I must be patient! . . . <u>One</u> thing I would like to know – have you mentioned to Miss S about Else L and Elsebeth J? Just so I know exactly what I'm allowed to say – because surely it is best if she does not hear about it first from someone else.[2]

As plans advanced for the marriage in August, Henning, who handled Ove's financial affairs in Denmark, paid off Ove's student loan of DKK 600 to the university residence.[3] He also explored Ove's idea of selling his bonds to reinvest in property, but the low value of the krone made decisions uncertain. Grete wrote in May that 'she looked nice, your wife. I think I could get to like her – perhaps',[4] and reported on her own burgeoning musical career. Meanwhile Ove's mother scoured the newspapers for advertisements for jobs,[5] confident that throughout his childhood he must have 'longed for home', and that returning to Denmark would be much better than acting on cousin Leif's invitations to America.

Ove and Li married on 13 August 1925: on a salary of £5 a week, they moved into a furnished studio in 7 Albert Studios, Albert Bridge Road, SW11. The apartment was located in a Dutch gabled terrace built in the 1880s by a retired sea captain, and was an easy cycle ride to Ove's office across Chelsea Bridge. The following year they moved briefly to Bedford Park in West London, and in 1929 to the first of two houses in Harrow; in 1932 they moved yet again, to a house in Hampstead Garden Suburb which they vacated at the beginning of the war, renting it to the photographer Wolfgang Suschitzky at £11.10 per month.

Ove had an extraordinary capacity to inspire and to give affection: and Li appeared at the end of a decade of emotional turmoil with Olga, Else, Elsebeth and Grete – quite apart from more superficial flirtations. Nevertheless, Li and Ove were devoted to each other and inseparable for the next sixty years. He was the apple of her eye, and the immovable focus of everything

she did; and she was his anchor and his conscience. On Ove's seventieth birthday, his long-standing friend Ole Haxen, who worked in the Arup office in Rhodesia (now Zimbabwe), recalled the gay apparel by which Ove and his cousin Leif stood apart entirely from all the other students. He also recorded his pleasure on discovering that

> he had found and married one of the most lovely girls I ever saw. Gems of such quality are utterly rare and far between and could hardly be come upon by sheer hazard. Knowing his thoroughness and fastidious taste I feel that he must have left a considerable amount of rejects behind him.[6]

During the first year of marriage Ove's inappropriate bachelor ways were forcefully drawn to his attention by his young bride. Loving notes from Li reveal traditional, but still not unfamiliar expectations. She apologised, for example, for being out when he got home from the office:

> My Darling! Don't be upset that I'm not at home. . . . I have such a terrible tummy ache, I'm not very well at all, and it's nasty, nasty, nasty. That's why I've lit the fire and hope it'll keep going until you're back – otherwise it's a good thing that I'm not back till 8.15, so your anger may cool off. Je t'embrasse, mon amour![7]

Social entertaining soon emerged as one of her duties, and she found herself leaving apologetic notes for being cross: 'Please don't be upset. You can invite 10 people for dinner on Saturday or any other day of the week, I promise I won't complain.' But: 'Please be so kind as to hang up your clothes in the wardrobe.' They took picnic lunches in Battersea Park, punted on the Thames and went to lectures by Bertrand Russell and Bernard Shaw. In the early years of marriage they enjoyed walks in Windsor Great Park and on Hampstead Heath, but these became impossible later as pain in Li's legs increased. She also practised the Alexander Technique to improve posture and a bad back, which made her movements seem somewhat stiff to outsiders.

Li's brother-in-law Gerald Davis sent a message in August:

Dear Mrs Arup! Dear Ruth
I am very sorry I did not kiss you in the taxi in Paris – when Ove kissed your sister.
 Now I can kiss your mother instead of you, which is much better!!![8]

At her request, most of Li's correspondence was destroyed after her death, but Ove did not for long engage in his introspective ramblings with her. In matters of morality and proper social behaviour there could be, for her, no oscillation

of the 'on-the-one-hand, on-the-other-hand' variety. In her moral domain there could be no qualifications about what was right, and even the suggestion of philosophical reflection was likely to weaken crucial family ties: to ask was to doubt, and to doubt was to undermine. Li did not enjoy Ove's philosophical disquisitions, let alone political discussions, because they might lead anywhere, and the wrong things might be thought; on social occasions she saw her task mainly as one of moderating his views, reducing the temperature, and oiling the wheels of friendly gatherings. By contrast, Ove and his male relatives invariably launched into loud arguments which, to them, were not at all alarming. After the war the Arup children were amazed to meet their Scandinavian relatives: the mountain walks, boating, dancing, drinking and 'wild freedom' of the vigorous Norwegian branches of the family contrasted dramatically with the restrained, well-behaved, even provincial behaviour of some of the Danish family.

For Li virtue was the guiding principle, and pleasure not on the *moral* agenda – it could be a gratuitous embellishment, although never a reward, as such. For Ove truth was the goal, attainable only by a proper proportion of hard work, rest and enjoyment. For him, the passions were the ultimate motivation to action, for Li they were the 'pagans of the soul'. He distrusted English politeness for its hypocrisy, and at parties liked to play the foreign fool who was ignorant of protocol; she was determined to enact the strictest social proprieties, even if it meant going to church.

In June 1926 cousin Leif reported on his own happy life and work in Bronxville. The Philadelphia exhibition to celebrate the 150th anniversary of the Declaration of Independence, for example, had been good for sales of Danish china, although it was otherwise huge and tasteless – and a financial flop.[9] Subsequent letters discussed his efforts to find out about the use of cellular concrete for house building, a technique for which he predicted a great future, and a year later, he again urged Ove to consider coming across, sharing accommodation and perhaps working together – they could write engineering papers and establish a great company, 'Arup Construction Corporation'. There was notable prosperity in the American building industry: 'Jews building apartment blocks, Irishmen doing paving contracts, Americans doing high-class residential construction and Italians making grading-excavating and mass concrete. A lot of them are illiterate, but are doing well nevertheless.'[10]

Shortly after they were married, Ove published his first technical paper. No one could have guessed that for the next half century no less than fifty thousand words would pour from his pen every year: articles, lectures, reports, speeches. In the spring of 1926 *Concrete and Constructional Engineering* pub-

lished Ove's reply to an article by Professor A. E. Richardson. Ove challenged the generalisation that architects are planners of structures, and engineers act more in the capacity of 'technical advisers'. In the case of 'engineering works, such as arch bridges with big spans, silos, hydraulic structures etc. [. . .] it is the engineer who of necessity is the planner of the structure [. . .] whereas the architect acts as adviser in matters of detail'. He went further: 'the best architecture in reinforced concrete is generally to be found among those big engineering structures'. He stated that:

> a well-designed engineering structure generally possesses a quality [. . .] accepted as an essential feature of good architecture, namely 'truth', whereby it is implied that the purpose of the building [. . .] is met in a simple, logical and economical way, and that this purpose is openly and frankly expressed in the building, without disguise of any kind, but with respect for, and knowledge of, the material employed.[11]

'Knowledge of the material', he added, 'belongs to the sphere of the engineer', and in the case of an engineering structure, 'the purpose itself is simple and clearly stated. And naturally imposes itself as the main consideration.'

By contrast, 'in ordinary building [. . .] the architectural problem is much more complicated. There are a hundred different considerations to conciliate. The possible solutions are much more numerous.' Because of this fact, 'the architect is naturally inclined to apply traditional forms and proportions, which were natural for brick and stone, but which do not fully utilize the extended possibilities of the new material'. During the 1920s, typical reinforced concrete structures had regrettably provided low thermal conductivity, poor sound-proof qualities and greater weight; new materials and practices which overcame these advantages had not yet affected the architecture of concrete buildings.

Later in 1926 Ove described in the same journal the scheme devised by Messrs Christiani & Nielsen, to strengthen three railway bridges over the rivers Tunaå, Nåså and Klinteboå, in Sweden; and the following year, in the same journal, he published a third article: 'Dolphins with loose filling'.[12] He observed that for centuries builders had sought to avoid working under water, but the introduction of reinforced concrete piles constituted a major step forward. Nevertheless, in deep water, or for vessels over 10,000 tons, the resulting jetties and other structures failed to resist major impact. Christiani & Nielsen had devised a method of driving piles, of reinforced concrete, steel or timber, in a circle held together by ties: the column was then filled with stones or gravel. Ove himself worked on all these projects: at Nybork,

Denmark, for Danish Petroleum Co.; on the Harwich train-ferry terminal; and on the Shell-Mex deep-water unloading berth in Southampton Water.

Looking back on his early years in London, Ove admitted that although he 'did not bother much about philosophy', he 'was still reluctant to get completely swallowed up by engineering or to take [his] career too seriously'. He did nevertheless gradually became more absorbed, and he was given responsibility. The practice in England in the 1920s was to observe a sharp distinction between the consulting engineers, who designed a project and served the client, and the contractors, who worked for profit. Christiani & Nielsen, although they were contractors, preferred to design their own jobs, and this undoubtedly influenced Ove's subsequent thought and practice. Moreover, English clients of the day often 'refused to adopt new ideas unless you could show the evidence', and Christiani & Nielsen's speciality in reinforced concrete was not much understood. In his melancholy moods, Ove believed that many of his 'best ideas lie buried in the files of Christiani and Nielsen', although he never explained what they were. He became frustrated by the professional constraints, and by contractors' almost exclusive emphasis on cost reduction – albeit to remain competitive. The problem was that in any construction 'something should be done to make it more pleasing, more satisfactory aesthetically': 'good architecture need not necessarily be more expensive', but the central point is that 'you cannot tack architectural advice on to an engineering scheme'. 'All manmade features are also architecture, and must be judged as such.' This bold redefinition abolished at a stroke a distinction between mere 'buildings' and genuine 'architecture' which had encouraged architects for five hundred years to regard themselves as special. Such 'exceptionalism' had been continuously trumpeted since architects had formally organised themselves into professional bodies in the nineteenth century. Ove's proposal fell on congenitally deaf ears. In any case, he wondered whether the ideal was attainable. Clearly it called for an individual in overall charge, who possessed the ability to judge architectural and structural quality, as well as functional efficiency, and also had the power and will to achieve perfection within a budget. Unfortunately, until long after World War II 'the idea of designing contractors was frowned upon'.[13]

Friends, family, everyone, encouraged him to follow up his enquiries about job prospects, but he could reach no decision. In April 1927 Ole Haxen was still encouraging Ove to escape from London and the generally boring engineers with whom he had to mix; like cousin Leif, he recommended the USA, of English-speaking countries, followed by South Africa and Australia – although he reckoned Ove would actually dislike the Americas. Peru or

Mexico were probably the best of the Spanish-speaking countries, but Brazil should be avoided at all costs.[14] On a recent visit to Paris, Ole had bumped into their mutual friend Solomon Rosenblum, who was 'still fiddling with atoms at Madame Curie's' but going to Coimbra – possibly secretly. Ove's male friends clearly felt a need to seek opportunities overseas; for the same reason, his highly educated female friends felt stifled by the small-town atmosphere of Copenhagen, where everybody knew everybody and embroidered upon every surmise.

In late February 1928 Ove was rushed to hospital with appendicitis, which caused a family scare, but he recovered quickly. His sister Astrid had been unable, in the late summer of 1928, to keep from Ove's mother that Li was expecting a child early in the next year, for which reason Ove and Li moved to Harrow in September. Ove moved into a guest-house near the nursing home to be close to Li, and Anja Merete Arup was born on 26 January 1929; everyone in the large and widely scattered families in Denmark, Norway, the United States and elsewhere was delighted. Shortly afterwards, Ove was getting first-hand reports on the 1929 Barcelona exhibition, one cousin assuring him that 'they have some light and heat effects that make you think of your childhood dreams about fairy castles'.[15] For many citizens in the Western world, however, such dreams were about to turn into nightmares.

For a generation to come, 29 October 1929 was a date that chilled the bones: millions of people in the United States, and then in Europe, were affected both materially and spiritually. Attitudes to employment, savings and investments, to rights and duties, quite apart from politics, changed virtually overnight. On that day, after a week of panic on the US stock market, sixteen million shares were sold: banks failed, major businesses collapsed and unemployment figures reached dramatically new heights, exceeding thirteen million. At first, the construction industries were not greatly affected, although cash-flow problems quickly developed and union anxieties soon increased tensions between management and workers. By the early months of 1931 both his sister Ingeborg and Mrs Arup were lamenting the depressing situation throughout Europe, and threats of Communist revolts in London. This was a reference to the National Unemployed Workers' Movement, which was founded after the Glasgow–London 'Hunger March' in January 1929, and which organised many marches and meetings for almost a decade, the most famous occurring in 1932 and 1936. Unemployment in Britain had reached almost three million by 1932.

Henning reported lockouts and spreading labour troubles in Denmark and at the same time, in early 1931, he and his wife Anna warned Ove about Mrs Arup's rapidly declining health:[16] they, and their sisters Astrid and Ingeborg,

had privately concluded two years before that their mother was not getting the medical attention she needed, because she was a Christian Scientist.[17] At the beginning of March they wondered: 'Perhaps it is wrong that we don't talk to her about dying.'[18] After a brief recovery, she declined further and died on 15 March, before Ove had been able to travel to Copenhagen. In any case Li was heavily pregnant, and their son Jens Mand Arup was born on 1 May – only a few weeks after Henning's own second son, Claus.

In Denmark, delays ensued over Mrs Arup's belongings, and it was not until the autumn that Henning was able to deal with the family inheritance. Towards the end of September, however, he was worried about the weakness of the pound and the DKK, and a second letter on the same day outlined the family position:

> Serious events have taken place on the money market, and now it seems unlikely that any real cut in wages will take place, when instead the value of the pound is being reduced. Unfortunately it seems tonight that DKK must follow the exchange rate of the pound, as from tonight gold export had been banned, and we have had no foreign exchange quotation or increase in the bank/market rate in this country. Otherwise you may have made quite a handsome sum by keeping your money in Denmark and spending it in England.[19]

He advised against investing in gold, because gold value might soon cease to be important. He had to invest their mother's legacy for Astrid and Ingeborg, as well as for Ove, since only small sums could be transferred between Denmark and the UK. A month later, Henning wrote to Ove in even more evocative terms:

> Everything seems so unsafe at the moment. I seem to feel that all the 'old things' – the home, traditions from before the war and from our home, from the days of Mum and Dad in those good stable pre-war times are breaking down and something hugely different is about to arrive instead. Personally, nothing has changed, though; I have an 'old-fashioned' home with wife and children, nice rooms and good friends; my job, too, as far as class and time go, is deeply rooted in traditions of past times. I earn a little money and have inherited a bit – everything is going quite well and I slave along in the old-fashioned way in the struggle to provide safety for my home and children – and yet from abroad new thoughts and unknown conditions are rushing in, a financial bond is no longer a bond, a good farm results in loss and ruin, and unemployment and insecurity rule. Nobody knows what next year or the winter will bring, and inside ourselves, we get an ever stronger feeling

that 'the good old days', which provided us with a quiet home and stable future, are never to return, but are to be replaced by something completely new. The old principles – capitalism if you like – is no use any more – can no longer handle things, and has to fall. And communism, 5-year-plans and the like are so strongly established – morally, too – these days that we are unable to resist, but if they did happen, justice is really to be found in the revolution since the old system has run off the tracks for good. And pacifism, international understanding, freedom and social tolerance these days face such huge – insurmountable – difficulties that we may no longer believe in evolution but are faced with revolution as the inevitable and only way out – although at the same time all our traditions and our milieu – middle class, bourgeoisie (not in the Marxist sense, obviously) – at the same time [*sic*] are knocked over and along with them the entire foundation of the work and the savings which we, true to tradition, have aimed towards. [. . .]

It is of little satisfaction to see our wealth and security grow while at the same time everything around us seems to be absolutely hellish and everybody is preoccupied with feathering their own nest. And at the same time we have to admit to ourselves that our own little ship is bound to sink, too, when everything else falls apart. For these reasons, I often feel like selling up and going on a long journey – better to spend it all before the others steal it. Or I feel like taking everything with me to Russia, where the new thoughts originate and apparently are realised through communal support of great general ideals and theories which must be a joy to take part in – instead of our situation where nobody needs our skills, where everything is just decline and new misery for which nobody knows the cure – and where the best and happiest thing of all, fruitful, blessed work for all cannot be found because nobody is able to give any directions as to where efforts must be made for the common good. The fact that millions of people have to be idle and unemployed while those and other millions pine for bread and the good things of life which could be produced by people's hands, this surely shows how warped everything is.

In the Soviet Union, as you know, there is no unemployment, and in a well-structured society unemployment does have to be out of the question since every job may be put towards the good of society and the growth of its wealth – there, only the question of how much rest from the toil we can afford is an issue, since rest, too, is one of the good things in life.

In this situation I really need to speak to you and see you – in an imaginary Armageddon we look to our nearest and dearest, and the assurance of unity here gives us much comfort and joy. [. . .]

> Another reason that I deal with this issue right now is that I have just heard a lecture on the radio about modern Russia, about the giant measures taken and the great determination, and this – that it seems to 'be a success' over there – is almost the only glimmer of light in 'external' life, when every day we watch the misery and aimlessness of 'western civilisation'.[20]

The apparently uncontrollable political and economic chaos around them dismayed the intelligentsia of Western Europe. Idealist propaganda from the Soviet Union, sometimes innocently propagated by visitors returning from carefully contrived tours, seduced many intellectuals about the reforms on offer and already achieved under the Marxist regime. News of the pogroms which had started in the 1920s, and by the late 1930s had claimed countless lives, was known to very few within the Hampstead intelligentsia – and was far from widely accepted. Indeed, at precisely this moment – October 1931 – Stalin's second wave of purges, targeted at religious organisations and the peasants, was gaining momentum; moreover, the food shortage in the countryside had become a famine, and by 1933 had claimed more than six million lives – more than the total population of any of the Scandinavian countries at the time, or Scotland and Wales combined.[21] And yet the Great Terror itself had not even begun in the Soviet Union; nor had the worst events in Nazi Germany unfolded. Today, the verified figures beggar belief; but when news began to filter out twenty years later, in the 1950s and 1960s, many active or former Western Communist sympathisers dismissed such reports as Western propaganda. Ove was not one of them, but took no pleasure in having his early warnings confirmed.

The Arups moved to 28 Willifield Way, NW11, in Hampstead Garden Suburb, in February 1932. Ove decided to decorate the house himself – so extensively, that he regarded himself as having acquired a potential career. During those same months émigré intellectuals and artists started arriving in England from Austria, Germany and further east, and Ove soon came across them. A few of the most left-wing among them had first of all chosen to go east, but soon returned, disappointed at the muted reception they enjoyed in the Soviet Union, although not disillusioned by the ideals being proclaimed. The architect Berthold Lubetkin who, like Stalin, was born in Georgia, had arrived in London in 1931; Sigmund Freud (from Moravia) and the art historians Nikolaus Pevsner and Rudolf Wittkower were among those to arrive in 1933, followed soon afterwards by architects Ernö Goldfinger and Walter Gropius.[22] Both Lubetkin and Goldfinger had worked with Perret in Paris and had learned from the master the possibilities of reinforced concrete construction: this very soon established a link with Ove.

Ingeborg was busy translating works on economics, and needed advice on some mathematical terms. The week before Ove and Li moved, she observed:

> These are worrying times that we live in – what is to come of it all? Is it all going to be smashed to pieces, this society which we in our short-sighted-ness have got used to seeing as a firm foundation for our existence. Are the current events to be seen as the last desperate attempts by the different nations of barricading themselves against a Communist system which becomes more and more successful the more the 'Capitalist' nations fail to get on. We ought to be together with lots of time for talking about all this because it is very interesting – albeit almost too interesting.[23]

The Arup family constantly exchanged recommendations of books and articles. Ove asked Henning to look out for recent books and articles on modern building materials, especially concrete, and Ingeborg regularly sent recommendations; but she confessed to being currently more interested in psychology than socialist thought. On his thirty-eighth birthday she told Ove that since his marriage his 'entire person' had been transformed. At the same date Henning was reporting 'much unemployment'.[24]

On 30 January 1933 Hitler became Chancellor of Germany: by April Ove himself had become extremely anxious about rampant German nationalism. But he was at last enjoying an interesting job on the harbour on Sark, and by the end of the year he had joined the Architectural Association. He had also met Lubetkin, who had contacted the Paris office of Christiani & Nielsen for advice – and they referred him to their London office, and thus to Ove. Through Lubetkin Ove joined MARS (Modern Architectural ReSearch), recently founded by a small group including the Canadian engineer and architect Wells Coates, Lubetkin himself, and Maxwell Fry, who had been trained in Liverpool.[25] All of them were idealists, and on the political left; some, such as Edward 'Bobby' Carter, librarian at the RIBA, were communist activists. MARS was affiliated to CIAM (Congrès Internationaux d'Architecture Moderne), founded in 1928, the leading figures of which included Le Corbusier and Gropius from France and Germany and Van Eesteren from Holland: these men 'undertook a complete reappraisal of the function and aims of architecture'.[26] Ove held that the modern movement often used reinforced concrete wrongly – 'it could be a very unsuitable material for housing' – although he saw a future for it for multi-storey buildings, to replace the entirely wasteful use of steel frames. He simply ignored the battlecry 'functionalism – fitness for purpose' because it merely promoted a style or fashion, although its trumpeters never admitted that fact. Nevertheless, he always

acknowledged a considerable debt to MARS, and to the international gatherings organised by CIAM. And he fully accepted Gropius's emphasis on teamwork, standardisation and prefabrication.

The first building with which Ove was closely involved – although his 'place was in the office' – was a small café and shelter, built behind the river wall on Canvey Island in 1932–3. At that date he functioned as architect, engineer and contractor to Christiani & Nielsen, and his design was almost certainly inspired by Le Corbusier. In retrospect, and arguably at the time, he deplored the cheapness and shoddiness of the workmanship. For some time he had been telling the family about his differences with his boss at Christiani & Nielsen, so they were not surprised to learn that, at the beginning of 1934, he would join J. L. Kier & Co., as director responsible for designs and tenders. This Danish company, which also specialised in reinforced concrete, had been founded in 1928 by Ove's acquaintances Jorgen Lodz and Olav Kjaer (later spelt Jorgen Lotz and Olaf Kier):[27] the firm wanted to move from Stoke-on-Trent to London. The opportunity to engage his frustrated yearning for creative design, whether under the heading of 'engineering' or 'architecture', was too good to turn down. And Kier agreed to Ove developing his recent association with Lubetkin. It was through Kier that he began his long connection with Tecton, the architectural partnership founded in 1932 by Lubetkin. Among other works, that group built the blocks of flats known as 'Highpoint' I and II in Highgate, the Gorilla House and Penguin Pool at the London Zoo, Finsbury Health Centre, and flats for low-income families at Rosebery Avenue and in Busaco Street, the first examples of 'box-frame' construction in Britain. Ove's starting salary with Kier was £800 per annum plus 5 per cent of the company's net profit, plus 20 per cent of profits derived from contracts with Tecton. An early assignment was a scheme to build a spiral tower at the end of Clacton Pier. Visitors would enter by a central lift, and meander down a spiral concrete ramp, passing shops and stalls: the owner and his family liked the scheme and a model, but it was never built.

As so often, his later memories of those times were benign. He recorded that he had

met a number of young people who really *were* interested in new ideas, who in fact had plenty themselves, and were very fond of discussing them. It was stimulating, amusing, and also puzzling. The puzzling part was that these architects professed enthusiasm for engineering, for the functional use of structural materials, for the ideals of the Bauhaus, and all that; but this didn't mean quite what you might suppose. They were in love with an architectural style, with the aesthetic feel of the kind of building they admired;

and so they were prepared and indeed determined to design their buildings in reinforced concrete – a material they knew next to nothing about – even if it meant using the concrete to do things that could be done better and more cheaply in another material.[28]

Ove was welcomed by the group because he was one of very few trained philosophers to engage avant-garde architects in critical analysis of their ideas, and his evident engineering knowledge could not be ignored by them. Ove recorded that Le Corbusier's Swiss pavilion – the student hostel at the Cité Universitaire opened in 1933 – 'made a deep impression on him. This *was* something. But what was it? Why did it have that effect?'[29] The echo of Henry James was not accidental.

That Christmas 1933, Ove's cousin Else Arup (Leif's sister) reported that she had recently been asked whether she was 'related to one of the nicest men in the world – well, it turned out to be you that he had in mind. He told me that [...] you had played together.'[30] More than thirty years later Jorgen Varming amplified this remark, confirming that he had met Ove in the early 1930s after a concert at the Institute of Danish Engineers in London, where he played Haydn's Cello Concerto and some Italian sonatas, accompanied by his aunt Cecilie, Oscar Faber's mother. He added: 'Ove was very musical, played the piano well, so our meeting led to so much music between us, and very close friendship with his lovely and intelligent wife Ruth, or Li, the name Ove gave her.'[31]

The son of a distinguished Danish architect, Varming had been educated in England. He formed a partnership with Niels Steening before World War II, and after the war worked with Ove on the projects in Coventry, Brynmawr (South Wales) and Dublin, and later on at Sydney Opera House; he also worked on atomic laboratories for Niels Bohr in Denmark. He typically played the last movement of chamber works standing up.[32] His cousin Dr Oscar Faber was recognised as the doyen of consulting engineers by the late 1930s.

From December 1933 Ove was working closely with Lubetkin, revelling in the engineering challenges posed by exciting new architectural forms. And he was later always keen to acknowledge that his 'first real teacher of architecture was Lubetkin. He taught me how good architecture was produced, and what a serious business it was'; indeed, his 'association with Lubetkin and Tecton had a decisive influence' on his career.[33] Lubetkin was a charismatic and forceful character. Educated in Moscow, Berlin, Warsaw and Paris, he was multi-lingual, highly cultured and, when he so wished, utterly charming: he appeared to know everyone, and in the feverish atmos-

phere of the 1930s seemed about to prosper. His politics were ideological and Marxist in all but name; he knew many of the progressive scientists of the day who were interested in the political implications of scientific findings. In the mid-1930s these included two Cambridge scientists, the erudite geneticist C. H. Waddington, and the polymathic Marxist physicist J. D. Bernal,[34] with whom Lubetkin briefly shared lodgings in London. Although he admired British toleration, Lubetkin distrusted the moderation and empiricism of British politics which had replaced the brief radical promise of the 1920s. He neither suffered fools gladly, nor respected those who merely acquiesced. Ove strongly disagreed with his ideological views, but for several years they worked together in relative harmony: arguably the most innovative engineer and architect working in Britain at the time, they were not British by education or temperament. Lubetkin showed Ove that good architecture 'involves taking infinite care over every detail' – he also conferred a fictitious doctorate on him, which sometimes irritated Ove but occasionally helped him (thirty years later, he always wore the ring conferred on him with an honorary doctorate in Copenhagen). In letters, Ove always addressed Lubetkin as 'Tolec' – his childhood soubriquet.

The calculations for Lubetkin's design of the Penguin Pool ramp at the London Zoo were especially complex and Ove referred, as usual, to the standard Danish reference book by his own Copenhagen professor, Ostenfeldt. While engaged in this work Felix Samuely, another arrival who had trained and worked in Berlin and Moscow, appeared for an interview, made some suggestions, and was taken on as Ove's assistant.[35] The solution for the Penguin Pool involved conceiving a ramp as a beam, and also increasing the thickness of the ramps towards their inside edge. Congratulations for this poured in, and soon afterwards for the prize won by Ove and Lubetkin for the innovative shuttering at Highpoint. Ove and the team from Tecton, together with their wives, used the prize money for a trip to France to see the work of Le Corbusier. To everyone's regret the relatively cheap construction of Highpoint produced shoddy results 'as with all these modern Corb-inspired buildings' – as Ove added.[36]

Ove was beginning to be exceedingly busy. In April 1934 both he and Henning had invested in an invention by C. W. Espensen for the extraction of electricity from water and hydrogen gas – he was able to generate 2800 volts and 6 ampere with the water device – but problems quickly developed over patents and funding, and legal proceedings dragged on for several years. Espensen tried to sell his invention for £10 million. By 1940 and now a penniless alien, he had persuaded the Ministry of Supply to examine both his pro-

duction of 'electricity from the hydrogen atom' and his design for a 'shell provided with a delay action fuze device'. Ove's lawyers, however, cautioned him:

> too much reliance cannot be placed upon the information [. . .] as we gather that the Ministry are prepared to investigate any kind of invention which on the face of it looks promising and that in this way they do investigate numerous inventions many of which are never taken up.[37]

Alongside his expanding commissions, in 1935 Ove gave the first of a short annual lecture course to fifth-year students at the Architectural Association on 'Reinforced Concrete Design': the fee was initially 2 guineas a lecture, but it went up to three in 1939. Because the school had evacuated to Hadley Wood in Hertfordshire by 1940, he was unable to travel out to continue the course, and it was taken over by Samuely. The lecture notes from which he spoke, like all his technical notes, were extremely clear and orderly, although that is not how students themselves recall the events, because he preferred to wander from his notes and expand on anything that occurred to him.

During the 1930s the British government had instituted what became known as the great 'Slum Clearance Scheme'. This was part of the context in which, in 1935, Lubetkin and his other Tecton partners, with Ove as engineer, won the Cement Marketing Company's competition for 'working-class flats in reinforced concrete': and a prize of £300. The *National Builder* published the plans, elevations and some design and constructional details:[38] other commended submissions by newly arrived émigrés included one by Eugen Kaufmann, for whom Ove was also advising engineer, and one by Serge Chermayeff with Felix Samuely as engineer.[39] The Tecton scheme, in reinforced concrete, was costed at £57,600, or £94 8s. per habitable room. In a review of the designs submitted, Elizabeth Denby sharply criticised the conditions imposed on the competitors: a five-storey limit, with no height variation, nor use of lifts; the limitation to one or two bedrooms, for families with children; and the mandatory use of combination coal ranges, which she regarded as entirely anachronistic in 1935. She also deplored acceptance of a density of fifty to sixty dwellings per acre, which was double the limit generally accepted abroad.[40]

During the summer of 1935 Ove published in *Architectural Design and Construction* a long article on 'Planning in reinforced concrete'.[41] It is a *tour de force*, echoing the classical statement of building practice by Alberti. Ove insisted that all elements of a reinforced concrete structure can be so connected as to form one unit, the joint being as strong as the rest of the structure. This 'monolithic' character has an important aesthetic dimension,

because it can be moulded into any shape. After an analysis of different building materials and their uses, he turned to the 'theory of planning', contrasting what he called an architectural with a structural approach. The latter aimed to satisfy three conditions: economy, simplicity and freedom of architectural planning.

To illustrate his essay, Ove included plans of a bungalow at Whipsnade designed by Lubetkin and Tecton, their winning working-class flat design, their new plans for Highpoint I and II, and flats by Ernö Goldfinger. He also included a sketch by the Finnish-Swedish architect Cyril Sjøstrøm (who changed his name to Cyril Mardall, and often worked with Ove) and, in sections on shuttering, his own design of sliding shuttering for J. L. Kier & Co. for a silo at Barking, and for Lubetkin and Tecton at Highpoint.

The construction of high buildings has always required scaffolding of some sort, although the precise methods of de-centring adopted by medieval cathedral builders, for example, was not recovered by modern architects or historians until the 1950s.[42] During the early 1930s and as a development of his underwater marine work, Ove had designed a system of climbing formwork for land buildings which dispensed with conventional and always intrusive scaffolding. The shuttering system was 'mounted on a movable platform which was raised by means of jacks, three lifts per storey, since it was not permitted to cast more than a metre or so at a time'. But his contribution to Highpoint extended beyond the means of construction. In his own words again:

At that time [1934], tall buildings were supported by an orthogonal framework of structural steel – the normal steel skeleton which is still in use [1974]. The calculations were crude – no account taken of the strength of a frame, simply a matter of columns and beams, and the more steel the better, since that meant bigger profits for the suppliers. The steel suppliers generally threw in the simple calculations required, and also the actual erection of the steel framework, a job they could perform quickly and efficiently, and without excessive demand for building space in a built-up area. When reinforced concrete was introduced, the steel framework was simply replaced with a reinforced concrete framework. If the wall panels too were of concrete, the regulations required that they should be carried by the reinforced concrete frame: they did not contribute to the strength of the structure, only to the load upon it. In other words, plain facts were denied. When Lubetkin first set out plans for Highpoint, he also had provided for columns and beams all over the place, and of course the whole building was also to be carried on stilts – that was a part of being modern. It also looked very well.

I at the time had long since, when building coal silos and the like, dispensed with columns in walls – and particularly at the corners, where they are totally unnecessary.[43]

To conform to building regulations they 'had to agree to double reinforcement, including an ungodly mass of transverse reinforcement in the relatively thin walls, which undoubtedly weakened them significantly, since it meant that concrete had to be poured in a half-liquid state'. Nevertheless, Lubetkin was delighted to learn that the walls could take over the work of columns and lintels,[44] and Ove believed that the significance of Highpoint for him 'lay in the almost perfect integration of architecture, structure and building method'. As a striking example of 'contemporary' architecture in London before World War II the building attracted immediate attention. A modern assessment should nevertheless also be recorded. Historians of architecture rarely criticise a building's functional weaknesses – how many comment adversely on the so-called 'great' cathedrals of Europe? – and almost never raise issues of maintenance:

> Highpoint I's pioneering reputation has always outshone its compromises: the ninety-degree overlooking of adjoining flats, the odd arrangement of service terminals, which made it necessary in some cases to enter a neighbour's flat in order to read the electric meter; poor acoustic and fire separation in the service lifts; and a high-maintenance envelope that has needed onerous repairs over the succeeding years. [...] the intention that foyer areas should function as a sort of social forum never came to fruition. Neither, for that matter, has the roof terrace – a key element in Le Corbusier's theory of modern building – ever been fully exploited, furnished or planted as originally intended.[45]

Ove himself was far more critical, as an old man, if not in 1935, and after listing a series of unacceptable features concluded: 'It's a muddy kind of structure, one doesn't know exactly how the stresses are distributed'; he did 'not like this kind of contorted structure'. The architects simply 'got what they wanted' by not consulting the client – 'what does the client know about architecture?' – the engineer was not asked – 'his job is to keep mum'.[46] By the mid-1980s he was yet more critical: 'architects don't mind cheating. Lubetkin would tell any lie to the client':

> A wall like the one at Highpoint would have been much cheaper to build with bricks, but he claimed it was functional and economic. It wasn't functional at all: it had to be 'Modern'. Functionalism really became a farce. What is wrong with a sloping roof? They can't afford to pay what it costs

to make a flat roof really waterproof. Lubetkin didn't care. He just cared for the picture in the architectural magazines. There is such a lot of humbug in architects, but there is such a lot of stodginess in engineers. I am almost in favour of humbug, temperamentally.[47]

Lubetkin apparently

often told me himself, that he is not interested in Truth as such; for him any statement, spoken or written, is just propaganda to further an aim which is considered to be of overriding importance for mankind. This is of course the normal communist attitude, which I know only too well having clashed with it on numerous occasions.[48]

Jens Arup recalls the only occasion on which he saw his father in an almost uncontrollable rage. In the tense days of the late 1930s, Ove had returned home after an argument with Lubetkin about communism. Lubetkin had made a preposterous proposal, which Ove refused to accept he really believed: Lubetkin coolly conceded he'd simply invented it for the purposes of argument and did not believe a word of it. Ove felt deeply insulted, since there could be no deceptions in pursuit of the truth: Lubetkin had been deceitful, irreverent, irresponsible.

As for Lubetkin's claims about Highpoint being particularly suitable for working-class families, by 1985 Ove thought that, leaving aside the reality of rental costs, 'the working classes were exactly the kind of people who would hate to live in these buildings with open planning'. They liked what they were used to, which included talking to their neighbours across the garden fence:

I could only work with Lubetkin because as an engineer with what was at that time an unusual experience in the design and construction of reinforced concrete, I had the last say which Lubetkin had to respect; otherwise I would have been swallowed up by Lubetkin's forceful personality. [. . .] we more or less agreed to put aside our basic conflict of ideology.[49]

An unintended consequence of Ove's involvement with Highpoint was that he gained 'a reputation for doing tricks with reinforced concrete', which then enabled architects to get their way: but his own goal was simplicity, because that is a necessary ingredient in 'total architecture'.[50] The final costs of the building, however, could not be overlooked, since they disqualified the scheme as a model of cheap housing. The larger three bedroom units were rented out at from £150 to £225 per annum, and the smaller two bedroom units between £145 and £175 per annum. An official report for the area, published in 1936, found that the maximum affordable rent for a working-class family was 10s.

per week (£26 per year), a sum already exceeded by 98 per cent of those who lived in houses assisted by the London County Council (LCC); rents of new LCC houses were beyond 58 per cent of those for whom they were intended. The Kensal House scheme, on which Maxwell Fry worked, opened in 1936, and rentals there varied between £25 and £30 per annum.[51] By contrast Highpoint II, completed in 1938, offered unequivocally luxurious accommodation, which offended Lubetkin's dourest socialist colleagues; but it did present design solutions that could be adapted to vastly cheaper social-housing schemes – solutions about materials, scale and detail.[52] The top-down influence of technical achievement and aesthetic precision, as in Ancient Rome, Renaissance Florence, or Louis XIV's France, is always a factor in the development of style and taste in the public sphere as in the private, in buildings, as in furniture and dress.

In February 1936 Francis Skinner, one of Lubetkin's partners and a committed Communist Party member, had sent Ove a membership form to join the Architects and Technicians Organisation (ATO). He suggested that they seek co-operation from MARS, and he enclosed the initial 'Memorandum for discussion' held at the Conway Hall a year earlier, in February 1935. One of its targets was the Architects Registration Act, recently introduced by the RIBA.[53] The memorandum accordingly opened with a bold statement of ATO's social, and therefore, political commitments:

Few of those connected with architecture have not at certain times appreciated the lack of conscious, unified control which they and allied technicians exercise upon the problems of society. [. . .] the architect is finding himself completely unable to assume his proper social responsibilities. [We] have started from the basis that, since the Renaissance, the architect's historic position has been one inseparable from patronage. This has led to a traditional attitude of sycophancy, the seeking of the interests of the private client as opposed to those of the community, and a consequent unwillingness to face up to those social responsibilities for the assumption of which many contemporary architects are – by training and experience – essentially qualified. [. . .] [The architect] is still not permitted to exercise fully his technical experience or satisfy his social convictions.

Countless phenomena may be discerned in England today which are clearly pre-fascist, and which will grow unless rigorously combated and overcome, to a fully Fascist regime in this country.

[. . .] essentially, [architect members] would participate in the struggle for an all-round advancement of working-class and middle-class standards of living.[54]

Ove was sympathetic with much of this, although he deplored ideological agendas. But he did not predict the hostile reception in some quarters to the self-conscious vocabulary – 'sycophancy', 'struggle', 'advancement of working-class [...] standards'. He had witnessed German nationalism in Hamburg before and after World War I, but he was also dismayed by the conservative, anti-intellectual practices within British professional institutions. At the time the adjective 'religious' in polite British society typically meant 'evangelical', and 'political' meant 'left wing': Ove was obviously foreign, and while clearly not 'religious' was a bit 'political' in the eyes of British colleagues. His initial unwillingness to acknowledge such perceptions, and their implications, created obstacles about which, in later years, he was quite bitter.

Ruth Winawer, Ove's devoted secretary of twenty years later, provided an unexpected link with these times. She had worked for the writer and poet Louis MacNeice for five years after the war. MacNeice had been in the same house at Marlborough College as Anthony Blunt, later to become famous less as the scholarly Master of the Queen's Pictures, than as the super-spy who, for twenty years, betrayed British and Allied secrets to the Soviets. MacNeice and Blunt remained close friends through their university days. MacNeice included a passage dated 1937 in his unfinished autobiography:

> While there were many motives driving the intelligentsia towards the C.P., there was one great paradox nearly always present; intellectuals turned to communism as an escape from materialism. Materialism, that is, in the popular sense – that materialism which in more easy and archaic pockets of the country bolsters up the physical comfort of individuals and which, in places where people think, had for so long acknowledged the principle of enlightened self-interest, of mere utilitarianism, as man's only ideal in a mechanistic universe. Marx too postulated (and aggressively) a mechanistic universe but with the aid of the dialectic he stood it on its head, brought back teleology.

At that time MacNeice was living in Keats Grove, Hampstead, less than a mile from the Arups in Willifield Way and their left-wing bohemian friends. He records frequent literary dinner parties attended by writers such as J. B. Priestley, Rose Macaulay, Hugh Walpole. And MacNeice describes his social set who were often active in the East End communist meetings of the time:

> The new gang was much more middle-aged in its behaviour, was addicted to committees. Committees to save democracy, to protect writers, to assist refugees, to pass, when everything failed, a measure of protest. The great subject was Spain. The English press of the Right and the Left over-

simplified this subject. The *Daily Worker* (then a very fashionable paper with the intelligentsia) naively assumed (1) that communism in Spain was the same brand as the *Daily Worker*'s, (2) that Republican Spain was whole-heartedly communist, (3) that therefore Republican Spain would win. The *News Chronicle* naively assumed that the cause of Republican Spain was the cause of democracy and English liberalism. *The Daily Telegraph* naively assumed that Republican Spain was completely red and that Franco was a gentleman and fighting for the English Upper Ten and the City of London. And all the time David Low went on drawing his brilliant cartoons, rid-dling Franco and the Chamberlain Government with ridicule, and having them published in the *Evening Standard* which was owned by Lord Beaver-brook who staunchly supported Chamberlain and regarded the Spanish Republic as part of the Moscow Menace.[55]

Blunt and MacNeice had been in Spain together during 1936, and MacNeice returned to Barcelona, to view the bombing, at the end of 1938.

Things rapidly deteriorated on the mainland of Europe: Italy attacked Abyssinia in October 1935, Hitler announced rearmament in March 1935, remilitarised the Rhineland in March 1936 and absorbed Austria in March 1938. Throughout this period Arup family letters expressed increasing anxiety about what to do and where various branches of the family should go. By October 1937 Henning cautioned Ove: 'I believe we are about to face hard times, even without the risk of war, and that therefore you would be wise to prepare yourself financially as much as possible.'[56] Ove decided that some aspects of his life might need revision: Krog-Meyer was tasked to sell off his mahogany and pine motor launch, with a 10-hp engine, which was moored at Kingston-on-Thames. At precisely this time Kier's offered an increase of salary to £1000 per annum plus 5 per cent of the company's net profit: his declared income for 1937 was just under £6000. He had recently completed sheds for the War Office at Purfleet and Sheerness, and large reinforced con-crete aircraft sheds for the Air Ministry, 300 feet long, 150 feet wide and 57 feet high, at Kemble in Gloucestershire. But he was already in discussion with his cousin Arne about setting up an engineering partnership.

News of these plans had inevitably leaked to the family, and Henning advised Ove to clarify all contractual matters at the outset before embarking on any new scheme.[57] On the seventh floor of Colquhoun House, Broadwick Street, Soho, Arup & Arup Ltd, Civil Engineers and Contractors started on 1 April 1938 with a capital of £10,000: Arne ran two other firms, Pipes Ltd and the Water Meter Company, and Ove acquired a 50 per cent share of the former. Three friends joined Ove in champagne to celebrate the opening of

the new firm: Ronald S. Jenkins (who had worked with Oscar Faber),[58] Henry Crowe and Ronald Sheldrake – Ove's cousin Arne had gone home. Ove expected to increase his design consultancy work, and happily nearly all their jobs yielded profits – for which Ove assigned the credit to Crowe – but within six months his activities took a different practical turn as a result of the Munich crisis in September 1938. He became embroiled in work of considerable political implications from which he naïvely thought he could remain detached.

While this new development gathered momentum, in early 1939 Jørgen Jørgensen wrote to ask about Ove's views of Neville Chamberlain, and Solomon Rosenblum sent greetings from Paris, recalling their student days together. Distressed by refugees everywhere, he precisely captured the resignation of so many Germany watchers: 'eventually the general reaction against brutality will create a Europe where without any ulterior motive, we may enjoy a smiling child or the quiet melancholy of a winter's day.'[59] For his birthday in April, Ove's sister Astrid wrote:

> in spite of the dark clouds that tend to darken life at the moment, I think about you everyday, since I do feel that you are somehow more involved than we are across here. [. . .] I'm sure that it's a good thing that Albion's lion still has its teeth and claws intact and is able to show them a thing or two; in some article or other (German) it said that a lion that failed to react when you tore off a couple of whiskers surely was ridiculous, but you shouldn't forget that it still was a lion, with the aforementioned attributes intact![60]

Childhood for Anja and Jens, at least as remembered, was puzzling. They were perceptive, sensitive and thoughtful children, and close to each other: their father's affection was palpable, and their mother's comparatively distant. She was beautiful and dressed like a princess whenever she accompanied their father, but the children thought of themselves as being third in importance. Her life was dedicated to her husband as head of the family, and then to her Danish family, about whom she seemed to feel some guilt. It was obvious that nothing but the best was intended for the children, but so much was unexplained and obscure. Peremptory instructions about right and wrong were especially puzzling: 'if you get your feet wet, you will catch cold'; 'if you touch this dog, it will bite you'; 'if you scratch that mosquito bite you will die from poisonous blood like that man in the coffin passing by'. 'After several experiments' the children discovered that such alarming threats turned out to be untrue.[61] Within a few years, the anxieties of nightly air raids merely fortified

anxieties about the meaning of it all: Ove was too busy to discuss with them precisely the same doubts about religion and morality to which he had also been subject when young. Adults unwisely told them to wait until they were grown up.[62] Introspection evolved into introversion, and Ove's indecision about which boarding schools the children should attend was unsettling.

For six years in the early 1930s and with increasing anxiety, Ove had crouched over the family wireless set in Willifield Way to listen to Hitler's ranting speeches, crackling and periodically fading on the air waves. Li could not understand why he paid any attention at all to such rubbish: family stability, at home and in Denmark, was her absolute priority, and she did not wish external politics to intervene. Many of the most intelligent of citizens failed to grasp the scale of imminent danger. Thirty-five years later, Ove was reminded of those days, by an émigré art dealer whom he supported:

> Do you remember that Sunday afternoon when you, Sjøstrom (he's got another name now) and I went punting? It was the afternoon before the declaration of war. I would not then have given either of us an eighty days life chance.[63]

'A hell of a row . . .'

In December 1937 local authorities had been charged by the Air-Raid Precautions Act with responsibility for 'the protection of persons and property from injury and damage in the event of hostile attacks from the air'.[1] The Munich crisis propelled the Metropolitan Borough of Finsbury, in east central London, to seek advice from Messrs Tecton 'on the suitability of the available basements for public shelters'. The population of Finsbury was almost 100 per cent working class, and much of its housing stock had been condemned since the beginning of the century.

Tecton had recently completed for the borough the Finsbury Health Centre, commissioned by the left-wing Alderman Harold Riley; the firm was also working on two large housing schemes in Sadler Street and Busaco Street. Through Lubetkin Ove became consultant to Finsbury Borough Council. He was given the brief 'to provide protection against a direct hit from a half ton bomb for the whole population of Finsbury at a cost which they could afford'.[2] Moreover they could build only downwards, and in the open squares, rather than in the streets. An effective concrete slab, expensive as it would be, would have to protect as many layers as practical for access, evacuation, ventilation etc. An economical way emerged of building large spiral ramps which could

later be used as car-parks: they were air-conditioned, subdivided and provided with bunks and lavatories: 'the so-called deep shelters'. Ove described the resulting controversy as 'a hell of a row . . . which lasted for years'.[3]

Even in 1932 the warning of the former (and also later) Prime Minister Stanley Baldwin to Parliament was almost a commonplace: 'the bomber will always get through.'[4] There was talk but almost no action. But the bombing of Spanish towns and villages during the Spanish Civil War suddenly alerted British civic authorities to their own inadequate safety provisions. *The Times* published a letter from the Mayor of Barcelona on 17 February 1938, a year before the end of that war, in which he stated that the city had provided 'an extensive system of underground refuges [. . .] there were 400 such shelters capable of accommodating altogether about 350,000 people'. Over a two-year period and after 250 bombing raids, casualties amounted to less than 4000.

In Britain, many people with left-wing sympathies had keenly followed events in Spain, but Finsbury's commission had been further animated by the recent appearance of a 300-page book, *A.R.P.*: published by Victor Gollancz for the Left Book Club, it was written by a local author – J. B. S. Haldane, Professor of Biometrics at University College, London. Twice wounded when serving with the Black Watch in World War I, Haldane ran the Nigg Bombing School for six months from August 1915, and later lectured at a bombing school in India. He had visited the Soviet Union in 1928, and encountered notions of Marxist science. The rise of Hitler forced him into political activity, and he visited Spain three times during the Civil War, advising the government there on air raids. Ever more convinced by Marxist philosophy of science, he had become Chairman in London of the Communist Party Air Raid Precaution Committee, although he formally joined the party itself only in 1942 – at which date it claimed some 7500 London members. At the time of the Finsbury Report he was writing a weekly column for the party organ, the *Daily Worker*: he became chairman of its board in 1940 shortly before it was banned from publication for two years on 31 January 1941, under the Emergency Powers (Defence) Act of 1940.[5]

In the light of Haldane's book, Francis Skinner was dispatched in 1937 to examine for himself the effects of bombing on Barcelona, several references to which are made in the Finsbury Report. Other technical publications on air-raid precautions appeared with regularity from then onwards. In October 1937 the Cement and Concrete Association sent a delegation to Paris to inspect the measures already taken to convert seven metro stations to full shelter protection;[6] Haldane published a paper in *Nature* in October 1938,

and in December Cyril Helsby, Samuely's new engineering Partner, presented a powerful and well-illustrated analysis of the situation in Barcelona to the Institute of Structural Engineers.[7] Helsby recommended that irregular warning blasts from hooters, as in Barcelona, were both audible and elicited responses superior to those resulting from single blasts, as currently proposed in Britain. His advice was heeded. Helsby also reported that Barcelona had endured 1800 raids, at a rate of approximately fifty bombs per raid: casualties in early raids were rarely fewer than sixty to a hundred; the figure for deaths had dropped to two per raid because of the excellent shelter provision. Bombs were dropped from 25,000 feet, which meant that they were released more than two miles from target: accuracy was minimal. He also stated that Spaniards 'have no use to-day for trenches in the manner recommended in England'. This was soon to become highly contentious. During discussion after the lecture, Dr Oscar Faber deplored the British government's parsimonious attitude to shelter protection: 'To suggest that the people of this country were not worth £12 to £15 per head when it was remembered what it had cost to bring them into the world and educate them did not seem to make sense.'

Ove was fully aware of all this activity, attending many of the meetings and regularly conversing with the main protagonists. He became a member of the ARP Co-ordinating Committee in December 1939, chaired by Haldane, but resigned from it just over a year later because of its dogmatic and ideological approach. Ove declared, in a letter circulated to the editors of all the main daily newspapers: 'I profoundly disagree with the policy of providing bomb-proof shelters. I think it unrealistic, futile, harmful and perhaps even dishonest to advocate such a policy at the present time.'[8] What Ove meant was 'fully bomb-proof in all circumstances whatsoever': for him it was more rational to aim to protect almost everyone from all but statistically few dangers than to aim for total protection which could be afforded for only a few people, on whom a direct hit was statistically remote. And, of course, he was deeply opposed to brick shelters in any shape or form.

Haldane was indubitably a world-class scientist, whose skills could be, and were, harnessed to the war effort; as in the First War, he undertook hazardous experiments and tests for the Navy and Air Force. But in the domain of politics he was governed by blind and unshakeable faith. His widow recorded that up to his death in 1964 he refused to believe the horrifying details emerging from the Soviet Union about the pogroms, death camps and suffering of countless millions: he was tied 'to the propaganda of King Street, to Party discipline, and to the sacred texts of Communism, the works of Marx, Engels, Lenin and Stalin'.[9] Ove simply could not grasp how some intellectuals became

paralysed by their fixations. On the other hand, it cannot be underestimated how much more comfortable he felt among distinguished scientists such as Haldane and Bernal who readily discussed Kant and Hegel, Engels and Marx: how different from British engineers.

When the first aerial attack on London had taken place in the previous war, on 31 May 1915, there were no civilian shelters: people took to the underground stations, of which eighty were soon adapted for such use. Officials reported that 12,000 people gathered at Finsbury Park station when police displayed 'Take Cover' signs. Although parliamentary concern about hygiene in such densely occupied shelters was reasonably allayed, strenuous efforts were made after the war to ensure that the stations would never again be put to such use.

Three claims, none of them supported by evidence, dominated debate between the wars. The London Passenger Transport Board argued against the use of its stations as shelters on the grounds that such use would impair services; they also knew that under the chairmanship of John Anderson, the Air Raid Precautions Committee of Imperial Defence had ruled out tube stations as a shelter option in January 1924. By 1939 he had become Home Secretary and, as Sir John Anderson, vigorously opposed the construction of deep shelters on grounds of cost. He and many others in authority also held that a 'deep-shelter mentality' would so sap civic morale that citizens would never emerge to carry on their duties. A final claim also influenced debate. After a school in Poplar, East London, had been hit in 1917, killing fourteen children, various forms of population dispersal had become official policy.

The death toll in London from bombing during World War I was 670: by May 1941 it had already exceeded 40,000.

Trench shelters, vilified by Ove in his Finsbury Report, had been crudely excavated in London parks in 1938, but were soon deep in filthy water – suitable only for excitable dogs. Small Communist fronts, such as the Women's World Committee against War and Fascism, observed that 'if park trenches were to be ineffective, at least savings could be made on the cost of burials'. In January 1939 Ove was discussing with the Hungarian refugee who was his Hampstead neighbour, Kalman Hajnal-Konyi, the construction of a 9-foot diameter tunnel from Mount Pleasant Post Office to their Northern depot: 'this tunnel should form part of Finsbury ARP scheme. On top of this there will be smaller tunnels connecting various deep underground shelters [. . .] with the same internal diameter.' Some of this work was eventually completed – with hourly labour costs at 1s. 4d. for a general labourer and 1s. 9d. for a bricklayer.[10] Since underground shelters were being constructed for VIPs and

the Royal Family at Windsor Castle, Lord Strabolgi, in the House of Lords debate on ARP in February 1939, asked why underground stations could not be used by ordinary citizens. Anderson convened a conference under Lord Hailey which upheld his own view, but provoked ever more vociferous Liberal and Labour Party hostility to his decision to abandon any 'general policy of providing deep or strongly protected shelters'.[11] A trial black-out was ordered in London for 10 August, but it was half-hearted, at least in the minds of its advocates.

The government's contribution to protection consisted in the free provision to households with an income of less than £250, of 'Anderson Shelters': designed in 1938 by William Paterson and Oscar Carl Kerrison, Sir John Anderson happily accepted the compliment of their nickname. They were cheaply made corrugated iron and steel structures, typically placed in domestic gardens, and capable of holding half a dozen adults: conscientious families half buried them in the earth and covered them with vegetation. By mid-1940 two and a half million Andersons had been supplied but they were not popular, and in the London clays their slatted floors invariably disappeared beneath inches of water. Ove was himself primarily advocating the construction of vertical concrete or steel drums, buried to a suitable depth, or half-cylinders placed on the surface. By 1940 Ove accepted that the latter did offer shelter, albeit without comfort, provided they were properly embedded; by December of that year, in a 'Report on indoor shelters', he was advocating table-shelters, with concrete or steel tops and protected sides.[12] Within a year Herbert Morrison, who replaced Sir John Anderson, had implemented somewhat similar proposals, and the table-shelters were popularly named after him – 'Morrison Shelters'. These were free to those with an income under £350 per annum, or could be bought for £7 by anyone else. They were designed for two adults and a child, were 6 feet 6 inches long, and had a minimum width of 3 feet 6 inches: the minimum height was 2 feet 4 inches. In fact, the designs adopted were by Professor J. F. Baker (later Lord Baker), an expert on steel frames, and scientific adviser to the Ministry of Home Security principally responsible for research on bomb-proof shelters. At the same time Ove adapted a design by B. Finch & Co. Ltd, Basingstoke, for portable pre-cast indoor shelters which, again, were half-cylinders. Having slept in all of the then available forms of shelter, I now remember a greater sense of security in Andersons, greater comfort in Morrisons, and distinct awareness of flimsiness in brick street shelters; in deep tube shelters one recalls both reassurance and concern that the electricity in the rails had been turned off.

36. Extensive damage during the Blitz, which began in September 1940, forced authorities to change their shelter policies. Ove was keen not to alarm his family about sights such as this, close to his office, 1941.

37. On grounds of safety, Ove and his colleagues fiercely opposed trench shelters, here being dug in St James's Park, London, 1938.

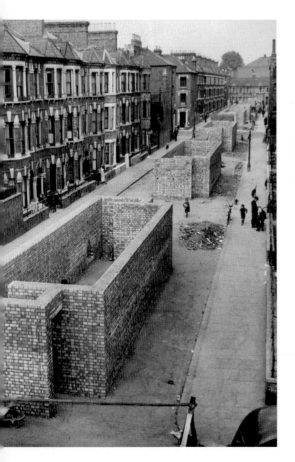

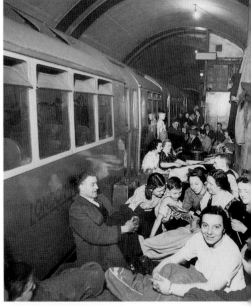

left 38. Ove judged brick shelters to be scarcely less dangerous than trenches. This row of shelters in Parkstone Road, Southwark, 1940, was completed just before intensive bombing: the interiors were sparse.

above 39. By the end of 1940, thousands of citizens preferred the shelter of underground stations.

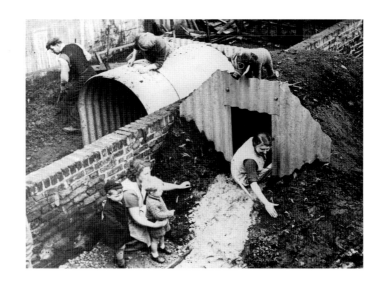

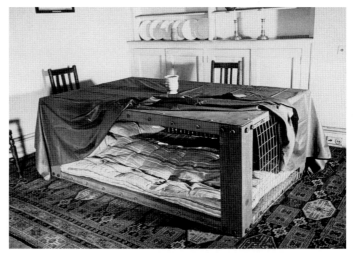

top 40. Anderson garden shelters, designed in 1938 by William Patterson and Oscar Carl Kerrison, but named after the Lord Privy Seal.

middle 41. Morrison table shelters, named after Herbert Morrison, were introduced in 1941 at the instigation of Ellen Wilkinson.

bottom 42. Ellen Wilkinson MP, dubbed 'The Shelter Queen' by newspapers, fought hard for adequate shelters. Ove approached her directly, as a friend of the Haldanes, 1943.

43. Julian Huxley, 1943.

44. J. D. Bernal, 1953.

45. P. M. S. Blackett and J. B. S. Haldane at the conference on 'Planning of science in war and peace', January 1943.

46. Sir John Anderson as Chancellor of the Exchequer, 1945. Anderson opposed Ove's ideas on the construction of deep shelters. Churchill replaced him by Herbert Morrison, and he was promoted ever up the political ladder.

48. Ove's early work had been on strengthening the foundation of jetties which became deformed under the impact of heavy vessels. Such work led to a major wartime commission.

47. Foreign Minister Jan Masaryk of Czechoslovakia, with the Soviet Ambassador, Ivan Maisky, 1941.

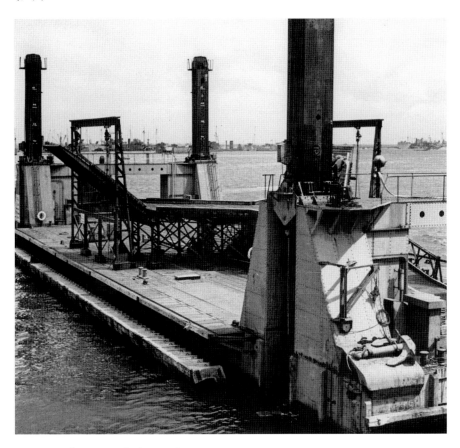

49. Ove's Baker gravity fenders in place, 1944.

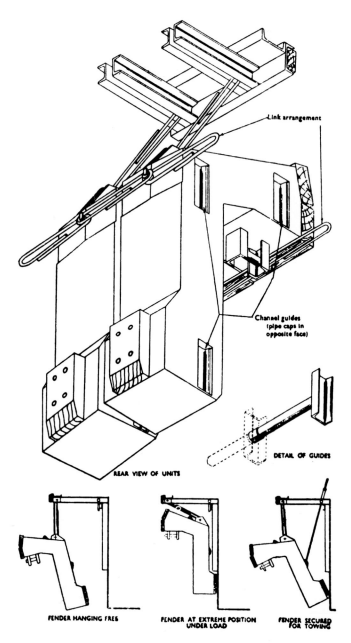

Link arrangement

Channel guides
(pipe caps in
opposite face)

DETAIL OF GUIDES

REAR VIEW OF UNITS

FENDER HANGING FREE

FENDER AT EXTREME POSITION
UNDER LOAD

FENDER SECURED
FOR TOWING

50. Ove and R. S. Jenkins adapted the original design of Baker fenders
for Mulberry Harbour, 1944.

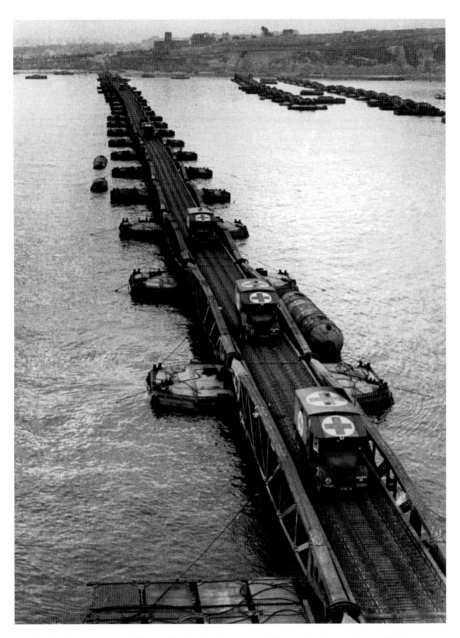

51. Pierhead pontoons, which could absorb the impact of heavy landing craft, enabled motor transport to be landed in almost all seas and to be driven across long floating bridges to the shore, 1944.

55. The Free Danish Army entered Copenhagen in April 1945 a few days before VE Day. Because of its relatively homogeneous society, there was less collaboration with the Nazis in Denmark than in other occupied countries, and also a marked reluctance to claim resistance as especially heroic.

56. Anja, Karin, Ove, Jens and Li at Dana, 1943.

facing page top 52. Ove promoted prefabrication for mass housing in the 1930s. By 1943 he was active in government plans for 'demountable' housing – colloquially called 'pre-fabs'. This house dates from 1944.

facing page middle 53. Prefabrication readily included two-storey structures, as here, 1938.

facing page bottom 54. Rapidly constructed estates of prefabricated houses were planned, to ease acute post-war housing needs, 1946.

57. The first offices, with an unconventional red door, of Ove N. Arup, Consulting Engineers, 8 Fitzroy Street, opened in 1946. The building, completed about 1760, became the residence of several distinguished people: in 1895 the painter James McNeill Whistler lived and worked there, to be succeeded by Walter Sickert and Augustus John, and later by Paul Nash.

58. Ove's first-floor office, 1952 – with finely balanced hanging plants.

59. Jane Drew and Maxwell Fry, 1951.

60. Le Corbusier (centre) and Walter Gropius (left), the two men who most influenced Ove's ideas as a young structural engineer, 1958.

left 61. The firm's early work built on the reputation established in Arup & Arup Ltd for thin concrete domes. Ove used this illustration of roof forms in his lectures.

below 62. Rubber factory, Brynmawr, South Wales, 1951, with thin concrete shell roofs designed by Ronald Jenkins.

63. The Bank of England Printing Works, Debden, Essex, 1951–6.

66. Ove was structural consultant for the Secondary Modern School at Hunstanton, Norfolk, by Alison and Peter Smithson, 1954. Although the building was widely acclaimed by architects, its users strongly disliked the extreme climatic variations to which it was subject.

facing page top 64. Ove promoted reinforced concrete box-frame construction from the 1930s. Tecton's design of Spa Green Estate (formerly Rosebery Avenue Housing Scheme), Finsbury, 1946–50, maximised prefabrication.

facing page bottom 65. The Trades Union Congress Memorial Building by David du R. Aberdeen, 1948–57, for which Ove was consultant.

67. Drake & Lasdun's Hallfield Primary School, 1951–6, for which Ove was consultant. This typical image records attractive, unpeopled spaces and pristine textures. Mid-nineteenth-century photographs of buildings, which required long exposures, typically omitted anything that moved. A century later, architects actively sponsored artistic photography of their work, which excluded all signs of human life. Photographers whose interest is in images can encourage architects to think of their work in terms of image making. In the absence of people or everyday objects, which provide a scale, architects, clients, critics and the general public can be as misled by photographs as they were by engraved elevations in former times.

At the beginning of 1939 Ove wrote to Lubetkin to emphasise that 'the report that I am producing is entirely my spiritual child. [. . .] The whole building up of the argument, the various concrete proposals, all originate with me.'[13] Thirty years later he told his staff: 'because Lubetkin's book *Planned A.R.P.* did not take [a] sober line I refused to be co-author [. . .] and published my own shelter book.'[14] It was neither the first nor the last occasion on which Ove had to combat claims by others to his ideas and achievements: in the present case, he had an uneasy feeling that since Haldane and Lubetkin were making all the noise, judgments about them would distort perception of the ideas they were canvassing – his ideas. And he was right.

Ove's report was published in February 1939, under the title *Air Raid Precautions: Report to the Finsbury Borough Council*. It consisted of a survey of needs and possible locations by the borough engineer A. L. Downey, and an analysis of possible structural measures by Ove – 'on whose investigations and conclusions our report is based'. The London and national newspapers gave prominent coverage to the report, and to the opening by Herbert Morrison of the exhibition in the Town Hall promoting it. Alderman Riley had produced a huge press release – measuring 16 by 13 inches – to obviate the need for journalists to take notes: amusing diagrams and cartoons graphically conveyed statistical information and the seriousness of the problems addressed. Under the headline 'You ought to know about Finsbury', the *News Chronicle* for 7 February 1939 accurately outlined the proposals, and reported a basic construction cost of £6 per head, rising to £10 10s. with the necessary extras of air-conditioning, lavatories, food storage and decontamination chambers: it described the structure as a six-storey, spiral concrete chamber, 65 feet deep, entered by a 50-foot wide ramp which enabled 7600 people to enter safely within three minutes. The following day, Haldane wrote a commendatory piece, describing the exhibition as 'a new stage in the struggle of progressive local authorities against the national Government for the safety of civilians'. He observed that one fifth of the Finsbury residents would still be more than 300 yards from the proposed shelters, which might prove too much within even a ten-minute warning system. Moreover 'we must beware of the fetish of uniformity so dear to administrators' and construct shelters appropriate to context. A typical Haldane conclusion about the shelter proposal typically irritated officials: 'If we do not take advantage of it, our blood will be on our own heads.' The *Daily Telegraph* restricted itself to a factual summary under the heading 'Ambitious plan', observing only that a construction time of seven to eight months per shelter might be a source of objection. The London *Evening Standard*, a Beaverbrook paper, like *The Star* and

the *News Chronicle*, continued its attacks on Sir John Anderson, who 'has not revealed the stature for his tasks': 'He must tell us why he is satisfied with half measures in the business of protecting the people.'[15]

Four weeks later Ove listed responses. He had himself circulated his report to several influential people, many of whom indicated willingness to act: General G. S. Collins, Director of Fortifications, thought the proposals worth pursuing and forwarded names; several offered to intercede with Anderson, including Dr Oscar Faber, Professor J. D. Bernal and Sir Henry Japp, a director of John Mowlem. The Chairman of the Parliamentary ARP Committee, Oliver Simmonds, MP, asked for an article for their journal, and Uxbridge Flint Brick Co. offered 2 acres free of charge for bomb and shelter tests.

The next month, in March, Ove issued a second report, published by Concrete Publications Ltd, under the title *Design, Cost, Construction, and Relative Safety of Trench, Surface, Bomb-proof and other Air-raid Shelters*. In the two years up to June 1942 a total of 413 copies had been sold, at 6s. a copy, yielding a royalty of £13 7s. 9d. Both reports reveal the shocked awareness of imminent war, and the general state of civic unpreparedness for it. Ove's preface to the March paper begins by stating that:

a complete scheme for the civil defence of the Borough [. . .] was not an ordinary engineering problem where the objects to be achieved, the methods of achieving them, and the stresses to be worked to are defined within narrow limits. It was rather a question of designing structures giving an undefined degree of protection against destructive forces about which very little was known. Not even the amount of money at our disposal was known.

The introduction to the first, February, report began by citing a German publication which 'advocated the complete annihilation of all the centres of supply in the enemy country'. It added: 'The recent experience of Spain, China and Abyssinia, also tends to prove the war of the future is likely to be fought on these lines.' A further comment should be noted: 'The publication of all data relative to civilian protection, at any rate as far as military considerations allow, is therefore an absolutely essential factor in maintaining morale.'[16] No widespread dissemination of such data was undertaken, because the report directly conflicted with Home Office plans. In March 1939 Churchill, who was still over a year away from holding office, was reported by his secretary at Chartwell as believing wide circulation of the book 'would not be helpful at the present juncture'; the argument seemed to be exaggerated 'in the interests of some particular scheme' with which the authors were associated.[17]

Moreover he, Churchill, understood from the Lord Privy Seal that 'properly reinforced basements will give a very large measure of protection'. The Lord Privy Seal was none other than Sir John Anderson. In fact Ove also studied German designs for 'Splinter and gas-proof concrete tube shelters', and used a report issued in July–August 1937 under the title 'The construction of bomb proof shelters' in *Bautechnische Mitteilungen des Deutschen Beton-vereins E.V.* The Germans had experimented with reinforced concrete pillboxes at the third battle of Ypres in 1917: they had proved virtually indestructible. There were two major irritants to both the opponents and the merely sceptical among Ove's readers – let alone Haldane's. First, the authors were fluent in German, and had carefully studied German technical reports; second, they were engineers and scientific experts, and had no difficulties with the reports, which were incomprehensible to most parliamentarians and their officials. Nevertheless, neither general readers nor government authorities could miss the political allusions of the report:

> It is *protection* that we should provide, and not mere accommodation. There are exact parallels in other domains of our national life. For instance, when the public conscience was awakened to the inadequate standard of working-class housing, a very tangible effort was made to arrive first of all at standards of accommodation which could be laid down as essential from the point of view of hygiene, amenities, and so on.

The report listed agreed facts about likely bombing raids, and added that on the reasonable assumption that bombs would be released at heights of not less than 12,000 to 15,000 feet, the extreme difficulty of hitting a given target from that altitude inevitably resulted in 'indiscriminate bombing'.

> For instance, a variation of 6 m.p.h. in the speed of an aeroplane travelling at an altitude of 15,000 feet can make a difference of 80 yards in the position where the bomb falls. As wind pressure and other factors cause constant variations of speed, it is practically impossible to consider accurate aiming from this altitude.[18]

The authors admitted that, in the absence of detailed British information, they had had to rely on 'foreign published information' about the penetrative and explosive effects of aerial bombs. They listed various types of bomb and their general effects – impact, penetration, shock, blast, splinters, falling debris – and then turned to protection. Ove's experience of marine jetties and wharves was immediately evident, with his emphasis on underground wall-strength to guard against caving in – despite his persistent reliance on the phrase 'and so on'. His

own proposals for the design of trenches explicitly conflicted with recently circulated government recommendations, which he severely criticised on the grounds that control, centralisation and inter-communication would be impossible: moreover, they allowed for no circulation or space for medical care, no rational access or exit routes, no natural ventilation systems or procedures for decontamination in the event of the much-feared and anticipated gas attacks. Finally, 'there is simply no room to provide anything like the necessary number of trenches'. Ove's impatience with the government policy of widespread dispersal of people and shelters was hard to contain: 'A little ordinary concentrated thinking will show that this calculation is mathematically fallacious.' Worse: the basements currently in existence combined 'the worst characteristics of both large and small shelters, coupled with innumerable other dangers'.

After more than twenty foolscap pages of closely argued critical analysis of current government proposals, the authors turned to the construction of 'vast' underground cylinders, following 'a system invented by Dr Arup'. Ultimately these derived from his design for dolphins and jetties. His 'doctorate', jokingly conferred by Lubetkin, now came in useful as a sign of authority when challenging government 'experts'. The cylinder construction dispensed with all framework and shuttering normally used for reinforced concrete floors:

> The first step [...] is to drive piles at close intervals all round the outside ring of the shelter, in the positions which are later to be occupied by columns which will support the floors and the detonating slab at the top. Earth within the outer ring of piles is then excavated and the ground shaped to the exact form of the first ring of the ramp, smoothed and covered with building paper. On the earth thus prepared the concrete of the first circular section is poured. [...] Once this first ring has set, the excavation is carried lower in the circular shaft at the centre of the shelter, and the earth is scooped out from under the concrete slab, which is now self-supporting.[19]

Ove illustrated three types of large, circular, multi-storey bomb-proof shelters, sheltering 270, 870 and 7300 people respectively – the largest of which could be used as an efficient car-park. Twin, ramped, spiral entrances enable the rapid influx of 7300 people within three and a half minutes. Air filters, modelled on those used in the Maginot Line fortifications, and a back-up internal generator, ensured both light, and clean air-conditioning.

In his March version, Ove devised ramps in the form of two helixes, one inside the other, echoing his design for the Penguin Pool at the London Zoo. Ove did not invent this form, of course, but he had no need to mention to his audience even British spiral precedents.[20]

In some anxiety Li went to stay with her sister Esther in Paris, in June 1939, and in August she went to the country near Didcot: the advisability of moving out of London was at the front of many people's minds. In April the French and British had pledged to support Poland, were it to be over-run; by 23 August Stalin and von Ribbentrop had signed a non-aggression pact between the Soviet Union and Germany, freeing Hitler to invade Poland and Stalin to invade Finland. Although the main text of the Nazi-Soviet Pact was known, its accompanying explanatory protocols remained secret until 1945 when Nazi archives were captured. Within one week, by 31 August, civilian evacuations began from London, and the British fleet was mobilised.

Britain and France declared war on Germany on 3 September. Within the next two days Norway, Portugal, Spain, Ireland and United States had all formally proclaimed their neutrality. On 6 September, Esther wrote to Li and Ove from Rothéneuf, three miles from St Malo on the northern coast of France: 'We are staying here for the moment; waiting with the other Americans [. . .]. Don't give up hope. Also you are not alone.'[21] Gerald added a postscript: '*Inconcevable*!! But fortunately there is the other side of the story.' On 2 October they were back in Paris, packing and preparing to leave for America from Bordeaux in two weeks' time. But by 22 October they were again in Paris: her mother's money to help them leave, forwarded via Li, had not arrived. Gerald's mother had gone to America, and on 12 December they were still stuck, some forty miles from Bordeaux – the only port from which they might hope for an escape westwards. Gerald added another P.S.: 'Christmas 1939! War, hate, Jealousy etc. Christ Victorious yesterday, today and tomorrow.'[22] Li replied by return, and Esther, too responded immediately: 'I really wouldn't like to fly just now and I am also wondering what might happen in Denmark, in that case there would be trouble for us, Gerald not being Danish. I always had fears in that regard from the beginning of the war. With my health everything is alright, my mind is a little upset, if mother is nervous etc. But in her letters to me she seems very calm.'[23]

Two months after the outbreak of war, on 9 November, Ove sent an account of his family life and circumstances to Henning and Anna. He estimated that the Finsbury ARP shelters, costed at over £100,000 should produce fees of £2500 – in fact, by June 1940 they had yielded over £3000. His consultancy fees for the year 1939 were £1183, and for 1940 £2239 – although the overall consultancy fees received by Arup & Arup from the Finsbury shelter project by 1942 had reached almost £11,000. From 1939 onwards the total British income of Ove himself never dropped below £3000 (now not far from an equivalent of £100,000): income from property and investments in Denmark was typically

retained there, and was supervised by Henning. Office overheads in 1940 included rental of Colquhoun House at £693, plus rates of £175, travel at £500 and a salary paid to Crowe of £975. So Ove reassured Henning: 'there is no doubt that the war has destroyed our chance of making a small fortune, but we should be able to make a living.' He reported that Li and the children initially went to stay with friends in Berkshire as the war started, and that he had 'moved our office to a shed in Virginia Water'. Luckily they were then all able to get hold of Arne's old house, set in an acre of garden, in Virginia Water, which was larger than their Hampstead house. They could not afford to run two houses, however, and did not intend to stay in Surrey for ever: they were also 'rather afraid of being dragged in to the social life here'. What arrangements could or should be made for the children? Anja was nearly eleven and Jens was eight, but their schools had moved into the country. Thousands of children were being shipped across the oceans. Was that something to be contemplated?

On the present 'phoney war' Ove felt that:

> the situation has somewhat improved as far as the war is concerned. I cannot quite see what Hitler can do. It is possible, and perhaps even likely, that he will try to let hell loose here, but I don't see how he can smash us up so badly that we shall be suing for peace, and unless he can do that he will be worse off than before.[24]

After World War I the Danish government had pursued a series of pacifist policies, but events in Germany in 1933 changed attitudes, and the Defence Act of 1937 permitted some modernisation of the armed forces. Even in 1940, however, these stood at only 14,000, of whom more than half had been drafted in the previous two months. In the spring of 1939, Denmark had been the only Scandinavian country to accept Hitler's offer of a non-aggression pact: this supposedly guaranteed a right to trade with other nations, but the deal was broken within six months. Denmark's effective isolation was sealed in August by the Nazi-Soviet Pact.[25]

In early April 1940 Danish intelligence failed to act in response to Admiral Canaris's carefully leaked plans in Berlin of a Danish invasion: no forces were strengthened until 8 April, and resistance to the actual attack the next day lasted a few hours in North Schleswig only. In most areas, not a single shot was fired. An unidentified friend from the British Expeditionary Force wrote to Ove and Li from 1 Corps: 'I am so sorry to hear the news today, and particularly for the anxiety you must have for all who are near and dear to you. It is dreadful to think of all the sorrow and distress which must result.' On receipt of Li's telegram the following day, Esther replied in her fractured

English from Arcachon, near Bordeaux – it is not clear what naval success is referred to, since news was both censored and often issued well after the event:

> it is so good to know that you and I still have each other, if only we could be together. Do keep your courage as much as possible. [. . .] Today I sat a long time thinking and I felt within my self that the best way to help Father and Mother and to be really their child is to be very courageous and pre-serve ourselves in order to help them the way God permits. [. . .] But the whole Denmark is weeping today, they will all be one heart and help each other. [. . .] Perhaps other countries will have things worse than Denmark. It is good that the Danes are so patient and calm of character. Everyone knows that such a condition is not going to last and that gives one courage. [. . .] Today we have the good news about the English victories on the sea – You know, goodness of heart is with us, all the same – Don't you think it is best not to try any relations with our people? It might harm them.[26]

A few days later Esther reported that she and Gerald had made contact with a Danish woman in the American consular corps, through whom contact might be made with their parents:

> Perhaps Father and Mother are not so unhappy as we think. It is so awful to know nothing but one mustn't imagine the worst. . . . [the American Consul] would tell, if he got any news from Copenhagen; but of course we can't send any that way as it might harm. You see there is a chance having news that way.[27]

Gerald wrote to Li and Ove the following week: 'We are also broken hearted, especially Esther who loved Denmark so! Don't you find it very cowardly to act the way the Germans do – pretend to be civilians, then all of a sudden change into soldiers?'[28] At the end of April 1940, and still in France, Esther counselled Li, now in the late stages of a difficult pregnancy, not to 'read any more papers from now on! Ove can always tell you.' She was glad to hear that they had acquired an air-raid shelter – an Anderson had been constructed in the back yard. At the beginning of May she advised Li to use their contact in the American Foreign Service to send 'an open letter without address of sender or recipients – and merely signing "Ruth" and speaking only about the family.' The following week Esther declared that 'last week I cried because of leaving but now it is over.'[29]

It was a close-run thing. France was invaded two days later, on 10 May, and within six weeks its army of five million, until then admired by many, was completely defeated. By a stroke of fortune Esther, Gerald and their boys

Andrew and Edgar obtained berths on S.S. *Washington* and on 26 May 1940 Esther reported that they were approaching New York. Just before leaving France they had received indirect news from Denmark about their parents. And they had met other Danes on the boat, who boosted their morale:

> At present they have enough to eat and continue their lives, but at the end they will be poor as the Germans go into the shops and buy things and pay with a piece of paper. There are many people out of work. Of course they can't do anything without permission of the Germans, but you see you shouldn't worry, they are not as unhappy as many other people and you can write them if you don't speak about politics. What Father wrote was quite exact. I am so glad I have spoken to these Danes I feel really relieved. Here is also a Russian conductor Malko who directed the radio orchestra in Copenhagen. When I speak with his wife I feel that the Danes haven't changed and that they will help each other.[30]

Two, even three, letters a week poured in from America. On 6 July Esther, surprised that in recent snaps Ove looked so like his cousin Leif, announced: 'I am going to register myself in the office of the English refugee children to be sure I get hold of Anja and Jens if they should come over here. So don't worry about that.' The following day, on receipt of Li's letter, she wrote again, about small-town New Jersey, London air raids, and France: 'Leif asked if you were on the quota to come over here or to Canada, I said, I didn't think so.' By the end of July they had moved to Summit, New Jersey, in which area they stayed for more than thirty years. She urged Li to send Jens and Anja over: Harms and Leif were willing and able to look after them, and Esther and Gerald would move nearby to help. Harms, indeed, would pay for the journey if necessary: 'if ever they come and you should lose connection <u>be sure I am looking after them</u>.' A few days later: 'If for some reasons or others we should be without communication don't forget, I now promise you to be brave and hope for the best for all of us. Then I hope you will promise me the same?' New family bonds had to be forged, and at the beginning of August she reported: 'Gerald went to see Leif and they became "Dus".'[31]

London was obviously a central target for bombing and Ove was relieved to have removed his family to Surrey. But home help for Li became a constant problem: their first Danish girl left to join the WAAF, and on 20 August 1941 Ove drafted an advertisement for *The Lady*, which included a description of the house:

> Wanted Kind and cheerful person, fond of children, accustomed cooking and housework, Modern electrified house in Virginia water. Room facing

south, central heating, H.C., Wireless. Excellent daily help kept. Happy life for suitable person [deleted] Apply Box . . .

Several replies were received, but Ove had to abort the exercise because Li was herself suddenly taken into a nursing home for a minor operation on swollen glands: he had to run the house by himself, and without a maid. So he advertised again:

We have a very nice medium sized house, with central heating and electric cooker and refrigerator. [. . .] We have a daily woman coming in every day who does the washing and looks after the rooms upstairs. We are Danish ourselves (although British subjects) and would particularly like to have a Danish girl. You would have a nice room . . . etc

The authors of the first Finsbury report in 1939 had acidly predicted that the government might well implement a policy to forbid use of the underground tunnels and stations as air-raid shelters. Although the reasons behind that prediction were known to few of their readers, facts soon seriously challenged the dogma they tried desperately to overturn.

When Churchill became Prime Minister in May 1940 precisely one branch of the London underground had been adapted for shelter use. As late as August the *Daily Telegraph* reported London Transport officials denying entry to anyone unable to prove an intention to travel, and of evicting travellers from the safety of the station to public street shelters. But on the night of 7 September 1940 Londoners took matters into their own hands: heavy bombing started and every night from then on, over 170,000 citizens sheltered in the tube stations.[32] The next day Churchill informed Anderson that he wished to see 'widespread utilisation of the Tubes'. But Anderson was well entrenched, maintained his opposition, and was surprisingly backed by the War Cabinet as late as 23 September. He fiercely defended his hostility to the use of stations, orchestrated a Home Office 'Note to editors' deploring it, falsified figures, and implied that any *men* who thus took shelter were virtually enemies of the cause. After three weeks of intensive bombing, however, almost 6000 Londoners had been killed,[33] and Anderson found it personally advantageous to reverse his position: promotion might be a way out. And it was. He was moved sideways, then became Chancellor of the Exchequer in 1943; in 1952 he was created Viscount Waverley and in 1957 received the Order of Merit. The government could not disguise, even from itself, that it had seriously miscalculated the effects of night bombing, the need for sleeping in public shelters, and the logistics of organising large civilian groups. They turned for advice on deep shelters to Dr David Anderson, who was a Joint

Consulting Engineer of the London Passenger Transport Board; and immediately accepted his recommendation to extend tunnelling for such purposes, within the existing tube system.

This began in January 1941, and eight new shelters were built, the first of which opened at the end of November; the other seven were not opened until July 1944, at which point 40,000 bunks in deep tube shelters were made available. In the meantime, five miles of deep tunnels had been adapted for vital war manufactures by the Plessey Company. As early as 1939 Sir Robert McAlpine & Sons had provided reinforced concrete protection for underground wartime headquarters of the Railway Executive Committee, and for temporary use while the War Cabinet Rooms were being constructed. In addition, by the end of 1940 seventy-nine tube stations were adapted for shelter, catering initially for a nightly average of 120,000 people; daily feeding arrangements for all of them were organised within four weeks, and although sixty-three million people sheltered in the underground stations throughout the war, there were no epidemics or outbreaks of disease. Some shelters were estimated to be able to hold large numbers: *The Times* in June claimed that the tube station at Borough, dating from 1892, had been adapted at a cost of £50,000; it now had eight entrances and a capacity of 14,000 people.[34]

Ove was very well aware that the Communist Party had noisily fostered disaffection, particularly in the East End of London, and through the columns of its national paper, the *Daily Worker*. Churchill's intense hostility to communism and its sympathisers, well known to his officials, indirectly influenced the outcome of the Finsbury proposals. In the six months immediately prior to its closure by the government, and beginning on the very day of the London Blitz, the *Daily Worker* strenuously promoted Haldane's ideas for reinforced concrete shelters: however exaggerated these strident efforts were judged to be, influential members of the government and their anxious advisers inevitably associated Ove's advocacy of something similar with Haldane's communist position, especially as it was delivered in the name of a left-wing borough, by someone who sounded suspiciously foreign. In any case, Haldane had himself named Ove's designs in connection with his own work and proposals. (In fact, Haldane had not only pinched Ove's original design for affordable shelters, but then adapted it by adding a 24-inch reinforced concrete roof, which negated the whole rationale of the design.) Moreover, Lubetkin had made no effort to disguise his visits to the Soviet Union in the 1930s, or his Marxist sympathies and friends. In 1939 the Nazi-Soviet Pact fostered paranoia among officials about all such émigrés, and their associates. Churchill may never have registered Ove's name when he read the Finsbury

report in 1939; nevertheless, Ove himself never forgave Churchill for heeding such people as Anderson, whose refusal to listen rested on ideology just as pig-headed as Haldane's. He could only guess, of course, that however worried everyone was about the Blitz, in the secret circle of the War Cabinet the even greater anxiety was about an almost certain invasion.

For as long as possible, the adornments and necessities of life had to be secured. Ove acquired a new Horner accordion in April 1941. Six months earlier he had sent his usual wine order to Mr Albert Herzog, in East Dulwich, which included:

2 bottles of 1811 Brandy	@ 360/- per dozen
One bottle Louis Phillipe 1830	@ 360/- per dozen
Four bottles Pommard 1906	@ 116/- per dozen
Five bottles Forsters Fleck	@ 78/- per dozen

Unfortunately Mr Herzog had been interned, and sent to Canada. Ove promptly wrote to Herzog with his condolences: and placed his order elsewhere.

Ove's third publication, under the title *London Shelter Problem* and dated 15 October 1940, appeared five weeks after the beginning of the *Daily Worker* campaign, almost exactly six months after the Nazi occupation of Denmark and two months after the fall of France. Esther and Gerald had arrived safely at the end of May and limited communication with family in Copenhagen was maintained, for the time being, by means of letters routed via the US.

Ove's new attempt, partly because of its more informal style and presentation, conveyed the urgency of the problem, but also his dismay that the Home Office had apparently grasped neither the nature of the Finsbury proposals nor the reasoning behind them. He wrote a heavily ironic Introduction at the expense of Sir John Anderson, who was commended for 'dignity' and for being 'victorious'. Ove drew a distinction between deep shelters protected by natural soil above, and the Finsbury proposals, which were for bomb-proof multi-storey shelters: 'heavily protected shelters are not bombproof because they are deep, but they are deep because they are bombproof.' The Home Office preference for low-cost, widely distributed small shelters 'explodes on contact with a minute amount of mathematical understanding'; officials seemed to think that 'as the officially sanctioned shelters are proof against anything but a direct hit, and as a direct hit will also destroy a considerably stronger shelter, there is no advantage in making them stronger.'[35]

In March 1940 *Home Security Circular No. 38/1940* had set out the new thinking. But Ove found the vacillating proposals for gas-proofing to be plainly

inconsistent with their other requirements for small street shelters. As a minimum step, filtration plants should be incorporated into all new communal shelters. However, night raids introduced an unforeseen requirement: the need for those taking shelter to sleep. Ove's social jibe intensely irritated officials who were already keenly aware of class tensions magnified by the crises and fanned by left-wing activists: 'desire for privacy is especially pronounced amongst the people with higher incomes or of certain social strata, and some of these can afford to pay for a more expensive private shelter, or are, at any rate, willing to face an increased risk from bombs to ensure privacy.'[36]

In arguing for ARP structures in reinforced concrete, not in brick, Ove was confronting deep-seated prejudice and ignorance in government circles. Reinforced concrete was still a newfangled material for most officials, journeymen and laymen alike, and in 1940 a majority of engineers advising the government had no firsthand experience or understanding of the material: the British knew about steel and about brick, not about concrete. Ove recorded that at the outbreak of war Finsbury Borough Council, following rejection of its proposals, 'was without a single shelter'. Accordingly, it took it 'into their own hands' to construct twenty-seven 'wall-shelters', catering for 11,750 people at an approximate cost of £8 per head – a cost increased because 'most of the shelters had to be dug into the ground'. The shelters were started 'before Home Office sanction could be obtained'. It therefore

> stepped in and prevented the construction of further shelters of the type, and also refused to allow: reinforcement of floors, waterproofing or gasproofing; drainage or artificial ventilation; installation of wcs, water supply or secondary lighting; or air-tight manhole covers for emergency escapes.

Ove added: 'some of these items were nevertheless provided by the Council.' When he wrote that, the shelters were filled to capacity, had inspired confidence and nobody had been hurt in the only direct hit.[37]

Ove also was highly suspicious about the unexplained cancellation from above, on financial grounds, of the contract for the original Tecton plan for Busaco Street, in Finsbury. The plan had been continuously revised and re-costed as new official requirements were issued, and a contract let to Peter Lind & Company, a respected Danish firm established in London in 1915, which was currently engaged on constructing the new Waterloo Bridge. Ove continued to work with the firm after the war – Peter Lind was one of his three referees for the chair at Imperial College in 1945. Ove soon recognised that events were now moving so fast that former positions must be modified:

'entirely new figures for the shelter space required will have to be computed. This must be done in each Borough.'[38] A clear policy about evacuation must be laid down, night requirements addressed, in terms of space, protection, comfort, and decisions made about the nature and extent of upgrading necessary. New reinforced concrete wall-shelters should be started, requiring release by the government of steel and cement. Ove did not think underground stations presented a general solution, especially if trains were kept running: and in fact they catered for only 4 per cent of the shelter needed by central Londoners during the Blitz, at which date 27 per cent were already using Andersons. By the spring of 1941, the steel table-shelters – 'Morrison shelters' – had been widely distributed.

Immediately he had finished this third attempt, *London Shelter Problem*, Ove circulated copies widely to influential people, with accompanying notes: all of them shared socialist views. Architect and engineer friends obviously received copies – R. S. Jenkins, Cyril Sjøstrøm, Jane Drew,[39] C. L. Franck, Lubetkin, Guy Morgan, 'Freddie' Skinner; scientists too, including Haldane, J. D. Bernal, Julian Huxley and A. L. L. Baker; politicians including Herbert Morrison, Ellen Wilkinson, Alderman Riley; writers and publishers such as Victor Gollancz, Kingsley Martin, Ritchie Calder; influential doctors such as the King's Physician Lord Horder and Dr J. N. Morris, Chief Medical Officer for ARP. Of particular note is the copy sent on 1 November 1940 to an official at the Soviet Embassy, A. M. Krainsky, with a friendly message recording earlier conversation and the ambassador's expressed interest. The breaking by Germany of the Molotov-Ribbentrop Pact was still eight months in the future – at which point the embassy had to reverse its former official position and rapidly devise, within one month, an Anglo-Soviet pact.

Ove had been extremely busy designing shelters for companies, local authorities and private citizens; more than thirty are listed from 1938 onwards, including adaptation of the basement of the Arup & Arup offices in Colquhoun House, Soho, for 77 staff and 323 citizens. By December 1940 his clients included the Air Ministry, Anglo-American, Gestetner, Tyresoles, as well as council authorities in Finsbury, Stepney, Hackney, Hayes and Harlington, Marylebone. (Sigmund Gestetner, the patron of Highpoint, promptly sent him the titles of two books on hydroponics, which he thought Ove should follow up.) The Anglo-American proposal generated a typical example of officialdom, about which Ove wrote to the Dowager Marchioness of Reading in June 1939 – at the suggestion of Lubetkin, who, of course, knew her. The Office of Works had turned down a proposal for an underground shelter for 250 staff at the Queen Anne's Gate offices:

because it would mean the temporary removal of some shrubs and the endangering of two young cherry trees which stand near the edge of the plot adjoining Bird Cage Walk. It is apparently the Park Committee which has lodged this objection, which has now held up the construction of the scheme for a considerable time. [. . .] It seems to me – also privately – that it is somewhat out of proportion to prevent the construction of this scheme (which may become important) for the sake of a few shrubs and young trees which could easily be replaced once the shelter is constructed.[40]

Alongside his earlier work with Tecton on social housing, Ove developed ideas for *Safe Housing in War Time*, which was printed by Gestetner Ltd and issued at 5s. a copy on 10 May. In October 1940 he issued a new appendix, entitled 'Dispersion', directed explicitly against current government policy. In a manner reminiscent of Haldane he stated:

I understand the sentence: 'Dispersal is the sovereign remedy against heavy casualties' as falling within the sphere of mathematics, or, more specifically, a branch of mathematics, the theory of probability. Moreover it deals with an elementary problem within that theory. Surely this is not a question which admits of any personal opinion? Surely we have not in the country arrived at a state where we speak of the Nazi, or Communist, or Home Office interpretation of mathematics? We look up a textbook, or we ask a professor of mathematics, and that's the end of that. Is it then, that I misunderstand the meaning of the sentence? Is it really a religious confession, or a prophetic utterance about the future? Obviously not. Well, then it should be possible to clear up the matter.

He threw down a challenge: 'Is there anybody – for instance amongst the mathematicians advising the Government, if they exist, who would come forward and prove to me that there is any essential mistake in the above statements? I promise to eat my hat if they succeed.'[41] This was a cyclostyled paper for possibly widespread distribution. But Ove had another route to explore: the parliamentary secretary at the Ministry of Home Security who was responsible for shelters, Miss Ellen Wilkinson.

As he admitted years later, Ove had been carrying out 'a war in two fronts, partly against the authorities whose handling of the affair was [. . .] deplorable, and the extreme left in politics, who were at that time agitating for complete protection for everybody against a direct hit of a half ton bomb'.[42] The ministry, however, provided a ray of hope, 'completely sincere in wanting to do the right thing for the people of the country'. Formerly a member of the Communist Party, Ellen Wilkinson had organised the hunger

march of October 1936, in which two hundred unemployed Jarrow ship-workers marched to London: at that date over 80 per cent of her constituents in the north-east of England were out of work. Ove had met her in Finsbury, and knew that she was a close friend of Charlotte and J. B. S. Haldane. His first letter is dated 13 December 1940:

> You've got to get this dispersal business right! When John Anderson went, and Herbert Morrison and you were put in charge of shelter policy, many people heaved a sigh of relief and expected that the end of the muddle was in sight. They must not be disappointed. Firstly because the shelter problem is important and the country cannot afford to waste more effort on ill-conceived schemes. But also because it is vitally important for the political situation after or even during the war to demonstrate that a progressive administration can free itself both from bureaucratic domination and popular prejudice and base its policy on scientific planning. It would be such a loss of opportunity simply to persist in the mistakes made by the previous administration. Herbert Morrison must mean something different from John Anderson! [. . .]
>
> You told me that you had argued the case at length with Professor Bernal who agreed with me, but who failed to convince you. Professor Bernal is an eminent scientist. You and Herbert Morrison are important politicians, leaders of men, but not scientists of repute. The problem falls inside his sphere, not yours. Is it likely then, that he is wrong and you are right? Does it not at least make you doubt a little to find your view rejected by him? Would you pitch your opinion about the behaviour of atoms against Rutherford's or Bohr's? Would you go to a butcher to get your shoes mended?
>
> If you should be just a little in doubt, would it not be better to submit the question to a number of scientifically qualified persons? Mathematicians or actuaries? Insurance Companies may be qualified to assess the risk in both cases. I will help you to frame the questions. But for heaven's sake don't rely on Home Office officials. [. . .]
>
> Is it preposterous of me to suggest that you should spend a week-end with me at my house in Virginia Water? I would fetch you and take you back, and you would get to know all that matters about dispersion and shelters. It is quite nice out here, and there is my chess board I told you about. You will like my wife and kids. [. . .]
>
> I would like you to understand, at any rate, that I am at your disposal and would like to help you make a success of your job. I am not normally conceited, but I think I could be of some use to you. I could help you to

deal with A.R.P. Committees and other bodies or boroughs calling for extreme measures without reflecting what you have said so far.[43]

Ellen Wilkinson signed her reply on New Year's Day, and the tone suggests that the official who drafted the letter for her was taking umbrage:

> You assume that Mr Morrison and I are determined to put the layman's opinion against that of the experts. But the fact is that we have to decide between two sets of experts: one set of eminent people who put your point of view, and another set, equally eminent, who regard dispersal as the only possible way of preventing terrible tragedies. When experts disagree, the Minister has to decide and the guiding lines in such circumstances must be those of practical experience. Our experience up to date has confirmed that dispersal does prevent big tragedies.[44]

Ove replied at the end of the week, again at length:

> Thank you very much for your letter. It puts the case very fairly, and I am fully aware of its tone of finality. All the same, if I may ask your indulgence, I should like to make a few comments.
>
> If there are really two sets of experts with opposing views, why not bring them together and have the question settled once and for all. It is inconceivable that the problem admits of more than one answer, as it falls within an elementary part of the theory of probability. It is only a question of defining the problem clearly, and agreement can be reached. Moreover it is important for the correct solution of the shelter question that agreement should be reached.

Confident that she well knew whom he was really addressing, Ove then proceeded to lecture her officials – whose second-rate quasi-academic obstinacy enraged him. He concluded:

> Your assertion can therefore only mean that great tragedies have occurred where a great many people have collected together in large shelters. But what kind of shelters? That is the point. I readily admit that most of the existing large shelters, with the exception of the tubes, are not very safe, and I think it likely that casualties would have been diminished had the people been accommodated in Anderson shelters or other comparatively safer small shelters. But to prove the value of dispersion as such you would have to prove that the casualties would have been smaller had the population of the large shelters which were hit, and also of all the other larger shelters, been distributed in smaller shelters giving the same small

degree of protection. And that can surely not have been proved by experience.

My proposal is of course to accommodate people in large shelters affording a much higher degree of protection than can economically be obtained with small shelters, and that would most certainly reduce the total casualties.

May I finally ask of you a favour? I have never had the good fortune of meeting any of the other set of experts who claim that dispersion is a means of preventing casualties, indeed I have never seen any arguments supporting the view. Sir Alexander Rouse suggested about two years ago that I should meet some of his experts at the Home Office, but in spite of several requests in writing from me, the meeting did not take place. Later I have on several occasions tried to find somebody who could explain to me the basis for such a theory, but in vain. May I ask you kindly to arrange such an interview? I should very much like to know whether there are any points I have overlooked, and in any case it would satisfy an after all natural curiosity to know the extent and nature of the differences of opinion.[45]

The correspondence rumbled on for another six weeks but, of course, no official stepped forward to answer Ove. Two meetings did take place, however. In May he went to see the construction engineer Guthlac Wilson, with whom he was to work on and off over the next four years, about his plans for 'safe housing'. According to Ove's diary entry of 21 May, Wilson 'Informed me that it was only a question of steel that was hindering the adoption of this scheme. The figure of 95 lbs in our scheme compared with 47 lbs per person in the official scheme.' Twenty years later Ove described but never named the expert to whom he was eventually introduced by the minister – was it Sir John Baker?

He <u>was</u> a mathematician, and a cultured and delightful person besides, and he surprised me by admitting straight away that I was completely right, a fact which the experts were perfectly aware of, but which I could not expect a mere Minister to understand. But there was more to it than that. What mattered was to keep people quiet, to give them confidence in the measures taken and prevent panic; this psychological or political aspect was really more important than the safety of the shelters. He went so far as to say that if a board which spelt SHELTER could make people feel safe in any old basement, he would be satisfied. I found this view a bit cynical and was worried about what the consequences might be, but there was not much I could do about it.[46]

In fact a letter dated 15 January 1941 from Concrete Publications Ltd almost said as much:

> I am sorry to say that it is not considered desirable to publish the note on the effect of bombing on concrete and brick structures, for the reason that if this became generally known the public might lose confidence in the brick shelters already erected. I believe it is true to say that the brick shelters are not popular nowadays, but it seems sound policy not to add to their unpopularity.[47]

5

Fighting incompetence

In April 1941 the Ministry of Home Security reissued its notice to homes and offices entitled 'What to do about gas'. The instructions began:

> Other countries lost their freedom in this war because they allowed the enemy to create confusion and panic among their civilian population so that the movement of defending armies was impeded.
>
> We are not going to allow that to happen here. It won't happen if we are all on our guard, prepared to meet anything the enemy may do.
>
> He may use gas. The danger is not serious if you do the right thing, both NOW and when the time comes. If you do, this weapon will have failed and you will have helped to beat it.

Ove was required to ensure that all such orders were prominently displayed in the office. The first and last for 'Fire fighting and fire watching' give the flavour:

> 1. By day and until 22.00 hours, each household is considered responsible for its own watching, i.e. should have an occasional look-out during an alert and keep a strict watch when planes are obviously near. [. . .]

6. Every householder should see that his neighbour knows where his sleeping quarters are, and where the Fire Fighting equipment, ladders, etc. are kept. He should put his house in his neighbours' care for Fire Watching in case of absence.

N.B. (a) An I.B. in the open should not be neglected; it may guide an H.E.
(b) During Alerts turn your radio down or off.
(c) Gas Masks should always be kept handy, and carried when answering a warning.

Anxiety defined existence for all with family in occupied Europe. 'Half way on the hill is the post office where we run twice a day and look at our "box" ':[1] Esther's lament from New Jersey ensured that Li wrote at least once a week. She disliked the move from Golders Green to Virginia Water, finding the house too big and unwieldy, the children a handful, the suburban atmosphere stifling, her friends far away. Esther tried to reassure her by reporting that their newly acquired apartment in Summit resembled Golders Green. After 7 September, however, news of the London Blitz reached America: 'how awful things are, how wicked the Germans and how brave the English are. I am thinking of you all the time and praying you are all safe. [. . .] I admire your courage. But it is better to die than become German.'[2]

From 1940 onwards Ove regularly took lunch at the best restaurants in town. For thirty years and more, his secretaries marvelled at his stamina, although quality, never quantity was his aim, and simplicity often a criterion: for example, six years after the war, a 'marvellous meal' in Milan, near La Scala, consisted of risotto, omelette and green peas.[3] Some of the eating establishments were local, in Charlotte Street or nearby, but some needed a trek, such as the Connaught, the Dorchester or Hyde Park Hotel. Apart from the Danish Club at least once a week, there were frequent lunches at the Café Royal, Rules, the Ivy, Escargot, Czardas, Barcelona, Wheeler's, Mirabelle, the Gay Nineties, Coq d'Or, Normandie. He often recorded in his diary both the menu and the wines – and also the cost, particularly if he had had to pay.

The rationale of mid-day dining, apart from the passions of a gourmet, lay in the night-time bombing raids and the distance of the journey home: cars could be used only for authorised business and the car journey was never less than an hour – three hours in the dense fogs of the day. Whereas the journey from Hampstead to the office never took more than forty-five minutes, the train journey to Surrey was never less than an hour and a quarter; the last train was at 9.44 p.m., so he had to stay in town, most often at the office or at the Danish Club, after late evening meetings or when on fire-watch. On

those occasions he invariably scribbled Li a reassuring note before and after the night's ordeals, while she spent lonely and anxious times with her fractious children in Surrey – Esther wondered if she might find calm by knitting, reading or playing patience. Little use was made of the telephone: but there were almost hourly postal collections up to midnight in central London.

To ensure continuity, both sisters numbered their letters, Li writing in Danish, and Esther, to comply with censorship, in English. Most of the letters went by airmail, and took about a week. On 14 September 1940 the Post Office delivered a telegram to Li from Stockholm: SENDING YOU GREETINGS FROM YOUR MOTHER WHO IS WELL HOW ARE YOU WIRE. A return wire reported good spirits and health, and the birth of Karin Annikki on 29 July.

In the early months of German occupation Esther received family letters from Denmark, and sent her mother's on to England. On 13 October 1940 Esther wrote on the back of the envelope of one of these: 'Since I am here I don't expect to find real friends. I tell all my secrets to baby!'[4] Her own post-natal depression, later followed by pre-natal depression, coupled with all the anxieties about her family and the war, were intensifying. She often wrote to Li every other day, frequently enclosing recipes for both the family and for baby Karin. In November 1940 Roosevelt won a third term as president and Esther rejoiced:

> I am so glad Roosevelt was elected, he is the dictator's enemy. It is so awful to think about all the misery of humanity today; but it seems to be a consolation to fight for what is right and then to know that the present condition will not last for ever. People don't want to be slaves anywhere. But I have better stop, only I think all the other things I write are foolish . . . I wish I knew what happened to all our friends in France . . . The English surely will win. It doesn't look so good for the dictators now. [. . .] When you feel lonely you could imagine I was just thinking of you at that moment.[5]

In January 1941, in the depths of depression, Esther met a Russian woman and her South American husband, who had escaped from Switzerland: they lost a baby two months after arrival: 'Now she got a wire from the unoccupied part of France that her Mother died in Paris. Isn't it awful. Yesterday she told me, she didn't cry in public! I don't know what to tell her!'[6] Did the sisters halve their own burdens by sharing them? Like hundreds of thousands of citizens throughout Europe, their concerns were for family, near and far: nothing was significant in comparison with their safety. Esther recommended Li to contact their father through the Danish Red Cross, using the abbrevia-

tion of her maiden name, Samuel, by which she had been known at the School of Household Management. It worked, and on 11 December 1940, Li received a return telegram, which had taken over a week to arrive: 'Dearest Sam, Wherever you may be, I wish most sincerely for you all to be able to sing our beautiful Christmas hymns in peace. Nis.' 'Nis' was the nickname of her closest schoolfriend, who was here confirming, in the vitally necessary indirect manner, that Li's message to her grandfather and grandmother had been received.

Esther became very friendly with the Czech composer Bohuslav Martinů and his wife, who escaped via Marseilles and Lisbon to New York in March 1941: in May she described his distress over the death back home of a young girl he had taken under his wing – 'Mrs M still doesn't like her even now she is dead.'[7] But Esther continued to suffer: Gerald's family made her feel totally unwelcome, and news of the death of both grandparents in Denmark in April 1941 and April 1942 further lowered her spirits.

In June 1941 Ove wrote to the headmaster of Dartington Hall School, in Devon, which he and Li were considering for their daughter Anja. They decided it was too far away, but he was keen to compliment the headmaster: 'I sensed everywhere in the various undertakings an endeavour to achieve the highest possible quality. This is in welcome contrast to the "arty, crafty" atmosphere which sometimes results in sloppiness and amateurism.'[8]

Stress was a plausible reason for a minor road accident in which Ove was involved – one of many in the coming years. This time his insurance company, the National Employers' Insurance, could not contain its irritation: 'We shall be glad if, on future occasions, you will kindly refrain from admitting liability no matter what the circumstances of the accident might be.'[9] The roads at night were almost as hazardous as in the days of Jane Austen, for whom moonlight alone was the answer. There were no street lights, no chinks of light from houses, no advertisement lighting: car-lamps were permitted to show only a small horizontal slit of light. Apart from this, drivers of domestic vehicles were invariably stopped for checks on permission to drive at all. Most of Ove's mishaps occurred in daylight.

There were intervals of relief: an excited correspondent who was training with the RAF in California boasted of dancing at Thanksgiving with Dorothy Lamour, Marlene Dietrich and Merle Oberon, and of talking to Herbert Marshal and Alexander Korda – names mostly unknown to Ove. There were also the lunchtime concerts at the National Gallery – at which Peter Pears sang soon after his return from the United States in 1942. In all, 1698 concerts were given between October 1939 and April 1946, but Ove attended only a

few of them: they were crammed to the doors with servicemen and women, as well as office workers and civilians keen to get out in the daytime. In any case, his need for food was greater than his need for music. But he tried to take Li to lunch and a light film or matinée once a month, sometimes with the children, especially if he had been away a lot: *Lassie come Home*, *Arsenic and Old Lace*, *The Man who came to Dinner*, *Abraham Lincoln* – and an occasional concert by Sir Henry Wood, or at Sadler's Wells. Reality, nevertheless, had to be faced, and Ove took Anja and Jens, then aged fourteen and twelve, for a walk through the ruins of the City in April 1943: the smells and threatening shapes of charred and jagged remains lingered in the memory.

Ove normally confronted Lubetkin's attempted bullying tactics head-on. In November 1941 he concluded a letter to him: 'I have no time now to deal with your innuendos, but if I can get a chance to come down to the farm, I will do so verbally.'[10] Lubetkin planned to send up geese for Christmas, and a debate ensued about transport arrangements. Ove replied on 29 December:

> Thank you very much for the geese. We had a hard struggle to get hold of them at Paddington Station, but by patience and bribery succeeded in extracting them from the enormous heap of Christmas parcels. [. . .] I received 12 geese and 1 cockerel, and also separately packed the cockerel for Kaye's sister. [. . .] Please let me have the bill and prompt payment will follow. The goose we had for Christmas was excellent, and we sent many kind thoughts to you and your staff on that day. [. . .] One of these days I hope to give you an exact statement of my attitude towards the Materialist Conception of History and all that, as also to the question of keeping poultry.[11]

In the next letter, Ove had computed the cost at the controlled 2s. 3d. a pound for geese of average weight 10 lbs, two boiled cockerels of 16 lbs at a controlled 1s. 6d., and agreed transport at £1 2s.: total £14 8s. The official weekly ration of meat at this period was 1s. 2d. per person; and at just this date, December 1941, the subsidised prices charged by the 'tube refreshments' scheme to the nightly residents of the underground station shelters were: buns and slices of cake, 1d.; apples, meat pies, 1½d.; biscuits and chocolate bars 2d. Cups of tea or cocoa were 1d. By 1944 most food was subsidised, and much was rationed, including bread, oatmeal, potatoes, cheese, butter, eggs, milk, sugar and meat – there was no coffee.[12]

In America Esther received almost weekly letters from Denmark from both her father and mother, which she forwarded with her own additions to Virginia Water. In one, she referred to a heart attack that Li had refrained from

explaining in September, and in another she repeated new worries: 'Tell me if Ove reads my letters.' 'And don't you ever imagine that we are not going to meet again! I simply cannot stand the idea, and if it is I am not going to look after myself!!! Hm.' In January 1942 she reported: 'I have been the same way as Ove with awful nightmares, yelling at night and jumping out of bed . . . Poor Ove . . . he musn't speak or think about "black" things before going to sleep.' One light moment: 'I cannot imagine Lubetkin and his wife as farmers!'[13] Ove periodically suffered from nightmares and was heard to shout out: in his final years, a recurrent dream which he recounted at breakfast consisted of his rapidly descending head-first down the banisters.

During his hectic efforts to promote and design shelters, Ove was also writing furiously on other matters. There are numerous typescripts from the 1940s, all of which had earlier draft versions, ranging between three thousand and ten thousand words. He gave at least half a dozen addresses or lectures each year: he wrote every one from scratch, however much he repeated himself. In September 1941 the British Association for the Advancement of Science held a meeting in the Royal Institution, to which Churchill sent an opening statement of goodwill. Ove spoke under the title 'Elimination of waste by planning and standardisation' and his presentation was chaired by the Soviet Ambassador, Ivan Maisky.[14] Only three months had passed since Hitler had launched operation Barbarossa on 22 June 1941, and the Soviets seemed to face overwhelming defeat. Nevertheless, within less than one month of that invasion an agreement of mutual assistance had been signed between Great Britain and the USSR. Western sympathy had swung back to the Soviets, displacing rage over both the 1939 Molotov-Ribbentrop Pact, and the partition of Poland between Germany and the Soviet Union. Ove knew Maisky, of course, because he had both designed an underground shelter for the Soviet Embassy and sent him, as requested, his publications on shelters. Ove took the opportunity, in distinguished company, to reiterate views he had been propounding for several years.

In January 1936 he had declared: 'It is for the Architect and the Engineer to join the widest resources of the industrial system to the fullest needs of society.'[15] In the 1941 address Ove argued that even an architect with the best possible technical education

> could not possibly, by himself, know about all the intricacies of modern technical developments which go into a building nowadays.
>
> The problem is the same here as in other spheres of human activity – a wealth of new knowledge, new materials, new processes have so widened the fields of possibilities, that it cannot be adequately surveyed by a single

mind. Corresponding to this increase of means, there are increased or entirely new requirements to be satisfied. Our needs increase with the means. Standards are raised, new services introduced.

This produces the specialist or expert, and the usual problem arises how to create the organisation, the 'composite mind' so to speak, which can achieve a well balanced synthesis from the wealth of available detail. This is, I suppose, one of the essential problems of our time.[16]

Only later, when he visited Harvard in 1955, did Ove learn that the philosopher William James had resigned from the university in 1910 over just this issue, after a decade of fruitless remonstrations. Ove was now launched on a three-pronged attack: on the ignorance of technologies and science among most people who celebrated the humanities; on the divisive specialisations developing among scientists and engineers themselves, leading to mutual incomprehension; and to the completely inadequate educational provision for humanists and scientists alike at both school and college levels. In the foetid atmosphere of the Blitz, of Barbarossa and other Nazi successes, truly radical debate was taking place among those who might be in a position to initiate change when the war ended. Moreover, the detail in which post-war reconstruction was being planned, at moments arguably of likely defeat, was not publicised at the time, and was little acknowledged thereafter. Censorship was severe and largely effective. But, even when news from the front was almost uniformly bad, and the highest priority was defence, post-war planning was occupying some of the best minds.

The following day, in a session chaired by H. G. Wells, the topic was 'Science and the world order' and the speakers were Max Born, Joseph Needham and Julian Huxley.[17] Huxley spoke on 'The scientific view of education as a social function' and his views greatly appealed to Ove, especially his sharp criticism of efforts by the churches to increase their influence over schools and their curricula. Shortly after this the British Association was trying to sponsor a monthly review, provisionally called *Solidarity: A review of the Allied Nations*.[18] Sir Wyndham Deedes, for the Ministry of Information, declared:

the victory to be won in this war is a 'moral' one. But to achieve a moral victory, social, political and ethical issues must be faced. In this field the 'State' has to tread warily, for it raises questions about which opinions vary greatly.

The journal was 'to symbolise the solidarity which it aims at establishing between the allied people in the first place, and again between science or technology and legislative and executive powers'.[19]

The extent and pace of civic co-operation increased as the news from the front worsened. Ove was frequently approached to talk to local groups, and he gave three lectures to the Friends' Ambulance Unit in October 1941 on 'Modern building technique'. Invitations to high-level conferences were attractive, although Ove generally accepted only if he was going to speak. He was tempted, however, by an invitation from J. D. Bernal to a meeting at Cambridge in October, addressed by President Beneš and Foreign Minister Masaryk of Czechoslovakia. This was to celebrate the tercentenary of the visit to England by the educational reformer Jan Amos Komensky (Comenius), who was influential in accelerating the foundation of the Royal Society soon afterwards.

A little more than three months later, Ove read a paper to a conference on 'Science and the war effort' organised by the Association of Scientific Workers. After attending a number of its meetings Ove joined that body in December 1942, at which time it had 9090 paid-up members. The theme was a central one for the association, dismayed as it was by the almost total absence of scientific knowledge among civil servants or even parliamentarians of the day. He stated:

> Whereas the pursuit of science used to be considered foremost as a means of finding the truth, so much so, that truth can only be defined in relation to the state of scientific knowledge at any given time, now the emphasis has shifted towards considering science as a means of achievement.
>
> We can almost define the scientific way of doing a thing as the successful way of doing it. If it isn't successful it isn't the fault of science, it is because we did not use enough science.[20]

Through his work with Lubetkin in Finsbury, Ove constantly found himself involved in politically coloured events, although he sincerely believed that his own political distance from his colleagues on these occasions was known, understood and accepted by observers. It was not: and it was naïve of him to think so. The desperate situation, and the exclusive concentration on the war effort, provided few if any opportunities for relaxed toleration of maverick, let alone, hostile political views. Miners, dock workers, and some other elements opposed the war, albeit on different and incompatible grounds, and had already organised strikes: almost anyone who associated with such groups aroused official suspicion.

In April 1942 the Mayor of Finsbury, W. F. Drake, wrote to several 'Friends', seeking support for an appropriate Lenin Memorial. While in exile in London in 1902 and 1903, Lenin had edited the revolutionary newspaper

Iskra (The Spark), which was smuggled into Russia and helped to foster resistance to the tsar. He had lived at 30 Holford Square, Finsbury, but this had recently been bombed. A plaque had been affixed to the remains, but it was now proposed to construct something more substantial. Lubetkin was deeply involved, somehow muddled the resulting accounts – Christiani & Nielsen sent various initially unpaid bills – but secured the Soviet Ambassador Maisky to open the designated site on 22 April.

The summer of 1942 was an especially grim period of the war. In August, immediately after the disastrous Dieppe raid in which nine hundred Allied soldiers were killed and two thousand captured, Ove cryptically recorded in his diary discussion with Wells Coates on 'doing something' about the demolition of the Rhine bridges: Ove was clearly not completely outside wartime planning meetings – he frequently visited airfields on unspecified business.

Fifty years after the event there emerged his solution to the so-called 'Problem for bomber command'. While fire-watching four or five nights a week, a fellow Dane, John J. Wilmers, tried to tackle a mathematical puzzle he had come across some years earlier.[21] On 4 March 1942 he took it to the Danish Club where he lunched each day. Ove was immediately interested in the problem and handed him the solution only one week later, thereafter apparently taking no interest in it. The speed with which Ove found a solution impressed everyone. The task was to drop a single bomb on an enemy target: the nearest bombers needed four full tanks of fuel to fly to the target and back, and since landing was possible only at the departure point, refuelling must take place in the air. The question: what is the minimum number of planes needed to ensure that one plane reaches the target, drops the bomb, and returns along with all the others to base? Ove's calculation was twenty. It was, of course, a purely mathematical problem, because there would be no problem if the capacity of the fuel tanks was increased – which, in fact, is what happened in almost all cases.

By that summer Li still found the Surrey house too much, and her health was not good. Esther felt the same way about Summit as Ove about Virginia Water – 'a soul-destroying place' – and she counselled her sister: 'I wish Ove would lock half the house and take the keys in his pocket. Don't be fuzzy!! Nobody will mind a little dust, but I will cry my eyes out of my head if you make yourself sick again.'[22] Close to the age of fifty, Ove himself was undoubtedly busy. He had always been anxious to provide home help to his wife, not least because he expected – and enjoyed – a perfect home: inevitably during the war, his own contribution towards this goal was only financial, although

ten years earlier he had decorated their Hampstead house. Men of his age, class, background and upbringing rarely did more than dabble in daily household chores: indeed, he prominently recorded in his diary the occasions when he did, and moaned about it in letters.

The battle of Stalingrad and the second El Alamein campaign, in September and October 1942, were crucial events for the Allies, if not yet turning points. Until then, most Danes supported the line of their coalition government, which had been elected on 8 July 1940 to co-operate with the Nazis, subject to certain conditions: that they retain parliamentary, legal and police authority and also maintain reduced armed forces. The Nazis soon broke their guarantees, forced 100,000 workers to Germany, and in 1942 appointed their own functionary to impose stricter controls, which prompted increased sabotage and widespread resistance. As a result, a full German administration took over on 29 August 1943: influential citizens were arrested, and Denmark's most powerful ship was bombed, although then scuttled by her crew.[23]

But, far away, and in another country, how was such news to be properly interpreted? 'I was so upset when we got the news about the revolt in Denmark, but I am proud of them. Each day brings nearer the end of this terrible war. The dirty Nazis certainly are lost. I knew they would never win. Uf!!'[24]

At the beginning of December 1942, however, the war was still going badly for the Allies on most fronts: but Ove was writing voluminously. Like many others, he was alarmed by the waste of time, man-power and resources caused by overlap and incompetent administration which too often failed to concentrate on immediate needs. In January 1943 he took part in a conference on 'Planning of science in war and peace', where he especially valued meeting the brilliant left-wing chemist and explosives expert Sir Stafford Cripps, who had recently returned as British Ambassador from Moscow. He was now Churchill's Lord Privy Seal, and fiercely complained of 'the typical British way of improvising an *ad hoc* organisation to deal with the various scientific problems as they arose'. Professor P. M. S. Blackett was even more critical, castigating 'the "Anti-Planners", whose idea of scientific leadership is that research should be done in monastic seclusion while a philistine world admires'.[25] Blackett, later Lord Blackett, received the Nobel Prize for Physics in 1948, and knew what he was talking about.

The following week Ove read another paper at a conference organised by the Association of Scientific Workers. Under the general title 'Scientists of the United Nations and the war effort', he chose, as his own theme, 'Denmark and the "cultural" invasion attempt'.[26] The dog-eared wartime paper, onto

which the ink-smudged details of the conference were roneoed, conjures up those dark days. Ove revealed that he was following developments at home with the closest scrutiny of underground newspapers. He named persecuted authors and outspoken clergy, which he would do only after taking the most careful advice. In brief, this was a skilfully orchestrated message to Danes at home, and resistance fighters everywhere, in the wake of 'the recent crisis'.

The Danish Emergency Fund had launched an appeal in June 1940 to help resident Danes deprived of former remittances from Denmark: Ove donated £25, and in October 1941 took out a subscription from the Danish Council for a Fighter Fund: this financed personal messages to Denmark via the European Service of the BBC. In December 1942, the week after his lecture, he sent a further £20 to the Free Danish Movement. In addition, since the occupation, Ove had been a subscriber to the Danish weekly newspaper *Frit Danmark*, published in Pont Street by the Free Danish Publishing Co. Ltd. It carried whatever news was deemed vital to sustain morale and stiffen resistance – in 1943, for example, it prominently celebrated the huge increase of resistance sabotage of Nazi installations, following the takeover by the Nazi administration; the Allied landing in Sicily on 10 July 1943 was headlined as 'The first Dictator felled' and accompanied by a photograph of Hitler and Mussolini, with the latter crossed out. As he had obviously intended from the outset, Ove immediately sent his 'cultural invasion' lecture to the newspaper. They replied by return of post that Reuters News Agency had already reported it, as had provincial papers: even more significantly, it had been reported 'on the 6 o'clock news on the day on which you spoke'.[27] The BBC news bulletins, beamed to the continent at 6 p.m. and 9 p.m., since 1940 had been read by a named individual – Alvar Liddell, Bruce Belfrage, John Snagge, Wilfred Pickles. The bulletins, heralded on the continent by the haunting morse-code signal 'V', broadcast Allied information and secret messages throughout occupied Europe: that was how most Danes learned about Ove's perspective on their plight.

Over a three-year period from 1940 many Norwegian fighters and 'free Danish' airmen visited and stayed at Virginia Water – including ministers of the Norwegian government in exile:[28] it became a haven of spiritual support. An American correspondent and one from the BBC also came several times. Ove never himself referred to these events, nor to his often successful efforts to secure the release of former friends or colleagues from alien internment on the Isle of Man in 1940, such as the architect Carl Ludwig Franck. Krog-Meyer stayed frequently – everyone said he was in love with Li – as did Ove's Finnish-Swedish friend Cyril Sjøstrøm (later Mardall), who also sang and

played beautifully to Li. Mardall recalled that 'Li's superb cooking and Ove's stock of wine added greatly to the joys and pleasures of life, when dining or staying the night':

> It was very fortunate that a German ship had been brought in as a prize by the Norwegian navy, loaded with aquavit. The cargo was promptly confiscated and shared out by all members of the government, consequently 'Dana' also had a stock of aquavit. The Ministers would gladly swap two bottles of Schnapps for one of gin.
>
> It would appear from this narrative that drink was our main concern and interest in life. This is quite wrong, we were also interested in women, not to mention song.[29]

The Arup children also remember the 'jolly Norwegians', who were especially nice to them, laughed a lot, played chess endlessly, and consumed vast quantities of aquavit. Occasional letters from Denmark, delivered by the Red Cross, were treasured for confirmation that members of the family were alive – they were naturally censored. From his own sources of information, Ove learned of the Nazi death camps: some of his acquaintances held that the civilised history of Germany rendered implausible the stories which were emerging, but he knew precisely what was happening. Of course, he never mentioned the Jewish ancestry of his wife and her family – most of his later colleagues never knew. Her beloved grandfather, a respected rabbi, played a significant part in the evacuation of Jews from Denmark to Sweden, and was active in the Resistance: he died, at the age of ninety-two, two days before SS agents arrived at his house to take him away. His two sons changed their names, and joined the underground Resistance. Among many others known to Ove in the Resistance was Elsebeth Juncker's brother, Flemming; he mysteriously stayed the night in Virginia Water two days before D-Day, and clearly did not come only for the drinks.

Ove began his 'cultural invasion' lecture by affirming that 'before the war there were few countries in which the hatred of the Nazis was so general throughout the population as in Denmark'; indeed, the few members of the Danish Nazi Party are 'so generally despised, that even the Germans realised that they could not be used to form a Quisling Government'. The Nazi 'kultur' meetings, designed to promote understanding of 'the Nordic-German peoples' and effect a re-education of Danes, was a huge flop. Nevertheless:

> They tried to bully village schoolmasters to conform in their teaching, with instruction given in German schools. They created disturbances in churches where the clergy spoke out against the anti-Christian doctrines of the Third Reich.

Having identified those Danish newspapers which were officially dependent on German news agency reports, Ove quoted from one Danish Nazi paper, to indicate its abrasive tone:

> Only a few newspapers write about the new ideology, while several hundred papers seek to throw suspicion on it and belittle it in every way. The radio, press, theatres, cabarets and news services all attempt to deceive the people regarding the new order and to blacken its supporters. It is typical of Danish character that the people – despite all the facts presented to them by the German papers – still believe in a British victory.

Ove reported that at the forefront of patriotic resistance were the high schools and universities: when the Germans forced an eminent Jewish scholar and social-democratic member of the Lower House to resign, the University of Copenhagen promptly appointed him Professor of Classical Philology. The rector had then instructed the Nazi-appointed replacement to postpone his lectures: they were never given. Shortly after these events, the courts upheld the Students' Association refusal to allow within its midst a special Nazi group. Ove then named prominent journalists and writers who had been imprisoned or put 'in concentration camps', concluding with the historian Wilhelm La Cour.

> The last named antagonised the Germans by publishing some pamphlets – distributed before they could be seized – commenting on the German nation during the Napoleonic wars. He gives a vivid description of Fichte's feelings under the French occupation, and how he sets his only hope on England 'that old, tough, fabulously slow and fabulously tenacious England ... freedom's last bulwark in Europe ... who would save all the other nations from oppression and thus earn Germany's undying gratitude.'
>
> And now, even Fichte, who has been called a pioneer of the Nazi movement, may not be quoted in Denmark.

Two months later Ove conveyed to the Association of Scientific Workers a further list of names, reporting arrests and imprisonments up to February 1943: he stated that the Germans had not 'as yet committed any murders in Denmark'.

At the end of his December broadcast Ove took a further step about which he must have sought official advice: he quoted at length from a recent copy of a Danish underground paper, which had rehearsed the resistance by the people of South Schleswig against more than fifty years of German oppression – of the kind he had himself witnessed. The writer had asked: 'what then are

our spiritual weapons?' The answer is: Justice, Truth and 'our Danish sense of humour'. 'Denmark is a prison, at the moment', but outside Denmark, 'there are hundreds of scientists, engineers and technicians' willing to help, although 'they are not always given the chance to help as much as they could'. Ove had inserted his own confession.

This final manuscript addition to his typescript was clearly addressed to his audience in London and the authorities there. It expressed his own intense frustration at failure to gain a hearing in official circles for his ideas. Some things, however, had changed in the course of the previous six months.

From the outset of war Ove and his cousin, as Arup & Arup, were extremely busy with wartime jobs. Since February 1942 they had been struggling with a top-secret commission by the Air Ministry, for the RAF Station at Eastbury, Middlesex. It was, in fact, the secret underground HQ of Coastal Command at Northwood, less than five miles from his house at Harrow. The site had been purchased in 1938 to be the front line Defence Headquarters; in spite of numerous reorganisations in the intervening years, it is still the Permanent Joint Headquarters of United Kingdom defence. They were undoubtedly invited to undertake the task because Ove was already well known to the key figures: Professor John Baker was scientific adviser to the Ministry of Home Security, Professor Blackett was director of operational research at RAF Coastal Command, along with C. H. Waddington, and Professor Bernal, Blackett's successor at Birkbeck, had recently moved from Bomber Command to be one of Lord Louis Mountbatten's personal advisers at Combined Operations. The challenge was to construct 'a large bomb-proof building about 200 ft long by 50 feet wide, dug into the ground'. Speed was essential, but excavation 'proved to be extremely difficult as the whole of the subsoil consists of clay, which keeps on slipping': this considerably delayed the start of the concreting until mid-June. There was another problem: 'the steel work, shuttering and concreting are continuously threatened by banks which are still on the move, and last week we had to take drastic emergency measures to save the batching plant.' Ove had to apply for an increase in his petrol ration to ensure his daily supervision of this work:[30] among others both R. S. Jenkins and Henry Crowe were also working on the scheme. No photographs exist of Ove's work, or of the Heysham Jetty whose design he modified for the Air Ministry, as he admitted in 1946 to A. L. L. Baker: and he rarely mentioned these assignments.

Meanwhile, in April 1943 he delivered an impassioned address to the Association of Supervisory Staffs and Engineering Technicians: 'winning the war and planning for peace are both essential, if we are to bring about a better world after the war . . . a lot of planning and co-ordination will be needed.'[31]

All of this was a prelude to insistence that it will be 'necessary to maintain a high degree of control in the building industry'. The question is: 'how such a control can be organised without destroying the individual's incentive to give of his best.' The lecture allowed him to vent years of frustration and signal the route he intended to follow, if possible, in the future.

After reviewing the new practices and controls that had, of necessity, been introduced during the war – supply of labour and materials, social legislation concerning labour conditions, contracting arrangements, architects as employees of ministries – he asked 'whether this merging of essentially two different types of organisation, bureaucratic control and competitive contracting is likely to prove successful in the long run'. Ove declared that under current planning authority regulations, which gave top priority to speed of construction, conservation of materials and dovetailing of labour, the more effort a consulting engineer put into calculating alternative schemes, the less he earned. Cynically, all an engineer need do was to construct the first safe scheme he could think of, and walk off with the fee. The possibility of defrauding clients was increased by 'the laws of professional etiquette' which discouraged criticism of colleagues. Moreover, lump-sum contracts, as distinct from either cost-plus contracts or, better still, target-cost contracts, too often promoted bad work. Ideally, payment by results might be best, 'but it is not an easy thing to do'. Ove could not forego the chance to repeat his own mantra: 'the necessity for combining the knowledge and experience of the contractor with that of the designer'. This was particularly necessary for any large-scale repetition, or specialised work in reinforced concrete, for example. He explained that building labour costs are reduced by 'extreme simplicity of design', 'frequent repetition of identical processes' and 'maximum use of labour saving equipment'. 'Simplicity of design' requires 'marrying design to construction, so that one suits the other'. Professional pride remained a major obstacle: 'there will have to be a breaking of the barriers between the professional men, the contractors and the workmen.' Finally:

> there must be someone who has power to take decisions inside a well defined sphere and he must then take the responsibility for those decisions. [. . .] On the planning side the important thing is that all the suggestions and criticism possible coming from below should be taken into account.

Such views were being voiced by an increasing number of men and women, both in the armed services and among those contributing to the war effort at home: they crucially influenced the dramatic election results of 1945 and the social changes that took place in the following decades.

From 1940 onwards Ove had undertaken many relatively small consultancy jobs integral to national defence, quite apart from numerous shelters: underground workshops and tunnels, reinforced water and oil-storage tanks, hangars, pillboxes, water towers, gun sites, slipways and concrete barges.

The underground work for the RAF at Eastbury was not finished until mid-1943, at the end of which year he was approached again on a matter of the utmost secrecy and speed. Diary entries record that on 3 January he received a telephone call about a 'very secret job' and five days later presented himself for instructions.[32] In terms of the overall scale of what he was told, his task was minute – albeit both vital and urgent: pierhead fenders.

In October 1943 the Ministry of Defence issued instructions to 550 contractors to build elements of what became known as Mulberry Harbour. The construction of a large breakwater could protect beaches for continuous unloading onto rafts, but was naturally subject to 20-foot tides: by contrast, however, a floating pierhead could turn round a landing craft in forty minutes, rather than the twelve hours needed for the double-handling method. Astonishingly, within nine months, by May 1944, ten miles of floating bridge, six linear miles of reinforced concrete caissons and twenty-three bridge heads had been constructed and were ready for use, and largely hidden. Few, if any, of the 45,000 men working at eleven scattered sites knew that during the previous two years military personnel had already constructed two fully equipped military ports inside Faslane on the Gareloch, and on Loch Ryan, near Stranraer. All of this was in preparation for the inevitable invasion of mainland Europe.[33]

Work on such a scale was unquestionably more difficult to keep secret than any other aspect of the war so far; indeed, it was the most important secret to be kept, apart from the Enigma and Colossus intercept systems and research on the atom bomb. Ove was invited to submit a CV to the War Office, explicitly describing his work on jetties. He recorded his work on the design of piled quay-walls for Hamburg, Stettin, Cuxhaven and Delfzijl in Holland – he assumed his reader would know that Christiani & Nielsen had constructed the new quays for transatlantic liners at Cherbourg and the Graving Dock at Saint-Nazaire. This was the only dry dock large enough to accommodate the German battleship *Tirpitz*, and access to it was successfully prevented by a famous attack in March 1942 during which the caisson was blown up. Ove never commented on whether he had been consulted by the Combined Operations planners about his design of the Cherbourg dock.

In the Christiani and Nielsen system of piled quay-walls, part of the fill itself is used to ensure the stability of the structure by means of a horizontal

loaded slab, which transfers the load to raking piles and shields the front sheet wall from excessive pressure. On account of its strength, economy and speed of construction, this type of quay is now used all over the world.

In the case of jetties, Christiani and Nielsen introduced the flexible piled reinforced concrete jetty without bracings. Mr Arup developed this idea further and in a series of articles in 'Concrete and Construction Engineering' in 1933 and 1934 showed that the best design for a piled-jetty was obtained by using a cross-section with two raking pile trestles (A frames), and that further stability could be obtained by loading these trestles. He has been responsible for the design of many jetties on the Thames, Solent, Clacton, Felixstowe and elsewhere, both for the War Office (Deptford) and the Air Ministry, the big petroleum companies and others.[34]

He had no need to detail this last assignment for his readers in the War Office, but three years later he referred to it: 'The design of the very important jetty and dolphins at Heysham for the Air Ministry, embodying moving bells to take the blows from 20,000 ton vessels on the Baker principle.' The 'Baker' referred to was A. L. L. Baker, who was currently a scientific adviser at the Ministry of Works: he had been at Kier & Co. during Ove's time. An improved version of his design was needed – Baker's long fenders were rigid and cumbersome – and with extreme urgency:

LST craft [Landing Ship Tanks] of approximately 2,500 tons displacement were to approach at speed (c. 4 knots) and be brought to rest by the buffer pontoons which were independent of the pierhead pontoon which the vessel came alongside. The pierhead fendering was required to:
[a] guide the ship on to the buffer pontoon
[b] protect the pierhead by absorbing the component of this kinetic energy of the ship, in a direction perpendicular to the pierhead pontoon, the amount depending on the angle of approach.[35]

In almost any seas, but especially when high-running, loaded landing craft were not easy to manoeuvre: even with bumpers, the force with which they inevitably hit the piers did tremendous damage and rapidly rendered them useless. Ove's protective fenders were concrete blocks, shaped like the inverted hammer of a piano which, because they were loosely hinged, absorbed the forces of contact: each fender was 2 feet long and weighed 2 tons. Overall they extended 150 feet along each pontoon, increasing the weight of each by 300 tons. Ove and Jenkins resolved two problems: the mechanical one of connecting short lengths of fender blocks such that their rotation did not increase the vertical load on the pontoon; and that of distributing the rotation later-

ally beyond the actual contact with the LST to ensure that nothing sharp damaged the bows. This required that no vertical forces be transferred between blocks, but also that horizontal forces be transferred between the blocks in the form of shear and couple. By an ingenious but strictly calculated system of links and guides, forces were appropriately and sequentially displaced, although with one unintended side-effect: 'an unending screaming noise as they ground together along the side of the pontoon'.

Ove was collected every morning by car, driven by a young soldier to whom the children loved to chat. One day he was not there: he had gone away, and been killed. Ove immediately discovered that most of his colleagues and friends in the buildings industry were involved in some aspect of Mulberry, including Ralph Freeman, Malcolm McAlpine, Norman Wates, Oscar Faber and Alan Harris, the last of whom supervised divers clearing the sea-beds for the arrival of the concrete caissons.

Shortly after the invasion, Ove received his first compliments on the design, from Lt Clive Entwistle, who was at HQ I Corps, British Liberation Army:

> Today I motored over to a vast new port we have opened on the site of a former fishing village. It is the most impressive sign of Allied power that I have seen since landing. I mention it to you since I remember you were designing the concrete jetties; and I thought you would like to know how wonderfully well they are working. [. . .] Congratulations on your really first-rate contribution to the Second Front.[36]

In March 1944, when he was working flat out on the Baker fenders, Ove had been offered a job inside the Ministry of Works, which he declined: but he was appointed consultant for several jobs, including a scheme in early 1945 for a prefabricated aluminium house, aluminium hangars, and concrete blocks of flats. In the meantime he had built a number of underground oil depots for storing aviation fuel, several of them at Much Wenlock.

In the mid-1930s Ove had drafted many notes on the importance of prefabrication, which was beginning to attract considerable technical and political attention. In October 1943 he prepared a ten-thousand-word Memorandum for the Directorate of Post-War Building, in the Ministry of Works, of which he had been a committee member for a year. The term 'prefabrication' had been misunderstood and misused by rival parties: it could refer to any or all of the issues of economy, speed and quality. It was thus essential to define how it might best be understood in the context of mass concrete constructions, and Ove undertook the task on numerous occasions before the war ended. At the same time he blasted off a furious letter to the

editor of the *RIBA Journal*. He described its recent article entitled 'House construction of a definite limited life' as 'a deplorable document':

> Prefabrication is only incidental to certain modern production methods which exploit the economical possibilities of quantity production. [. . .]
>
> If the task is to provide a large quantity of goods which have to fulfil the same purpose then standardisation and, wherever possible, machine production is the way to do it economically, and to suggest that it should be done uneconomically just in order to preserve certain traditional methods of construction is, I am afraid, to fight a losing battle.[37]

A few months earlier he had argued that antediluvian building practices were often defended by shoddy thinking, if not even by irresponsible word-play:

> Our language is not a scientific instrument – in the theory of science words therefore give way to signs and formulas. The meaning of a particular word comes to life when the word is considered together with its context – it is the whole sentence or paragraph which conveys the meaning, not the single word. [. . .]
>
> A 'planning jargon' emerges, not so much by coining new words with exact meanings, but by using old words in a new sense, or in a new combination. This leads to ambiguity because these words become associated with different ideas in different people's minds, and may even be used to mean different things in one and the same article. Alternatively, they may not be associated with any ideas at all.[38]

For everyone life was tense: fire-watch duties increased and the pace of life did not decrease. At the beginning of 1944 Ove was discussing the design and production of a demountable house[39] – popularly called 'pre-fabs' – as well as two-storey prefabricated houses; he was preparing an article on reinforced concrete for the first issue of an *Architects' Year Book*, edited by Trevor Dannatt and Jane Drew, and also translating some Danish contributions for them; he was discussing box-frame construction with everyone. This last topic, which had interested him for a decade and which he had used in Finsbury, now became a matter of urgency because the predictable but poorly grasped consequences of war threatened a crisis in the building industry. As so often, government ignorance and ineptitude contributed to the problem, but Ove's goal was genuinely progressive.

Traditional practices could not address current needs, within either the volume or timescale required.[40] New techniques and materials were available, but few architects were able to understand or take advantage of them. No

reduction in the cost of the carcass of buildings had occurred, and the quality of workmanship had declined; government support of prefabricated schemes had resulted in expensive, sub-standard temporary buildings. Extensive standardisation on a large scale could reduce waste and cost, but there was no agreement on what and how to standardise. One positive step would be adoption of the pre-war Danish method of Box-Frame Construction (BFC). This made a clear distinction between the structural and non-structural (or 'in-filling') elements of a building: the former consist only of cross-walls and floors, which take care of all the loads and wind-forces acting on the building, and provide standardised conditions for the fixing of the non-structural elements. These latter include external skin-walls, partitions and all internal equipment. The box frame – in appearance, like a traditional egg-box on its side – can be constructed in any suitable material; and everything in the in-filling can be prefabricated, from the doors and windows to fitted cupboards and services. But Ove insisted that BFC restricted none of the three essential freedoms in design: the architectural freedom in the scale and relative position of the 'pidgeon holes' in the box, and its elevation; the structural freedom to use any appropriate material; and the structure-independent freedom to change or improve the in-filling or space-enclosing elements. The freedoms were important, in order to forestall mind-numbing uniformity which, in 1924, Ove and Grete had feared might result from some of the Bauhaus ideas. Governments often did ignore the freedoms available, and dispiriting low-rise and high-rise dwellings were constructed in many urban areas. By contrast, 'pre-fabs' turned out to be popular and, against the wishes of inhabitants, were pulled down in later years only by embarrassed local authorities which regarded them as socially demeaning.

To convince various officials, local and national, as well as influential advisers, of his ideas, Ove cited comparative costs: a pre-war block of flats, costed at £43,000 in 1938, was costed in 1945 at £75,000 using traditional pre-war methods; using quantity production methods of the sort Ove advocated, the costs would be £65,000.[41]

In spite of excruciating lumbago, dental problems and other ailments, let alone worries about family at home and abroad, Ove revelled in the demands of urgent war work and challenging post-war planning. So much so, that his old architect colleague Guy Morgan complained in late August 1944 that 'the strength of your personality made me faint nearly. Actually at the office when you came over at luncheon on two occasions I felt I might pass out.'[42] This reaction in fact resulted from six years' overwork, but he was referring to their first meeting since Ove emerged from a serious illness.

On 5 July 1944 he suffered a burst blood vessel caused by a duodenal ulcer and was rushed for a blood transfusion into the Middlesex Hospital: he stayed there for six weeks. After a further two weeks at home, he began suffering from neuritis – high temperatures and swollen arms. Nevertheless, he was soon able to embark on extensive reading, and he recorded his verdicts on the authors and their works. He greatly appreciated Bertrand Russell's *The Conquest of Happiness*, William Gaunt's *The Pre-Raphaelite Tragedy*, Alexander Woolcott's *While Rome Burns*, Somerset Maugham's *The Narrow Corner*, H. D. Trail's *Sterne*. He admired the 'pride' in Karen Blixen's *Out of Africa*: 'she is an aristocrat and interesting in so far as the aristocratic point of view appears in its purest and most attractive form.' He also enjoyed several travel books. He recorded at length his approval of Derrick Leon's biography of Tolstoy, which directed him back to Tolstoy himself. Like most readers he was intrigued by the fourth volume of Boswell's *Life of Johnson*, which sent him to read *Rasselas*. Among novels he read the Abbé Prévost's *Manon Lescaut*, Balzac's *Père Goriot* and La Fayette's *Princesse de Clèves*. A special note is made of Ambassador Maisky's autobiography *Before the Storm*: 'describes Siberia, where his father was an idealistic scientific army surgeon. Typical Russian revolutionary, idealistic, but fanatical and egoistic youth. More propaganda than unbiased analysis, but still good.' Maisky was a prominent figure in sections of London society and his book was being widely read: Ove, of course, knew him. Surprisingly, Ove listed only one Danish book, by Troels-Lund – one of his sister Ingeborg's favourite writers. This is a 'very interesting book, depicting with Danish wit the 16th century zest for life'.

As soon as he went back to work he developed abscesses at the roots of six teeth, and a Wimpole Street specialist advised immediate extraction of all of them as well as any other trouble-makers, in order to deal with his persistent neuritis. This time, Li put her foot down: they went to another dentist and his teeth were preserved, although his neuritis reappeared from time to time.

Ove's prolonged illness provided him with precisely the time for reflection that he had lacked during four years of hectic activity. Now almost fifty, he decided to recharge his intellectual batteries and to re-examine his views.

6

A new start

Some adults retain the ability to wonder like a child: whether or not they study philosophy, they never cease to question. Ove was such a person. From his fifties onwards he frequently referred to his lifelong interest in how things could be explained, what people meant, and how these interests echoed his early philosophical efforts. With his training as a philosopher, it was imperative for him to articulate his ideas: unexpressed, they had no form and no coherent content. Conversation, of course, was the best way to wander among inchoate musings: exploration and improvisation were of its essence. But writing was the ultimate test.

Among his friends, in the vibrant cultural life of Hamburg in the early 1920s, Ove had been regarded as something of a leader. London, as he encountered it, was a severe shock. Almost a decade passed before he found himself reinvigorated by the Bohemian intellectuals escaping from mainland Europe. Passionate discussions, invariably in German, with members of the Bauhaus, with disciples of Le Corbusier, and with immigrant scholars from central Europe, led him to reflect on the banners under which various parties were supposed to march. Many were overtly left-wing, and regarded social reform as a necessary partner to any defensible idealism. Even in the 1930s it was

obvious to many that the scale of rebuilding called for throughout Europe was immense, although the details often emerged only later in wartime and post-war reports. For example, although he himself had been working in the neighbouring borough of Finsbury, Ove did not know until he read William Holford's 'Profile of Bethnal Green' in 1946 that 89 per cent of all households had no bathroom.[1] The only source of hot water for 78 per cent of all households was by boiling a kettle on the kitchen range. The idealism of privileged social reformers was frequently unsecured in firsthand experience or statistical detail; change was more important than wasting time on establishing or understanding the facts.

Before and during World War II Ove took part in numerous discussions with social reformers and scientists such as G. D. H. Cole and J. D. Bernal, with concerned émigré architects such as C. L. P. Franck, Ernö Goldfinger, Peter Moro, Eugene Rosenberg (who was joined by Mardall), Frederick Marcus and Arthur Korn and with engineers such as Felix Samuely: with each of the architects he worked later as consulting engineer. He became increasingly critical of abstract theoretical claims. He had been hostile to what he called 'ideology' since his early studies of philosophy, and his commitment to practical engineering normally distanced him from whatever architectural posturing he encountered.

In the UK the formal distinction between architect and civil engineer is datable to the incorporation by royal charter – the Institution of Civil Engineers in 1818, the Institute of British Architects in 1834. When Ove arrived in London, the engineering profession, in its various divisions, occupied a lower social status in the UK than architecture; its brief moments of esteem in the nineteenth century had faded along with British industrial leadership, and it never again enjoyed the respect it earned in Denmark, France or Germany. Like nurses and midwives, to use Ove's analogy, engineers were typically taken for granted. Until he was well established Ove adopted a surprisingly deferential tone towards architects when insisting that they should work together with their engineers from the outset of a design task. He had sensed that, rhetorically and politically, this was necessary to obtain a hearing for what was pretty radical stuff. Indeed, an admirer confirmed this to Ove some forty years later – however much they agreed with him, almost no engineers dared risk alienating the hands that ultimately fed them.

But few of Ove's friends actually engaged him in discussion about either his own or rival philosophical views: Maxwell Fry did, although he was not deeply philosophical. Their correspondence over the next decade reflects their moods and anxieties. They first met in 1934 when Fry was building a house

in Hampstead and helping refugees to find sanctuary in the area: Ove himself was then working with Lubetkin on Highpoint. Fry had formed a short-lived partnership with Gropius – who soon left for Harvard because of lack of commissions – and in 1938 mounted an exhibition with Yorke and Wells Coates. In October 1944 Fry wrote from the Gold Coast:

> What are we going to do after the war? This turgid activity that occupies the time of so many of the architects not in the services does not seem to me to be in tune with our coming responsibilities. I had a bulletin from the Mars Group that was aimless and very low pitched. It made me feel that all interest in the art of architecture might be heretical, and from the temper of some of the more politically minded architects, punishable . . .
>
> Gropius wrote in a recent letter to me that it was the damage to Europe's mind that mattered, and here are people denying the spirit as hard as they can go, not daring to look up for fear they might be blinded by the light. And I am so sure that if the life of the spirit cannot be revived in Europe again then it has passed its useful period, destroyed by itself. I will play a Bach Suite in a few minutes. It is a recording of the Mengelberg Orchestra in Amsterdam. Supposing we were unable to revive this, or the Berlin Philharmonic after the war? And what value lies in a composer like Benjamin Britten, an artist, in restoring us to life again![2]

Ove started a reply by return of post on 2 November, but did not actually complete the letter until 30 December. He reported on his recent duodenal ulcer, his consequential tiresome diet, and the luxury of extensive reading while recuperating. To introduce his reflections he cited the famous passage from Book 3 of the *Meditations of Marcus Aurelius* which counsels attention to the smallest beauties of nature's processes, such as ripening figs or olives or corn. Ove almost never gave quotations in his letters, partly because of the haste in which they were scribbled – and he would lack the relevant text – partly from fear of condescension. He continued:

> I was trying to convey, that what you see depends largely on the colour of our spectacles, – a remark, the triteness of which does not detract from its truth, – (gosh!) and I was willing to admit, that my spectacles possibly were a bit clouded. That is to say, that my private affairs aren't exactly flourishing. I am fed up. 'Frustration' sums up the situation. I have got plenty of good ideas, and I could get still more if I was given any problems to tackle, but 'I am apparently not wanted'. [. . .]
>
> It is of course open to question, whether it is at all possible so to arrange affairs, that frustration does not become fairly general. It can possibly be

said to be the most important problem of our age. But I am damned certain, that it is not necessary to make such a muddle of things, as is done by the various Ministries and Departments dealing with physical reconstruction. It seems that the departmental morass is able to swallow up and neutralise even the best brains without appreciable effect on the confusion. There must be something radically wrong with the whole organisation, that is obvious, but whether any remedy is possible short of a clean revolutionary sweep, I don't know. The trouble is, that a revolutionary sweep is neither clean nor cheap, it means the destruction of much that is valuable, without guarantee as to the result. [. . .]

I wish somebody would write a manifesto or declaration, not so much of human rights, as of human duties or human values, a guide to behaviour to which all men of goodwill, all with a social conscience and an interest or faith in humanity in all countries could subscribe. I dare say it is futile, because even if a measure of agreement could be found as to aims, there would certainly be disagreement as to means. Frankly, I can't see the way out, I must confess, that I view the immediate future of the world with foreboding. There are too many signs, that the old greed and stupidity is at it again, and is gaining ground. [. . .]

There is of course the possibility of turning one's back to all that and live for private enjoyment. Escape through Art, for instance. Personally, I don't think it is possible, I am not sufficiently an artist, on the other hand I have a latent – more or less – inclination to worry about the problems of humanity . . . Incidentally, I did not mean to convey that I consider Art as an escape from social problems, Art is social, Art is one of the hopes, possibly the chief hope of mankind. It should be the foundation of education, as Herbert Read says.[3]

This lament identified a common flaw in socialist thinking – to much of which he was sympathetic: its concern for rights at the expense of commensurate duties. But he was also indulging his gloomy streak, tolerated by his male friends, but about which almost all his women teased him, and which darkened with age. The optimism with which the new world would have to be constructed after the ravages of two world wars was difficult for exhausted survivors to sustain; to many throughout Europe, speculative ambition seemed often to sit uneasily alongside struggles to exist.

In January 1945 Max Fry and Jane Drew, whom he had married in 1942, were trying to secure contracts for Ove in West Africa. As requested, Ove sent a testimonial outlining his career, ending with a caution:

This report mentions the firm of Christiani and Nielsen a good deal. I may warn you, however, that there are vague reports that Dr Christiani, the head of the firm, has behaved in a somewhat collaborationist way under the German occupation of Denmark. This in no way detracts from the valuable engineering experience I obtained when working for this firm (long before the war) but it is just possible, that the firm is on a black list and it may therefore be wise to make it clear, that I am in no way implicated.

He also described one of his earlier projects:

Mr Arup was designer and consultant for one of the most difficult marine structures in this country, the deep water jetty and dolphins at Heysham, constructed for the Air Ministry by Trinidad Leaseholds Ltd. The design was partly in reinforced concrete, and partly in structural steel. The dolphins comprised loaded pile groups to take large horizontal forces, and rocking 'bells' on the Baker weight lifting principle.[4]

He added that the largest span bridge he had so far constructed was 100 feet, although he had also designed a number of schemes that were not built.

Just prior to this forward planning, in December 1944, Ove had decided to respond to Brigadier Sir Bruce White's thanks for work on the Baker fenders. He needed to express his bitterness:

I only wish there had been more occasions during the war, when our design organisation could have been given a chance to show its mettle. I, like most people, have been anxious to contribute my best to the war effort, and have been longing to get my teeth into some real problems where my experience could have been used to better advantage than in the routine work which has mostly fallen to our lot.

However, if the problem of making use of every man to his full capacity could have been solved, the war would have been won by now. I am glad at least to have been of some small use in this instance.[5]

In 1945 Ove's old Sorø friend Solomon Rosenblum, still working at the Curie Institute in Paris, came to stay several times, and in February Ove submitted his application for the Professorship of Concrete Technology at Imperial College, University of London. His referees were Professor William Holford, his Danish colleague H. P. T. Lind, and the Lord Forrester, who had been director of the Association for Planning and Regional Reconstruction, and with whom Ove had been working since 1941. The salary was £1250 per annum and he was interviewed in March. He submitted several questions to the administrators: who would be his boss, and would he become bogged down

with administration; would he have assistants and money for experiments; would he be entitled to travel in search of contracts? None of the official candidates was successful; the original fender designer, A. L. L. Baker, was approached and appointed.

The war in the East had still not ended by April 1945, although there was already talk of establishing the United Nations in San Francisco: but Ove was 'worried about what to do about Germany, Poland, Greece, San Francisco and the future peace – if any. It is difficult to see how an awful mess can be avoided. Never mind, what must be, must be, so let's have a bit of red again!'[6]

Victory in Europe was declared on 8 May, and on 20 May Ove wrote to thank Esther and Gerald for their Victory Parcel. Li and Ove, now on a diet, were already talking about going to Denmark for the first time since 1938. Their transport arrangements followed a familiar pattern: 'when we had planned to go home by car, we found that the car wouldn't work, so in the end we all three – Anja, Li and I – had to stay at the office. We had one divan between us.' His plan to dissolve his partnership with cousin Arne had not yet succeeded: 'it seems to be very difficult to reach a solution. It is almost as bad as between the allies! I hope differences with Russia will be settled soon, it is absolutely essential. If only Roosevelt hadn't died!'[7]

On the same day he wrote to his cousins Leif and Edith in America to tell them that 'this Professorship business is off': he was slightly irritated that a non-candidate had been appointed, but also relieved because the post would have restricted his designing activities. He reported:

> a cut in rations of meat, sugar, margarine and butter. And that matters very little compared with the mess we seem to be landing ourselves in in Europe. If we can't collaborate better with the Russians, God help us. Perhaps matters will be smoothed out at the highest level, but I wish Roosevelt hadn't died.[8]

This commonplace view was expressed, of course, in ignorance of Stalinist terrors which had continued from before the war, and of Roosevelt's own less than enthusiastic sympathy for things British. Ove did not discover until later that in the originally suppressed preface to *Animal Farm*, George Orwell had deplored the 'nation-wide conspiracy to flatter our ally':

> The servility with which the greater part of the English intelligentsia have swallowed and repeated Russian propaganda from 1941 onwards would be quite astounding if it were not that they have behaved similarly on several earlier occasions. [. . .]

For quite a decade I have believed the existing Russian regime is a mainly evil thing, and I claim the right to say so, in spite of the fact that we are allies of the USSR in a war I want to see won.[9]

In early June Fry replied to Ove's April letter:

Kumasi, where I am staying with the Chief Commisioner of Ashanti, in great comfort. He has been in the Guards, has long been a Fabian, has the hearts of all Africans here, and ours too. A most rare person. How difficult it is, he says, in doing his job not to fall back on Aristotle! Fall back on Plato, says Jane, education through art – and that's how the trouble began. What an argument! Not that J knows much of Plato, and probably less of Aristotle. But that, quite rightly, and in her case only, does not deter her as she lets fly to right and left. As for me I confused Aristotle with Socrates, but then I am still a sick man. From this you may gather that there *are* clearings in the great African forest.

I have been reading Machiavelli, and am surprised to see how much he must have been consulted by the various countries now so anxiously fighting to be at peace with each other. I do hope they will leave us time to build something quietly. I don't think even a 15th century Florentine, if he were transported here, could complain of lack of incident, though he might well complain of the cumbersome scale of the thing and the absence of a human hypothesis.[10]

Ove could not resist the challenge:

We were naturally pleased and relieved at the quick liberation of Denmark and Norway, and hope to be able to go there soon. We have had letters, and everything is o.k. with the family.

Education through Art is alright – I realise more and more that Art is the goods, Art is understanding, you can't even be good without a feeling for Art – but I don't see what Aristotle or Plato have to do with it. Plato is a bit old fashioned I think, a bit of a fascist, he still believes in the absolute – never mind I should have liked to listen to the argument![11]

Jane's gastric malaria, however, lingered on and in July she wrote to Ove in her typically hyperbolic manner: 'I am not feeling witty or bright I would like you to be calling for me to take me out on some kind of London night I hanker after the big city at times and an evening of really good and rather aimless talk.'[12] In September she confessed: 'I long for Chelsea at times or Paris studios where talk seems to mean a lot and people get wildly moved by ideas.'[13]

Countless families, gradually reunited, reflected on the ravages of two disastrous wars – or *one* interrupted Great War – and the social revolutions they had provoked. Throughout their lives, Ove and Henning remained close, and each valued the views and advice of the other: Ove relied on his brother for financial and legal guidance over family affairs, and whenever they met they embarked on long philosophical and political discussions. Henning wrote at length from Copenhagen in August, almost six years since his last review:

V.J. Day today – finally this 2nd world war is over. – One is so oddly empty after so many years of senselessness; all my normal activities were interrupted at the outbreak of war. – The six years were a long, long interruption, a period so full of meaninglessness and evil which turned upside down all habitual ideas and ideals that it is very difficult to find your way back to normal, peaceful existence; even for me who actually hardly has been directly affected by the war, hasn't seen a single person die violently, and barely heard – at any rate not been near an exploding bomb; and yet there has been such a shift in the whole of one's attitude to life that it is difficult to get back and happily, optimistically get going on the peaceful rebuilding that is expected now – and which all of us have been longing for. However, it is not really because the war has shown me that the old ideals have to be thrown overboard, that now there is a new and better spirit which sweeps everything old aside – all the new excitement and yelling and screaming about the will to defend, national enthusiasm, hatred of Germans, revenge over all opponents, intolerance and callousness and pharisaic self-satisfaction and the making of demands and requests don't exactly seem better than the old ideas of pacifism, love of neighbour, and Christian or humanistic ideals, which, before 1939, I thought would make the world go forward. And it strikes me as a silly and sad idea that humanity should be saved by taking to the sword and by consistent toughness. But now all the world is making a noise; propaganda, demands, cynicism and platitudes are to be heard everywhere, and all the violent and conflicting opinions make you put your hands in your lap, intellectually speaking, and become an apathetic spectator, – it is, after all, impossible to get a hearing for quiet and considered talk.

[later: dated 20/8 45]

Well, that's how far I got on V.J. Day. – And those thoughts were not particularly jolly. However, perhaps everything will turn out much better than it seems, – it is at any rate pleasing that the present moment makes all future possibilities conceivable, from the best to the worst; and since it is impos-

sible to get an overview over things today, one may as well be happy at the thought of the best, as unhappy in fear of the worst; and then, for the rest, be content with every day that one is granted life in peace and happiness in one's own little world: the home and the near ones.

In this regard it is so wonderful that we have peace again so 'the near ones' once again can get in touch. It has often been bad not to know how things were for all of you over there, and the six years of separation can never be regained. I would so like to be sitting with you all in your living room chatting about everything and swapping opinions and ideas about past and present! [. . .]

But you wanted to hear a bit about my business, Ove. . . . We don't have any troubles. But the business has undergone big changes. All building construction, which previously was my main business, has stopped. During the war I had a good deal to do buying properties for people, placing their funds, etc., – but now that, too, has stopped and there is actually nothing that produces an income, except for the administration of real estate which nearly covers the expenses on the office. So, if nothing new happens, I must expect a considerable reduction in fee-income, but then on the other hand my capital has increased steadily before and during the war so that its proceeds actually should suffice for living, – unless this situation is transformed by the new tax laws that are expected and which are likely to take a lot. However, in that case I have to be happy about the time that has gone well, and happy that the children have gotten so far and seem well able to manage on their own in due time. Besides, surely one may hope that there will be work to get again when peace-time is coming.[14]

The letters of Max and Jane were ecstatic about the job prospects ahead of them in West Africa – hospital, school and university buildings 'on wonderful sites with no tiresome LCC departments to apply to'. In October Ove confessed: 'I am afraid I have noticed in myself a slight – or perhaps not so slight – disposition to envy. I consider it to be unfortunate that one cannot be in two places at once.'[15]

In most of occupied Western Europe, major industries had increased both their output and profits during the first two years of Nazi occupation, and some entrepreneurs even expanded when economic decline set in. This was because Germany's policy towards occupied territories was one of exploitation and colonisation – although Hitler had no intention of European partnerships. But, by 1945, physical and metaphorical 'rebuilding' had become the first European necessity. German industry had been destroyed and needed to start again; the Allies themselves had to rehouse millions of people and re-

establish their social structures. The economic challenges that all this would involve were only vaguely grasped, and Ove himself was not optimistic about the wider picture: his negative feelings towards Russia are revealing. As he put it to Max and Jane:

> Things don't look too good in the world. The Russians are mad or wicked, the Yanks half mad, and the British well meaning but not very effective. Anyhow it will be interesting to see what comes out of it, although there are some frightful possibilities looming ahead, if we are not careful.[16]

In the middle of 1945, and in spite of frequent meetings over his appointment as a consultant to a scheme in Finsbury, Ove found himself in heated correspondence with Lubetkin who had complained 'most bitterly about the characteristically casual and negligent way you have been treating the survey of the Sadler Street site'. He continued:

> I begin to realise what is the trouble in collaborating with you, although I suppose I am not too early in doing so. Your method seems to be to take one into your confidence in displaying a most pathetic picture of your private and business complications, and use that as a means of not delivering the goods.[17]

Ove replied:

> In view of your last appallingly rude letter, I had decided to adopt an attitude of silent aloofness until I gained a fuller understanding of what caused the letter to be written in that form – a temporary loss of self-control or shrewd calculation. And now I needs must mar the effect of offended dignity by asking for the return of that cine-kodak 8 which you borrowed last spring, and I want to sell it – together with the rest of the outfit – to tide me over a temporary financial embarrassment.[18]

In his reply, Lubetkin could not quite remember what had made him so mad, but he observed that their former friendship and fruitful professional collaboration had waned – perhaps Ove had lost his youthful enthusiasm, or had become too busy hunting for jobs? 'With the unfailing charm with which you carry things off, you never let us know directly that you were feeling fed up with us': the end of the war seems not to have released 'untapped stores of enthusiasm . . . (Maybe all the Committees have sucked you dry).'[19]

Lubetkin had tried to interest Ove in some new schemes for Finsbury, but Ove had spent all the time ruminating on possibly becoming a professor; accordingly, while cherishing friendship, professional collaboration between

them had better cease. As usual, when challenged by a close friend, male or female, Ove was taken aback and galvanised into a vast introspective response. The earlier letter had struck him as 'vicious, ill-tempered, deliberately insulting, out of all proportion to the occasion', and the new one, albeit an improvement, still rested on misunderstanding. In fact, Ove had been feeling unwell after the aforesaid lunch and needed to rest:

> I still feel a thrill when I visit Highpoint or Finsbury health centre. I think there is nothing like it in England that I know of. When working with other architects I have the feeling that they don't care for architecture, or rather, don't know what it is. You have taught me what it is, and I have the greatest respect for your high standard and idealism in this respect.[20]

There is no reason to doubt the sincerity or truth of this acknowledgment in June 1946: Lubetkin was the most distinguished architect with whom he had worked at that date, and probably the most intellectual architect with whom he ever worked. After conceding that he had sometimes lost interest during the turbulence surrounding the shelter episodes – which 'had nothing to do with architecture, anyhow' – Ove added that 'there are people who disapprove of you, and [. . .] this disapproval may have been extended to me in a few cases'. Aside from this, however, 'my close association with you has been extremely beneficial to me'. A late thought occurred, however: 'Can it be that you are dissatisfied with my political convictions, or rather lack of convictions?'

Ove's former assistant John Henderson, awaiting demobilisation in Lahore, wrote to say he had read Ove's letter to the *Architects' Journal* on box-frame construction:

> I remember this time 6 years ago one hot Saturday afternoon I went in your Ford to your house to survey your garage for an air-raid shelter. We had coffee in the garden and I saw the new picture which you had just bought. You then suddenly remembered an appointment with Lubetkin and disappeared in the blue.[21]

A visit to Denmark in the autumn of 1945 included discussion of collaboration with the firm of Steensen & Varming, and the possibilities of getting foundry work carried out abroad; Ove also renewed his acquaintance with the architects Vilhelm Lauritzen, who had been in the year ahead of him at Sorø, and Arne Jacobsen. In December he was appointed consulting engineer for a new bus station in Dublin, and thereafter flew to Dublin almost every month for three years: he later declared that 'it opened up a new world for

me'. Jenkins was frequently involved in the same project, as was Ove's friend Jorgen Varming, the English-educated Danish heating specialist.

At the beginning of 1946 Ove had a number of meetings with Le Corbusier: this was because Entwistle, Arup and Varming had decided to enter the large Crystal Palace Competition, and several ideas were explored. The requirements were for exhibition halls, sports halls, an opera house, a concert hall and a theatre, restaurants, a stadium for a hundred thousand seated spectators and a car-park for five thousand cars. Ove paid Entwistle and an assistant to work full time on the competition, plus drawing office expenses: if a prize were awarded Ove would take one third. In their competition entry Entwistle and Arup remarked that 'the roof has become a fifth façade' when viewed from certain angles – a phrase Jørn Utzon appropriated to publicise the Sydney Opera House a decade later. Everyone was appalled by the prize-winning designs: in the *Architects' Journal* Le Corbusier declared that they made him 'sick at heart', whereas those of Clive Entwistle and his friends witnessed 'an eminent sense of architecture'. Maxwell Fry also wrote a laudatory piece, for which Ove thanked him at the end of May:

> You have arrived at a position 'where your name carries weight in all camps', and you have arrived there by being yourself, not through compromise, but through integrity. [. . .] nobody reading your review can be in doubt where you stand. You have, to a large degree, nullified the disastrous effect of the official award.
>
> And you do it in a masterly way: not by saying that the premiated designs are lousy – which I would be tempted to do, and which would get you nowhere – but that they simply 'fail to move you', which is inoffensive and yet devastating. Well done![22]

A few months earlier, in February 1946 Jane Drew, on behalf of her fellow editors Herbert Read, Trevor Dannatt and Max Fry, had invited Ove to join the board of the *Architects' Year Book*. He agreed, and immediately started refereeing submissions. By that spring his health had been fully restored, and he ventured an uncharacteristically whimsical letter to Max:

> May I animadvert on your letter in the Horizon? Not that I dislike it – rather, I think it makes me like you. But it produces in me an impulse to parody your style and to tease you: no doubt an undignified pose for an elderly gentleman. But that way of writing – beautiful perhaps – isn't it a little self-conscious? Does it spring forth spontaneously from a ground manured with sixteen and 18th century culture, or is it a carefully nurtured hot-house plant? Does your conversation with J flow continuously at this

high level? Now glowing, then moving? Should there not be somebody to take notes? Or is my good-natured – for I vow it is – malice born of envy? Would I myself write thus if I could? Who knows? The temptation is there – latent at least.

What you say is right and, I think, worth saying. That bit about architectural space is of the essence of architecture and your illustrations are apt. And the leg-up you give faith, spirit and what-not, comes in useful. And why should not the English language be treated as a work of art: should Shakespeare's heritage be thrown overboard? And yet! Doubts befall me.[23]

While all this was going on, a new office was opened in Dublin at the end of March. And on 1 April, Arup & Arup Ltd was dissolved, after endless bickering about final details which dragged on until 1952: on 1 April 1948 he had admitted in his diary that 'When on the point of agreement I spoiled the matter by refusing to acknowledge that his terms were reasonable, and now the matter is in abeyance.' Ove N. Arup Consulting Engineers was established between 1 and 6 April 1946.[24] The main office occupied part of the top floor in Colquhoun House, Soho, the firms of his cousin occupying the rest; there were also two smaller offices in Sackville Street and off the Pentonville Road. Ove was two weeks short of his fifty-first birthday, a late age to launch out on one's own.

Some four years earlier, during his campaign for underground shelters, Ove had written a paper for the British Association for the Advancement of Science meeting on 'Science and world planning'. He had stated that modern buildings were 'often badly planned, badly ventilated, badly heated, etc. In other words, only limited use is made of all the existing technical knowledge.'[25] Designers lacked appropriate information because no one person could 'hope to be familiar with the complete range of modern technical possibilities': 'new knowledge, new materials, new processes [have] so widened the field of possibilities, that it cannot be adequately surveyed by a single mind'. Because 'our needs increase with the means' the problem arises of 'how to create the organisation, the "composite mind" so to speak, which can achieve a well-balanced synthesis from the wealth of available detail'. This is 'one of the central problems of our time'.

That belief signalled, perhaps, the ultimate motivation behind what was to become one of the largest engineering consultancies in the world. His premise was this: in the modern world of increasing complexity and rapid change, only the widest co-operation can resolve the issues that may arise. Architectural harmony could be achieved only if architect and engineer collaborated intimately from the start – assuming availability of all relevant technical infor-

mation, and appropriate experts. Certainly, in the USA, large firms already existed, staffed by experts in various fields who saw their work as part of a whole, and who mutually co-operated towards its implementation. But the typical profit motive of such firms could create problems: financial success can, but often does not, mesh with the interests of society as a whole. In any case, Ove held that no group was likely to cover a wide enough field: the limited knowledge they had was often commercially guarded, and there was needless reduplication of effort by rival concerns. An alternative was to establish state-funded institutions for the collection, classification, testing and dissemination of unbiased information: authorised testing bodies of materials, tools, plant and processes would require permanent 'powers that are contrary to the interests of some commercial firms'. A corollary was that the publication of unbiased information 'should logically be followed by a restriction of production to useful products'. This would certainly 'interfere considerably with the present organisation of industry'. 'Everywhere the same or almost the same problems crop up', and 'if the best possible solutions were found to these problems and embodied in a series of standards' the design and production tasks would be greatly simplified.

Over the next fifty years such standardisation did take place, in some realms and professions more than others, but the revolutionary tone of Ove's remarks in 1942 should not be overlooked. His concluding paragraphs would have left no one in doubt: 'hand in hand with the standardisation of those units from which planning proceeds, should go the standardisation of human needs'; minimum housing and workshop standards 'should be laid down and applied universally', together with building regulations which would be monitored 'on democratic lines to allow revisions and additions to penetrate from below'.

> There must somehow be power to direct or influence production. The centre of gravity must be shifted from private enterprise to public service. [. . .] Organisation of industry and communications, the planning of towns and agriculture, the extension of social services are all problems which, so far as I can see, cannot possibly be left to private initiative, but which everybody now realises ought to be tackled in the interest of humanity.

There remained a major difficulty: 'getting agreement as to what benefit to humanity means, and also of overcoming the fact that people are more concerned with benefit themselves than humanity. It becomes therefore a moral or social or political problem.'[26] In 1942 Ove had a particular audience in his sights – public administrators and lacklustre traditionalists in engineering and architecture. But, as he admitted three years later, to all whose primary

concern was financial profit and commercial advantage, his programme smacked 'too much of totalitarian regimentation, centralisation, government interference with Industry and private initiative'. His goal had been to harmonise his notion of limited standardisation with the least restriction on design freedom. However, it was unclear whether his ideas could be embodied or promoted by a single firm, and whether he later thought his own firm did so; the limitless requirement of flexibility, in the face of changing needs and increasing complexity, might seem to suggest co-operation between multiple enterprises rather than incorporation within one organisation. But these were largely theoretical concerns for Ove in the 1940s.

The war had barely ended when Ove found himself once again engaged in arguments about mass housing, and rehearsing his position as a member of the Government Prefabrication Committee: 'prefabrication' was not a panacea for all problems – questions of cost, quality, quantity and working conditions need examination in each context. He doubted any architect's ability to decide priorities or provide the necessary leadership to drive through decisions.

Form and function were the two most publicised concepts associated with modernism, but Ove was increasingly irritated by their vagueness and lack of definition. Shortly after establishing the new consultancy in 1946, he published an article on the newly fashionable topic of shell construction, especially for large uninterrupted spaces. This was mainly intended to publicise the Dublin Bus Station which his firm was currently building. He began with, for him, a surprisingly abstract statement of his position:

> Architecture is concerned with the enclosure or division of space. Space is confined by curves or lines. A study of surfaces, their arrangement and intersection, is, therefore, of the essence of architecture. This fundamental fact is obscured by the difficulties obstructing the physical embodiment of our ideas.[27]

Our ability to think of new possibilities is always influenced by our existing beliefs. In the building industry, as elsewhere, new materials such as steel and reinforced concrete were at first used in imitation of old: the tradition was to think 'in terms of columns, piers, architraves, beams, trusses, rafters, as the elements of architecture – all members necessitated by structural and not by functional requirements'. So, at first, 'reinforced concrete was used as a substitute for timber and steel, and assumed the forms characteristic of these materials. The column, the beam and the slab were thought of as separate members.' Such an approach ignored the plastic and monolithic character of reinforced concrete, 'which can be moulded and built up to any shape, after

which the whole structure forms one jointless unit': this unit can be calculated as such. It became possible to design thin plates or shells for enclosing space or for retaining or containing solids or liquids.

Apart from the complexity of the calculations involved – recognised in the nineteenth century – the major new problem concerned temporary formwork for reinforced concrete, which made up a large proportion of the overall cost. Obviously the cheaper possibilities would be plane surfaces rather than curved, single rather than double surfaces, and flat slopes rather than steep ones. General membrane theories were made applicable to large span roofs only around 1910 and every aspiring engineer had marvelled at what resulted: the huge hangars begun by Freyssinet in 1921 are 190 feet high and span 295 feet. Engineers tried to control the complexity of their calculations by confining the use of curved shells to surfaces with relatively simple geometric properties – spheres, cylinders, paraboloids, hyperboloids, cones. Ove noted in passing – and the reference is significant in view of later work on the Sydney Opera House – that design calculations for the Copenhagen Broadcasting House by Lauritzen took four engineers six months. One new idea influencing design was a realisation that a slab is stronger when resisting forces in its own plane than when perpendicular to it. In his article for *Architectural Design* Ove referred to concrete shell roofs which spanned more than 200 feet, but which were only a few inches thick. These dimensions were soon dramatically exceeded.

Although he had worked in London for more than twenty years, success in his new firm would depend on making new contacts, not merely consolidation of old. The key was Ove's membership of the MARS group, as he explicitly acknowledged. He was, indeed, the only engineer in the group but, more significantly, he was almost unique among engineers for his genuine interest in architecture. Nevertheless, for more than a decade after 1946 money was very tight: clients and sub-contractors were slow to pay, and the new firm survived on an overdraft for much of the time: initially, of £1000 from the National Provincial Bank. Even in mid-1953 Ove was being summoned by the bank manager to discuss the overdraft. For many years staff were paid in cash, in brown envelopes, the highest wage earner in 1947 being Peter Dunican at £7 per week. There was often no cash in the bank, and Ove sent urgent messages by means of a junior secretary to Max Fry, to Tecton and others, to ask for loans – and instructions to wait for an envelope which would contain the requisite money. Pay-day was halfway through the month, because the firm could not afford to pay in advance, nor commit everyone to debt by waiting until the end of the month.

Unlike his partners and colleagues, Ove was psychologically cushioned by his private income from family property and investments in Denmark although, for tax reasons, it was initially left there: his declared British income in 1949 was just under £6000, although outgoings were high. In Britain he held no stocks and shares, and only one life insurance, deriving from his time at Christiani & Nielsen. He did not believe in the instruments of capitalism: for him, all the risk was in the business, although he was later persuaded to set up off-shore trusts for his children and grandchildren, and subsequently enjoyed a very generous pension himself. And he regarded personal property differently. He always looked back on the early days of his firm with nostalgia although, absurdly, he first publicly bemoaned the size of the firm at the second Christmas party in December 1947. In those days he knew everyone, had a finger in every pie, argued about each and every case, and rushed about from sites to committees to dinners. And his ritual moans, except by new staff, were with equal regularity ignored. Geoffrey Wood, who began working with Ove in Christiani & Nielsen in 1932, remembered that Ove had struck him as more a 'drawing office man' than someone 'interested in doing things with his hands'. This was not true of his old age, when Ove spent much time and effort designing chess sets and table utensils. On the other hand, from the 1950s at least, Wood considered his actual physical contribution to any job to have been minimal. In the early days of the firm there seemed to be no meetings to decide what to do, and yet there was a strong sense of teamwork. Even Jenkins, who was regarded by everyone as the brain and the backroom boy, and who shut himself in his office, was accepted as pivotal to all serious problem solving.

There was a ruthless side to Ove's character, deriving from his search for truth and for perfection: 'even his friends came second' to these goals, Wood recalled. Having employed J. B. Priestley's daughter to work on the Aero Research factory at Duxford, Cambridgeshire, in 1947, he replaced her on another job a couple of years later. His view was: 'Not the best we can do with what we've got; but the best we can do with anything we can lay our hands on.' Such an approach fed the inventive side of Arup work.[28]

Ove openly enjoyed being at the centre of attention and, later on, being famous. He especially enjoyed being Queen Bee at the summer outings held over the first ten years, before the numbers became too unwieldy. The early jamborees took place in Margate, but they later always consisted of boat trips on the Thames. Coaches conveyed the whole staff from and back to the office, together with hampers and Ove's accordion, which he expected, and was expected, to play for dancing. Unpredictable weather was the annual anxiety,

but they relied on Dunican's flair for imaginative forecasting and were often blessed with a perfect day. Ove was an accomplished squeeze-box player, improvising dance tunes and folk songs with great aplomb, while simultaneously smoking a cigar.

From the beginning, and increasingly as his personal distance from assignments diminished, he was the front man: his personal charm and style defined the firm he wanted, and was the greatest advertisement for it. Like the famous architects with whom he effectively hob-nobbed, he was the person the clients wanted to meet, even if all the detailed work was done by others. The luncheons, the dinners, the parties were all part of the collegiality Ove sought to establish, and within which he believed constructive thought and decision making could best take place. At an after-speech dinner at the Savoy in 1955 he observed: 'Humanity can be roughly divided into two categories; those who eat the icing first, and their cake afterwards, and those who save their icing till the last moment. I belong to the latter category.' He then added: 'You come to a meeting to meet people. If you want instruction on your special subject, then you go to a book, to a technical publication, or you meet the expert face to face. But meetings are for meeting people.'[29]

A large number of lunches with Max and Jane took place throughout the spring of 1946, often joined by others such as the Finnish architect Alvar Aalto, and the influential American historian and champion of modern architecture, Henry-Russell Hitchcock. There were still regular meetings with Lubetkin, who had moved to a farm in Gloucestershire in 1940, and irritable inspections of the increasing dilapidation at Highpoint, now ten years old. Regular lunching haunts included Claridge's, the Connaught, the Athenaeum and the Reform Club, the White Tower, Rules, Scott's, Escargot, and a dozen other smaller establishments. A satisfactory lunch with Miss Beckett at the Danish Club in April 1948 yielded the comment: 'She was marvellously attired in the new look from Paris.' For several years after the war ended Ove sent gift parcels of tobacco twice a year to his brother in Denmark, 'limited to £5 in value including expenses': this nevertheless catered for 2000 cigarettes (Senior Service and Churchman's No. 1) and half an ounce of Player's 'No Name' tobacco: later, he was able to get wine delivered to Ingeborg, also.

Some of the meetings of MARS in the previous year had been disappointing and in September 1946 Ove attended a long meeting on the future of both MARS and CIAM with Giedion, Wells Coates and Van Eesteren. The group did not formally disband until January 1957, but had been disintegrating for years: in 1944 great offence was taken at John Summerson's observation that the modern movement was 'nothing but the federated achievements of a few

men of exceptional vision'.[30] Nevertheless, in 1946 several more meals with Giedion took place, and they enjoyably discussed the latter's views on monumentality in architecture. But little was resolved about the organisations. A swollen leg prevented his attendance at the CIAM 6 Conference at Bridgwater in September 1947 – although he did get to the London party for delegates. And in the spring of that year Ove, Anja, Maxwell Fry and his daughter Ann visited Denmark together, where they met up again with Steen Eiler Rasmussen and Vilhelm Lauritzen. Maxwell Fry recalled that Lubetkin 'was constantly trying to drag us into communist politics' in MARS, and strongly disapproved of Fry's active council membership of the RIBA in the 1930s. Lubetkin himself conceded that he had 'tried to bring a philosophical and political position to the group, but nobody else was talking that language or understood those terms'.[31] This confession, in old age, partly explained the cooling of relations with Ove. Lubetkin deplored the fact that Wells Coates, for example, 'took the empirical view that there was no need to define content, or the limits of modern architecture'; whereas he, Lubetkin, 'had always the belief in theory underlying practice, and that without theory practice is blind'. When asked, thirty years later, to reflect on CIAM, Ove seems to have been more critical than he was at the time. His being an outsider had been an advantage to his membership of the 'propaganda centre', but he quickly discerned a serious problem because 'the people who instigated the movement knew next to nothing about science or engineering construction'.[32] Moreover, architecture had gradually become 'a genteel occupation', and architects regarded design and building as two different domains. Worse: it was 'as if there is a streak of dishonesty running through the architectural profession. They do not face facts, they fake facts.' This did not mean that architects could or should be dispensed with – albeit advanced technologies were already beyond the ken of all but specialist engineers; on the contrary, architects were needed more than ever, because architects deal with human beings.

From 1946 onwards Ove came under pressure to take charge of technical education at the Architectural Association, but having failed to gain the Chair of Concrete Technology at Imperial College, he continued to waver about teaching duties. It is notable that even by that first autumn, both Jenkins and Peter Dunican were pressing Ove hard to sort out the office organisation and staff procedures in the new firm. He, himself, had decided to seek membership of the RIBA and the Institution of Structural Engineers: he was increasingly keen to be seen, but decreasingly inclined to get involved with associated organisational duties: as he openly confessed in 1972 'I am a bad institution man'. He declined to be Director of Research for the Cement and Concrete

Association: but, impressed by the dining facilities, he joined the Arts Theatre Club, and also Murray's Club. Correspondence resumed with Lubetkin, who in the summer of 1947 was in the process of dissolving the Tecton Partnership. In a remarkable letter of July, Lubetkin set down some of his convictions:

I have the unfashionable conviction that the proper concern of architecture is more than self-display. It is a thesis, a declaration, a statement of the social aims of the age. Its compelling geometrical regularities affirm man's hope to understand, to explain and to control his surroundings. By thus asserting itself against subjectivity and equivocation, it discloses a universal purposeful order and clarity in what often appears to be a mental wilderness.

To me this represents the CONTENT of architecture. [. . . which] means a world outlook, a visual guarantee of the consistency of the whole human experience. It can be a potent weapon, a committed driving force on the side of enlightenment, aiming, however indirectly, at the transformation of our present, make-believe society, where images outstrip reality and rewards outpace achievement.

But the universal will to change cannot be taken for granted. Change is not welcomed by entrenched privilege, nor by the indolent, whose highest aspiration is to return to 'normality', to business as usual. [. . .] For these, one sure way of defending that which exists is to disarm the art of architecture as a social force, making rule-of-thumb technology its be-all and end-all.

FUNCTIONALISM was the first rock uncharted by any theory (in a society where abstract thought is deeply distrusted) on which Tecton started to founder.

But the dislike of theory is itself a kind of theory, which reflects man's unwillingness to control events, and thus it implies the acceptance of things as they are, and bolsters up the status quo ante bloody bellum.[33]

To Ove, these reflections of Lubetkin amounted to armchair Marxist metaphysics; the views on theory absurdly ignored the perspective of the empirical sciences which seek to influence events in a context of constant change, and which defined Ove's own approach. Lubetkin was right that Ove's rejection of theory, or rather certain kinds of theory, was itself a philosophical view; and that they held diametrically opposite views of what philosophy itself should or could be. Lubetkin went on to deride 'those who have nothing but contempt for speculative thought', and for pragmatism which reveals itself as

having 'vested interests in what is rather than what might be'. In a passionate outburst on modern art, which Ove pinned to this letter, Lubetkin insisted that

> Modern Art is rooted in the protest against that fraudulent authority whose calculating and codifying activities were mistaken for rationality. [. . .] Real protest is neither extravagant nonsense nor malignant absurdity. It is rather the inspiration of noble simplicity, the limpid clarity of classical calm and sense of order. This is the only way to affirm human dignity and worth, the only way of calling the gigantic bluff and finding a way out.

Lubetkin, when so minded, could nevertheless resort to charm. In the unlikely event that Li could be persuaded to join Ove on a visit, the invitation to her should not be taken 'as a standardised prefabricated modular sentence, but as a custom-built, purpose-made, individually conceived, built in-situ invitation (architect-designed)'.

Although the British economy struggled through 1947 and 1948, professional visitors from overseas increased in number, and in the spring of 1948 Ove was delighted to meet and entertain both August Perret and Eugène Freyssinet, two giants among proponents of pre-stressed concrete, the former as an architect, the latter as an engineer himself. He later visited Freyssinet in his Paris factory. Ove was already working on a new factory for Aero Research at Duxford, in Cambridgeshire, and shortly afterwards Robert Matthew and Leslie Martin asked him to be the engineer for their new concert hall – subsequently the Royal Festival Hall:[34] but Martin was over-ruled by officials in the London County Council, on the grounds that Ove's firm was too small. Ove later secured the commission for the temporary concrete footbridge to the Festival Exhibition and, in the drizzling rain, watched George VI from a distance open the Festival of Britain. They also went to a reception for the King and Queen of Denmark: 'who did not come'.[35] By 1951 Ove had joined Li in practising the Alexander Technique, in his case for lumbago. She was not in good health and missed Anja's wedding to Keld Liengaard in April – although she saw the couple at home in the evening.

Cars were necessary for Ove's business: but also for his self-image. Throughout the war, and afterwards, he had to seek authority for an additional petrol allocation, and he also needed authority to change cars. In October 1944 he exchanged his small 6.7-hp Fiat for a 1935 8-hp Rover. But this gave a great deal of trouble and was declared unroadworthy by the end of the year. He sought permission from the Ministry of War Transport to exchange it for a new Ford 10, Morris 10 or Austin 10. In fact, he bought a 1935 15-hp

Daimler instead, which did 16 miles to the gallon: and he was immediately fined 20s. for speeding. He also entered into correspondence with the Automobile Association:

My passenger espied a teapot in a window of an antique shop. [. . .] Owing to the attraction which antique shops have for some people, we were away longer than anticipated. Returning with an uneasy conscience, I found a policeman waiting for me. He courteously informed me that we had been away eight minutes, and that my car had caused an obstruction, owing to the necessity of the 'bus or 'busses pulling out into the road when leaving the 'bus stop.

I had not thought of this aspect of the matter, but have no reason to quarrel with the statement. I regret any inconvenience caused and plead guilty. I think it just that I should be punished for my lack of consideration.

My passenger has already received his punishment as the teapot, when he brought it home, did not find favour with his wife.[36]

By 1948 he urgently needed a better car for business, and acquired a 1938 25-hp Alvis. He was the third owner of this vehicle and paid £1250. But it did only 11 miles to the gallon, and in 1953 he sold it and bought a Rover 75: and immediately encountered an obstacle: 'I felt a heavy bump at the back. It made a dent in my car. The other car was more severely damaged. I maintain absolutely definitely that I had no blame. I did not brake suddenly.'

Writings poured forth, invitations to lecture mounted, and travel to more exotic places beckoned. First, in December 1946 to Kuwait as guests of the Kuwait Oil Company, accompanied by Jane Drew who, then in her mid-thirties, was magnetic in every sense. Fifty years later she suggested that Ove had disapproved of her behaviour with a sheikh, but whatever happened with whomsoever remains unknown: in the manner of Henry James, his closest friends always assumed that 'something happened'. They spent sixteen days in Kuwait and two days in Dhahran, and Ove's task was to present a consulting engineer's report on the desert sites at Ahmadi and Fahahiel, which had been selected as locations for new towns. His ten-thousand-word report identified major challenges: he discovered that the supply of coarse aggregate for making concrete was done by hand – 'stones of various sizes are collected from the surface of the desert by hand'. He also noted: 'With the temperature range from 36 to 118 in the shade, and sun temperatures up to 170, precautions must be taken against the effects of heat expansion of materials.'[37] Jane, of course, was already alert to such problems from their experience in Nigeria and the Gold Coast.

In February 1948 Ove became a founder member of the Institute of Contemporary Arts: many of the most prominent people in the arts were active members, including actors – Peggy Ashcroft; composers – Benjamin Britten, Lennox Berkeley; artists – Graham Sutherland, Henry Moore; writers – Osbert Sitwell, Stephen Spender; national museum directors such as Philip Hendy and John Rothenstein; and the great patron of modern art, Roland Penrose. Ove attended numerous events over the next decade, usually with friends, and he often chaired meetings and contributed to discussions. With a wider remit than MARS – and including most of that group – the ICA was the first British organisation that promised to satisfy Ove's philosophical and broad cultural interests. This was something for which he yearned, not least because he missed the excitement of his wartime collaboration with future Nobel prizewinners. Happily, many speakers at the ICA were as outspoken as he. Accordingly, in a lecture on 'Mechanical draughtsmanship', he had no scruples over asserting that 'the average level of unintelligence of the human race makes it imperative to adopt certain watertight conventions which cannot be misunderstood. The strength and peculiar qualities of engineering training lie in these sacrosanct conventions.'[38] During the first year a distinguished committee under the chairmanship of the avant-garde artist Richard Hamilton planned an exhibition based on the book *On Growth and Form*, by D'Arcy Wentworth Thompson. Ove had long been an admirer of Thompson's work, and later recommended it to Jørn Utzon – although Utzon denied the acknowledgment.

Ove's intimate friends detected his intellectual snobbery, and he not infrequently left Li on her own to entertain 'boring' wives who were visiting, while he disappeared into his 'den' alone or with their spouses. Li's sharp disapproval of such behaviour was kept strictly within the family: and the children were regularly lectured on the social imperative of being equally gracious towards all guests. Ove was not immune to social snobbery either, particularly in the British context. Li herself rarely accompanied him to lectures or discussions, even if he was a speaker: and although her exquisite appearance at formal openings invariably attracted compliments, she herself disliked the noise, the crush and the social artificiality of the gatherings. What she hated most of all was the blatant behaviour of fellow guests who, as she perceived it, spoke to her only in order 'to get at him'. She often went home early, by herself. There was, perhaps, an insoluble paradox in all this: her first and absolute duty was towards her husband, to whom she devoted her life. She held, much more strongly than Ove, that the only purpose of education for girls was to ensure their fitness as wives for serving their husbands. She

instructed her older children accordingly – which later worried Anja, in particular. One consequence of this was that, by taking a back seat, Li invited responses as if she were invisible – and forceful people such as Jane Drew simply ignored her presence. Like many women of her generation, however, she came to resent not being treated as a full human being. Possibly because she associated her mother's divorce with strong-willed self-indulgence, Li held that only one will could or should prevail within a family, and that must be the father's will. Ove was allowed to trade on this himself, and even his older intellectual sister Ingeborg surprisingly deferred to him on almost all occasions.

Early on in their marriage, Ove discouraged Li from sending recipes and articles on domestic matters to English or Danish journals, or pursuing interests outside the home. Widely admired as an outstanding cook, devising her own recipes, making her own jams and sauces, she was said never to have bought a tin of food. After moving to Virginia Water Li took up gardening, and both there and in Highgate created colourful and striking results which were cherished by family and visitors. More domestically, she was also an accomplished seamstress; she was thus able to send the small children to school with perfectly mended clothes, to their humiliation by their snobbish contemporaries who wore only new clothes. Li had suffered from varicose veins since schooldays, and often had to sit with her legs up for long periods, reading biographies voraciously: she was particularly fascinated by the Bloomsbury group, members of which were still around. It was never clear whether this was because she thought their lives provided insight into the British character, or merely provided a contrast with her Danish experiences. Unlike Ove, who never prepared for a holiday abroad or to a new destination, Li enjoyed travel books and was the only person informed before they set off. She also read the *Times Literary Supplement* from cover to cover, leaving the *New Statesman* for Ove to dissect with equal thoroughness.

Ove himself enjoyed the verbal gyrations of Laurence Sterne, the whimsy of Edward Lear and a certain boyish prankishness – he spoke of the English tradition of 'facetious *plaisanterie* . . . whimsical banter'[39] – but he was never comfortable with the coarser dimensions of British humour, and on many occasions declared: 'I still don't know why that joke was funny.' He revelled in the linguistic opportunities, but he was never quite sure how to respond to 'the decencies so closely woven into the British character'. For example, 'any success should always be due to luck or the excellence and generosity of friends [. . .] and you must manage to convey the impression that you and the firm are all that they don't claim to be.' He was never seen to roar with laugh-

ter at a British joke, although he would readily try to diminish the primness of a social gathering by zany antics.

His apparent suspicion of and overt discomfort at English wit or irony may have had its roots in the fact that English was not the language of his childhood. That is when we all absorb a vast range of allusions, practices, colloquialisms, slang; whoever comes late to a language at some point is excluded from access to the inner meanings that bond groups together. None of the continental immigrants with whom he worked and spent so much time in the 1930s broke through these barriers, and from the 1960s onwards Ove's English struck younger colleagues as archaic and time-warped. For similar reasons, and like many who tease others, Ove himself was less keen on being teased – 'it all depended'. Nevertheless, close friends did speak their minds, and most of the time he respected them for that: it was what he himself always did, sometimes with less than sensitivity to the context. Colleagues frequently reflected on these traits: some reluctantly accepted an explanation of Scandinavian 'bluntness', but some concluded that he knew very well when he insulted or hurt others – Li's sharp reprimands were witnessed by close friends; others, again, held that he had no conception of Adam Smith's moral injunction to see ourselves as others see us – a phrase famously adopted by Robert Burns in his poem 'To a Louse'. Certainly, when young, his friends kept telling him to be less self-absorbed – but so did he himself. He had also reflected on social manners and proprieties, deploring their indefensible excesses while accepting that some conventions were necessary.[40] Writing from Dublin in 1949, Raymond McGrath reprimanded Ove for the tone of a letter, and received a contrite reply:

> The letter wasn't cross at all – it would be practically impossible to get cross with you. It was simply dictated in a great hurry and, therefore, not carefully phrased.
>
> On the other hand, my secretary is very cross with you for calling her 'Tomato Patch' and I don't know what you are going to do about that.[41]

A few months later, nevertheless, Ove had to advertise for a secretary, and one candidate enclosed a photograph. In his rejection letter, Ove returned the photograph. But this prolonged the correspondence.

> It grieves me to think that you could bear to part with a picture of my sweet self! But, darling, you must either have wee drappie o'Scotch blood in your veins or your new secretary slipped up. Your letter was unstamped and thereby relieved me of a very hard earned 5d.[42]

Of course, Ove could not resist:

> What is the good of keeping a reminder of what I have missed in not seeing
> you in person? [...]
>
> I can't bear to think of your financial loss on my account, so I am enclos-
> ing $7\frac{1}{2}$d – 5d for the letter and $2\frac{1}{2}$d for your reply.
>
> But don't reply to this letter now – then you would again be out of pocket.
> And, honey – I'm 55 so it wouldn't pay any dividend.

Summer holidays with the family to Denmark, Norway and Sweden resumed
after the war, and were usually accompanied by drama, if not farce. Flying
back from Denmark in 1947, 'one engine stopped and we had to come down
at Hanbury where we stayed for $3\frac{1}{2}$ hours waiting for repairs'. The 'Great
European Tour' in the lumbering Daimler in April 1949[43] was preceded by
questioning everyone about what to see and where to stay. Creative driving,
cavalier disregard for the conventions of time-keeping, and random acquain-
tance with the points of the compass conspired to disrupt most of their plans.
They missed the boat from Dover to Calais; and they missed the boat back.
They failed to find their Paris hotel until after midnight, and at the crossing
into Italy things took a new turn: 'we had to stop the car on an incline to be
inspected by Customs. We could hardly move it again but we managed to
limp into Italy where we . . . we gave up.' They abandoned the car, and hired
a taxi to Portofino, over 120 miles to the east: at Savona, past midnight, the
taxi-driver also intended to give up, but after forceful persuasion he contin-
ued, and the Arups were so warmly welcomed at Portofino that they stayed
for a week. They did not enjoy Bellini's *I Puritani* at La Scala because, by
then, Ove's back hurt very much and he was tired. They arrived home, in need
of a rest, and Ove rushed off to dinner at the Institution of Structural Engi-
neers: which proved to be 'a very pompous and very boring affair'. The now
regular visits to Denmark enabled Ove to see again almost everyone from the
past, such as Grete and Elsebeth, whom he visited on her farm, surrounded
by her husband's French family.

Many adjustments took place after the war, social as well as physical. In
December 1948 Li received a letter that dramatically signalled the constraints
already challenged, as well as Li's unease on many British social occasions:

> It was a joy to see you again and since Mr Arup danced with me I suppose I
> am forgiven but I should like to tell you that I think you must have misun-
> derstood the whole argument which caused the trouble. You see it was sup-
> posed to be a purely philosophical discussion concerning the existence of God
> and it was because we did not get anywhere with it that we used the subject

of divorce to illustrate the modern habit of changing the meaning of current words – divorce as divorce was not being discussed and in any case at the time we did not even know that there was a divorce in your family and now do not know who is divorced so we certainly were not implying that Mr Arup was not a perfectly good husband. The discussion was entirely impersonal.[44]

The writer had worked with Ove in Christiani & Nielsen from the 1920s and she was referring to a dinner party in 1938, a decade before the letter. Ove very well knew that in most parts of Britain it was socially improper to discuss in mixed company any potentially contentious subject: religion, politics and sex were taboo, and personal tragedies, such as divorce or cancer, suicide or bankruptcy were unmentionable. This remained the case until well into the 1960s, but whereas Ove had no intention of yielding to such inhibitions, Li felt that her duty as hostess or guest demanded it. Her discomfort at these social proprieties was not helped by the fact that in sixty years she travelled very little in Britain: visits to Ireland outnumbered all other journeys outside London. The reason was simple. Her first duty was to her husband: her second was to her family in Denmark, about whom she continued to feel guilty, possibly because of their own relative good fortune in England. So Denmark remained the focus and goal of her emotional ties. They did enjoy several visits to North Wales, however, to stay with the architect and social reformer Clough Williams-Ellis,[45] along with Robert Matthew and others: as Jane was also a frequent guest on Clough's estate at Portmeirion, Li's enjoyment of these occasions was diminished.

During his childhood, Christmas was the most important social occasion in Ove's calendar; and it remained so thereafter. The search for a perfect Scandinavian Christmas tree for the house entailed endless comparative visits to tree specialists, and the unwrapping of each candidate specimen. His choice of a personal Christmas card to the staff, together with a message, occupied him for days: and the lunch was a matter for serious negotiation, a new restaurant being challenged each year. Mr C. Ktori, manager of the Akropolis Restaurant, 22 Percy Street, received typical instructions in December 1949, to provide for thirty-eight people from 1.15 to 3 o'clock:

> We should be seated at a 'T' shaped table, all in one room. I think a lunch of soup or hors d'oeuvres, roast turkey or goose and vegetables with, say, ice-cream and fruit as a sweet would be most suitable. I understand the charge is 5/- plus 2/6d per head with wines etc extra.

At the beginning of 1950 Ove made a list of twenty-eight projects with which he wished to be associated from the early 1940s.[46] Among the architects he

named, including the Frys, were Guy Morgan, Michael Scott and the firm of Yorke, Rosenberg & Mardall (YRM). The principal works in progress were:

1. Bus Station and Office, Dublin: Estimate total: £800,000 (including £200,000 engineering works)
2. Aero Research Factory, Duxford, Cambs: total works £120,000
3. Standard Yeast Factory, Dovercourt, Essex: engineering works £300,000
4. Factory at Inchicove, Dublin: structures and engineering £275,000
5. Domestic flats London: Paddington total cost £4 million
 Others total cost £2 million
6. Schools and College: Gold Coast and Nigeria: consultants £600,000
 Mental Asylum £400,000
 New University, Ibadan: total cost £2.5 million
7. Kidbrooke Comprehensive School, London: total cost £2 million
8. New Government Offices, Dublin: total cost £4 million
9. Factory at Brynmawr – all buildings and foundations £300,000
10. Festival of Britain: collaboration with Fry-Drew etc. —
11. Technical College, Peterborough: structural design £100,000

He decided not to include several items from his draft list, including underground petrol storage tanks for the Air Ministry to his own design, the jetty and dolphins at Heysham, and a 'jetty and pierhead for a 50 ton crane founded on a 90 ft monolith for the Air Ministry at Felixstowe'.[47] The following year he decided to list the areas of his buildings covered by reinforced concrete shells[48] – that, after all, was the distinctive contribution made by Jenkins, and therefore a defining feature of Arup work:

	Sq ft of floor area covered
Donnybrook Garages, Dublin	40,000
Newport Factory for Monsanto Chemicals	5,000
Brynmawr Factory	112,000
Peterborough Technical College	26,000
Kidbrooke Comprehensive School	14,000
Debden Printing Works	120,000
Broadstone Bus Station	228,000

The rubber factory at Brynmawr, South Wales, attracted considerable attention because of the large-span, double-curvature, concrete shell roofs designed by Ronald Jenkins.[49] He and Ove were awarded the Coopers Hill War Memo-

rial Prize for their paper on the construction: this consisted of a bronze medal, a certificate, and a cheque for £10. 16s. 11d. It is not recorded how this was divided.

Ove had made a number of loans after the war to the flamboyant but dysfunctional architect Clive Entwistle, who repeatedly sought an extension to repay. Entwistle was supposed to be collaborating with Le Corbusier in designing the United Nations building (the latter's role was small, the former's undetectable), but whether concerning financial decisions or other arrangements, every new crisis generated immensely long and pitiful narratives. By 1951 Ove was becoming irritable: a few naïve debtors discovered rather late that there were sometimes understandable strings attached:

> I take it as sign of your healthy optimism that you expect to send me a cheque within two months – an optimism which my more sceptical mind is unfortunately not able to share. However, the surprise if it should happen would be proportionably greater, and of course there is no doubt that you damned well ought to do something about it.[50]

Even in mid-1964 problems had still not been resolved, on either side:

> We only hear from you when you want something out of us, whether it is money or introductions et cetera, and I don't think that you have ever given any thought to repaying us the considerable debt that you owe us. I am sure that in all these years there have been times when you could have done something about it, and the fact that you didn't naturally makes me less eager to help you to recommend you strongly to anyone else.[51]

Expansion and explanation

Although the London practice opened in 1946, a Partnership was not established, nor the first Partners appointed, until 1949 – Ove, Geoffrey Wood, Ronald Jenkins and Andrew Young; after two years Young left to be Chief Engineer of the Coal Board. The new arrangements were a partial response to the accountants, who had suggested in 1948 that the financial management and prospects were so poor that the firm might have to consider future closure. Wood had joined Christiani & Nielsen as a tracer, during Ove's time there, and then became Senior Engineer at Kier & Co. in 1935. Jenkins had originally been taken on by Ove at Kier's when, in ignorance of the fact that they had advertised a post, he had called in at the office to enquire about opportunities. Ove assumed he was a candidate, chatted about philosophy and mathematics and concluded: 'Well, you can come.' Ove chose his initial team from among the people he knew and, above all, liked: apart from the new Partners, he had worked with most of his other assistants as well – Peter Dunican, Henry Crowe, Vic Kemp and George Dell. There were fewer than twenty people altogether in the firm. His procedure was to decide whether he could get along with someone, irrespective of his or her formal qualifications or proven accomplishments, and then credit that person with the integrity and

capacity to get on with the job. Jenkins was accepted as able to help out on any complex mathematical problem: Geoffrey Wood could get things done, not least because of his war experience in India where he had endured a full dose of mutual contempt between architects and engineers; Peter Dunican was head of the drawing office.

Such trust and respect defined the collegial atmosphere and informal ambience Ove enjoyed: these attitudes may have derived, or at least been strengthened, by his public school education, although few of those he interviewed had themselves benefited from the same privileges. He himself also associated it with 'the feeling of "Brüderschaft"', which prevailed in the MARS group and which he found inspiring. His approach initially succeeded, no doubt, because he had worked with all the principals for some years; the optimism and occasional utopianism at the end of the war had created a social space for idiosyncratic practices, including practices with some business intent. If trust was the cement of teamwork, it also signalled commitment to certain attitudes, above all independent critical thinking, not mute endorsement. Ove always insisted that, even if an agreed formulation had been reached, there are always many ways of solving a problem. And the Partnership was not fuelled by a profit motive; all the staff knew well that financial reward was not the priority. Proclamation of such an attitude attracted idealists and mild eccentrics who would not fit within many establishments, and it helped foster the pursuit of excellence; but it also generated misunderstanding and hardship, especially since Ove himself was manifestly unaffected by financial self-denial, and could be alarmingly insensitive to the modest lives his staff were forced to live. But if his private means protected him from some of the disagreeable consequences of running a business, his own temperament disinclined him to run an office. In the words, suitably bowdlerised, of one of his earliest colleagues: 'He couldn't run a mother's tea-party' – since his student days he had sought to charm women into bailing him out.

Within a couple of years his Partners were both frustrated by these developments, and concerned that barely any money came in their direction. When asked what was causing the palpable malaise, Geoffrey Wood bluntly told Ove that they 'did not trust him any more', and felt like pawns serving his personal gain. In ways that were more British than the British, Ove sometimes refused to face up to delicate personal questions: or financial problems. He was offended at the meeting summoned by the Partners, but Jenkins resented the way in which their criticisms were dismissed. Having announced that he was 'going to be very blunt', Ove sharply observed that 'you do not like to be reminded that you are only junior partners or even employees'. He

objected: 'I do not like the part given to me'; he wanted 'to be a consulting engineer' himself, 'to deal also with technical problems'. He saw his leadership of the drawing office, over the past twenty years, as 'somewhat on the lines of a conductor'. And whereas he had earlier worked on technical problems with Jenkins, he now 'hardly dare make any suggestions of a technical nature to the partners – and if I do, they are quite likely to be turned down without being given a trial'. He added: 'Unfortunately, I am also debarred from collaborating with Hobbs or any of our other bright lads because I have no jobs to design myself. And all engineers are busily engaged on jobs allocated to other partners.'[1] Tempers cooled: until the next time.

The first African offices were opened in Ibadan, Nigeria, at the end of September 1951, and in Salisbury, Rhodesia (now Zimbabwe), six months later. Clearly other overseas offices were likely: but the unplanned expansion inevitably generated some problems and misunderstandings. Colleagues soon learned that Ove loved having money but displayed a deep, possibly Lutheran, disapproval of spending it. He often showed no sympathy for, or understanding of, others who wanted it, and whenever tackled on the matter standardly declared: 'I don't see why people want all this money. You only need two meals a day.' As he receded in his Alvis or Daimler to dine at the Ritz, or dress for Glyndebourne, only disbelief held in check dramatic reactions to such remarks.

Close friends, and colleagues such as Ruth Winawer and Peter Dunican, confronted him on these peccadilloes, and they had some effect, although he would often retort that it was with his capital of £10,000 that the firm had started – money recovered from the dissolved partnership with his cousin. Ruth Winawer pointed out to him that the women in the office did not receive equal treatment, although she well knew what the prevailing British views were in the 1950s and 1960s. Why, after all, would a working woman want, or even merit equal pay with a man? An official at the Ministry of Housing informed Jane Drew in the mid-1950s: 'Miss Drew, you don't realise that women's labour in the home is free and doesn't contribute to the income of the world.'[2] At that date, the majority of middle- and upper-class women in Britain were expected to stay at home and run the household – for their husbands, children or for their aged parents; men's wages were typically double those of women, because they were supposed to cater for dependants. Single incomes supported most families, and the miniscule number of university-educated women (0.1 per cent of British eighteen-year-olds in 1953) rarely found employment that matched their abilities. Indigent gentlewomen were regrettable, and warranted symbolic inclusion in perhaps one or two minor

social occasions; but many men held that any woman forced to earn a living had ceased to be 'proper' and must have brought disgrace upon her own head. The building industry in general, and the engineering profession in particular, were almost exclusively male preserves: spouses were merely spouses, and although some of the Partners' wives shared a social life, Ove was not uniformly complimentary about the choices of his colleagues.

Ove personally interviewed and selected all the staff in the early years of the firm, often to their consternation. Jim Morrish, later a divisional director, was interviewed in December 1946, and Ove did all the talking. At the end, Ove declared: 'There is nowhere for you to sit, so I cannot take you on.' Three weeks later he rang back to say that there was now room, and he offered £1 a week. This was less than Morrish was currently earning from paper rounds, but he was told to enrol as an 'indentured student' at the Brixton School of Building. Within a few weeks Peter Dunican informed Ove: 'There's this cocky young sod called Morrish who comes up to the job – you'd better take him.' He started at £1 5s. three weeks later. Later still, when he and Daphne Brewer announced that they intended to get married, Peter Dunican, for whom she was then working, insisted they go immediately to the Registry Office: married couples in the same office were practically unheard of in the UK, least of all in the conservative engineering world.[3]

Five years later, Derek Sugden was greeted by: 'You're a friend of Bob Hobbs.' 'His name is Ronald Hobbs.' 'We've already got a Ronald, so he is Bob.' 'Why don't you call him Jack Hobbs.' 'Who is he?'

Things did not improve. 'What shall I ask you?' 'Am I a qualified engineer?' 'Are you?' 'Yes.' 'What shall I ask you next?' 'You can ask me what I've done.' 'What have you done? Well you have a nice face. How much do you want?' 'Seven hundred and fifty pounds.' 'That's an awful lot of money.' Derek Sugden began in June 1953 on £720.[4] Geoffrey Wood, who had worked with Ove in Christiani & Nielsen since 1932, thought that Ove's holistic approach was arguably more like that of a woman, in contrast to the severely sequential thinking of most men. He agreed with Ove's own view that interviews and appointment by the boss helped attract people who, for all their eccentricities, would work as a family.

In the early years of the firm Ove had no intention of being *primus inter pares*: there were no '*pares*'. But by September 1951 Peter Dunican, who had joined Ove and his cousin Arne as an engineer in 1943, was once more pressing Ove hard to confront escalating managerial problems.[5]

Dunican was the stepson of a policeman in South London, and had made his way via Battersea Polytechnic under conditions of considerable hardship:

he may not be the last non-graduate to become Chairman of Arup's, but was almost certainly the last non-graduate to be President of the Institution of Structural Engineers. A man of unquestioned integrity, he was one of the few colleagues, along with Jack Zunz and Povl Ahm, who spoke without fear or favour to Ove, and he was respected for it. As usual, Ove omitted to acknowledge this, but a few weeks before he died made some amends in his seventieth-birthday tribute to Dunican. Ahm, Ove's younger Sorø colleague, who became Chairman of Ove Arup & Partners in 1984, insisted that 'without Peter Dunican there probably would have been no Arup's' as it is today. Dunican was passionately concerned about social issues, and was a member of both the Labour Party and the Fabian Society. He became a Partner in 1956, and succeeded Ove as Chairman of the Partnership in 1977; but for years he had *de facto* been running the office. In a long handwritten note he suggested that 'except for financial and capital control all the Partners should have equal voice in the affairs of the firm'. While profit division might be adjusted, 'the establishment of a reserve fund out of profits is imperative'.

Dunican's second imperative was that Ove 'should be relieved of all routine matters to enable you to perform your proper function of leading the team. To enable this to happen one of the Partners must be delegated the responsibility and authority for running the office.' Jenkins should be assigned the responsibilities of 'Chief Engineer', but there was another issue: 'job credits'. Dunican observed:

> I should have thought it was clearly understood all jobs were carried out by the firm collectively. Except in very special cases no mention should be made of the partner in charge. After all no job is the personal property of any one of the partners. [. . .] The firm should have a motto 'not mine, not thine, but ours'.

All of the Partners were socialists of one kind or another, and while this ensured heated disagreement on some things, their shared sympathy for collective responsibility meshed well with existing engineering traditions and practice. Above all, it also reflected Ove's philosophical views about ideas and their implementation, while explicitly contrasting their self-image with that of architects. Ove held that ideas cannot be owned by anyone: they are not possessions or heritable property, even though human frailty often deceives men into claiming proprietorial rights over them. He also knew, of course, that along with emphasis on individualism in Western history, artists in particular had come to claim uniqueness for their ideas – a view to which he himself occasionally succumbed.

Dunican thought it reasonable to 'consider the business from the financial angle as your personal property': the operating profits, however, albeit dependent on Ove's capital, should not accrue only to him, because they were a product of the Partnership. 'The logical development of your firm should have been (1) Ove Arup, (2) Arup and Jenkins, (3) Arup, Jenkins and Partners.'

Ove was at first reluctant to institute structural or managerial changes, but he rarely tried to reverse decisions once they had been taken; mistakes could be rectified, occasional staff let go, and nostalgia indulged for the days when, in his eyes, he owned the firm and had a hand in everything it did, but the rational decisions of the team defined the duties and their attendant responsibilities. Moreover, Ove's own views did evolve in the light of experience, and the manifesto he proclaimed twenty years later embodied a number of modified ideas. In 1957 he told a colleague that 'I'm really an anarchist at heart – not on the theoretical side', and asked his listener whether he had read Kropotkin. Ove was familiar with the works of this Russian aristocrat in two areas, geographical exploration, and 'anarchist-communism' based on Thomas More's *Utopia:* after his death in 1921 there appeared his posthumous *Etika* (Ethics) in which he tried to present ethics as a science. Ove had to grapple with the perennial conflict between freedom and authority, alongside the desirable growth of the firm which would exclude him from personal involvement. There were arguably more intractable issues, of a philosophical nature, which he had not expected to re-emerge in his own firm, ranging from ethics to educational reform. The almost anarchic management in the early days certainly contributed to what became the Arup firm's distinctive approach, but a necessary ingredient of that approach was inadequately addressed: the scale of enterprise and activity within which it would best work, and outside which it would not. Ove did perceive the problem, but did not know what to do; and for years he tried to duck the issue.

Only with very few people, working on roughly the same wavelength, however eccentric each might be, could a collegial approach be maintained: large colleges and large universities have faced exactly the same problems. Ove could not function, even when he tried to behave, as a *pater familias* over what was no longer a family. The hugely successful global enterprise today, with over seven thousand employees in fifty or so countries, has necessarily lost some of the ingredients that ensured its success, while it has acquired others. The question is whether there are appropriate directions or additions for the original elements in entirely new contexts. The holism that Ove championed made considerable sense for large-scale jobs and housing schemes, but was hardly tenable for the small-scale demands of a single domestic house.

He himself did not seek to describe the various ways in which the legitimate contributions of specialist knowledge can be absorbed within an approach of mutual understanding and co-operation. His ever-larger firm in fact set up specialist units under the corporate umbrella: in American terminology, the small liberal-arts college became the giant graduate university. The paradox is that Ove's goal of bringing disciplines together was achieved by establishing a single catch-all practice, outside which architects and engineers remain as separate from each other as they were when he started his campaigns, eighty years ago. On a dramatic scale he achieved many, if not all, of his goals: and yet few have sought to replicate his agenda – those who have, have usually been former members of the firm who were inspired to carry the traditions forward themselves.

Just before Christmas 1950 Ove held discussions with an Indian colleague from Christiani & Nielsen days about who might be an appropriate architect for a new capital of the Punjab: after considering Lubetkin, Fry, Denys Lasdun and some others, they had settled on Le Corbusier, who would make twice yearly visits from Paris to India.[6] It seemed that he would choose Fry Drew as his British Partners: he did, and Nehru duly appointed Le Corbusier, his cousin Pierre Jeanneret and Fry Drew. Jane became intimate with both Nehru and Le Corbusier, although her remarks about the architect thirty years later were acid, as they tended to be of numerous previous liaisons.

Max sent a series of letters from India to Ove. Soon after arrival he wrote:

We are in the throes of it now. Corbusier and Jeanneret are here. We are in the third day of analysing our problem, and from first principles, as though another man had never done a plan.

It is remarkable to see Corb at work – admirable. His concentration flows like a force but it takes the facts, the elements of the problem, as though they were friends. He introduces them to each other, they mingle and talk, and the answer begins to emerge.

Nothing appears to be forced, but in the assembling of the helpful facts selection and reflection takes place. The child will be the fruit of good parents.

I feel that I am put to school again. You know that I don't think very clearly and rely upon intuition. But I now see how little clearly I think and how much better intuition can be with the help of some logic and a disciplined approach.

Our days have been spent between a large table strewn with plants and expeditions to the site, which is very beautiful [*he enclosed a sketch*] imperceptibly sloping towards low hills, tawny and lavish with a background of the Himalayas. On the plain there is an agriculture of completely ancient

type, done by men and cattle with wooden ploughs. The villages are of mud mainly but full of beauty and the people are handsome and independent. The agriculture is dying as old agricultures all over the world are dying. But today it is complete and completely self-sufficing.

All round are green fields of new wheat and the remains of the sugar crop standing like golden monuments above the green. At intervals are groves of dark green mango trees more prominent than the low villages. The general impression at this season resembles a stretch of English parkland, grave, sombre, but vivid also. [. . .]

Jane and I have not yet actually exchanged letters.[7]

Six months later he reported:

My life is not so much lonely as single and concentrated. [. . .] But at the end of the day there is the hotel bedroom and the single sleep.

Jeanneret and I sit talking in French and drinking in Scottish and I like the conversations well enough and I read a lot – very mixed reading, now a Tolstoy, next a Conrad, or Bertrand Russell, followed by Sartre, and Anthony Trollope standing up to either. [. . .]

I suppose I am no mystic but I can't really believe in the Eastern idea of absolute personal salvation, communion with the infinite etc. It is I suppose the end of all philosophy – the search conducted finally through the only channels possible which are in the individual. And yet each individual is his mother incarnate. Individuals for the purpose of philosophy are always men, aren't they?

Here there is a terrible disregard of the miseries of poor people and there must be where poor people are so plentiful. The typical mystic is also poor.

What Indian mysticism gives is a proper mistrust of western mechanisation, but the static state it encourages or prolongs passes by many a chance of bettering the life of both rich and poor. Art is stagnant which is to say that life is also. And where life is thus, there is ugliness – corruption, simony, nepotism and petty and continuous tyranny. Women are depressed and rule tyrannously, and fear is everywhere.

But there is also much beauty. Poverty is accepted and long custom and usage has decorated the life of the poor with some few but simple and beautiful utensils, and habits of living – so much of it in the open – that seem to have nothing of hardship, of ignoble dirt, or degradation. [. . .]

Corbu is producing some very grand stuff – too grand perhaps for their pockets, but full of fine imagination. [. . .]

P.S. What a wonderful rascal Cellini was. I loved that book.[8]

Jane had not been free to go to India at the beginning of the year, but was able to do so nine months later. Just forty years of age, she wrote a long letter to Ove while flying out. Was her choice of novels as pointed as it sounds?

I've been reading Madame Bovary and now Anna Karenina. I like Russians. Their standards are passionate and lively all the filing cabinet attitude of committee life falls away. I am now feeling I want to live in a big house old house in Simla with a large garden. Max says many such are available. [. . .]

Max and I are finding a way together it is always like that when we have been apart. How difficult human relations are. You were very dear to me those last days in England – much of my life felt such an act with you I could be more genuine. [. . .]

I like to think of that last visit to your office and the big rather blown up woman's head in fact the whole of that picture and you and your nice Ben Nicholson coloured toy from the business efficiency exhibition beside your desk.[9]

Short messages from Max and *billets-doux* from Jane arrived with monthly regularity, but eight months later still, Max sent reflections from Chandigarh:

We have been considering what we are here for. [. . . There is] not a thing either useful or ornamental that is not of proportions satisfying and inherently beautiful. [. . .]

The village people are intensely attached to their house which indeed is but an extension in mud and thatch of their lives. It is tragedy enough that we will destroy what is dear to them, but our tragedy is to realise how little we can put in its place that has anything of the beauty of what we destroy. These people are poor but they are surrounded by the essentials of life to which they have given a setting of beauty. The poor of our city are to be given two small rooms, a verandah and a w.c. and this with a great effort. To make them economic they will be built in rows and they will be sanitary, but they cannot be beautiful in the high sense in which these village houses are beautiful and we are stricken with grief to think that we may be doing a bad thing, taking away the narrow lane, the close courtyard, the unventilated rooms and with these taking away what may be most desired and most desirable. We lack time. What we are trying to do in months can only be achieved in years and years and years by people living by degrees in the pattern they find from among the facts of life that press onto them. We, pretending to be gods, claim to know what these facts are and to be able to respond to them, but in fact we feel clumsy in face of what we see to have become beautiful only in the long course of patient assimilation

from which the responses come nearly unconsciously, as instinctively as the responses of animals. [. . .]

[Women and men] partake of the same gentle beauty as of the animals. They are in our sense of the word utterly ignorant and this ignorance takes them to the heart of many matters hidden from our sophistication. With their high gentle manners, defenceless and entirely one-way, they accuse us of all the superficiality with which we pursue our avocations and demand that we should be pure. Our purity, when we have it, is vouched for by Mozart and Turgenev and some others, but we may sin greatly by the way, and have these villagers for silent witnesses. It is a heavy load and we don't rightly know what to do.

I doubt whether we know what to do in Europe where we deal with the known facts of industrialised building which we may be thought to have mentally assimilated. Never do we build homes for those we intend to. They always cost too much and are occupied by the class above, but we continue to chase the will o' the whisp [sic] of industrialism though it is inherently against the best spirit of man.[10]

Several weeks later, Jane herself wrote:

I have been sitting drinking brandy . . . Why do I hate the whole idea of marriage laws of this convenient life? [. . .] I know Corb enough to know how important he is; but he may fail because here he is unsatisfied in the wrong way – like T. S. Eliot he has a bitter streak though less than he – he has chosen that 'last infirmity of noble minds' and his way of life is urban classical, but the way to death. For Dictatorships have one ending, fixed relationships, but enhance in the end the value of anarchist art.

I still think with pleasure of the brief time we had in Arabia and remember the wonderful quiet of the sands and the little henna legged donkeys.

Soon, soon, we shall meet. Take me for a walk and talk for a year, two years. Max and I have lived like clinging vines on each other no other mental vitality or life.[11]

Not all had been calm in London either. During the autumn of 1951, while Dunican was on holiday, the government dramatically cut funding for public buildings. Ove panicked and summoned the staff, inviting them to look for other jobs: he did not sack anyone, although his diary records that he told six of them 'that they must go'.[12] Several did nothing and simply stayed, hoping to be paid when a cash flow resumed. Two days later he found his Alvis stuck in the flowerbed at home, after a failed attempt to steal it: he dragged it out with the Daimler.[13] When Dunican returned he reinstated all who had not

found alternative employment and gave Ove a piece of his mind. Within a few months Ove was feeling more confident, and bought a putative Corot from the Arcade Gallery Ltd for £350, and soon afterwards three more French paintings.

Although he had published his views for almost twenty years, Ove found it important to tell potential clients and their architects how his firm differed from others. Thus, he told Geoffrey Jellicoe, for whom he had lectured at the Architectural Association before the war:

> I think we differ from most other consulting engineers in that we are extremely interested in the contractor's point of view – we do not want to dictate a solution to the contractor, we want to work with him to help him to find a solution which is best for him as well as being architecturally satisfying.[14]

'Touting for business' at the time was, of course, 'thoroughly un-British', and against the rules of the Association of Consulting Engineers. Ove adopted a strategy by no means unfamiliar to his colleagues: he tried to be the first to congratulate prizewinning designers of prestigious buildings. On 13 August 1951 Ove and Li set off on holiday for Portmeirion – where 'Jane came over several times'. His cheerful secretary wrote with news a couple of days later, and commented: 'Rather nice for you that so many of the people you know are in the same area. Now how was that managed? And the proximity of Jane is, I think, from the point of view of Ove getting away from things a BAD THING.' She then added a postscript:

> Red hot from the Dunican news service (you want good news, we don't have it) comes this latest, greatest, shakiest piece of inside information, hot from the tape but two minutes ago and delivered to your correspondent direct by Mr Dunican IN PERSON.
> Winners of the Coventry Cathedral Competition
> 1. Basil Spence, of Edinburgh
> 2. somebody Hunt of Cambridge.
> . . . Suppose we shan't be building it?[15]

Ove did not need a prod. He immediately wrote to congratulate Spence on winning the competition – although he had in fact assisted the Smithsons and thought their design rather good.[16] But Spence was away on holiday. As soon as he returned in October, he invited Ove for lunch 'to discuss a proposition', and asked him to be consultant to the project: two days later 'competition' drawings were despatched to Ove's office.[17] Ove tried the same tactic on Eero Saarinen, when he won the competition for the US

Embassy in Grosvenor Square, with less success: but Ove's biggest success was yet to come, and indirectly involved Saarinen.[18] His British colleagues could never decide the extent to which Ove knew he was contravening current practices.[19]

In spite of his protestations to the contrary, Ove never abandoned his more formal philosophical interests:. In the spring of 1952 he played host to, and attended the lectures in London on Kierkegaard by Professor Jørgen Jørgensen, with whom he had kept in touch over the years. Ove's family had also kept him informed of Jørgensen's successes, including translations of his books. The London audience included A. J. Ayer, C. E. M. Joad and Haldane, as well as the Danish Ambassador.

In the New Year's Honours list for 1953, Ove was awarded the CBE, and after the investiture in March he took his family to lunch at the Ritz. As the firm became established and better known, old acquaintances sought to be associated with it. Shortly after Ove's investiture, Olaf Kier wondered why they had not been asked to tender after the Lubetkin jobs in Finsbury, to which Ove responded that their jobs so far had 'all involved builders' work as well as civil engineering, and I realise that your firm is not really equipped to tackle this kind of work.'[20] In fact, a year later they did co-operate on the TUC Headquarters Building in Great Russell Street.

Of greater interest to the family, however, was the purchase in March of a large house in Highgate, at 9 The Grove, in the back garden of which Ove planned to build his own house. He had been alerted to the property by Cyril Mardall, who lived a few yards away, and the plan was to sell on the house, while retaining the garden himself. At the same time he was discussing the possibility of working with Goldfinger on flats in Hampstead, but boys' toys threatened to get in the way: 'went to Czardas for lunch in his new Rover, which inspired me to have one myself.' That spring was especially hectic, because Jens was getting married, and Ove duly spent time selecting appropriate silver for the occasion: he recorded a sumptuous family lunch 'back at the house'. Henning and Ingeborg came over for the celebrations in June, and stayed on to join Ove and Li at Aldeburgh, where they heard Britten and Pears. In July there was a work and holiday visit to France, a visit that was even more chaotic than usual. Ove's diary is at times indistinguishable from a script for Jacques Tati: tree fell on garage, hotels overbooked, missed plane, car broke down, gave lecture – rather dim lot – had to cancel Furtwängler concert. And when Anja and Keld returned after more than a year travelling on the continent, he recorded: 'when we were at breakfast saw Anja's and Keld's tent in the garden.'[21]

Back in 1947 Ove had challenged Sigfried Giedion to reform the organisation of CIAM, of which he was Secretary General throughout its existence from 1928 to 1956. But Ove sadly reported that:

> He said he was not interested in defining modern architecture, but was only interested in what modern architecture should now do. It seems to me, however, that it is not so much a question of what should be done as how it should be done.[22]

However, in July 1951 Ove did attend the CIAM meetings held in Hertfordshire and London. The theme was 'The CORE as an expression of life', translated into French as 'le coeur'. The organising committee consisted of Gropius, Van Eesteren, Ernesto Rogers, Giedion, Chermayeff and Jaqueline Tyrwhitt,[23] and Ove intended to hear the papers by Gropius and Le Corbusier, both of whom he entertained – but he missed Le Corbusier because his car broke down. However, he met everyone at dinner at Jane's, where 'there was a deep psychological discussion centred on me!'[24] He greatly enjoyed discussion of the 'core'. Giedion invited him to Switzerland; Gropius spoke very well; and life was good, except that Li remained in poor health for most of the summer.

The final report of the meeting reflected many of his own ideas: beginning with the premise that 'architectural schools are mostly inadequate'. The authors claim that 'ideally the Architect, the Engineer and the Builder should be the same person', and that 'teaching of method is more vital than imparting information':

> Contemporary building is rapidly changing in character and in cost from one which is predominantly structural, with emphasis on space enclosure to one in which mechanical equipment and services become governing factors, and emphasis shifts to control of environment.
>
> [. . .] the prevailing atmosphere of 'learning' should be replaced with that of enquiry and experiment which characterise the most influential disciplines of our day.[25]

The authors tried to define their notion of 'core':

> The 'core' is a place where people may gather together for leisurely intercourse and contemplation, whether this be in a small community open space or in the largest city centre.
>
> The core is an artefact: a man made essential element of city planning.[26]

A circular to the delegates stated:

An essential feature of any true organism is the physical heart or nucleus, what we have here called the CORE.

For a community of people is an organism, a self-conscious organism. Not only are the members dependent on one another but each of them knows he is so dependent. This awareness or sense of community, is expressed with varying degrees of intensity at different scale-levels. [. . .] At each level the creation of a special physical environment is called for, both as a setting for the expression of this sense of community and as an actual expression of it.[27]

The authors here acknowledged, and even more explicitly two years later, that their views were rooted in philosophy and sociology:[28] but they became aware that their approach did not appeal to their intended audience. Perhaps they should focus more on the questions that absorbed architects and which they were more competent to tackle? Ove entirely agreed with such practical focus, although he accepted the implication that few architects and even fewer engineers reflected philosophically at all. He also openly confessed that the CIAM conferences in Paris, Aix and elsewhere 'provided a unique opportunity to meet interesting people from all over the world in beautiful surroundings'.[29]

Max and Jane continued to send commentaries from India; the one sadly reflective, the other frequently hyperbolic. In February 1953 Max had been drinking aimlessly into the night at the residence of a rich young man:

The philosopher asks me to deny the self, to struggle free of the self towards the apprehension of godhead; but the study of myself, the listening to me, is a constant necessity and second nature to an artist; and furthermore, unless I had an audience capable of understanding me my quality as an artist will diminish or turn into madness. Therefore if art has value self is important.[30]

And a few months later:

Corb doesn't [. . .] care about economy. His High Court building is wildly expensive. He worked out his details for an R.C. building of generous sectional dimensions which the engineers here adhered to exactly and filled tight with reinforcing rods. Nobody will know what is inside the concrete and perhaps it doesn't matter, considering the distant future, but it turns my puritan soul inside out and I suspect that plasticity in design may border on theatricality and theatricality as you know borders on immorality and – The High Court will be a very grand building I think, extremely noble, but unrepeatable. This is Corb the pure artist.[31]

Six months later Jane again confessed:

> Do you know that you have been the pin up boy on my dressing table for
> the past many months?
>
> Max and Corb are asleep lying like Roman Senators with their hands
> gripping their shoulders . . .
>
> Dear Ove that one could fly and send messages from soul to soul other
> than by the little way of black marks on paper.
>
> If only I could compose you a piece of music or an ode . . . I want to be
> crystal and look I am mud . . .
>
> Mind you take me out when I return to some of your flesh pot restau-
> rants to lap a bit of London life. I can't live in this rarified strata for ever
> – Oh for a Paris café a bottle of wine and a friend.[32]

Ove complained to his new architectural assistant Philip Dowson: 'I do wish
she didn't sometimes talk to me as if she were my mistress.'

In the autumn of 1952 Ruth Winawer was doing temporary work, after
seven years at the BBC in the Features Department, where she had been Pro-
duction Secretary to Louis MacNeice. On 6 September she replied to an adver-
tisement in *The Times* for a Private Secretary to a Consulting Engineer. The
usual duties were supplemented by a requirement to 'generally keep employer
up to scratch'. Ove sent all the applications to a handwriting analyst. Ruth
stated that she had been a Senior Secretary at the BBC and needed to earn
not less that £10 9d. per week. Ove made a brief diary entry for 17 Septem-
ber 1952: 'interviewed Mrs Winawer: very cultured and rather left wing intel-
lectual: I fear that the job is a little too mundane for her.' Ove did what he
always did: he made a short list of five candidates, took each of them to lunch
at the Arts Club, and did all the talking, in the most charming and attractive
manner – although never about himself. No candidate had the remotest
chance of answering any of the questions that were occasionally thrown out.
He rang Ruth to say that he could not offer the job because another girl had
assumed she had got it, and he had not the heart to tell her she was mistaken.
Ruth was furious. Two months later he rang again to say the first girl was no
good, and asked Ruth for advice – which she declined to give: a week later
the girl had decided to join her boyfriend in Wales, and Ruth accepted an
offer. Ove was some fifteen years older than Ruth. Approaching sixty, he
'seemed quite old' to her, partly because his manner contrasted with the BBC
informalities to which she had been accustomed: the engineering profession
harboured few mellifluous poets or multi-lingual actors such as Dylan Thomas
or Peter Ustinov. She recalled her first day:

Ove Arup arrived looking harassed and carrying a patent lemon-squeezer, slightly bent. When in my rash and rather touching eagerness to show myself as an efficient secretary I looked helpful, he off-loaded the lemon-squeezer into my hands, and asked whether I couldn't take it back to Heal's and say it was no good. Heal's naturally observed the bend, but 'as it was for Mr Arup' they reluctantly agreed to take it back. The pattern was set. From then onwards I was to have ample opportunity to observe members of the general public doing what they didn't want to do 'as it was for Mr Arup'.[33]

On all professional matters everyone accepted that an always overworked Peter Dunican ran the office; but from the outset, Ruth became invaluable as an additional conduit for the views of Dunican and a small group of other staff. She soon discovered that Ove needed constant reminders: 'You will remember, won't you [. . .] to check with the air companies the times of the planes.'[34] She liked commenting on accents. A Swedish visitor had just been summoned home because his firm had 'just got two big new "yobs" (as he will call them, in opposition to all advice)'; and she had already discerned what Ove wanted to hear: a new girl had been appointed to the office, 'well-educated, nearly 22, quiet and self-possessed and not at all pushing. [. . .] As to looks, she will add to, rather than detract from, the already high standard of the beauty chorus.'[35]

But if Ruth was an inevitable sounding board for staff opinion, she was also the eyes and ears of Ove in the office. On his long overseas trips she wrote to him up to three times a week, with business news, office gossip and occasional social comment: she very soon took the opportunity to spell out what was often said, but what was too easily ignored in the hubbub and bustle of office life.

Their young manager in Lagos, for example, had written frequently about the trials of setting up an office, and Ruth emphasised that 'the general wear and tear in that climate without a proper office behind him must be a great strain'[36] – Ove had never lived in the tropics, and was resolutely resistant to looking after himself. After reporting that the firm's overdraft stood at £300, Ruth tactfully warned him about an over-hasty proposal to appoint someone. And the office rites amused her: 'I gather that the Christmas card each year is a personal thing, and is sent with your signature alone.' Dunican

engaged a new chap, after having exercised great diplomacy to get him to shave off a beard – fortunately he knew a friend of the chap's. He seems to have a thing about beards – all he can say is 'Well, engineers *don't* have beards, that's all there is to it'. He seems to think it is the prerogative of architects.[37]

Ruth had already discovered Ove's opinion.

Only after Ruth became his secretary did anyone cast a critical eye over his writing, and only then did he come to appreciate such judgments – some of the time. She arranged most of Ove's overseas trips – he hated both 'gilded palaces' and primitive provision – and she also dealt with some domestic matters. The family lawyer advised against renting out their garage in Highgate to a local couple, and this prompted the comment: 'I didn't much fancy the sound of them on the telephone – the wife was terribly Kensingtonian and would-be upstage. (I hope my slang is not too esoteric for you – Marjan [her husband] always cross-examines me as to the exact meaning of such phrases).'[38] Ove understandably prided himself on his English – it was his third language – but he sometimes succumbed to pedantry, and Ruth (an Oxford graduate in English literature) enjoyed teasing him about some of the subtleties he missed. He may well not have seen the implications of her remark about the drawing office staff: 'the comic characters have put on their door an enormous notice which reads: "Under New Management . . . Frying Tonight" ' – during the war, this laconic notice on fish-and-chip shops was associated with bankruptcy, absence on war service or death. In the autumn of 1954 'new jobs seem to be rolling in', including 'something for a Colour Television firm . . . I must say that I am allergic to anything concerned with Television. I fear the worst.'[39] Ruth had been closely involved with the best BBC radio programmes and with writers of distinction; the opportunities in television for such people seemed to them to be limited. The first sight of television for many in Britain did not occur until the coronation of Elizabeth II in June 1953, which the Arups watched from the luxury of Costain's Head Office in Regent Street: all-day television was a decade away, and colour transmission even further.

In October 1954 Ruth reported that an LCC development licence, but not a building licence, had been secured for the new Arup house in Highgate; Erhard Lorenz continued to work on the drawings, although the old house had not been sold. Ove had two reasons for asking Erhard Lorenz to design a house for them in Highgate. The first was that Lorenz was Danish, and Ove might thereby avoid tiresome rivalries between British architects with whom he had himself worked and who might have expected a commission; moreover, he much liked his work in Dublin. The second reason was unknown to everyone outside the family: he was Else's brother.

In 1954 Arup's had opened offices in Lagos, Lusaka, Johannesburg and Bulawayo, and in 1955 opened an office in Kano. Ove hugely enjoyed travelling round to these new places, being fêted and, in particular, joining in family events of his young staff. His fun and informality, and especially his delight

in children, endeared him greatly to everybody, although he never detected or grasped the problems his staff faced of cultural and climatic dislocation. As a result he was amazingly tactless, but so triumphantly that most people forgave him, even if they did not forget. He would comment on confined living spaces or limited facilities or unusual social practices, and encourage staff that things would be better for them when they earned more money – staff who were putting their best foot forward for the boss's visit. An employee from Jane's and Max's office in Accra wrote, in 1950: 'you were a most welcome breath of sincerity in the midst of all the confusion of thought and hypocrisy which we have to put up with out here.'[40]

From 1954 onwards Ove's publications increased rapidly. Several addressed the evolving relationship between engineers and architects. When the design is of 'an "architectural" structure', 'a kind of dual control' occurs, because 'the right structural solution is only part of a wider problem', since the architect has the last word on 'the effect on the architecture'. Of course, architectural guidance varies 'in intensity, quality and kind', but more puzzling for an engineer is 'the fact that there are a number of incompatible "ideologies" – or bits of them – floating about amongst architects.'[41] Ove was searching for 'a criterion by which to judge the "goodness", "rightness", "excellence", or "merit" of an architectural structure', and he often began by 'trotting out', as he put it, Wotton's 'time-honoured conditions for well building: *Commodity, Firmness*, and *Delight*'.[42] By distinguishing between the architect and the artificer, Wotton openly challenged Vitruvius's insistence on uniting the two aspects of architecture, and he thereby accelerated the separation of engineering and architecture.

In this lecture, 'Structural honesty', given in February 1954 in Dublin and the following month in London, Ove argued that 'firmness' covered both structural stability and durability, and that these were merely the conditions of the other two notions, commodity and delight. Moreover, while cost and artistic value are strictly independent, the notion 'economy of means' itself involved both aesthetic and financial matters. 'Architecture is not only Art' – contrary to what many prominent architects and their supporters proclaimed: 'To me, the skill of an Architect, and the excellence of an architectural solution is measured by the ratio between what is obtained, and what is expended.' Rather oddly, Ove then expressed these ideas in a formula, echoing early eighteenth-century attempts to calculate values:

$$\text{Excellence} = \frac{\text{Basic Commodity} \times \text{Excess Commodities} \times \text{Delight}}{\text{Cost}}$$

He conceded the virtual impossibility of putting a monetary value on either Excess Commodity or Delight, but emphasised two points: first, to judge merit it is essential to know something about the Architect's 'brief'; second, every building should fulfil its primary functions.

For Ove, the structure of a building – that which holds the whole thing together – is only a means to an end. 'Good building is still practical building. [...] If the Architect cannot himself use a slide rule, and if he cannot make a quantitative cost analysis of alternative planning solutions, he is in danger of losing touch with the foundation of practical facts, on which alone his Art can flourish.' Architectural merit is unattainable without practical knowledge. Of course, 'if we look at a building purely from an aesthetic point of view, as a piece of sculpture or a series of delightful views, then it is most unlikely that our aesthetic requirements will coincide with the most economical solution.'[43]

For thirty years already Ove had endured the ignorance of engineers and architects in Britain about anything philosophical. He had to embark on an educational mission to alert his audiences to the criteria of merit, and the nature of value judgments. He cautioned that 'Architecture may have to be judged differently from other visual Arts', since Architectural Delight is not the same as either pictorial or sculptural Delight. Ove set out some important differences:

> For one thing you can move into it, you are affected psychologically – and very strongly, I should say – by proportions of spatial enclosures and sequences, perhaps by instinctive sensations of weight or uplift, by effects of light and shade and textures, by a sense of organisation and control of space.[44]

Such views were familiar to anyone who had looked at Alberti in the fifteenth, or Claude Perrault in the seventeenth or William Chambers in the eighteenth century: they were prominent in Geoffrey Scott's *The Architecture of Humanism*, to which Ove referred on several occasions. More recently, Steen Eiler Rasmussen, whom Ove knew well, had expounded similar ideas: he had been Jørn Utzon's professor in Copenhagen. Such views were not commonplaces to laymen, however, and they very rarely figured in discussions of engineering structures.[45]

Ove then asked a crucial question: who is qualified to judge or, more specifically, who is qualified to assess 'the feeling for structure *as structure*'? Ove accepted that, since prior experience and thought influence our perceptions, we may wrongly believe that we are responding to 'mere' appearances, when

our minds have in fact already processed our sensory data. Too many people – laymen and professionals alike – base their judgments on mere 'appearances, and may not know the difference between the supporting and the supported parts of a building'. There is a further point, however. The demand for 'structural honesty' in buildings is made only by 'a certain school of architects. It is a piece of ideology, an aftermath of functionalism.' Such claims failed to distinguish economical use of materials from economic means of production, and the terminology mirrored the 'pathetic fallacy' of poets in the nineteenth century – ascribing human traits to inanimate objects. 'Honesty cannot be found in structures', only in architects and engineers. Architects dishonestly disguise their aesthetic preferences behind alleged economic or structural necessities; they imply that since those dimensions are typically outside the architect's own personal and artistic control, he is exempt from what may be judged as failures. In brief, the engineer carries the can.

This had been a sore point among engineers for a long time, but it now became a central tenet in Ove's campaign to get architects and engineers to collaborate closely at the earliest possible stage. Historically this had not needed emphasis. In the past 'the Architect knew all there was to know about building', but the proliferation of new techniques and economic complexities had made it impossible for any individual or any single profession to grasp all the implications.[46]

In the 1950s Ove willingly agreed that aesthetic matters are important when architecture is considered as 'Art', but no one was left in doubt that such an approach was at best incomplete, and at worst, morally irresponsible. 'Morally irresponsible' because the architect, whether he likes it or not, is engaged in public moral acts, and he is deceiving the spectator by his claims: architecture can 'only thrive' when 'human values' are put first. In a lecture to the Architectural Association in 1954 Ove asserted that when Le Corbusier created his first modern buildings, 'it was not as a result of technical necessity. Technically, the buildings were probably not so very good, they were at any rate expensive and difficult to maintain in good condition.'[47] Of course new technical developments enhance aesthetic sensibility, and architecture can thrive only where there is a freedom of choice and human values are put first. But Ove was unequivocal: he did 'not believe there is such a thing' as structural honesty. In underlining what to him was the commonplace, albeit fundamental, distinction between motives, achievements and consequences, Ove assumed he would secure immediate agreement. He was profoundly mistaken: the pride and pretentious claims of architects were invulnerable to intellectual challenge, especially by a professional subordinate.

At the end of January 1955 Ove made his first visit to the USA, accompanied by Li and her mother. Some of his relatives and friends had been living there for thirty years, but unhampered by experience and forearmed by prejudice, Ove knew he would hate it. He was wrong: and graciously admitted it. He had never been embarrassed about admitting ignorance or mistakes. Indeed, he insisted on immediately accepting responsibility if he believed the firm to have been in error; this discomfited his colleagues – and bequeathed a legacy of integrity which came to be universally admired. He was to be a visiting lecturer at Harvard, but the financial arrangements were left remarkably vague. Ruth Winawer surmised that 'perhaps they think you are so eminent that you are not interested in money. They little know.'[48] Throughout his life Ove remained incredulous at how low academic salaries and lecture fees were in contrast to his own consultancy fees. However, when he visited Harvard he mutely accepted the university's own working assumption: that the kudos acquired vastly exceeded any pecuniary disadvantages.

Ove wrote a chronicle of his visit, in a series of letters to his family and the Partners, commenting on matters almost entirely absent from his other public writings. Ruth reported the delighted reaction of his colleagues, and conveyed office news in return, beginning with Geoffrey Wood's arrival at Fitzroy Street in his ancient Rolls.

In his first letter, dated 25 January aboard the *Ile de France*, he contrasted their roomy, mahogany-lined cabin with the appalling 'decoration of lounge and dining-saloon. Very gaudy, glaring neon lights, tubular steel, glass – frightful. I thought I would get very depressed by these surroundings – but strangely enough, although I don't like them, I seem to have got used to them.' When he ventured up to the boat-deck next afternoon he found, to his surprise, that 'it is nice up there, things are genuine and right and beautiful, in contrast to the architecture within.' The winter storm worsened, portholes were covered, everything was battened down and access to the deck barred: they stayed in bed most days, nibbling on apples if they failed to stagger to dinner. For days Ove suffered from headaches and dizziness, but worse was to follow: attempting to tie a shoelace he strained his back and suffered acutely, he assumed, from his old lumbago – only lying down alleviated the pain. He was very sad to miss the gala night. A junior in Fitzroy Street suggested that 'someone of Mr Arup's eminence shouldn't have to tie his own shoelaces' – and Ruth plaintively cried: 'I wish somebody would prop <u>me</u> up sometimes.'[49]

Resuming his commentary from his sister-in-law's house in New Jersey, Ove reported that Customs had confiscated some Danish salami, believing it to be a minor atom bomb; his cousin Leif had then driven him about the city, which

'really is an interesting place – rather different than I expected, in that light [early morning] the skyscrapers don't look too oppressive, it was rather friendly and spacious – of course relatively, which means compared with my ideas about the place.' He was shown the Guggenheim, the Museum of Modern Art, the top of the Empire State Building, the Rockefeller Center, the UN Building, the Lever Building 'and a very exciting new bank on 5th Avenue by Skidmore, Owing etc – the same that did the Lever building'. The highway up to Harvard was 'marvellous, double carriageway, and part of the way "Parkway" for private cars only'. Unfortunately, as soon as he got to Harvard his back pains again forced him to retire to bed. Food at the otherwise 'very English' Faculty Club was American, including 'oyster stew and sword fish (very good)'. He declared after a long walk in the moonlight over the snow-covered campus that 'it was really very beautiful', in spite of the intense cold. At the first meeting with the departmental chairman, and subsequently the students, Ove proposed a complete revision of the term's teaching plan: the chairman proved to be very sensible – 'in other words he agrees entirely with me!' Ove liked his students but was not sure that they were very bright.

Ove stayed alone in the Faculty Club over the first weekend and endured a still commonplace experience: there were no weekend facilities and no one to talk to – 'apparently as it is nobody's business to look after me nothing happens unless you make a fuss.' This prompted Ruth to reply: 'I always thought America was a barbarous country and now I know that as always I was right.' She advised buying a tea-making apparatus, but also this: 'if you are left like that again I should model myself, if I were you, on a small baby, and make a terrible, very loud FUSS.'[50]

At the end of the first week Ove was delighted by an Arts Symposium, not least because his 'heretical' views were 'well received by the floor'. The speakers were Chermayeff, the painter Ben Shan, Sweeney (Director of the Guggenheim – 'what he likes is what one should like to be in the swim') and Giedion, with Gropius prominent in the audience. Ruth artfully enquired, by return:

> Did you drop any frightful bricks? I'm sure you are by now aware of the attitude of mingled pride and alarm noticeable in your devoted staff when you rise to your feet to utter in public. I think it is like having a rather brilliant but unsubdued child, who from time to time seems to take a certain pleasure in setting the cat among the pigeons as the phrase goes.

Ruth added that the Danish Club annual chess championship had been won in his absence by someone else; on his behalf she had declined the offer of a

lower placing – 'If you can't be first, I was quite determined you shouldn't be second or third.'[51]

Ove fetched Li from New York, moved out of the Faculty Club and into an apartment of the Hotel Continental, in Garden Street, Cambridge. They much enjoyed the train journey up from New York to Boston, seated in the 'parlour' car, sipping orange juice at a dollar a glass. He observed that 'there are really three different kinds' of landscape:

> The urban scene, very disorderly, with factories and yards and cemeteries both for humans and for their cars, highways and 'turnpikes' . . . old ramshackle houses and bits of waste land full of paper and other rubbish, electric pylons enormous parking areas full of cars etc. Then there is the suburban landscape full of rather nice wooden houses without fences or gardens, but rather well sited in a landscape of shrubs and trees and outcrops of rock. The country itself is the same, undulating, mostly covered with small trees, very bleached and dry looking – there is nothing green, only yellow and grey. The air is very crisp and the light clear and sharp, no English mistiness and softness. The landscape must be very charming in the spring, and especially the 'fall'. We cross many frozen rivers, and pass quite a few lakes. The land is not used for anything productive – only as sites for houses, factories, etc. Apparently it doesn't pay. Here farming is an industry, it is the machines that do the work, and this hilly land is not suitable for machines and not very fertile either.

Li instructed Ove to buy galoshes to cope with the rain and slush, which he thought 'preposterous', prompting Ruth to retort:

> You seem to have a very strong feeling about galoshes. I think your public school must have been very British, because that abhorrence of galoshes is ingrained deeply in the majority of the British, but I thought that Continentals didn't have it, but had more sense. It is true Marjan has so far refused to wear them too, and he has been unable to provide any good reason for refusing to do so.[52]

Ove decided that Boston was 'very English, shopping streets like parts of Oxford Street, but great disorderly parts near the docks'; the new overhead through-way was 'a heavy and clumsy steel construction like most of the bridges and highways' – since demolished. He was very taken by the fish and fresh fruit. Even more interesting, however, was a lecture at which he learned that a three-point shell support for Saarinen's new Kresge Auditorium at MIT had cracked through deflection – 'possibly they don't know how to calculate the thing not having Ronald around.'

Ove frankly admitted that since Li arrived 'and we got installed in our little flat things have of course improved enormously. I am now being looked after, given wholesome meals, discouraged from smoking too much or going out without coat and getting wet.' As he never prepared for a visit to a new place by advance reading, he was constantly surprised by what he saw. They were taken 'to the something Gardner Museum – a fantastic Italian home or palace full of Art treasures – some very good – left by a rich woman and endowed with more money than they can use, so they spend it on gorgeous flowers and on concerts Sunday afternoons.' It is unclear why Ove remained so unprepared for travels he looked forward to, except that he lived intensely in the present. His childlike pleasure in discovering what others already knew never diminished. He planned to attend a 'stag' dinner in Washington 'where I shall incidentally meet President Eisenhower'. And he had begun to meet interesting people, including many old faces from CIAM gatherings: 'what with Giedion, Miss Tyrwhitt, Gropius and all such of Polish, Mexican, Austrian & Swiss professors – there is plenty of opportunity for good company, but it takes a long time to get going.'[53]

On the way to Washington he stopped off at Philadelphia, where he was taken immediately to a 'dusky' bar: ' "places" here seem to me either to be excessively lit with neon light – it can be quite unbearable – or, if they aim at an intimate atmosphere, you can't see what you are eating or who you are meeting!' After dinner and talk with the students, his public lecture, with over 120 slides – 'a record – for me, at any rate' – went on beyond 11.00 p.m. Back at Dean Perkins's beautiful house he was poured 'a lonely whisky which I didn't even finish', because Mrs Perkins had gone to bed. Ove was thrilled to find that the superb guestroom had 'an excellent selection of books': 'Edgar Allan Poe in an old edition, Colette, and others'. Next day he discovered that Mrs Perkins ran 'a really wonderful furniture shop . . . It is about the best shop I have seen anywhere – I was tempted to buy a lot.' The gathering in Washington was the 30th Annual White House Press Association Dinner: 'I spoke to the Vice President Nixon, and lots of others [. . .] the Chief Justice Warren, Duke Ellington, The Speaker etc.' As for the food and wine: 'The drink was Bourbon – no sherry. . . . Dinner somewhat crude, with only a little American Burgundy of unknown vintage and doubtful quality – I mean with the President there . . . one would have expected something more stylish – people drank Bourbon and beer.' Because of the din, he could not hear the speeches very well, nor grasp their apparently witty allusions, but

> the artists were terrific, absolutely top class in their respective spheres – the practically nude lady being thrown about by a gentleman in evening dress

rested with the greatest of ease on any part of his body supported only by a few of the gentleman's fingers, and with his legs arranged in the most unlikely places. [. . .] The President was rather sweet and made a nice little speech of thanks for everything – without great political significance. He did not mix with the crowd like the other politicians, so did not have the chance of meeting me.

The following day Ove was taken to 'the absolutely fantastic State Museum of Art – or whatever it is called. They have pinched – or rather bought – many of the best paintings, a glorious collection of French Impressionists for ex. I could hardly tear myself away.' The short visit away from Harvard ended with a day in New York, where he saw Mies van der Rohe and 'several things could be said about that'. But were not: at least on paper.

Ove's last report from the US is dated 25 March 1955, after a gathering at the Waldorf Astoria in New York, where the Danish Engineers had invited Ove to their 25th Jubilee. He found this event 'not up to French or Belgian standards in refinement', and 'disappointing as far as wines go': 'some sherry fore and aft and about one glass of claret in the middle – at least I only got one, in spite of protesting to the waiter, which the lady on my right insisted I should do.' His opportunity to observe other guests from the top table of 'honoratiores' was hampered by 'the obligation of keeping some conversation going with my two lady neighbours who made up in age what they lacked in charm.' Apart from his cousin Leif and his wife Edith, Ove met several old college mates 'who said they remembered me but had expected to see a mane of black hair'. Ove was especially pleased to meet Ambassador Henrik Kauffman, who had been Danish Minister in the USA during the war and who 'rallied all the "free Danes" in support of the allied cause and was an inspiration to them all'.[54]

These thoughts prompted Ove to reveal something of his feelings about Britain: 'It is strange how America manages to change everybody who settles here. You meet "foreigners" everywhere, Poles, Latvians, Italians, Scandinavians, Germans – they speak with an accent but they are accepted and behave as American Citizens.' Li and Mrs Hahn arrived back in Harvard and were a great social success: 'One thing which simply overwhelms the locals here is seeing my mother-in-law smoke cigars, they think it is marvellous and incredible.' The volume of invitations and dinners increased as their visit neared its end. Ove returned to New York for a medal ceremony celebrating the new Manufacturers' Trust Building on Fifth Avenue by Skidmore, Owings & Merrill [SOM] – 'a really exciting building of stainless steel and glass, with luminous ceilings and abstract sculpture'. 'The other exhibits were awful, I

thought. Frank Lloyd Wright evidently thought the same . . . he stalked out in disgust and disappeared.' A quick visit to Chicago, delayed by snow, resulted in a hasty check in at the Palmer House – 'you had to cue [*sic*] up for "checking in" and for the elevator and for "checking out" – all pretty inhuman. It took me nearly half an hour to get my suitcase.' After a reviving Italian dinner they all went to a very late party on the top floor of Mies's lakeside apartments: 'the most exciting thing I have seen. The walls all glass, and a view over Chicago by night, with fantastic square shapes looming up with glaring lights behind and between – it was wonderful and incredible view.'

In Chicago Ove continued his recent attacks on 'structural honesty' in his lectures at Harvard and the Illinois Institute of Technology. He enlarged on his belief that 'all things of quality require a certain effort to achieve', by suggesting that a 'part of beauty' is 'economy of means . . . for its own sake'. 'The aim of the structural engineer' is: 'to provide the necessary stability of the building at as low a cost as possible consistent with the preservation or creation of commodity and delight.' Ove conceded that, aside from his limited personal expertise, 'an imaginative designer is likely to be also handicapped, if he is not himself a contractor, by his inability to back up his own ideas.' He also emphasised the need to educate clients to understand what good architectural solutions might be in a rapidly evolving context of new materials and methods of construction.[55]

Ove and Li arrived back to be greeted with sixtieth-birthday celebrations in the office: all the staff, Li and her mother, Karin, Anja and Keld, speeches, a silver bowl from Georg Jensen, photographs, 'squeeze box music and singing and dancing'. Within days, he was deep in discussions about plans for his own house, work at Downside Abbey with Lionel Brett and at Nottingham University with Basil Spence.[56]

Soon afterwards his ideas reached the public forum of the BBC, and its associated publication *The Listener*, and Ove found it convenient to refer to names familiar to his audience. He began by referring to a talk by Maxwell Fry, given in February 1955. Fry had insisted that the central criteria of modern architecture were 'carefully analysed function, honestly expressed structure and the demands of applied sociology'. Ove immediately dissociated himself from Fry's 'excessive admiration for all things technical' and 'for the "honest expression" – whatever that may mean – of the structure'. Ove found 'so much enthusiasm for the means of building' highly suspicious. He detected its roots in the 'inspiration from primitive art, from the new patterns and images brought to light by scientific investigation and made accessible by modern photography and reproduction techniques'.

Many people in the visual arts had been thus influenced at the turn of the twentieth century. But although they had learned to see beauty where they had not previously looked, modern architecture had still not produced 'a new architectural language' which found universal acceptance:

> we see the romanticism of a Frank Lloyd Wright side by side with the classicism of a Mies van der Rohe. We see the beginnings of a great many different fashions, with clichés originated by the great going their round in architectural magazines.[57]

Ove was objecting equally to the pretentious classifications of architectural historians, and the meaningless jargon of architects themselves: in his view, neither enhanced practice or understanding. The mantra that particularly irritated him was the 'expression of structure', especially when proclaimed as a universal criterion – in 1971 he even prepared a list of 'devices' used to hide what was really being done in all the buildings he had worked on, ranging from the Penguin Pool and Highpoint, through Coventry Cathedral, to his own Durham bridge and the Opera House.[58] Diverse structural forms, such as cantilevers or shells, are usually developed by engineers for utilitarian or economic reasons, although they also fascinate architects. But architects often use a structural feature for purely aesthetic ends, when there is neither economic nor structural reason for their use: examples are the footings ('a kind of ball-bearing') of the internal columns of Basil Spence's Coventry Cathedral,[59] and Saarinen's similar use of steel hinges in the MIT Kresge Auditorium. The puzzle is this: 'in large-scale and difficult engineering structures, such as bridges, dams, and long-spanning roofs, economy and beauty often coincide . . . if a clear and simple structural idea is logically pursued': but 'it is not at all easy to cash in on this fact in architecture'. 'The moral streak', by which means become aims, was present in Victorian architecture before it pervaded functionalism, and it led 'to the naïve assumption that straightforward, unadorned, economic building will somehow display the quality which is so admired in engineering structures'. In fact, so-called expression of structure makes more sense in buildings providing large spaces; but it remains the duty of the engineer to point out that 'the beautiful structure is rarely the same as the economical structure.' He concluded with a classical affirmation: 'a certain simplicity, a sense of the unavoidable, of essential rightness is, I think, common to all great art.' The notion of propriety or appropriateness was to reverberate through Ove's writing for the rest of his life.

After such high-profile remarks Ove was invariably asked to comment on the education of British engineers. He always denied any qualifications for the

task: and, with equal predictability, promptly launched into an enthusiastic criticism of 'the jungle of British technical education'. Should an undergraduate course be regarded as a sufficient, stand-alone training for the majority of engineers, with additional post-graduate courses for specialists? Specialisation is the sticking point: 'in some ways the curse of modern civilisation. [...] [S]pecialisation is an evil because it makes a person narrow-minded and makes communication with others difficult'; moreover, 'imagination and invention – essential for a creative engineer – flourish on cross fertilisation from other fields of knowledge.'[60] In Britain many critics lamented overcrowded undergraduate courses, arguing that both theoretical and mathematical work should be reduced. Ove held, to the contrary, that 'in these days creative design is severely handicapped if not founded on a thorough theoretical training': undergraduates 'know far too little solid geometry, theory of structures, etc. and, incidentally, they are often not able to draw'. He also thought they should know more about modelling, and particularly aesthetics. He celebrated the admirable practice of his first employers, Christiani & Nielsen, of distributing to all their engineers 'a whole library of original reports on interesting jobs, designs, tests, original inventions and various design data'. The majority of civil engineering jobs are undoubtedly routine, but Ove insisted that the theoretical tools of previous generations cannot be ignored by those who are at the forefront of thought – how can anyone know where they are, unless they know something of how they got there. He suggested both three- and five-year courses, and a critical analysis of educational techniques apparently untouched for over a century.

However, at this point, his plan to replace 'making notes at lectures' – words transmitted insensibly from the notes of the lecturer to the notes of the student, without passing through the minds of either – by regularly revised, peer-reviewed, 'authoritative, readable and up-to-date books', aroused fierce academic opposition. In fact, such texts had long existed in some professional fields, such as medicine and law and, in less than a decade after Ove was speaking, became a staple of Britain's Open University. But on 25 September 1958 Ove pinned a note to his talk:

> I am rather shaken by the unanimous opposition of the Professors who have had experience of teaching students which I have not. It seems, therefore, that I have to admit the possibility that some students get on better without textbooks, but I must say that it is inexplicable to me.

Ove's own pre-war lectures to students at the Architectural Association were typed out, but he never formally stuck to the text. There is no indication that

he discussed methods of teaching, when he applied for the Chair at the University of London in 1945. But even in 1958, long-overdue reform of teaching methods in the older universities was still more than a decade away. Within a few months, however, he began to refer to a new project, although the dramas ahead were barely detectable.

During the spring and early summer of 1956 Ove felt, with justification, that things were going well: he contemplated buying a two-door 1950 Bentley. Peter Smithson was designing an office for Arup's; Ove himself was discussing designs with Sir William Holford for the Precincts of St Paul's; he was seeking advice from almost everybody about the house in Highgate and designs for the garden – as well as built-in furniture from Heal's; Queen Elizabeth laid the foundation stone of Coventry Cathedral, which the Arup firm was doing for Basil Spence. There were meetings and dinners with Maxwell Fry, and with Gropius when he received the RIBA Gold Medal – in his own Gold Medal address in 1966 Ove affirmed that, properly understood, Gropius's Bauhaus ideas were still correct. There were also discussions with Peter Chamberlin on his scheme for the New Barbican; the Glyndebourne season, of course, and a 'wonderful' concert in Salzburg with Bruno Walter conducting the Vienna Philharmonic.[61] And a granddaughter arrived: Joy Gudrun Liengaard was born to Anja. Ove was thrilled. He was also experimenting with thin members of pre-stressed concrete, which he called 'pencils', and which he used as railings for the balcony of his new house: but he failed to interest anyone else in their production.[62]

Elsewhere, however, anxiety was growing.

Political tensions dominated the lives of many Europeans during the late summer and autumn of 1956. In Poland and Yugoslavia, in Hungary and in Czechoslovakia, resistance to Moscow's policies resulted in strikes and demonstrations throughout the region, and the Soviet Union made ever more bellicose noises in response – an annual ritual since the Berlin airlift of food to the British and American sectors of the city in 1948. Further east, Colonel Nasser nationalised the Suez Canal in July. Ostensibly this was to raise revenues to finance the construction of the Aswan Dam, from which the US had withdrawn funding, as a reprisal for Nasser's purchase of tanks from a communist Czechoslovakia. These events prompted secret talks between the British, French and Israeli governments by whom a plan was devised to attack Egypt, and to repossess the Suez territories. At precisely that moment, in Cyprus and elsewhere, British troops were preparing their winter gear and camouflage for possible action against Soviet incursions beyond their existing boundaries of control, about which British intelligence was well informed.

On 15 October Ove opened an exhibition of pottery by Lucie Rie at the Berkeley Galleries. He frequently bought contemporary furniture and pottery for the house or his office, and acquired his first Lucie Rie pieces in 1945. She had arrived in London as a refugee from Vienna in 1940, and he admired her approach and that of her assistant Hans Coper: 'they did not want to be considered as artists making collectors' pieces for connoisseurs and art critics.' Rather, they were 'endeavouring to make practical and pleasant things for the home' – 'useful and beautiful things'. Their refusal to condemn 'their public as Philistines' appealed to him, and he applauded their insistence on establishing 'contact and understanding between the artist and audience which is so essential for the thriving of true Art'. Ove rehearsed his view that a good deal of talk by critics, laymen and even artists themselves is indefensible:

> The fact is, that you can only understand Art by paying some attention to it – by seeing it, reading about it, thinking about it – but mostly seeing it. You will find that your first reactions will gradually change – you will find out more about what you really like.

He then suggested that 'the position is much happier in the sphere of pottery', because 'everybody is interested in it. It has got everything: function, form texture, colour. It is useful, gives pleasure to the eye and above all to the touch.' He added:

> The best way to find out whether a piece is good or not – or at least whether you really like it or not, is to live with it for a long time, in fact to buy it. When you are hard up and yet manage to buy something, you very soon learn if it is good or bad.[63]

This view, that ownership can be a sufficient, although not a necessary, condition for serious appreciation of an object, was the antithesis of the doctrine, associated with Kant, that true aesthetic judgment required complete disinterestedness; and that since ownership must represent an interest, aesthetic judgment precludes ownership. Since his early student days Ove had rejected Kant's position, and he here celebrated his empiricist views on aesthetic judgment.

A week after opening the exhibition, Ove set off for Africa, returning just before Christmas. His reactions to what happened the morning after he left were from a distance; but not at all disinterested.

On 23 October Soviet tanks fired on demonstrators, mostly students, in the centre of Budapest: two days later over a hundred people were killed. A full military offensive was launched on 4 November, resulting in a death toll in

the following weeks which ranges between six thousand and twenty thousand in rival histories. In the face of massive strikes, draconian measures were implemented by Soviet placemen, and a black period ensued in Hungarian history which did not end until Soviet troops finally departed in 1991.

The following week, on 29 October, Israeli troops invaded the Gaza Strip, and the British began bombing Suez two days later. Paratroopers on 5 November, followed by commandoes the following day, achieved rapid military success. But Eisenhower, on behalf of the US, in conjunction with the United Nations and, ironically, the USSR, roundly condemned British action. All troops were withdrawn in March 1957. Nothing had been gained by the escapade into Egypt, and much lost; nothing had been gained by ignoring Hungary, and much lost. Another thirty years of economic, social and political stagnation disfigured central Europe.

Would these events affect business opportunities for Arup's, or modify political attitudes in the firm? Clearly, tensions in Europe might lead to the postponement of intended commissions, and the Middle East looked distinctly unsettled. The answer to both questions is a qualified 'yes'. Indeed, the firm's greatest challenge, and success, would take place at the farthest distance possible from such political tensions.

In Nairobi, Ove was delayed by security checks set in place for a visit by Princess Margaret. Peter Dunican told Ruth that if he had been in charge of the security check 'he would take one look at you and lock you up at once. This is known as "How to put people's minds at rest and remove their fears." Of course it all comes from wearing a beret.' Impressed by the order and efficiency of the ICI boardrooms, Dunican asked Ruth to attack Ove's office, and she wrote to tell him of the result:

> we put the long tables together down the middle, and put chairs round it, and concealed the nudes, and put blotting paper and scribbling paper and sharp pencils on the tables in neat piles until everything looked perfectly beastly and business like. This was all prepared last night, but ha! What do you think happened. A poltergeist or something crept in at night, cut the sash cord of one of the windows, and down it crashed and [the] window was wide open to the wind of heaven (North, remember) until after lunch for the afternoon session, and the room uninhabitable until then. So that shows what happens when one tries to put on airs in this place. Let it be a lesson to us all. They are about to go. I shall hasten to replace the nudes.[64]

Ove was an enthusiastic but clumsy amateur photographer, changing his camera to benefit from new developments. In 1947 he bought a twin-reflex

Rolleiflex, and the week before setting off for Africa, a Hasselblad, later exchanging it for a Pentax Systematic: he also took 8-mm film. In the 1950s, however, American-made colour film was difficult to obtain. To Ruth's disapproval, the shop manager had obtained some film 'under the counter' – Ove never scrupled to obtain the best things, such as Italian shoes or stockings for Li,[65] whatever machinations were necessary. But Ruth could not avoid political comment, in the context of the invasions of Suez and Budapest:

> I can't think what will have happened by the time you get back if events move as fast as they're doing now. I think it is monstrous that the present situation has developed, and people have taken these frightful decisions without, it seems to me, having the power of reason at all.

Ove had heard Eden's broadcast about the invasion of Suez but commented only two weeks later, when he wondered whether 'the ugly political situation alters matters'. The next day Ruth reported on Ronald Jenkins's radio talk which impressed her 'very much':

> I almost understood it. Moreover, contrary to my expectations, his voice was very good, much more resonance and what they call 'quality' to it than in the flesh. He also sounded terribly up-stage. I told him that he sounded like an Archdeacon who came of a very good family, which amused him. He said that Third Programme listeners probably thought that Engineers were rather a scruffy lot anyway.

She added 'a nice story':

> Mary, the waitress at Bertorelli's, has always wanted to know what Ronald Jenkins does. The others told her that he was going to broadcast, and she was all agog. And asked what he was going to broadcast about. When they said 'Stresses and Strains', she was delighted, and said 'Ah, now I know. He works for a corsetiere'.[66]

Three days later Ruth complained of freezing at home, but more importantly, MacAlpine's Christmas lunch loomed:

> I wonder what book you will be given. It must be rather difficult to choose, because I think most of those attending such functions usually look as if they read nothing but the Financial Times and the Engineering New Record. If I had to choose I think I would give you all Ogden Nash. Then at least your families will benefit.

Did Ove catch Ruth's implied comparison between his rhymes and those of Nash?[67] As his return approached, she reported that they all felt 'like that bit out of the Book of Common Prayer (?but how should you know it?) "We have done those things which we ought not to have done (probably) and left undone those things which we ought to have done".' The incontestable absence from Ove's mindset of the English Prayer Book was only one of the barriers to his cultural understanding: he always felt that his British colleagues were denied insight into Danish minds, but he rarely doubted his own access to theirs.

Ruth's remarks about Ogden Nash reflected the verse messages, for birthdays and Christmas, with which she countered Ove's rhymes. In December 1956 she composed an 'OVODE' to accompany her Christmas present to him of a large dish:

> This is a receptacle
> To provide you with the spectacle
> Of mirrored fruit – recumbent, mute
>
> And
> When things get a bit <u>much</u>
> Due to there being only twenty-four hours in a day
> and nobody telling anybody anything
> and one's back hurting and <u>such</u>
>
> Then
> This is the thing
> You can seize and fling
> At any member of your female staff*
> And then lean back relaxed after a long hearty laugh
> (*Important note: Secretary excepted)

In early 1957 Ove had a series of discussions with Sir Keith Joseph, a wealthy and influential Cabinet Minister (in three Tory governments), about possible appointments. Nikolaus Pevsner asked Ove to nominate a dozen of 'the most interesting new structures which needless to say should also be architecturally satisfying': it was proposed to illustrate these in the architectural section of the 1958 Triennale. Ove's list included buildings with which he was associated, as well as two that he had not then seen, in Mexico and Melbourne. The names of the architects are here added in parentheses.[68]

1	Unité d'habitation, Marseilles (Le Corbusier)
1A	Turin Exhibition Hall (Nervi)
2	Terminal Station, Rome (Calini, Montuori, Castelozzi et al.)

2A TUC Memorial Building (David Aberdeen, with Arup)

3 Bus Station and Offices for CIE, Dublin (Michael Scott, with Arup)

3A Lake Shore Drive Apartments (Mies van der Rohe)

4 Lever Building, NYC (Skidmore, Owings & Merrill)

5 Library UC Ibadan, Nigeria (Fry, Drew & Atkinson)

6 Hallfield Primary School, Paddington (Drake & Lasdun, with Arup)

7 Mexico University (Candela)

8 Swimming Pool, Melbourne (Murphy, Borland & McIntyre)

9 Brynmawr Rubber Co. factory (Architects Co-Partnership, with Arup)

In those same early months, a growling peace hovered over the snows of central Europe and the torpid plains of Egypt. Much further away, however, a drama of parochial politics and intrigue was about to achieve global significance. At one level there was trivial, and therefore bitter, rivalry between Sydney and Melbourne, which had achieved great publicity for hosting the Summer Olympic Games, opened by the Duke of Edinburgh on 21 November 1956. But there were clashes between town and country politics, state and nationwide priorities, and passionate defence of traditional European culture by a tiny minority.

Job 1112

On 29 January 1957 Ove left for Dublin: the BBC headlines that morning reported Lord Home's announcement that the House of Lords would admit women. But at breakfast in Dublin the next day, Ove glanced at *The Times*, and on page 5 a brief item stood out. His own life, and that of the Partnership, was about to change in dramatic and irreversible ways. The heading read:

<div align="center">

The Future Sydney Opera House
To cost £A. 3,500,000

</div>

The opening words did the trick: 'The Danish architect Mr Joern Utzon, has been awarded a £A.5000 prize for the winning design for Sydney National Opera House.' A lecturer was quoted as enthusing about 'groups of delicate white shell vaults', and readers were informed that 'the larger hall will seat between 3,000 and 3,500, and the smaller one, 1,200'. In the final paragraph it was stated that the winner had been 'awarded the Copenhagen Academy's gold medal in 1945 for his design of a concert hall. He was a student of the famous Finnish architect Aalto.'[1]

On the other side of the world, the *Sydney Morning Herald* for some days had been carrying banner headlines about President Eisenhower and Secre-

tary Dulles distancing themselves from UK policy in the Middle East. But it changed tack on 30 January: a large photograph of an architectural model dominated the front page, accompanied by the heading: 'Dane's controversial design wins Opera House contest.' The *Daily Telegraph* of Sydney carried a more local reference. Two Hungarian competitors in the contest, Kollar and Korab, had received a mention by the judges. Kollar had arrived in Australia in 1951, but he told the press that 'we were deep in the middle of it when the revolution broke out in Hungary. For a long time we debated whether we should abandon everything and go to Budapest and join forces with the fighters there.' In March 1966 Kollar re-emerged to play a role in the dramatic events of that time.

On 2 February the *Sydney Morning Herald* carried a statement by the chairman of the competition jury, Professor Harry Ingham Ashworth, who was revelling in the excitement and attention. In asserting that their aim had been 'to find a fine piece of imaginative architecture' he quoted Walter Gropius: 'Our great heritage seems to have left us stunned and bereft of original impulse and from being participators and creators, we have changed into connoisseurs and scholars.' This observation, by the founder of the Bauhaus, precisely echoed anxieties expressed in France and England at the end of the seventeenth century and the beginning of the eighteenth. Ashworth here alerted spectators to the danger of elevating the building to the status of 'art', thereby exempting it from a necessary and secure foundation in the skills of craft: above all, the building had functions to fulfil.

Among the competitors were Ove's friends Peter and Alison Smithson (with Ronald Jenkins as their structural consultant) from Britain, Richard Neutra from the USA and Harry Seidler from Sydney itself. The winner, however, was Jørn Utzon, born in 1918, the son of a well-known boat builder and designer, from whom he learned respect for precision of design and workmanship. After a poor school record, he barely met the entry conditions for architectural study, and departed from Copenhagen for Stockholm immediately upon qualifying in 1942. Sweden was formally neutral, and its capital was a thriving cultural centre for refugees of all kinds, not least Jewish families dramatically evacuated from Denmark.[2]

From the outset of his career Utzon tended to work alone; he was neither a scholar nor an intellectual, and disliked attention from those quarters as much as he distrusted large organisations. Such attitudes served him ill: the charm he exercised over others masked his own insecurities and fostered self-deception of tragic proportions. At the time of the Sydney competition, Utzon had already won seven of the eighteen competitions he had entered since 1944:

but none of his submissions had been commissioned. He had become a skilful and fluent draughtsman, but had built very little, and had almost no experience of clients or their political contexts when he received the dramatic news from Sydney.

Few, if any, of the principal actors in the unfolding story either knew or considered relevant any of this background. Ove himself may have heard of Utzon from Erhard Lorenz, who had recommended the young architect to Alvar Aalto's office in Helsinki back in 1945,[3] or from Utzon's former professor, Steen Eiler Rasmussen. In any case, Ove needed little time to reflect: here was a Danish architect about to undertake a large commission on the other side of the world: surely he needed Danish help. He sent off what he later described as his 'cheeky' letter, dated 3 February. It is not clear, however, when or where it was received, because Utzon was just departing for London:

Dear Architect Utzon

My congratulations on winning the First Prize! I am very pleased that it was a Dane who won it, and after having seen a sketch of your project, I am even more pleased – and also somewhat surprised – that such an imaginative, but unusual design has actually been chosen to be built, instead of merely being praised, as is mostly the case. [. . .]

My firm has on occasions been involved in competition designs, which did not follow the known and conventional methods of building, and consequently were discarded with the quite untenable and possibly also dishonest motivation that they could not be built, as for instance Crystal Palace and Coventry Cathedral. At the moment we are actually working on both these projects, but not on the original competition designs which we supported.

As far as I can see, it will not be so easy to calculate and detail your design so that your idea is realised in the fullest sense, and for it still to be economically viable. Neither do I think that you can count on the Australian workmen and technical resources being of a similar standard to those in Denmark. But from what I have seen of your work, and from what I have heard about you from other Danish architects, then I think, however, that you will surmount all the difficulties and create a building which will be of great liberating importance to today's architecture.

If my firm can assist you in some way or the other, then I shall be very pleased. I have more than thirty years' experience in working with British architects and institutions, and my Partner, Mr Jenkins, is no doubt the leading authority on the calculation of shell structures. No doubt you have your own consulting engineers, but it might be possible for us to give you

some good advice. In any case I shall be pleased to meet you – are you passing through London on your way to Australia?

I am visiting Copenhagen next week to interview a few engineers to work in Nigeria, but then you had perhaps already left? Anyhow, the best of luck!

P.S. If you don't know who the hell I am you may think it very odd that I write to you: you may be right!

The two overseas members of the jury, Leslie Martin and Eero Saarinen, interviewed Utzon in London two days later, and Ove had him to stay in Virginia Water. Ove then visited him the following week in Denmark, and was telling people that they were going 'to do the shells'.[4]

The outlines of the saga are well known to many Australians, but some of the background needs to be rapidly sketched, because myths and inaccuracies have been promoted by interested parties.

In 1947, at the age of fifty-four, the British-born avant-garde conductor and composer Eugene Goossens, after tenure with orchestras in Rochester, NY, and Cincinnati, was appointed conductor of the Sydney Symphony Orchestra. He immediately campaigned for a concert hall capable of holding 3600 people. This was a thousand more than could be accommodated in the Sydney Town Hall, which staged his concerts organised by the Australian Broadcasting Commission. In conjunction with Karl Langer, a far-sighted Viennese planner who lived in Brisbane and Sydney, he also vigorously canvassed the idea of developing Circular Quay as a cultural landmark, and Bennelong Point as the site for an opera house. In 1947 this all seemed extremely far fetched.

Goossens had seen several of the new opera houses and multi-purpose halls that were being built after the war, including the San Francisco Opera House. In his prominently published newspaper articles of 1949 and 1950, however, he explicitly listed, in order of importance, the events to be catered for in Sydney: first of all, concerts, then opera and finally spoken drama. The auditoria for these should cater for audiences of 3600, 2800 and 1120 respectively.

Goossens knew all the prominent citizens of the day, and had bent the ears of many. In April 1952 the newly appointed Premier of New South Wales, Joseph Cahill, whom Goossens had come to know as Minister for Local Government, announced that Sydney was to get its opera house. A crucial player in this decision, and in what followed, was Charles Moses, who had served in both world wars, and was General Manager of the Australian Broadcasting Commission. For several years he had been party to discussions for appropriate cultural facilities. The combination of Lt Col. Moses, Goossens and

Cahill was in itself an unlikely one, even in the slowly awakening context of post-war Australia. But a final member of an improbable quartet entered the stage at much the same time: short, bespectacled, somewhat rotund, and with a stentorian manner, Lt Col. H. Ingham Ashworth arrived from England in 1949 to take up the Chair of Architecture at Sydney University. He spoke as if the colonies were about to be sorted out, and in the small social and professional circles of Sydney he, too, rapidly came to know the influential citizens. In 1954 he set his fifth-year students a design project for an opera house on Bennelong Point. The results were not inspiring, but they helped to prompt the Labour premier to convene a public discussion, and establish a working party. The quartet proved surprisingly effective in consolidating support among widely disparate constituents. Even more important was their resistance to local architects who fiercely opposed an international competition for the job: the eventual selection of an unknown Dane induced apoplexy among some of them. But a decisive push had been given a few weeks beforehand with the first effective moves towards establishing the Australian Elizabethan Theatre Trust, to oversee national ballet, opera and theatre companies.

There was, of course, concern about financing any building, and city dwellers and politicians also completely underrated the depth of rural hostility towards ostentatious urban expenditure. There was, moreover, hostility from old and often poor settlers towards new, European immigrants who wanted to promote cultural activities. But by May 1955 the State Cabinet had approved Bennelong Point as the site, against twenty other contenders, and the nomenclature of the project was itself virtually set in stone: *The Opera House*. An Opera House Committee took almost a year to prepare for an international competition for the building – although local and national bodies continued to oppose the idea of an outside architect.

Before things could get under way, however, Goossens was forced to resign and leave the country in March 1956: as a result of a tip-off, pornographic material was discovered in his luggage by customs officials. Unfortunately, he was the only participant in all the debates with any extensive knowledge of music and its physical requirements, or of the likely needs and developments in opera house design. No one else knew enough: worse still, they did not know they did not know. Ignorance of music was arguably the greatest handicap suffered by the client, the winning architect and the judges alike: because, in designing a building for the making of music, the architect must understand the needs of the musicians first, and their audiences second. Many perceptual factors influence the behaviour and responses of both groups, but an architect who cannot hear the viewpoints of different musicians is doomed.

The four assessors of the competition for a 'National Opera House' were Ashworth, and the New South Wales government architect, Cobden Parkes; together with Leslie Martin and Eero Saarinen, who was working on the US Embassy in London and the TWA Terminal building in New York. In spite of Martin's experience in London, none of the assessors had much understanding of acoustics, the science of which was in its protracted infancy. As a result, no mention of either acoustical criteria or any other potentially complex technical matters was mentioned in the competition announcements: nor was anything said about costs.

The following year Ashworth sent in statistical data to the organisation under whose overall banner the competition had been conducted, the Union Internationale des Architectes (UIA).[5] Some 223 competition entries were eventually received. Question 35 revealed something that the four jurors later came to regret, although it was in fact quite normal in competitions at the time: 'the conditions of the competition did not call for any consulting engineer to be associated with the competitor when submitting his scheme – consulting engineers have since been appointed to work in conjunction with the architect.'

The Assessors' Report, dated January 1957, became available on 6 February and, like almost every public statement about the project, had also been written by Ashworth. The introduction wisely stated that 'it is unlikely that the winning scheme will be built without alteration or variation':

> The drawings submitted for this scheme are simple to the point of being diagrammatic. Nevertheless, as we have returned again and again to the study of these drawings, we are convinced that they present a concept of an Opera House which is capable of becoming one of the great buildings of the world. [. . .]
>
> The great merit of this building is the unity of its structural expression. One of the most difficult problems of opera house design is to relate the stage tower to the separate and surrounding buildings and this becomes of particular importance on this exceptional site.
>
> We are aware that it is open to many points of detailed criticism and a number of corrections would have to be made, but we feel, at this stage, the general breadth of the imaginative concept is an over-riding consideration.

The Competition Requirements had stated that 'no restriction is placed upon either the number of drawings or the size of the sheets'; furthermore, 'the Assessors feel that the cost of the building cannot be limited to a specific

amount'. These freedoms could be defended on two grounds: there were, at the time, no funds whatsoever to build any winning design; moreover, their official freedom might encourage competitors to be especially imaginative. But there was at least one great danger: competitors could easily persuade themselves that costs were really none of their responsibility.

On 1 March 1957 a leading article in *The Builder* had voiced criticism of the jury's procedures and verdict. Ove immediately responded, and his letter was published on 14 March:

> The point of competitions is that the promoters and assessors don't exactly know what they want – they want the Competitors to tell them what they can have, so that they can make a choice.
>
> Any architectural competition is a compromise between the desirable and the possible. Many desirable features are mutually conflicting; you have to choose between not only how to build but also what to build. That, incidentally, makes it easy to criticise any design, because nearly every desirable feature means the exclusion of another – and you certainly make the most of it in your criticism of Utzon's design.
>
> In most competitions the conditions are far too elaborate. The Assessors, by asking for too much, unwittingly exclude a lot of possibilities which they had never thought of, and they do not leave enough scope for the imaginative designer.

Clients and assessors are, indeed, often initially unclear about their needs and the possibilities for meeting them; and juries do try to predict the promise of initial designs. But decisions not to ask or press certain questions carry risks, and in the present case, had disastrous consequences. Ove himself overvalued the imaginative scope available to those architects who wilfully avoid clarifying functional requirements. International architectural competitions have been contentious for almost two hundred years, but they preclude neither rigorous procedures nor informed clients.[6]

After their meeting in London, Leslie Martin and Saarinen told Ashworth that Utzon 'might need help on the management and financial side' but even more 'with the technical problem of calculating and later building the very complicated shell vault system'. Accordingly, 'he should work with a firm of the standing of Ove Arup and Partners in London, or Christiani and Nielsen in Copenhagen'.[7]

Here, precisely, was one of the assumptions the assessors had made in awarding Utzon the prize: that a candidate who showed exceptional promise would be able to learn from all the professional advice to which he would

now have access – he would have to grow into the task, but he was trusted to be up to the job.

Ashworth was extremely busy writing to everyone he could think of. Saarinen had reported Frank Lloyd Wright's irritable dismissal of Utzon's design, to which Ashworth responded that the design appeared 'to be almost based upon earlier teachings of Wright himself!' On the same day, 28 February, Ashworth informed both Stanley Haviland, Chairman of Sydney Opera House Executive Committee (SOHEC), and Utzon himself that Ove Arup & Partners of London should be the engineers for the work. Haviland was Under Secretary in the Department of Local Government, and was thus a direct link with the State Government Cabinet.

With that letter, Ashworth opened a supportive correspondence with Utzon. Both Ashworth and Martin were much admired by contemporaries for their courteous and tactful approach; but their sensitivity to different audiences and their subtle command of English could be sometimes tragically missed. Ashworth urged Utzon not to be upset by comments probably fuelled by political motives, but added:

> I think if I were in your position, I would most certainly come out here on your own, on an exploratory trip to make yourself acquainted both with the site, with the people immediately concerned with the project and with the general political situation which appertains.

Utzon followed Saarinen's advice to undertake 'a study tour to four or five new opera houses and concert halls in Europe'; and, after meeting Arup, he acceded to his appointment. What no one knew at this stage was that Felix Candela in Mexico, himself a master of concrete shell construction, told a colleague of Ashworth's, George Molnar, in that same week that the 'shells are not self-supporting'.[8]

Behind the scenes things seemed to move swiftly. Back in London, the Building Group at Arup's had been formed, the forerunner of the architectural wing, Arup Associates. Ove was advising Denys Lasdun, who had been a junior member of Tecton in the 1930s, on his design for the new headquarters for the Royal College of Physicians; he was also discussing new buildings for Clare College, Cambridge, with Leslie Martin. And he had lost his briefcase – again. This was particularly embarrassing because it contained drawings by Basil Spence, to whom the taxi-driver returned the case. However, it also contained drawings by other architects. From this, Spence discovered that Ove had been tapping everyone's professional brains for design improvements to his new house, which he then passed on to the young architects Stallard

and Walker, who had taken over from Erhard Lorenz on his return to Rhodesia. Spence was incandescent – both he and Lasdun deplored the architectural expansion about to occur in Ove's firm. Mumbled apologies, philosophical clouds and alcoholic haze eventually soothed egos. Forty years later, the house was commended for excellent insulation and well-detailed windows, and was described as very much a family house. But its gestation period had been uncomfortable for everyone. Once Ove saw Lorenz's first drawings for the proposed house in Highgate, he kept changing his mind about the designs.[9] The biggest challenge turned out to be the kitchen. Lorenz had located it facing north into a bank of mud. When Li discovered this she was appalled, and pointed out that since she spent much of her day either in the kitchen or in the garden, she required the kitchen to face south onto the garden. It was done.

Social life continued apace, nevertheless, and Ove was enjoying conversations with Alvar Aalto, who was an old friend of Max and Jane, Gio Ponti from Italy and Saarinen, who now regularly appeared in London.

By April, less than three months into the Sydney project, Ashworth gently warned Utzon to think how he might respond to public challenges about acoustics, sight lines, stage facilities, access – about none of which he had provided any details. He then had an alarming thought: 'I am assuming that the model you have produced illustrates your winning scheme':[10] this was a wise, if over-subtle reminder that the assessors needed detailed evidence of sustained thinking sooner rather than later. They could not know the extent to which they would be disappointed. On 24 June Ove reminded Ashworth of Jenkins's expertise in shell design, and added: 'Mr Utzon has some excellent but rather costly ideas for internal and external facing of the shells.' Just over three weeks later he warned that the more they delved into the details the more they discovered that they were faced with 'an extremely complicated and difficult job'.[11] A major task would be 'to reconcile the conflicting claims' – by which he presumably meant the architectural, structural, functional, financial and temporal requirements. To the Secretary of SOHEC Ove declared that the calculation of the shells 'will call for the development of new techniques both for the calculation, testing and construction'. This was due not only to their size and unique shape, but because 'the shells are different in shape, so that there is no repetition as is normal in reinforced concrete work'. The professional syllogism seemed unchallengeable: since Jørn Utzon had specified concrete in his competition entry, and Ove Arup was an expert in reinforced concrete, it followed that Arup should fulfil the architect's requirement. Moreover, the competition jury had been officially advised by the firm of quantity

surveyors Rider Hunt & Partners that the Utzon scheme was the cheapest of all the finalists. The firm did record that the likely final cost of £3.6 million (A$7 million) should be treated as little more than 'an approximate estimate', although the random figure hardly qualified as even a guess. But no one was unduly worried.

The building could no doubt have been built in other ways, possibly more cheaply, while retaining essentially the same appearance; but the client did not challenge the architect's insistence on concrete for elements that would never be seen. Utzon's dogma was that the 'architecture should be expressed through the structure': to which Ove responded on numerous occasions, by citing Geoffrey Scott's severe criticism of three fashionable fallacies in architectural aesthetics – the literary, the functionalist and the moralistic.[12] Following Scott, Ove argued that Utzon's requirement was, at best, a 'psychological' one, to do with perceptions only:

> it has nothing to do with choosing the most efficient structure. The spectator does not in fact understand the subtleties of a modern concrete structure, whose strength in any case may be hidden from the eye in the form of reinforcement or cables. It is not so much a question of how the structure really acts, but rather of how the spectator thinks it acts, or whether he can relate it to some simple structural facts which lie within his experience.[13]

Ove described several of the early discussions, during one of which the architect insisted on a variation in the beams supporting the concourse, on purely aesthetic grounds: the result would have been invisible, and the cost prohibitive. In fact, that particular issue was resolved because the heating engineers could not accommodate their services within the architect's design: but a recurrent problem had been signalled.

Ove held that although human beings are moved by their emotions, they must never relinquish the relentless duties of rational thought, because nothing is immune from reflection. Accordingly, the best efforts of other human beings require of us our fullest intellectual and emotional engagement. Our aesthetic judgments, for example, involve and demand thought, and are as challengeable and revisable as any others. Every child, of Ove's generation, learned Horace's warning 'Quandoque bonus dormitat Homerus'; to suggest that something by even the greatest geniuses might benefit from revision implied neither equality with those artists, nor personal knowledge of how to effect improvement. Nor did it betray the replacement of emotional response by thought alone. The astonishingly successful romantic view of artists as legiti-

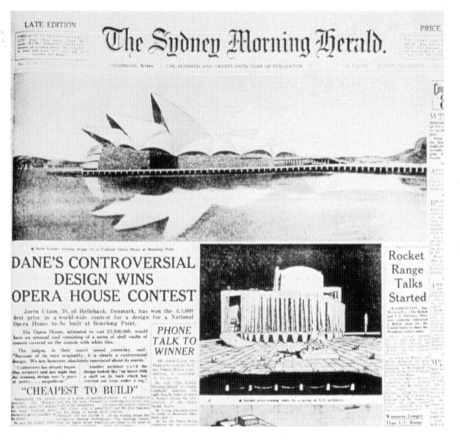

DANE'S CONTROVERSIAL
DESIGN WINS
OPERA HOUSE CONTEST

Joern Utzon, 38, of Hellebaek, Denmark, has won the £5,000 first prize in a world-wide contest for a design for a National Opera House to be built at Bennelong Point.

His Opera House, estimated to cost £3,500,000, would have an unusual roof consisting of a series of shell vaults of cement covered on the outside with white tiles.

The judges, in their report issued yesterday, said: "Because of its very originality, it is clearly a controversial design. We are, however, absolutely convinced about the merits."

Controversy has already begun. Another architect said the One architect said last night that design looked like "an insect with the winning design was "a piece a shell on the back which has of poetry . . . magnificent crawled out from under a log."

"CHEAPEST TO BUILD"

PHONE
TALK TO
WINNER

Rocket
Range
Talks
Started

68. One of the announcements that propelled the firm onto the world stage: *Sydney Morning Herald*, 30 January 1957.

69. While designing the factory at Duxford for CIBA in 1959, Ove learned of the adhesive properties of an epoxy resin marketed as Araldite. He applied this knowledge to construction tasks at Coventry Cathedral and the Sydney Opera House.

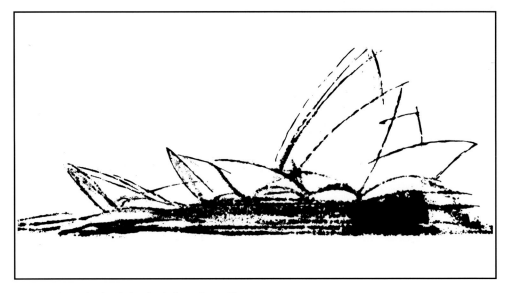

70. An early sketch for the Sydney Opera House, 1956–7.

71. Bennelong Point, future site of the Sydney Opera House, 1955.

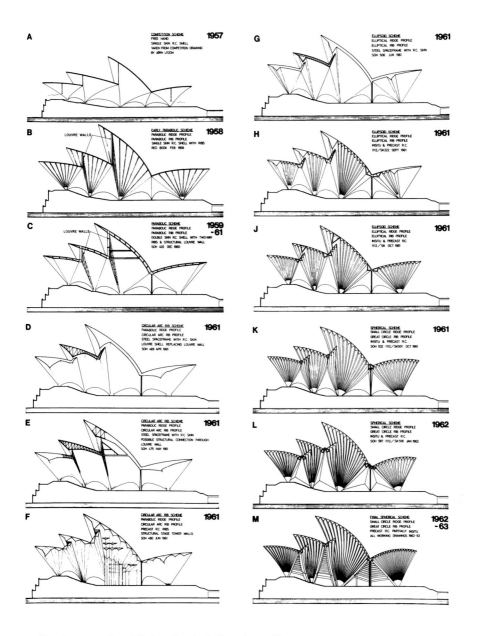

A COMPETITION SCHEME **1957**
FREE HAND
SINGLE SKIN R.C. SHELL
TAKEN FROM COMPETITION DRAWING
BY JØRN UTZON

B EARLY PARABOLIC SCHEME **1958**
PARABOLIC RIDGE PROFILE
PARABOLIC RIB PROFILE
SINGLE SKIN R.C. SHELL WITH RIBS
RED BOOK FEB 1958
LOUVRE WALLS

C PARABOLIC SCHEME **1959 -61**
PARABOLIC RIDGE PROFILE
PARABOLIC RIB PROFILE
DOUBLE SKIN R.C. SHELL WITH TWO-WAY
RIBS & STRUCTURAL LOUVRE WALL
SOH 402 DEC 1960
LOUVRE WALLS

D CIRCULAR ARC RIB SCHEME **1961**
PARABOLIC RIDGE PROFILE
CIRCULAR ARC RIB PROFILE
STEEL SPACEFRAME WITH R.C. SKIN
LOUVRE SHELL REPLACING LOUVRE WALL
SOH 469 APR 1961

E CIRCULAR ARC RIB SCHEME **1961**
PARABOLIC RIDGE PROFILE
CIRCULAR ARC RIB PROFILE
STEEL SPACEFRAME WITH R.C. SKIN
POSSIBLE STRUCTURAL CONNECTION THROUGH
LOUVRE WALL
SOH 475 MAY 1961

F CIRCULAR ARC RIB SCHEME **1961**
PARABOLIC RIDGE PROFILE
CIRCULAR ARC RIB PROFILE
PRECAST RC RIBS
STRUCTURAL STAGE TOWER WALLS
SOH 480 JUN 1961

G ELLIPSOID SCHEME **1961**
ELLIPTICAL RIDGE PROFILE
ELLIPTICAL RIB PROFILE
STEEL SPACEFRAME WITH R.C. SKIN
SOH 506 JUN 1961

H ELLIPSOID SCHEME **1961**
ELLIPTICAL RIDGE PROFILE
ELLIPTICAL RIB PROFILE
INSITU & PRECAST R.C.
1112/SK222 SEPT 1961

J ELLIPSOID SCHEME **1961**
ELLIPTICAL RIDGE PROFILE
ELLIPTICAL RIB PROFILE
INSITU & PRECAST R.C.
1112/SK OCT 1961

K SPHERICAL SCHEME **1961**
SMALL CIRCLE RIDGE PROFILE
GREAT CIRCLE RIB PROFILE
INSITU & PRECAST R.C.
SOH 532-1112/SK501 OCT 1961

L SPHERICAL SCHEME **1962**
SMALL CIRCLE RIDGE PROFILE
GREAT CIRCLE RIB PROFILE
INSITU & PRECAST R.C.
SOH 597-1112/SK518 JAN 1962

M FINAL SPHERICAL SCHEME **1962 -63**
SMALL CIRCLE RIDGE PROFILE
GREAT CIRCLE RIB PROFILE
PRECAST R.C. PARTIALLY INSITU
ALL WORKING DRAWINGS 1962-63

72. Development of roof designs for the Sydney Opera House, 1961–3.

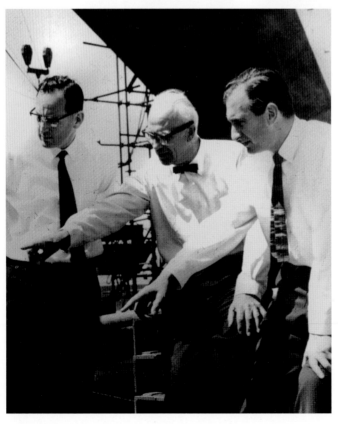

above left 73. Pier Luigi Nervi, a distinguished exponent of concrete shell roofs, 1959.

above right 74. Leslie Martin.

left 75. Mick Lewis, Ove and Jack Zunz: Sydney, 1964.

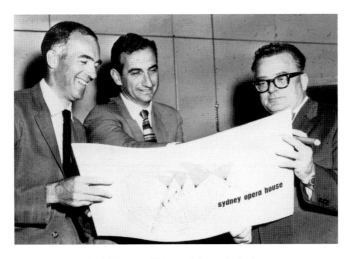

76. Jørn Utzon, Jack Zunz and Harry Ashworth: Sydney, 1962.

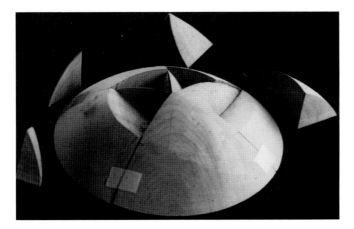

77. A model of the sphere and its detached segments, 1962.

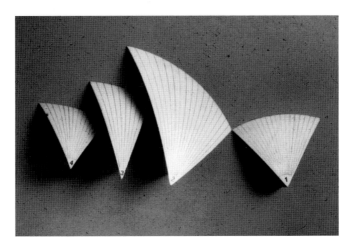

78. The roof shells separated from the sphere.

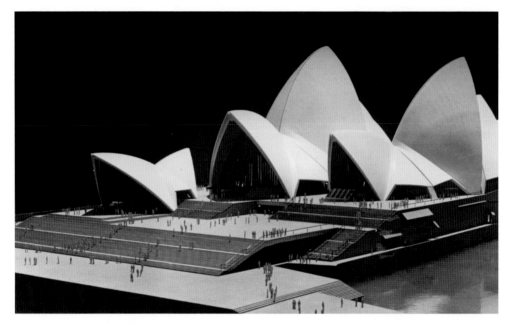

79. Exhibition model of the Opera House shown in Sydney, 1957.

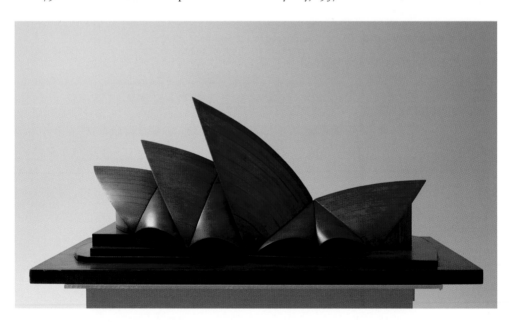

80. Arup site model, 1962–3.

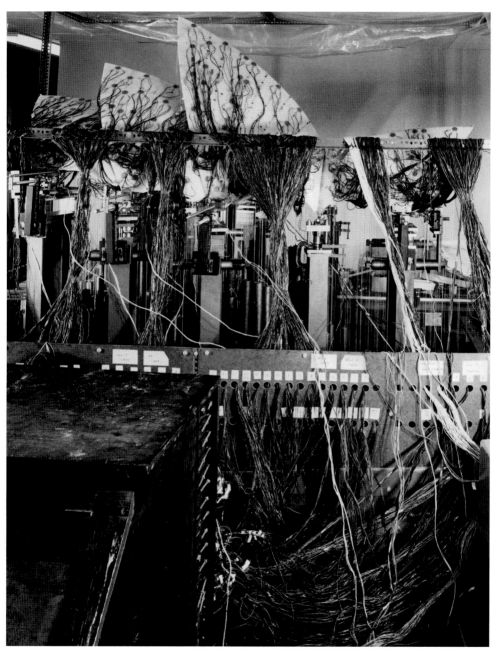

81. Model tests at Southampton University, 1961.

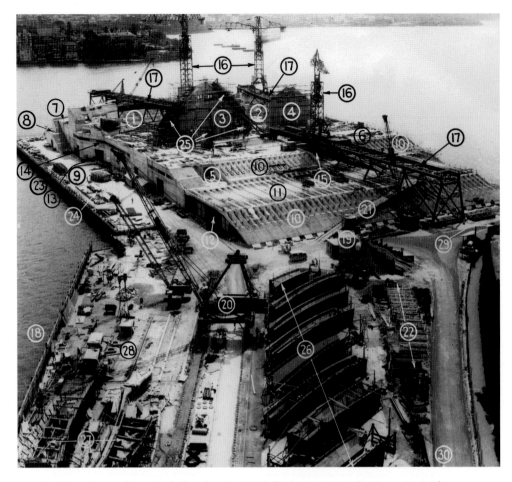

82. Precasting yard for side shell arch and main shell rib segments, indicating main site features, 1963. Young secretaries referred to the site huts in which meetings were held as 'Cockroach Castle'. (Numbers in parentheses are those of seating capacity unless otherwise indicated.)

1 Major Hall auditorium (2800)
2 Minor Hall auditorium (1200)
3 Stage wall Major Hall
4 Stage wall Minor Hall
5 Position of restaurant area
6 Chamber Music Hall below this level (310)
7 Major Hall bar and lounge areas
8 Route to construction offices
9 Western Broadwalk
10 Approach steps (93 yards wide)
11 Concourse
12 Motor car entrance
13 Entrance to Experimental Theatre (430)
14 Some of the dressing-room areas
15 Entrance to ticket office and cloakroom areas—also through here to Chamber Music Hall on right
16 Tower cranes (tallest 240 feet above sea level—can lift 20 tons at 50 foot radius)

17 Crane bridges
18 Circular Quay east
19 Concrete batching plant
20 Whirler crane
21 Temporary access during construction
22 Cradles to position steel reinforcing
23 Formwork for side shell beams
24 Formwork for side shell slabs
25 Construction commencing on first group of side shell ribs
26 Formwork for pre-cast segments of ribs of main shells
27 Formwork for pre-cast segments of side shell ribs
28 Some pre-cast segments of side shell ribs
29 Area of viewing platform and proposed pavilion
30 To entrance gate

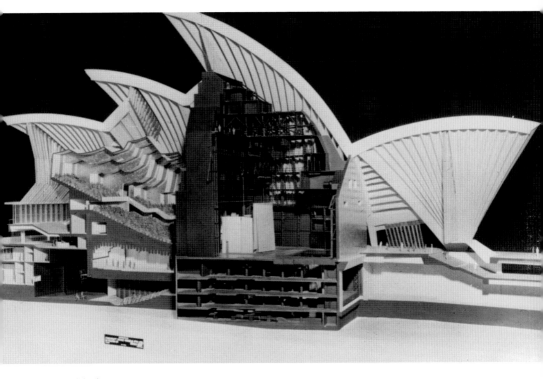

83. Model of Opera House interior, 1965–6.

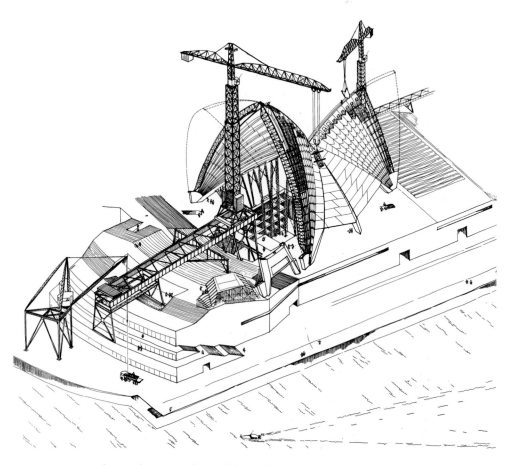

84. Isometric drawing by Yuzo Mikami of the roof construction sequence, 1963.

facing page 85. The erection arch designed for construction of the shells, together with a tile segment awaiting fixing, 1965.

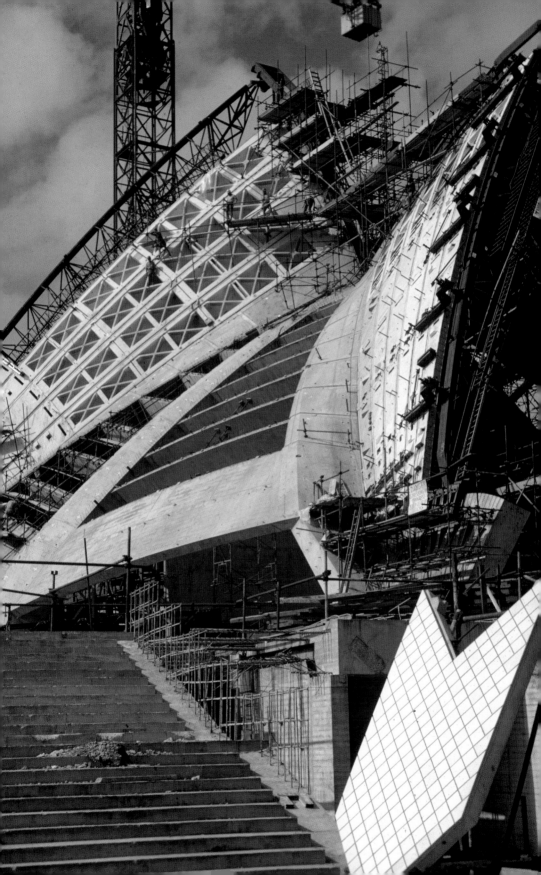

86. Sydney Opera House: modern floodlighting creates new shapes and images.

87. Model for proposed Coventry Cathedral, 1951.

88. Basil Spence.

89. Nave of Coventry Cathedral under construction, 1958.

facing page 90. Scaffolding Coventry Cathedral nave, 1960.

above 91. Underpinning the foundations of the crossing tower, York Minster, 1966–73.

left 92. Movable cover, mounted on rails, which protected the nave during restoration after the fire at York Minster, 1984–8.

mately self-centred, unchallengeable, and exempt from reciprocal human engagement, benefited no one; and it typically placed enormous burdens of understanding and compromise on all who had to work with such artists – as too many people, over history, found out too late.

By July Ashworth admitted to Martin that they had overlooked certain matters: 'I do feel we were rather delightfully vague with regard to acoustics'; to which Martin responded, equally late in the day, that the acoustic requirements for opera and drama 'are to some extent in conflict with each other'.[14] Ashworth also sought confirmation from Haviland that it was 'still considered essential that opera should be staged in the great hall' because it would be a great deal simpler if it were 'essentially a symphony concert hall'.[15] By October 1957 Ashworth was warning Utzon of growing concern:

> I am sorry if perhaps you feel I am harping on this question of acoustics, but I do realise that it may be one of the things which will cause you more difficulty than anything else, because however mathematically correct the building may be, there is always the question of personal opinion and personal taste which could cause disagreement and dissension in any event.[16]

Two weeks later the Secretary of the SOHEC, R. J. Thomson, sent a reminder about the 'priorities of usage of the two halls as stated in Appendix 5 to the Conditions of Competition': among these, 'the large hall must seat 3,000 persons'. This issue became a stumbling block: indeed, three years later it was necessary once again for Ashworth to issue clear instructions:

> One should not lose sight of the fact that the Major Hall has to be used for multiple purposes and that Concerts have already been given Priority No. 1 and Opera Priority No. 2. [. . .] the principal use of the Major Hall will be for Concerts and [. . .] as far as possible, the hall must be 100% perfect for this purpose.[17]

At that point, he invited Utzon to present transparency overlays to illustrate his proposed designs for the stages, compared with those of the Vienna State, Salzburg, Hamburg State, Mannheim National and Malmö Civic theatres.

In London, as the hectic summer season of 1957 approached, the Arup household was unusually busy. In June they moved into their new house at 6 Fitzroy Park, Highgate. And at the vast neighbouring mansion of Witanhurst, where Lady Crosfield held a pre-Wimbledon tournament, Ove was delighted to meet Maria Bueno, Jaroslav Drobny and other tennis stars. In July the family visited Oslo and Copenhagen, in part to attend a symposium on 'Shell roof construction'. There were also new toys to acquire: anyone with a keen sense

of design simply had to have a Citroën DS 19. Ove was strongly advised against it, for maintenance reasons, but Peter and Alison Smithson had one: 'You see I do really like it.' One duly arrived, after chaotic negotiations with the importing agents. The first day, upon leaving lunch at a nearby restaurant, he could not insert the doorkey. Dunican, keeping a benign watch from the other pavement, shouted: 'Other way up.' Once seated, however, Ove could not remember how the levers worked, but loudly decreed that there was only one alternative – either forwards or backwards. He chose the wrong one, rocketed backwards into a parked car, and roared off in the other direction, with the dashboard warning lights flashing hysterically. Jacques Tati was back in town.

The problems posed by the winning design drawings were now becoming dramatically apparent to almost everyone: they were unusually sketchy, lacked all measurements, and had been submitted in the absence of any engineering advice. The site boundaries specified by the competition had also been exceeded, which infuriated some competitors. Utzon had envisaged the roof as thin shells: but this was technically impossible, because the proposed shape introduced high bending moments, whatever structural system was used. The problems faced by the structural engineers were unparalleled in their experience, but their resolution propelled Arup's onto the world stage, and secured the firm a place in architectural and engineering history.

Although Ove hugely appreciated Ruth's regular letters from the office, especially those that contained gossip, he never asked himself if good advice was tactfully wrapped up in the badinage: if you needed to alert him to something, you had to hit him with it. In January 1958 Ruth reminded him that Peter Dunican was expecting some gramophone records, 'to give added charm'. She had, of course, met Utzon several times in the office, but there is a frightening prescience about her observation.

> The trouble with some people, is that they have too much of that doubtful commodity, at least the trouble is that some people use it instead of what they should use, which perhaps they haven't got. I'm always suspicious of charm, to the extent that when I find it radiating from a person I have only just met I watch very carefully indeed to see if that is all there is, or if it is just a charming addition to something good underneath.[18]

She sent another warning in April:

> Best wishes to Mr Utzon. I have terrible forebodings that you will egg each other on to do rash things. It is because you both seem to throw ideas like fireworks, and you are both receptive of new and unusual ideas, so that to pedestrian types like myself there is the ever-present fear that your com-

bined impulses will drive you into rashness – in other words that you will set out for the horizon without the necessary bits of paper.[19]

Jack Zunz had arrived from South Africa and his visits to the office were eagerly anticipated by everyone. Born in Germany, he had started by studying mechanical and electrical engineering at the University of the Witwatersrand in Johannesburg, but graduated in civil engineering. Having joined the firm in 1950, he proposed closing down the Arup office in South Africa towards the end of that decade because of the intolerable political situation there; Ove was soon to ask him and his colleague Michael Lewis to take over the Opera House project. Ruth remarked:

Peter says 'You know, I could talk to Zunz for days on end'. He is very easy to talk to. I talk to him about children and you and so on, Peter talks jobs and staff, and no doubt Jenkins talks sums and everyone finds him equally sympathetic.

That inspired a THOUGHT for her Christmas Card that year:

> Just for one brief bent moment
> In my little parabaloid shell
> I'll relax on a folded slab
> And lay down my conc-hrrete* pencil.
> Away from the stresses and strains
> Of ovoid and Jenkular p-hrroblems*
> Away from Geewooddian frolic
> And far from Petrunican wit . . .
> I'll just sit quietly and think about
> knitting.

> [*This is the Danish 'r' as in 'hRruth'.]

In Sydney several factors now came into play. Utzon had travelled to Japan in 1957 and to China the following year in search of further inspiration; he had also discussed the question of glass walls with Saarinen. Everything was at a preliminary stage. But, despite warnings from Ove and his team that nothing should be done without adequate drawings, Premier Cahill insisted that construction work start in February 1959, immediately preceding an election that he might not win. Even though the brief had not been completed, and there were no finished or dimensional drawings, they must begin. To facilitate this, all parties agreed to divide work into three stages: the base, the roof shells, and the fit-out of the theatres themselves.

Cahill's political decision to start at once, paralleled in many public buildings worldwide, from the Australian Parliament itself to the Canadian Museum of Culture and the Scottish Parliament, generated a sequence of avoidable misjudgments, and threatened to sacrifice merit to the meretricious. In all these cases the intended sculptural effect remained incomplete, and the functional requirements were not met. It is nevertheless true that the alternative was equally risky: had construction not formally begun when it did, the whole project might have been abandoned as a result of changed political circumstances. But in August 1959 Utzon warned Ashworth that they had 'serious problems that must be solved immediately in almost every part of the building' and that he could not 'leave the decisions to anybody else'.[20]

While Ove and his team struggled with initial calculations, he received a highly confidential telephone call, in June 1958, from the Surveyor to the University of Oxford: if the university were to establish a new college, and if they were to appoint a Danish architect, would he care to nominate someone, and would he be willing to work with that person? Was this credible? As usual, Ove jumped in. No, he would not at this stage recommend Utzon, but would strongly recommend Arne Jacobsen: and of course he would be privileged to be Consulting Engineer. Philip Dowson was despatched to meet Jacobsen, and St Catherine's College, Oxford, began to see the light of day; its first master was the historian Alan Bullock. Dowson reported that when Jacobsen was asked what he would do if the Oxford people did not like his designs, he replied: 'I shall go on talking until they agree to them.' Ruth commented that she had met someone like that before. Ove confessed in his speech that year to the annual dinner of the Society of Danish Civil Engineers in Great Britain and Ireland, that all the 'important positions on the job' – the Opera House – were old friends from before the war, including the engineers Steensen and Varming: and all were Danish – except one, who was Swedish.

The magnificent site of Bennelong Point in Sydney Harbour is bounded on three sides by sandstone sea-walls: it consists of fill to various depths, deposited on deeply faulted sandstone which itself is interlaced with clay and ironstone seams. Through all of this water seeped. Clearly the design and construction of foundations for the Opera House would be crucial first steps. The client had stated that firm sandstone existed at depths of between 3 and 5 metres; this was not fully checked, and later turned out to be inaccurate, necessitating expensive re-examination, but ulimately no significant remedial action. The initial work involved sinking 700 steel-cased concrete shafts, a metre in diameter, around the northern perimeter: mass concrete foundations replaced defective rock. Construction of the foundations began in the absence

of detailed architectural drawings; but the base or concourse of the Opera House also had to proceed in ignorance of the structure it was to support. Inevitable later changes to the design of the roofs and supporting structures increased the load on the foundations beyond expectations, and some of the foundations had to be strengthened. There remains no perceptible evidence of these processes, and many of their results are invisible. Is a spectator's experience of the building complex enhanced by an understanding of what cannot be sensed?

Sydney Opera House, without its distinctive roofs, is a reinforced concrete monolith surrounded on three sides by a walkway, and on the fourth by a large pre-stressed concourse. The monolith is almost literally 'scooped' out for the seating tiers of both main halls. But, of course, it is by its roofs that the Opera House is recognised. Utzon's first idea was that the main hall would have four main pairs of surfaces:

> Each surface was a triangle in elevation, with boundaries formed by curves in space geometrically undefined. In cross-section, a pair of surfaces (or shells) formed a gothic or ogival arch. The main shells were connected to each other by a further series of surfaces termed 'side shells', also geometrically undefined.[21]

At their first meeting with Utzon the engineers had realised that the dimensions of the proposed building were vast, and not readily appreciated: the engineering challenges would be equally vast. But if the roofs were geometrically undefined, nothing at all was determinate about the interior – acoustic requirements, size and detail of stage machinery, internal finishes. The large bending moments inherent in the roof shapes were the first major headache: it took four years of intensive calculations to implement the architect's essential ideas. The aims were to accommodate the stage towers and auditoria roofs, to provide stability under all possible loads, to establish wind loads and temperature variations on the vast curved surfaces, and to evolve a construction method which encompassed the variable geometry of the roofs. Computers and model analysis were needed to establish forces, moments and column loads. All of this gradually rationalised the design and construction, which the architect himself openly welcomed. Tests on large perspex models revealed that shear forces and bending moments were greater than anticipated; and there were larger results for load distribution to the foundation than could be predicted 'by any analytical technique then known' – perfect examples of experiment trumping theory, and of the fact that structural changes in one area almost inevitably generate the need for changes in others.

Further work showed that whereas a 'three-dimensional steel skeletal framework' was possible, the concrete surfaces would then play only a limited structural role. A second possibility, and the basis of what was finally built, consisted of fanlike ribs which could build up the roof surface. The height from springing point to the top of the largest shell is 54.6 metres, the length between the tips of the end shells of the larger hall is 121 metres, and the overall width of the largest shell is 57 metres. One major problem in constructing the Opera House was to design elements susceptible to prefabrication, in order to avoid pouring concrete *in situ* on formwork – the costs of which would have been astronomical. Ove, of course, had been promoting prefabrication since the 1930s, and with increasing vigour on his wartime committee. His initial idea of ribs was unworkable, but it provided the impetus for developments. Moreover it brought him back into participation from which he had either been excluded, or excluded himself, when Ronald Jenkins, the Senior Partner, was in charge of the shell design. Jenkins, however, had reached an impasse, and in September 1961 withdrew from the project in considerable bitterness: 'Of course I have to accept your decision on the form of the Sydney superstructures, although I regret it. . . . I think the conflict of opinion can be detached from personalities.'[22] Ove was somewhat in awe of Jenkins's mathematical abilities, and they had worked together since the 1930s; indeed, he often stated that Jenkins's abilities had enabled the firm to undertake technically demanding work and had helped to establish their reputation. Moreover, the firm funded his theoretical publications. But for some reason, Ove did not, or could not, or was not allowed to, help Jenkins in any of his work, and they never became really close colleagues.

In February 1959 Ruth sent an illuminating report to Jack Zunz on life in the office:

> He is in his usual state of not being able to reconcile himself to the fact that he can't be in two places at once. And I must say it is a pretty severe attack just now, because there are so many frightfully interesting things going on here and stretching into March for which he is really indispensable that if it were in my power I should certainly divide him into two.

She then listed work with Jacobsen, Spence, Goldfinger – 'dozens of jobs, not to mention our new offices'.[23]

3 September 1959 was the twentieth anniversary of the outbreak of World War II: to everyone in Australia, and to most Europeans, a date never to be forgotten. On that day, Ashworth launched the Sydney Opera House Appeal. He repeated what he had said at the opening ceremony six months earlier:

New ideas are always on the brink of disqualification and in this Competition considerable thought was given to stating clearly the intention or aim to be achieved and leaving the manner of their achievement to the competitors. . . .

It should be reiterated that although the building has been termed the Sydney Opera House, which is indeed a dignified title, in essence the buildings comprise a great centre of music and drama in which opera will play a small, though, of course, not insignificant part. It is felt essential that this should be stated in view of the misconception which obviously still exists in the minds of many.

Ashworth was right in every respect. But no one else was minded to modify the growing misconception: least of all the politicians. Every generation, and many sectors within it, monitor their vocabulary for political correctness: succeeding generations find the reactions of their ancestors almost incomprehensible. In Australia in the late 1950s what is now regarded as racial and sexual abuse was commonplace; at the same time, in polite society, terms such as 'adultery', 'abortion', 'divorce', 'epilepsy', 'schizophrenia' could barely be spoken. In the present case, the very words 'Opera House' resonated with exotic, old European overtones, together with cultural and class expectations. To some Australians the words belonged to the vocabulary of an alien elite, and this belief fuelled arguments about philistinism and cultural backwaters which raged for another thirty years.

At the end of November 1959 Jenkins wrote to the Executive Committee, over the signature of Ove, stating unequivocally that 'drawings which show the intention in principle are not a sufficient basis for preparation of detailed drawings to the contractor'. Arup's had been

leading a very much hands-to-mouth existence in the issue of working drawings in an attempt to enable the Contractor to keep to his programme. Frequently, finished reinforcement drawings have had to be altered at the last minute which has resulted in a standard of work with which we do not like to be associated. In our opinion this sort of thing cannot go on.[24]

But it did: for years. Another factor in the evolving saga was not confronted: except when the Arup team was talking face to face with Utzon in Denmark, and at the outset between the London and Hellebæk offices, there was a diminishing flow of information between the two teams: and ultimately, none. Packets of disembodied information arrived in London or Sydney, for action by the recipients. This was not the way to engender mutual respect, let alone mutual understanding.

In March, back in London, the Partnership moved from the Victorian offices at no. 8 to the new office building at 13 Fitzroy Street. But, for the project, 1960 was not a good year, and there were anxieties for Ove: even at the end of the year he was confessing to Ashworth that 'the whole job proved to be much more complicated than anybody had anticipated'.[25] But he continued to speak his mind, and many at the receiving end continued to be hurt. When Richard Sheppard won the competition for Churchill College, Cambridge, Ove told him it was not the most exciting design, but nevertheless did spring 'from a conception of how life in college should be lived, and it stands or falls with the validity of that conception'. He added: 'I don't suppose that my firm shall have the pleasure?' Sheppard himself did not think the design 'was very brilliant', but thought 'I would make a pleasant if anonymous background for living – which is what most colleges are, and there are only a few exceptions.'[26] Arup did not secure the commission.

On 21 March 1960 sixty-nine Africans, protesting against the pass laws, were killed by the local police at the township of Sharpeville. Their commander declared: 'if they do these things they must learn their lesson the hard way.' On 30 March the South African government declared a state of emergency and Jack Zunz wrote to Ove the following day, reporting that neither he nor Michael Lewis wanted any 'further part' in what was happening there.[27] They were also concerned about the overt anti-semitism of the Afrikaners, which could dangerously erupt.

In April the Taxation Office in Sydney informed both Utzon and Ove that they would qualify for no exemption from Income Tax in Australia. In June Stephen Haag, who later joined the Committee, sent a list of critical questions about the Opera House stage in the Major Hall, which Ashworth forwarded directly to Utzon – Haag was in charge of opera productions at the Elizabethan Theatre. After taking technical advice, Utzon followed Haag's 'very valuable' suggestions to make some modifications. Nevertheless, Ashworth perceived the necessity of his own personal intervention, and two months later, in August 1960, he arrived in London. With Ove and Utzon he visited Covent Garden, the Festival Hall and the Coliseum; and with Utzon alone he visited the Mannheim Theatre, the Vienna Burgtheater and State Opera, and the Salzburg Festival Hall. In Vienna they attended performances of *Rheingold* and of *Moisasurs Zauberfluch*.[28] After visiting Copenhagen and Utzon's offices at Hellebaek, Ashworth travelled to Cambridge for meetings with Martin and then to London and Southampton to discuss the roof model tests with Ove and Jenkins. Ashworth had brought with him searching questions and sharp criticisms from the Executive Committee, but the minutes of

their discussions reveal that Utzon was no more willing or able to respond to them in person than in writing: vague promises and reassurances were all that Ashworth extracted. Utzon was instructed that it was 'a mandatory requirement from the Client' that 'the Architect be represented in Sydney from 1st November 1960'. This was less than two months hence, and not at all what Utzon intended. Ashworth informed his Sydney Committee that both Arup and Utzon were emphatic that the control 'must remain in London and Denmark'. Nevertheless, Skipper Nielsen was despatched by Utzon, together with a potentially offensive warning to Ashworth: 'Skipper is not a social type and he dislikes that side of the life, so please do not televise and broadcast him and all these things.'[29] This was not a good start. In fact, the Executive Committee 'had been very disturbed' by the absence of representation in Sydney, and 'very dissatisfied at receiving tenders in a form which could not be considered and which were unrelated to any original estimate'.[30] Ashworth's own draft notes for the official minutes are even more acerbic: 'it was ridiculous' that Utzon behaved as he did, and 'the fiasco may be repeated' unless strong measures were taken. Unknown to the committee, however, Utzon's separate office minutes of the same meetings, edited from notes taken by Arup's man Kelman, are anodyne and complacent, omitting mention of nearly all the committee's formal questions and anxieties.

Like almost everyone else, Ashworth had been beguiled by Utzon's charm and by the enthusiasm of his very young assistants. He wrote a glowing report to the Executive Committee which, of course, was devised to allay their anxieties. But when a copy of it was received back in Hellebaek, it unintentionally hardened Utzon's resolve to ignore criticism from overseas. There was no mutual understanding, largely because there was no proper communication between Australia and Denmark. The totally inexperienced design team, working in the almost monastic seclusion of Hellebaek, knew virtually nothing of what was going on elsewhere, and this suited them very well; but Ashworth justifiably felt that his teams, embroiled in the noisy mayhem of town and country politics, knew far too little of what was being done by the Architect, and this suited them very badly. Indeed, he cabled Colonel Moses of the ABC to suggest that a documentary film be made of the work being done in the model shop, and commented on the difficulty of thinking in three dimensions and the necessity of 'constant recourse to three-dimensional models'. Moses was a crucial player in the whole saga, having been party to the very earliest and tentative discussions ten years earlier for appropriate cultural facilities.

Utzon had reported on extensive model building as early as November 1957. While Ashworth's remarks were necessary to maintain some measure

of harmony among an increasingly fractious Executive Committee, he failed to mention the deeply traditional nature of Utzon's method. By Roman times models were an entirely familiar element in the building sequence, and their advantages and disadvantages well understood. In the first century BC Vitruvius was explicit:

> Not everything can be carried out according to the same principles. There are some things that achieve large-scale results like those achieved with small models. And then there are other things for which models cannot be made at all, and they must be built to scale in the first place. And some things that seem perfectly realistic in a model vanish when their scale begins to be enlarged.[31]

To supplement such an ancient view, Ashworth's committee members might have welcomed this more recent statement:

> I will always commend the time-honoured custom, practised by the best builders, of preparing not only drawings and sketches but also models of wood or some other material. These will enable us to weigh up repeatedly and examine, with the advice of experts, the work as a whole and the individual dimensions of all the parts, and, before continuing any further, to estimate the likely trouble and expense. Having constructed the models, it will be possible to examine clearly and consider thoroughly the relationship between the site and the surrounding district, the shape of the area, the number and order of the parts of the building, the appearance of the walls, the strength of the covering, and in short the design and construction of all the elements discussed. It will also allow one to increase or decrease the size of those elements freely, to exchange them, and to make new proposals and alterations until everything fits together well and meets with approval. Furthermore, it will provide a surer indication of the likely costs – which is not unimportant – by allowing one to calculate the width and height of individual elements, their thickness, number, extent, form, appearance and quality, according to their importance and workmanship required.

The embarrassing feature of this statement, however, is that it was made around 1450, by the learned Renaissance humanist and architect Leon Battista Alberti.[32] Vitruvius and Alberti rightly stated that there are both technical and aesthetic reasons for not arbitrarily enlarging the scale of something – Aristotle, one source of such ideas, had warned against overlooking the relevance of size and scale (and the distinction between these notions) in all walks of life. In the modern context, however, there was another issue:

the independent, and not always complementary roles played by physical modelling, on the one hand, and mathematical modelling on the other. This last, which was a rapidly advancing technology by the 1960s, was still *terra incognita* to most architects. But not, of course, to Ronald Jenkins, who in 1953 gave modern advice on behalf of Arup's: 'To "blow up" any results from a model chosen at random, stresses and deflections must be adjusted by a factor which includes the relative spans, loads, extensional and flexural rigidities.'[33]

Every serious builder, architect or designer since the fifteenth century knew about such matters, albeit with modest mathematical precision, and a vast number of models of churches, palaces and public buildings, as well as of smaller edifices, existed around Europe.[34] The great model of St Paul's Cathedral by Christopher Wren was only one of the best-known models in London. Had Ashworth emphasised what was entirely traditional, alongside what was innovative about Utzon's procedures, both Architect and Client might have come closer to mutual understanding and co-operation. As it was, Utzon and his young assistants cultivated outright disdain and derision for the Client – with inevitably disastrous results. Ashworth sensed the problem, and in a widely distributed talk of June 1961 asserted that:

> the model shop is [. . .] of course in reality but an extension of the practice adopted by the great architects of the Renaissance who invariably produced models of their proposed buildings. Model making serves a number of purposes. It explains to the layman exactly what is proposed. [. . .] It also assists the Architect in that again he does not delude himself – this can easily occur if he relies upon two-dimensional drawings – many problems become more readily perceptible in a model and thereby can receive adequate attention and a solution found before work on the site commences.[35]

Ashworth also reported that he had been 'particularly impressed with the vast amount of trouble being taken to create beautiful interiors for both the Minor and Major Hall. The Architect had a very unique design for a suspended tent-like ceiling in the Major Hall.' What Ashworth did not know, at this stage, was that Arup's sole model maker, David Armstrong, had made a cardboard model of one 'shell' based on rough drawings of the ribbed scheme, and that the model helped everyone then to resolve both technical and visual problems. Good: but there was now an urgent need for *detailed* drawings: without which, nothing, or at least nothing fully satisfactory could emerge.

A little earlier, at the beginning of October 1960 Utzon had sought advice from his quantity surveyor, Ralph Goddard, and had proposed an abbrevi-

ated account of his intentions to the Executive Committee. With cynical pre-science, Goddard had commented:

> I am not sure as to whether or not your shortening of the report is right. After all when the Committee read this report there is a good argument for blinding them with science and lots of words. I am inclined to think that the psychological approach should be one of a rather lengthy report and them letting Ashworth interpret it to the Committee. You and I obviously know that this is a lot of rubbish but we are after all dealing with laymen and to a certain extent 'selling our goods'. I don't think you should make the Committee's job easier. Let them suffer and they will be tickled to death for they will in their pompous way sit for hours on it.[36]

If Goddard had a hunch that Utzon could succumb to his own 'rubbish', he did not have to wait long for proof. Unfortunately, like Ashworth in Australia, his co-operative approach misfired, or rather was ignored. In November Goddard warned Utzon to 'avoid being too formally committed to a very hard fixed price contract figure' for stage machinery: and that he should 'not worry too much about dates' although if they got in a jam he would be very willing to help.[37] At just this time, in November 1960, Jenkins was also sensing problems ahead, and warned Ove, who was in Africa.

While Ove was away he received a totally unexpected letter from an old acquaintance, Alan Harris, a senior consultant civil engineer who had recently addressed the RIBA on engineering:

> To see you in the audience made a very piquant situation. It prompted me to write you a line to say something which has been on my mind for some time. Those engineers who work with good architects in a spirit of harmony and common aims are really a new race, created by, and creating, a new sort of architecture and, thank God, a new sort of architect. The whole situation is almost the invention of one man, yourself, and both architects and engineers should be profoundly grateful for it. Your capital contribution has been little understood; rest assured that I at any rate appreciate it. While there are a lot of us elbowing one another to follow you, you blazed the trail.[38]

A certain disregard – some would call it realism – for escalating costs existed among other members of the design team apart from Utzon himself. His theatre consultant Walter Unruh wrote to Ashworth in June 1961 about the stage lighting equipment, and adopted a position that was becoming alarmingly familiar: 'after the final establishment of the Opera House nobody will

ask about detail costs, but only criticize the artistic performances and the technical effects possible.'[39]

In London, Ove had continued discussions with Pier Luigi Nervi, and introduced him when he was awarded the RIBA Gold Medal in 1960.[40] He had been fascinated to learn, of course, about Nervi's strategies and model tests in designing and constructing vast reinforced concrete hangars for the Italian Air Ministry in 1935, and again in 1940. They spanned 330 by 135 feet internally – but Nervi reported that 'the Germans destroyed them when they retreated'. Ove was also privately envious that Nervi had designed and built himself a 40-foot ketch, using ferro-cement. But, as he had done in 1955, Ove could not pass up the opportunity to express his agreement and disagreement with Nervi's views, because they now related directly to the Opera House:

> He is still the archetypal builder, for whom the ends and the means fuse into one harmonious creation. [...] The starting point is the need for economy. Naturally, a great and beautiful structure is the end in view [... but] Designing in reinforced concrete it is essential for economy to lead the forces down to the ground by direct thrust.[41]

Because repetition is the key to economical formwork, it followed that 'a simple geometrical shape for the roof is preferable, because it can be subdivided into identical elements'. In 1955 Nervi had said that 'the outward appearance of a good building cannot, and must not, be anything but the visual expression of an efficient structural or constructional reality'. Ove denied that this maxim could be 'the main criterion of architectural merit': it did not fit many obvious major works – Le Corbusier's Ronchamp Chapel, or several buildings by Mies van der Rohe and Oscar Niemeyer, and it overlooked his long-held belief that size and scale are always relevant to criteria of merit. Indeed: 'Nervi's own obvious interest in form is not always the visual expression of structural and constructional reality.' Formal and spatial relationships, on the one hand, and structural rightness, on the other, can conflict:

> the idea that the correct functional, the correct structural and the best possible aesthetic solutions are one and the same thing must, I am afraid, be abandoned together with the older philosophers' dream about the harmony and ultimate identity of truth, goodness, justice and beauty.

Ove's own philosophical interest had here provoked him to challenge, in the most public forum, generalisations that were largely publicity slogans – or stylistic banners, within the philosophically unrigorous world of architects. Ove was explicit:

Whilst I do not think [. . .] that Nervi's architectural philosophy can be said to cover the whole field of architectural criticism, I still think his approach to design is much more valuable, and in much more need of restatement than any other architectural maxim I have ever heard of.

Building is 'art inside a limited framework, where certain rules must be obeyed. Nervi's kind of logical build-up of the scheme is to my mind the essence of good engineering and good architecture alike.' Architects naturally

forget about the more sordid facts of life because they – quite legitimately – get absorbed in the aesthetic aspects of their work. That is where art criticism steps in, and all sorts of violent arguments rage about styles, movements or philosophical approaches to architecture: [. . .] renewal of the architectural content [to the discussion] can only come from a return to the fountain-head, the art of building.[42]

This was Ove's practical view of philosophy, in the tradition of Cicero and Hume, rather than of Plato or Kant – as he gleefully said on more than one occasion, 'Kant failed in his heroic attempt to establish a universal science of ethics', embodying absolutes.[43] Life itself, in all its particularity, is both the source and the ultimate test of any defensible philosophical claim: whoever ignores that fact must be rebutted. The irritation which many of Ove's engineering and architect colleagues felt towards such remarks stemmed from their view that philosophy should be left to philosophers, who could then be conveniently ignored. Ove should not legislate on their architectural manifestos: if acolytes swayed to their incantations, that was enough. For Ove, it was more than enough. He feared that flamboyant rhetoric and incontinent generalisations easily attracted indefensible attention, as he was forced to reiterate one year later: 'I am not really attacking Nervi – he is on the side of the angels in this matter – I am defending him against those who would use his words to defeat his spirit.'[44]

In fact the views Nervi expressed in 1955 were virtually indistinguishable from Ove's. Like Ove, he was wholly opposed to considering a structure solely 'on the basis of its external appearance', and he held that the architect of the future 'Must possess – and synthesize in himself – aesthetic sensibility, profound understanding of structural needs, and a precise knowledge of the methods, possibilities and limitations of constructional techniques.'

In his own speech, Ove rejected any talk of 'a universal and perennial style of truth': for him it had an 'ominous totalitarian ring. Like *gleichschaltung*.' This was because it could never come about 'without the imposition of an ideology': 'building technique is only a means of accomplishing with the least

effort that which we want to accomplish – but it cannot tell us what we want, or what we ought to want', one of which 'roughly deals with aesthetics and the other with ethics'.[45] This was a distinction at the forefront of his mind.

In September 1961 the quantity surveyors told Utzon that Arup's found it impossible 'to give any sort of estimate of the special measures that will have to be taken' to complete construction of the superstructure. Accordingly, they needed 'to emphasise the importance of the strictest control of cost on the shell contract'. By the very same post Goddard sent a separate 'Personal' letter to Ashworth:

> There is no doubt in my mind that the job could be stopped if Utzon has his own way, for he has no idea of economy, and therefore a lot of trouble could fall upon your shoulders. [. . .]
>
> I cannot help thinking that you can have a super Opera House, with reasonable finishes, and adequate seating, for a much less figure, but I am not prepared at this stage to say this could be accomplished with Utzon working in Copenhagen and living in dreams. [. . .] We will endeavour to the best of our ability, to bring Utzon to what I call a realistic approach.
>
> To me it stands out a mile that if you want your Opera House built for an economic price, you will have to, in your normal wise way, approach Utzon, and explain to him that he should associate with a local well-known architect in Sydney to supervise the works, on a firm contract, and this local firm would be precisely briefed by you, after Utzon had stated his case.[46]

So concerned was Goddard that, on reflection, he sent Ashworth a third letter on the same day, this time headed 'Personal and Confidential'. He was 'really most worried' and 'very concerned at the figures we have arrived at'. He went to see Utzon in Copenhagen and reported by telegram: 'Poor Fellow has been badly shaken and I am sure he will co-operate in making substantial savings.' In October he tried to reassure Ashworth, and himself, that 'looking at the matter psychologically, it would seem that he has now tied himself more personally to you and your Committee, by his decision to settle in Australia';[47] moreover 'Jørn has persuaded Ove Arup to give an estimate for the Shell construction'. Nevertheless, two months further on, at the end of November 1961, Rider Hunt had to repeat their advice to Utzon:

> in our opinion the total cost of the project can only be held to a reasonable level by the exercise of a very strict cost control and by the full co-operation in this connection by the consultants at all stages [. . .] the strictest control must be exercised on expenditure.[48]

Utzon would not, or could not, respond to this advice. He decided to lean on his friend Ashworth, claiming: 'we are very lucky that we have been so stubborn because this last scheme, which as you know we have been working on the last eight months, is rather revolutionary and elegant and its simplicity will save a lot of money.' By now, however, Ashworth was not so compliant: firstly he reminded Utzon that he was 'far away and it is difficult for you to realise that the ordinary public cannot understand why the Opera House should take so long to build'. Bizarrely, within a few weeks, Ashworth was also telling Ove that the enormous distance of architect and engineer from the site enabled them both to get on with things unhampered by trivia.[49] Nevertheless, he followed up his warning to Utzon with another message, three days before Christmas:

> It is felt quite firmly here that before a decision can be made to import yet another item from overseas, the whole problem must be better documented. [. . .]
>
> It is felt that you should be able to inform the Committee what actions you have taken and with what results to obtain the kind of tile required in Australia. [. . .] the Executive Committee are quite sure there would be tremendous opposition to the use of foreign tile unless a satisfactory case can be made. [. . .]
>
> All this, I am sure, must seem very tiresome from your point of view, particularly as you are so far away from it all, but I am quite sure that if the job is to go smoothly, there is no object in antagonising local manufacturers and producers needlessly.[50]

A contrite reply duly arrived in mid-January: 'I want more than anything to have everything made in Australia and avoid any political trouble for you and Mr Haviland and I quite understand the Committee's reactions.'[51] But once again Utzon had asked Ove to discourage criticism from overseas, and Ashworth duly received a 'Personal' letter from Ove, originally drafted and typed by Ruth Winawer at the end of September, but now re-dated seven weeks later, as an attachment. It was characteristically generous towards Utzon:

> I am writing this private letter to you, because we are not quite out of the wood yet – although we see daylight ahead –
>
> If you examine Nervi's structures and domes or hangars they are all based on the repetition of precast units, and we had often discussed the possibility of using such a method with Utzon, but the fact that all the shells were different seemed to preclude this. However, in the course of our discussion

Utzon came up with an idea of making all the shells of a uniform curvature throughout in both directions – in other words they are all cut out of the same sphere. This would mean that every segment of the shell was identical.[52]

Ashworth replied by return of post:

Obviously nobody here is really knowledgeable or at all conscious of the vast amount of work and enquiry you have had to undertake with regard to the shell roof and I suppose the continued lack of authentic information out here tends to exaggerate such anxieties as do exist.

I know that you do not feel that I, myself, am in any way critical of the development of the project. I at least have some small appreciation of the problems involved. On the other hand, I do feel it is my duty to try and minimise such criticism as is inevitable and do what I can to assist you and Joern in this regard. Obviously members of the public tend to feel that the project is taking a long time and compare it with other large buildings being erected in the city. This, of course, is quite fatuous but nevertheless does happen.[53]

Much ink has been spilled over who first thought of the solution eventually adopted for rationalising the roofs – the architect and his supporters alike claimed to recall the precise *eureka* moment in Denmark at which Utzon had the requisite flash of inspiration; the engineers and some of their associates, with equal conviction, recall discussion in both central London and at Ove's house. In modern times, architects have been prone to seek individual credit and claim originality, while engineers regard their solutions as team efforts emerging from multi-disciplinary contributions. Fifty years ago the normal professional subordination of the engineering consultants to the architect meant that, even if the architect had not made the design decision, and the engineer had, the former would have claimed to have done so, and the latter wouldn't. In fact, the existing evidence shows that Arup's canvassed several possibilities for the geometry of the shells, from parabolas to ellipsoids and spheres. In early February 1962 Jack Zunz sent a message to Ove, on holiday in Austria. He could not know that Ove was about to be dangerously ill:

The enclosed sketch was the bombshell which Buus [Mogens Prip-Buus, one of Utzon's assistants] brought with him on Monday. The hope is that the intersection shells will now be made of a sphere of the same radius as the main shell. The structure as it is shown is unworkable because of the abrupt

cut-off but we have already made some suggestions on how this can be over-come . . . this will mean considerable recalculation. [. . .]

I have explained to Buus in detail how difficult it is for us to maintain enthusiasm amongst the people working on this apart from the political difficulties which may arise in Sydney. [. . .]

For the rest life carries on in its usual chaotic way.[54]

The essence of the scheme finally adopted is 'that each main shell has its external surface described as parts of a sphere'; indeed, each triangle, which forms the outer surface of the shell, is a portion of sphere. Each shell is made of two mirroring halves, and each half consists of a series of concrete ribs. The ribs spring from a reinforced concrete pedestal and radiate from the podium, becoming wider up the shell. The size and weight of the segments of each rib were determined by the capacities of the largest cranes available: three tower cranes were acquired from Europe, each capable of lifting 10 tons 100 feet away from the masthead, the majority of the ribs being 15 feet in length. The rib segments were erected with the aid of a huge moveable and sectioned steel arch, which was more economical than fixed scaffolding. The arch was positioned to allow for each new rib, and when that was constructed the arch was moved on tracks to its next position. The arch followed the geometry of the ribs, and ball joints allowed its two halves to swivel. The precision with which the segments needed to be cast, pre-stressed, assembled, bonded and bolted together entailed surveyors working inside the structure, and continu-ous computing of surveying calculations, together with the use of sliding bear-ings and bolts and jacks. Strictly speaking the roof is not a set of 'shells': that term belonged to 'early pious hopes that membrane action would largely suffice to support the structure' – but the term has stuck.

Utzon's enthusiasm for the ribbed scheme also revealed an attitude of which even his closest assistants became only slowly aware: 'I don't care what it costs. I don't care how long it takes. I don't care what scandal it causes. That is what I want.' Zunz was stunned when he first heard this, and Utzon's cavalier attitude to costs was to cause endless friction. Increasingly he insisted that provided a beautiful building resulted, the end justified the means: the public never asks what the Pyramids, the Acropolis or St Peter's cost. Of course, Utzon was wrong: he did not specify which 'public' he had in mind, nor how narrowly he interpreted 'cost'; nor did he acknowledge that it is entirely contingent whether records of expenditure or memorials to workers survive.[55] The most valued achievements have always involved costs, very often lives: on reflection, many people are appalled at the expense of life in building St Petersburg or the Pyramids, and do not regard the end as having

justified the means. He told Lewis that the acoustics didn't matter, and the number of seats didn't matter, provided audiences were overcome by the beauty: this was his response to an alarming piece of information. It had emerged that by designing the roofs out of a single sphere and by letting the great circles generate the rib forms, the internal clearances had been dramatically reduced. The volumes could never meet the Client's stated requirements. Quite literally, the inside would be what was left, after the outside was finished.

Within a year of starting work on the roof design, Ove had enjoyed several long conversations about the design and modelling of shells with both the Spanish and Mexican engineers Eduardo Torroja and Felix Candela, during their visits to London, and with Pier Luigi Nervi whom he already knew and greatly admired: all three overseas engineers severely criticised Utzon's published sketches.[56]

No one doubted Utzon's self-questioning search to achieve his dream; but by now he was beginning to treat any question by clients or partners as negative criticism. As if to celebrate an enveloping unreality, Ove became momentarily engaged in yet another grandiose proposal: to move the statues at Abu Simbel, on the Upper Nile. In an attempt to avoid lifting them, Geoffrey Jellicoe invited Ove in March 1962 to form a partnership, Arup-Jellicoe, to enclose the whole of the sculpture site 'in a circle of glass and reinforced concrete'. Ove declined, although Povl Ahm worked out a detailed scheme along these lines.

In fact, Ove had been taken seriously ill, and was away for three months. For decades he had suffered from low blood pressure, and over many years had periodically, sometimes dramatically, fainted: this caused considerable anxiety among his family at home and in Denmark. The strain of overwork on the Opera House took its toll. Soon after arriving in Austria for a skiing holiday he collapsed and was rushed to hospital with a suspected heart attack. Li was understandably distraught, but a fellow guest at their hotel turned out to be a heart specialist, and immediately took charge of the patient, the hospital and subsequent events. After some weeks of complete seclusion, Ruth Winawer went to his house each day with any urgent correspondence.

Obviously, Ove could not himself travel out to Sydney with Utzon and Zunz. They, however, had to delay their plans by a week, because the engineering drawings were not ready: this was fortunate. The American Airlines flight from New York to Los Angeles, on which they had been due to fly, crashed on take-off with the loss of all ninety-five lives. During their journey westwards, Utzon expressed another extraordinary view, which he repeated

later: he did not care whether the job was cancelled because he had solved all the problems in his head.

The journal *Architecture in Australia* published eight progress reports on the construction of the Opera House between September 1960 and October 1968. By 1962 commentators were finding it difficult to distinguish well-informed criticism from spite. Desmond O'Grady, in *The Bulletin* for 28 July 1962, remarked that both kinds of criticism had been evident 'since the project was first mooted in 1947 and the most recent squabbles must be seen in the context of the whole opera house story, which is made up of four main elements: design and construction, fund raising, administration, and politics.'

In his final draft of April 1962 to the Secretary of SOHEC on both estimates and the time schedule, Utzon proclaimed:

> The building is conceived as an architectural entity which is achieved not by artificially collecting a miscellany of architectural features, but by a progressive purification of structure, based on ideas stemming from the function of the project. Nothing can now be deducted without destroying the whole idea.[57]

This last proclamation was not an empirical claim, but an abstract and essentially romantic dogma. To strive for coherence and unity is one thing, to claim that nothing in a result can be changed without destroying the whole is another. Certainly Utzon and the engineers were locked into sequential problem solving, each successive decision constraining the next: but this is not what he emphasised. In any case, such rhetoric was by now counter-productive in the ears of the Client. Of course, as Goddard had said, every architect must develop a marketing vocabulary to promote an as-yet non-existent building – the final detail and effects of which even the architect is ignorant. But few architects are willing or able to modify their sales-talk to clients who challenge its hyperbolic character or its pretentious abstractions: and Utzon was not among them.

At the beginning of June 1962 Haviland conveyed to Utzon a sustained and detailed critical analysis of the proposed stage design by Martin Carr, who was on leave as a stage manager at Covent Garden to work with the Elizabethan Theatre Trust.[58] The Theatre Trust had always had a close interest in developments, and was represented on Haviland's Executive Committee by Haag. Indeed, the criticisms took further those of Haag, which had been sent to Utzon two years earlier. The acoustic adviser Lothar Cremer, in 1966, confirmed that Utzon's designated maximum seating capacity for the Major Hall, in 1962, was 2000; he, Cremer, was appalled to discover that the Client's

competition requirement was for between 3000 and 3500 – figures that Utzon had neither attempted nor approached: moreover, Utzon had not abandoned placing some of the audience behind the stage, even when the Client rejected the idea. Carr was fully aware of this dramatic shortfall, but he began by asserting that 'whatever the outside of the building is like, the primary importance is the stage'. He criticised the shape, height and width of the stage, the physical facilities for artists, the location of dressing rooms, the widths of doors and lifts, and the location of lighting switchboards – all matters which, even after Utzon's departure, were never fully resolved. He entirely agreed that the exterior design was 'exceptionally beautiful', but for a highly technical building such as an opera house, competitions were not the best way forward. Perhaps, five years into the project, the Committee would now deign to answer some questions?

> the knowledge of the Architect concerning the detailed interior planning and
> [. . .] what advice he took on this subject and at what time in his preparation of his designs he took this advice? Whether he made a full study before
> he put pen to paper or whether it came after the design had been selected.

Carr was himself an expert and gossip was widespread: he must have been tipped off by someone on the Committee for his letter identified crucial problems, and he had scored with every punch. But the referee was not about to award him even one round. On the contrary, the Chairman of the Executive Committee, Haviland, not only postponed a decision, by sending the criticisms to Utzon to sort out, but threatened Carr about his future career. Carr did not report, and the press did not discover, this Stalinist tactic at the time, but the minutes recorded everything. Two months later, in August, the Lord Mayor asked why no proper public relations exercise had been undertaken to inform the public of progress and promote interest – nothing was done for another two years – but Haviland furiously disclaimed any authority so to act. In fact, he deeply resented the criticisms that were increasingly made by experts on the one hand and by the Client on the other. In the same week, the Minister for Public Works, Ryan, questioned the stability of the shell roofs, the novel design and 'the very great cost involved'. He suggested that another Consultant be required to check the Arup firm's work and calculations, and Haviland was instructed to ask for Ove's 'opinion as to the method of approaching the second Consultant'.

At the end of the month, Ryan telephoned Jack Zunz in London at 2:00 a.m., the day before he and his family were due to go on holiday: would he please fly out to Sydney immediately, preferably accompanied by both Ove

and Utzon. Ryan did not know that Ove had been very ill, and away from the office for three months, but Peter Dunican insisted that Ove should make the effort to go: and the long journey began. Zunz and Utzon arranged between themselves who was going to speak about what at the Cabinet Committee, but they had reckoned without the boss. Ove lunged forward, and held forth, uninterrupted if not always coherently, for forty minutes. The assembled company was dumbfounded: no questions were asked. Everyone was sure they had got the drift – in a manner of speaking – and the minutes recorded that: 'the members of the Cabinet Committee were very impressed. We have reason to be grateful for their help.' Although different in form, Ove's charm could be just as effective as Utzon's: each enveloped a suppliant in a fog of enthusiastic babble. And when they were together?

Premier Heffron confirmed Stage II, and announced an increased estimate cost to £12.5 million.

Summarising these events in September 1962, R. J. Thomson, Secretary of the Executive Committee, wrote a confidential report for the minister about the original estimates in 1957 for the winning designs. He rightly observed that they

> were taken out for comparative purposes only and, although they were quite valid for these purposes, the fact that they were necessarily based upon the very limited information available from the competition drawings meant that they had little value as indications of the true costs of erecting buildings in accordance with the various conceptions put forward by the competitors concerned.[59]

Thomson added that as early as January 1959 the engineers had doubted they could supply the constructor 'with working drawings so as to enable work to proceed without interruption and in a properly phased manner'. Nevertheless, it was 'beyond doubt that a most rigid supervision has been exercised by the resident site staff and that there is no ground whatever for complaint that cost exceeds the value of the work done'. He concluded: 'the 1962 estimate of £12.5 million is the first real estimate of the overall cost of the building.' In fact the minister often felt that the committee left him in the dark. In October 1962 Haviland was sharply informed that 'at times Press releases have been the first indication that the Minister has had of important developments in relation to the project.' How did he propose to answer criticisms from the Auditor General, press and parliament concerning 'the great amount of money which will become payable to the Consultants because of the increases in the estimated cost of construction'?[60]

At the office Christmas party for 1962, Ove made his annual speech: 'Loyalty is of course a great thing, teamwork is necessary, team spirit even, but not group think, not Big Brothership. We must not strive to produce or take "yes-men". Let us remain a collection of oddities if you like . . . My country right or wrong is not the right slogan.'

9

'glory or blame . . . at the edge of the possible?'

Utzon and his family planned to leave Europe on 26 December 1962, flying westwards for a three-month trip to the United States and Tahiti before going on to Australia. They arrived in London on Boxing Day, where Jack Zunz had hired a room at the Aerial Hotel, Heathrow, to enable the Arup team to discuss matters with him. Zunz brought a list of sixty-three 'Matters affecting Utzon', and remonstrated with him for disappearing for three months, leaving the consultants with no architect to talk to. Utzon later complained that decisions had been made in his absence, which was not true. It was beginning to dawn on several participants that tensions were emerging between the architects and consultants.

An absurdity of the gathering was appreciated only later – by some. It was the coldest December since 1947, and soon exceeded even the records of the late nineteenth century: the Thames was partly iced over, freezing fog hampered all transport, power supplies broke down everywhere, and the heating in the hotel failed. Ove had still not fully recovered from his serious illness earlier in the year, and felt unwell: he sat with his feet in the bath, trying to

keep warm, and communicated grumpily through the bathroom doorway: and then departed. The meeting was attended by a younger South African colleague of Jack Zunz, Michael Lewis, who was going to represent Arup's in Australia. As he broke a leg in Israel on the way, he did not reach Sydney until April, a month after Utzon. From the outset, they did not get on. Lewis was a disciplined and practical engineer who, like everyone else, was inspired by Utzon's architectural vision and totally committed to bringing it to realisation. But he distrusted Utzon's charm, and the clap-trap with which he tried to bamboozle client and public alike. Lewis's loyalty and integrity over the next four years, documented in all the papers from the Cabinet to the site office, contrasted dramatically with Utzon's often high-handed behaviour – equally recorded.

The longer Utzon failed to resolve any issue, large or small, the more he began to distrust everyone else, including his own staff and consultants. Lewis shared the view of others that because Utzon became famous before he had done anything, he suffered both from the fear of having to prove himself, and the conviction that he was exempt from any need to. Utzon was convinced that his task was to have design ideas, but he seemed to lack appreciation of their consequences. Moreover, since he rarely expressed precisely what his ideas were, his responses to those who tried to interpret them were never fully understood. It certainly assisted Utzon to know, as it did anyone else, what his expert advisers might be able to do, before he finalised his own proposals. But at the outset he largely detached himself from such concerns, in order first to focus his attention on the sculptural forms: these became his priority, whereas the Client emphasised the functions he had been commissioned to satisfy.

Utzon constantly proclaimed two views: first, that he had finally solved one or all problems 'in his head'; second, that nothing should go ahead because a more perfect solution might emerge at any moment – this claim was fuelled by recognition of the inter-connection of all decisions, and the knock-on effect of any one of them. But engineers face precisely the same challenge as architects: the material embodiment of decisions destroys the seductive promise of revisable ideas. In any case, Arup's quickly detected that, in addition to claiming that he had 'solved everything' – in his head – Utzon relied on others to do anything difficult or detailed: absorbed in design, as he was, he produced minimal documentation himself. During the almost exclusively engineering stages at the outset, this was not an obstacle. But, as the project developed, he increasingly resorted to declaring that as long as people were bowled over by the beauty of the building, negative criticisms of the process or product

would disappear. In terms of audience attendance, spectator interest, journalistic attention and architectural reputation, Utzon was right. The primary concern of audiences is the event they have come to witness, or in which they participate: familiarity with the place, and the emotions associated with such events, displace questions of impracticality, discomfort and maintenance, except for those who have to make things work – on whom responsibility devolves. Users, however, always have to adapt to the facilities available: to them, the challenges created by inaccessibility for the aged or infirm, moderate acoustics, reduced seating provision, innate inflexibility, inadequate facilities backstage – none of these factors is resolved by public acclaim of the sculptural forms. Nevertheless, the failings of the Opera House have not redounded to the discredit of the architect. And the superb engineering has not been credited to the engineer.

In London not all was peace and goodwill. In January 1963 Peter Dunican distributed yet another memorandum to his fellow Partners, with a particular nod towards Ove himself:

This is supposed to be a partnership and I think the time has come for some plain speaking. There is far too much concerned with 'I' and not enough 'we'. Sydney highlights this. Ever since the summer of 1961 the interests of the job and the firm have been clouded by an undercurrent of conflict. In my mind there is no doubt that the basic decision taken with respect to Sydney in September 1961 was correct although I think the way it was implemented could be argued about. [. . .] So let us stop indulging in the cult of personality and all that. [. . .]

May I remind you of the Battersea Coat of Arms. It is a shield surmounted by a dove carrying an olive branch, and it has the superscription 'Not mine, not thine, but ours'. It is with this in mind we should try to move forward.

One immediate result was a formal statement at the end of March about 'the organisation of the job'.[1] The preamble asserted that 'clearly the Architect has the overriding responsibility for the whole of the scheme. It was his genius that produced the sketch design which won him the competition, he gets the glory or blame for the success or otherwise of the whole thing.' But the existing arrangement was bifurcated in that the 'structural consultants have a direct contract with the client i.e. the Premier of New South Wales and are responsible to him'; and the specialist consultants 'are made responsible not to the architect, but to the structural consultants'; all this is 'absurd and cannot be allowed to continue'. Arup's objected to taking the resulting 'gamble whether the fees recoverable from the client are sufficient or not to cover the special-

ists' fees'; furthermore, they were currently not compensated for the financial risks involved. Since the architect chooses these specialists he should assume the normal responsibilities. In their efforts to assist Utzon with professional, financial and managerial advice, the Client had proposed appointing Arup's as 'co-principal agents with the Architect', but Utzon objected: the practice in Australia was for the architect to appoint consultants when required, and, to this end, his fee was inflated. He was overruled and Arups were appointed as Consulting Structural Engineers. For thirty years Ove had been arguing that such muddled division of labour had to be superseded: had he not finally found a talented architect who understood and truly embraced the integration of architecture and engineering?

The additional tasks – normally falling to the architect – that Arup's had undertaken for Stage I, and would presumably be expected to undertake during Stage II, could not 'possibly be construed as falling under our duties as structural engineers': worldwide searches for materials and equipment, for cranes and systems of erection, design drawings of the tile lids, and the innovative but extensive use of 'electronic computers' for innumerable calculations. By December 1962, Arup's had worked 175,000 man hours on the job, and estimated a further 300,000 for the completion of Stage II: they stood to lose between £100,000 and £200,000 on the structural work alone. They then stated: 'we want to make it quite clear that we do not aspire to become co-principal agent with Utzon nor do we recommend such a course.' The principal reason was that the 'brilliant' winning design depended:

> for its success on the subordination of every detail to the overriding architectural or aesthetic conception. This strict enforcement of aesthetic control and striving for perfection is of the essence of the job. It means that nearly every detail is unique and has to be invented, checked, discarded and reinvented in a never ending search for the correct solution.

The State Premier was no doubt encouraged to read Ove's concluding declaration that Utzon, as a designer, was 'probably the best of any I have come across in my long experience of working with architects'. Moreover, 'The Opera House could become the world's foremost contemporary masterpiece if Utzon is given his head.'[2]

Arup's knew well that almost any complex construction job generated personality tensions; they fully accepted that project leaders and managers are responsible for anticipating problems and minimising their adverse consequences. If the leaders and clients came into conflict, issues had to be quickly identified and mutually resolved. Jack Zunz cautioned everyone that they were

working at 'the edge of the possible'; and as soon as he arrived in Sydney, in the spring of 1963, Michael Lewis warned Ove about 'distinct signs of a rift' between the Opera House Committee and the Public Works Department. Lewis instituted and chaired weekly site meetings, which always concluded with a list of 'Unresolved Design and Construction Problems'. There were never fewer than nine items on these lists, and in November one stated: 'Complete detailed specifications required for all aspects of the work.'[3] A month after his arrival, in May, Lewis sent a memorandum to Ove and Jack Zunz in London.[4] He fully endorsed the existing plan to start Stage II 'before making detailed plans for the completion of the job': the contractual complexities were getting worse, and the government was impatient of further delays and costs. He counselled strongly against drifting into *de facto* administration of the whole project without authority to direct the work, or payment for it. The crucial question was whether Utzon was willing and able to set up the necessary organisation on the site to run Stage II and Stage III. Lewis correctly surmised that Utzon would not like anything he was proposing. Indeed, in September 1963 Utzon heavily reassured Zunz that he was '100% sure of your great skill and sincerity and when I say your, I mean you and Ove Arup and Partners'. But, and there was a very large 'but':

> Only I, I am sure, can possibly visualise the final picture of the Opera House. [. . .] No matter how difficult and heavy it is for all of us, I cannot leave any detail to other hands, and especially in this building . . .
>
> I think my mistake has been that every time you have had new people coming into this scheme, as now for instance Mr Lewis etc. I have not been able, even if I have tried hard, to make them understand what great danger there lies in side-tracking and not even the smallest detail, which, in the newcomers' mind has no importance, could from the architect's point of view, be left over or taken carelessly, because a number of details always add up to a total picture. [. . .]
>
> I would be very glad if you and Ove would write a stimulating letter to Mic and the staff here stating that the reason for our fine collaboration has been a mutual respect and that this mutual respect must be our main base for our relations in the future for Stage III.[5]

In the Sydney meetings, Utzon reacted intemperately to anything perceived as criticism, and he informed the Director of Public Works that he was not 'altering' designs, but 'developing' them. Ove's team subscribed to the essential scientific view of unending sceptical scrutiny – the probability of error always challenged the possibility of success: no engineer can afford to sub-

scribe to the dogma 'My country, right or wrong', as Ove had himself insisted in his Christmas message to staff. Utzon, however, demanded uncritical adherence to his views, and proclaimed the Romantic myth that criticism destroyed sensitive talent. No one of calibre could work in his team, nor he with them: he treated his team of newly qualified young graduates like puppets. He proudly told Premier Renshaw the following year, on 2 October 1964, that some of his consultants 'have actually resigned because of their lack of tenacity to strive with me to obtain this high quality'.

All values have costs: resources necessary to implement them, and sacrifices to sustain them. It can be argued that the most important resources are not physical: they are beliefs, and virtues such as willpower, courage and determination. Under pressure to act, however, few of us reflect on the costs of our values, because few of us are fully aware of what our values amount to. To Ove, such reflection, self-absorbed as it might be, had been second nature since student days; with advancing age, however, he became increasingly depressed that so few shared his concerns. The ceaseless self-criticism he advocated rested on a foundation that was understood by few of his colleagues – it did not entail, indeed, it could not entail Utzon's perpetual postponement of action on the grounds that something better might turn up. To Ove, the fact that all our ideas and practices have an effective lifetime, and ultimately need replacement, was not a threat that inhibited action, but a challenge that warranted enthusiastic enquiry and confident enactment of the decisions made. Utzon's idealism and striving for perfection appealed to Ove's own aspirations: it was one of his most painful discoveries that they lacked all intellectual foundation. Ove was only too familiar with his own preference for contemplation rather than action – hadn't his mother constantly told him to 'Stop brooding: do something!'? – and of the self-deception it generated.

The charm with which Utzon seduced most of his listeners was a device to get his own way: ultimately it deceived himself as much as his victims. His poor academic background, hampered by dyslexia, arguably contributed to his vilification of even mundane requests for discussion, as revealing a philistine failure to perceive his transcendent artistic vision. At the outset he was well aware that he knew nothing about opera houses, and even less about acoustics; nothing about Australia, and less about its history or political contexts. But whereas he was forced to take remedial steps about the former he did nothing about the latter, even after he took up residence in Sydney. Aside from occasional necessary public presentation of his ideas for the Opera House, Utzon, like most of his colleagues, became something of a recluse, spending time with his family and the design of their private house. His

detachment from, and often overt disdain for, local interests, practices, culture and history neither healed misunderstandings nor created a context for mutual respect. Tensions inevitably increased when he blatantly excluded participants by speaking in Danish to his own team. In fact, although he did properly analyse the physical contexts of his commissions, he never investigated the complexity of their social and intellectual traditions: this led to the severance of his involvement on several later occasions, including the National Assembly in Kuwait.

Australian sensitivity to patronising comment was marked, and any failure to honour sacrifices in two world wars, for example, was understandably resented. To Australians, nothing Utzon claimed about the artist differentiated him from any other human being. Architects and painters, composers and gardeners, cooks and tailors, surgeons and generals, sailors and explorers, mathematicians and philosophers, even politicians and secondhand car salesmen – all, at the outset, are equally ignorant of the precise end results of their efforts, and often of details about the journey to them. Architects must persuade clients to trust them to create something worthwhile out of currently indeterminate ideas; their own anxiety is that until the building is finished, they do not know whether and how it works. But their right to our trust entails their duty to reward it.

For some years Ove could not admit that only a cultural revolution could rescue all those who had been seduced by the romantic artist's self-image. First of all, it required acceptance that most of our beliefs and values derive from other people, not from our own firsthand experience. Once we grasp the social dimensions and origins of our views we can begin to see the importance of understanding the contexts in which we find ourselves. And here the crucial facts are that contexts change, all ideas are obsolescent, and issues of ever greater complexity cannot be resolved by individuals alone. These insights underpinned everything Ove did, but he had reached this position a long time ago, and it rarely occurred to him that few colleagues had undertaken the journey, let alone found the map. There was, in addition, an unintended consequence of Enlightenment thought and practice which no one knew how to tackle: focused empirical research created a division of intellectual labour; from this, in turn, emerged specialists who could neither understand, nor communicate with each other. Broader vision was necessary, but specialisation led to narrower vision. Did this mean that holism was unattainable by professions committed to increasing specialisation?

While on a Christmas visit to the family in Copenhagen in 1963, Ove was interviewed by *Berlingske Tidende* and remarked of the Opera House:

I dare say it is one of the most difficult engineering works the world has seen . . . a fantastic mathematical problem which Jørn Utzon never dreamed about when he, with his vivid imagination in a somewhat unrealistic way, designed the great, graciously formed concrete shells.

He added that 'our firm has become so big that I cannot any longer keep in touch with individual jobs'.[6]

Three months later, in March 1964, Utzon agreed to report to the Minister of Public Works 'for a lot of things' but not for all: 'none of the people in the Minister's department had knowledge of the theatre' and at the later stages of selecting furniture and decoration he had no intention of advertising his decisions. In the same month, the Secretary of SOHEC, who died a year later, recorded that 'there had been a lot of circumstances associated with the project but not recorded on paper which he has witnessed and which might be useful in any publication of the history of the Opera House'. While all accounts are selective and require interpretation, the absence of any report leaves the pastures open to the dragons of pure invention. Regrettably, the professional etiquette and integrity which required many participants to maintain silence means that some important elements in the saga have been lost.

From the middle of 1963 onwards Utzon received increasingly firm letters from the Department of Public Works, on behalf of the Minister, seeking clarification on many matters, especially escalating costs and the time factor. His assistant, Bob Maclurcan, accompanied by Lewis, was sent to inform Ryan of greatly increased estimates; the minutes euphemistically record that Ryan was 'very amazed'. In preparation for a meeting to which he was summoned in June 1964, Utzon himself drafted notes on what 'The Minister may ask for': they might include rigid cost control, as for Stage II and a lump maximum cost. He observed that the latter 'Naturally is out as there is no limit. Should aim for [the former] without any maximum.' At the meeting itself Ryan emphasised that he, as 'Constructing Authority, was the principal and the client to whom the Architect was responsible, and that the Sydney Opera House Executive Committee was an Advisory Body'. Utzon was informed that his earlier reply of 24 March 1964,

stating inter alia that he could not allow Mr Wood access to drawings and documents and claiming that the Minister had clearly stated that Mr Wood was only to be considered as a carrier of information, has been received with disappointment. Mr Ryan stressed that this attitude was entirely wrong, and that Mr Wood represented him and he would expect him to be taken into full confidence and consultation at all times and on all matters

affecting the design and construction of the Opera House so that he could keep the Principal informed of what the Architect was doing and had in mind to do and at the same time acquaint the Architect with the Principal's views.[7]

During the southern winter months of June and July, technical problems arose over the ceramic tile lids, crafted and made in Sweden, which were due to be affixed to the roofs. One question concerned insulation. The architect understandably wanted to avoid failures which had occurred elsewhere when polystyrene sheeting had been used. But the engineers advised that its absence 'would cause stresses in the structure that had not been designed for and probably could not be designed for with the present cross-sections'. The main problem concerned temperature variation over the roofs, as Jack Zunz reported to the committee:

> The radial temperature distribution in the rib is non-linear. Unfortunately this means that, even if each rib were completely free to expand and bend, internal stresses would be set up analogous to the stresses which cause failure of a glass vessel if it is heated or cooled too rapidly. These stresses might be of the order of 450 p.s.i and represent a loss of pre-stress for which it would be virtually impossible to compensate.

The Premier issued a stern rebuke to Utzon, reminding him that 'the expenditure of public moneys and cost is of the utmost importance'; 'decisions involving expenditure will be made by the Minister'. The estimates had indeed dramatically increased: the quite arbitrary estimate of £3.6 million (A$7 million) of 1957 had reached £25 million (A$50 million) by July 1965, and then doubled again. When the building finally opened in 1973, the expenditure had exceeded A$102 million. Over the next thirty years, major adaptations and extensive maintenance cost three times that amount; the annual running costs, exclusive of salaries, in 2004 exceeded A$2 million. Profits from the Opera House Lottery, launched in January 1958, raised over A$100 million of the original costs, and underwrote much of the subsequent expenditure. By the 1960s it was already apparent that at least 40 per cent of the costs of any complex building would be in its engineering and services, and some clients were discomfiting architects by regarding their work as merely forms to keep the rain off the engineering. However unintentionally, such attitudes only hardened architectural ambitions to create primarily aesthetic sculptures.

If the use of computers was indubitably the most striking of several innovations in the construction of the building, another innovation might strike

some laymen as alarmingly risky: the use of epoxy resin for jointing pre-cast concrete. Nevertheless, in the early 1960s, following their use of epoxy adhesives in the building of Coventry Cathedral, Arup's explored precisely this possibility for the Opera House. But rather little was known about resins: for example, the effect of weathering of the concrete on adhesives, the short- and long-term bond strengths under different conditions, their fire resistance, and their mechanical properties. That was not all, because the ribs of the Opera House shells are inclined at various elevations: the angle of the jointing face to the vertical varies from 15 to 85 degrees, and the complex stresses across the glue line, caused by the pre-stress, moments, shears and tensions, needed to be calculated. All of these details were means to an end, means about which both Client and general public remained ignorant.

Nevertheless, the emerging structure increasingly attracted admiration. In July 1964 an article by Patricia Rolfe celebrated the fact that 'the inescapable and dazzling thing about the Sydney Opera House is that to see it is to believe in it'. She counselled 'those near to it', however, to improve their communication with a genuinely interested public.[8] Behind the scenes, however – and not always behind – acrimonious debate about seating numbers continued and intensified. The 'Competition Regulations' of 1956 set fourteen seats as the maximum number between aisles, or eighteen in the case of concentric circles. Utzon was designing rows of forty, which followed a long-standing practice throughout Europe. (The arrangement today, by Peter Hall, includes rows of forty-five seats, which meet no modern access, health, fire or safety requirements. At no stage did Utzon himself consult local officials about the regulations.) Utzon's acoustic consultants repeatedly told him that the stipulated seat numbers of the Client's Brief could not be provided, nor could the acoustic requirements be harmonised with some of his architectural proposals: he resorted to his favourite defence of an imaginative analogy. He informed Ryan in September 1964 that 'ideally, a hall could be compared with the inside volume of a string instrument' – which is acoustic nonsense. By such remarks Utzon excited increasingly cynical comment from the teams on site. Like many architects and interior designers he disliked signposts and notices disfiguring the clarity of his spaces, and reported that he had read of recent experiments with rats. Placed in a box with two tunnel escapes, one of which had walls tapering to a smaller funnel exit, the majority of rats chose the narrowing exit. Utzon 'felt that if rats did that, and mice did that, then people might do the same thing'.

From the beginning of 1964 Utzon dropped all first names from correspondence with his consultants: 'Dear Sir' was substituted. He had first used

this petulant device two years earlier, but had received a sharp reprimand from Ove. By the end of the year Utzon was ruling who could speak to whom, which did nothing to promote harmony. He convinced himself that Arup's thought they could administer Stage III better than he would or could, and insisted: 'It must be made clear that Michael Lewis keeps out of any negotiations, discussions or remarks regarding Stage III with the Public Works Department, the Trust or Constructors.' He told Ove that anyone could learn management skills, whereas creative genius such as his own was unique. In addition, he formally complained that, although they had official Public Works Department approval, Arup's were setting up a permanent office in Australia. However, contrary to explicit assurances to the Client, Utzon himself had been engaged on other projects, and entered competitions throughout his Opera House commitments. There was nothing unusual about this, since everyone engaged in commercial activity needs to look ahead for future employment, whether architects or consultants: he had simply lied to the Client – not for the first time: in his CV he claimed to have won a prize in the same Crystal Palace Competition that Ove had entered. His complaint about Arup's was properly ignored. Michael Lewis in March reported that Utzon 'believes that we should never say unpleasant things to anybody': this was an instruction to others. Lewis added:

> we must at all costs eliminate the emotional content of our thoughts, principally that we are all conscious of the tremendous effort which has been necessary to bring Stage II to the successful (I hope) conclusion and feel a little disappointed that we are not given the sort of acclamation which we deserve. It is unfortunately one of the facts of life that, having led Utzon by the hand for approximately six years, he now finds this association a slight embarrassment and would I am sure be very pleased to see us step down.[9]

By August, Lewis had reviewed the growing crisis again. He warned Ove that Utzon's misplaced optimism in his ability to charm the Premier would leave him with the unenviable choice 'between resignation or complete subjection to P. W. D. influence on the design. Either case, you will agree, could be catastrophic for the success of the project.' Lewis then proposed an arrangement parallel to that adopted by Arup's for the structure, and also adopted by other consultants for the stage towers machinery and electrical work. The proposal was that Utzon should establish an office to produce contract documents and working drawings, under someone independent of the Architect except for liaison purposes. At that time there was no one in Utzon's office who would 'even dare to blow their noses without first consulting' him. Utzon

predictably rejected any such proposal, on the grounds that Le Corbusier, Mies van der Rohe, Alvar Aalto and Frank Lloyd Wright had all tried the plan without success. In London, when they met, Ove surmised that Utzon would try to shorten any discussion, which he did: 'the whole time was taken up in trying to convince me that he could not tolerate it' – 'it' being the sidelining of Ashworth and Haviland by the Premier himself. Ove insisted:

> We have a duty to the Clients. We must not be a party to deceiving the Clients in any way. We must put our cards on the table and we must not make promises we have no power to implement. If we get into a difficulty because the Client wants us to do something which we are unable to do because Utzon has not given us the necessary information then we can only state the facts, after giving Utzon sufficient warning.[10]

Ove and Jack Zunz normally travelled to Australia westwards, stopping at Los Angeles or Hawaii en route. Ove would usually lose something – his spectacles in Los Angeles and his chopsticks in Hawaii – except that they would often turn up still in his pocket. On arrival anywhere, he ritually inspected the rooms of his travelling companions to ensure that his were the best. On arrival at Bondi Beach, he promptly complained to Zunz that his own room was inferior: Zunz exploded and received the plaintive, and somewhat disingenuous rebuke: 'Why do you take everything I say so seriously, just like Li?' In 1964 Zunz discovered a new, cheaper eastwards route to Australia, with intermediate stops in Moscow and Delhi, and they set off in that direction. But within a few days Ruth enclosed 'a nasty note from Mr Utzon. Perhaps it's not nasty – it may just be his English.' In any case, 'what on earth did you say in Russia that ditched old Khrushchev? I knew there'd be repercussions.'[11]

Faced by unresolved problems, architects, consultants and contractors understandably concentrate on positive news. Ove and Jack Zunz naturally presented their best front to the official committees. Minute 78 of the SOHEC, dated 20 October 1964, recorded Ove as saying 'that incredible difficulties had arisen because there was no precedent for this project. The building had now progressed so far that he had no fear of anything disastrous occurring.' Jack Zunz 'stressed its quality as second to none', and Utzon, in commending Hornibrook's (the Hornibrook Group Pty Ltd were responsible for the construction of the shell roofs in Stage II, and for interiors, promenades and approaches in Stage III), reported that 'he had not seen anything in Europe to equal their precision'. In fact, a few months earlier, Utzon had already signalled his intention to separate himself from the engineers, and to resist any

inclination to assign credit to them. And his junior staff were writing to their families back in Denmark to say that future resignation from the project had to be contemplated.

On all his visits overseas Ove acquired things – often to the embarrassment of his staff, who were left to despatch enormous parcels home to the UK. He had always been a collector, and years before had bought from his colleague Wengraf two large Senufo bird sculptures from Côte d'Ivoire. On his African trips he bought tribal works, including weapons, fabrics and baskets. During the present trip to Sydney, the most fashionable general store in town, David Jones, staged the first large national exhibition of Aboriginal bark paintings, including some pieces from the Northern Territories. Ove bought almost the whole exhibition. Three days later, after his meeting with the Minister, he returned to the show and complained bitterly that most of them were sold: 'Mr Arup: those are the ones you reserved.'

By the New Year, increasingly firm letters were despatched to Utzon from the Minister's office. Ryan's insistence on his role as Client over the previous year or so, and demands for clear answers, not only rattled Utzon, but fuelled incipient thoughts of withdrawal:

> it is desired to inform you that no purpose would be served at this stage by examining figures prepared in 1961 on outdated documents to support a much lower estimate than the current one. [. . .]
>
> Delays will inevitably result unless the information is supplied and you are accordingly urged to give the matter your immediate attention; in particular, the full and detailed description of what is being done and what is proposed to be done, which was asked for by the Cabinet Sub-Committee over four months ago, should be submitted without further delay. [. . .] Your attention is also directed to the fact that replies are outstanding to many departmental letters and it will be appreciated if some effort could be made to have these given prompt attention and appropriate replies forwarded.[12]

Utzon's grasp of English did not enable him to detect the tone and subtlety of the adjectives, adverbs and tenses in this instruction. The Minister was keen to learn 'whether and how the building will be built, when, at what cost and whether it will work'. Utzon ignored the issues in a miasma of self-justification: everyone now knew that he never answered any question put to him, but whereas that had been originally ascribed to a charming artistic evasiveness, it was now put down to stupidity, ignorance or disobedience.

Utzon spent a good deal of time between July 1963 and February 1964 working out his ideas for designing the new Zurich Theatre. In May he won

first prize, although the project was eventually abandoned: he immediately entered the competition for the national opera in Madrid. Sigfried Giedion, who lived in Zurich, had discussed Utzon's work with him, and was in the process of updating his popular book on modern architecture. By December Ove's long-standing friend Jaqueline Tyrwhitt had translated Giedion's German text for an English edition. Giedion sharply distinguished between what interested an historian and what interested an architect, but contrary to what a reader might expect, made no reference to engineers at all. This was especially pleasing to Utzon: 'The architect is little interested in when or by whom a certain building was erected. His questions are rather: *what* did the builder want to achieve and *how* did he solve his problems?' Giedion conceded that Le Corbusier was 'the sole pioneer who never broke off a contact with the past', and he then asserted:

> The autonomous right of expression must again exert itself in building, over and above the purely utilitarian. We are fully aware that at the present moment only a masterhand can dare to manifest the independence of expression from function.[13]

Giedion's grandiloquent support could resolve no current practical difficulties. Yet Utzon had been provoked into reflection upon his activities and commitments: what resulted, in January 1965, was a long 'Descriptive narrative' headed 'Sydney Opera House'. Often cited by later historians, it attracted little critical analysis, largely because to his acolytes it was an *ex cathedra* pronouncement by a supreme 'artist': and the Client was merely irritated. Utzon began by declaring that 'the halls will form another world – a make-believe atmosphere, which will exclude all outside impressions'. But the Executive Committee already knew that he had not discussed with any theatre producers or performers what they themselves either currently desired or foresaw as future developments. The Committee, which had commissioned a functioning concert hall and opera house, were stunned to be told that 'the full picture can only be viewed from such a distance as the Harbour Bridge, Kirribilli or Lady Macquarie's Chair'. Did this imply a small sculptural piece in a picturesque jigsaw, rather than the giant structure currently under construction on Bennelong Point? He added, however, that 'a number of solutions [. . .] had been developed' for the walls and ceilings, to which Ashworth added a large marginal comment in ink: 'but not accepted'.

Seventieth-birthday celebrations in London for Ove were no doubt a welcome break from growing anxiety. Meanwhile there were changes in Sydney: Davis Hughes took office as the new Minister with responsibility for

the Opera House on 1 May 1965. Having expressed his determination that the building should not 'take another fifteen years', he was relentlessly subjected to Utzon's ripostes. Immediately after any meeting, Hughes would send him a letter: 'without fail, in two days time I'd get one back denying everything we'd ever said. The fact that there was a girl there taking it down was quite beside the point.' Davis also thought that Utzon's small full-time staff of seven, as he was probably incorrectly told, was 'ludicrous'; and when Utzon 'wanted a fee himself as Engineer advising himself as Architect', Hughes could scarcely believe his eyes and ears. But he wanted to be fully informed about progress, and Jack Zunz submitted a succinct account of the 'practical' challenges they had faced arising from 'casting, handling, storing, positioning, joining, stressing, sealing and finishing, tiling, and waterproofing precast concrete units of considerable weight at varying but substantial heights in different positions'. Zunz also outlined the range of problems solved in constructing and affixing the tile lids on the roof. Of course the thin sections had to be strong, corrosion resistant and able to adhere to concrete under temperature variations; after involved calculations, it was finally agreed to position segments within the remarkably small tolerances of half an inch.

Arup's were not themselves responsible for the running of the complex site, but every decision had to be minuted for distribution to everyone involved: insurance for the transport and distribution of wages; insurance against earthquakes and tidal waves – almost nothing was known in the late 1950s about tectonic plates; rat and possum control; prohibition of alcohol on site, but provision of smoking breaks; complaints from citizens that lights from the building site were shining into apartments; procedures to follow after thefts, damage or other losses. In fact the overall loss of major and minor plant up to 1970 was 0.60 per cent of the total book value of around A$250,000, and an annual construction expenditure which peaked at around A$16 million. Health and safety checks were of crucial importance and the safety record throughout construction was extraordinary: accidents did occur, for example when parts of a crane collapsed and limbs were damaged; but in fourteen years of construction there was only one fatality, to an offsite worker. Tensions on site did overheat at the threshold of danger, and union strikes impeded initial construction, but none of these signally affected fundamental architectural or engineering work.

As on any large construction site, arrangements had to be made for weekly or fortnightly copyright photographs, showing progress and any detailed matters required for further action. From 1962 monthly aerial photographs were taken by a man called Bowden; repeated requests, urgent and insistent,

were made of him for his account, which was inevitably mounting. But nothing ever appeared. One day the plane circled the site for a much longer period than usual: Bowden had been caught for counterfeiting US dollars, with which he had bought his plane. He had experienced no need to send an account for his photographs: that was, however, the last flight of Bowden before his enforced absence, at public expense, from public life.

By July 1965 tensions everywhere had worsened. Lewis formally minuted his request

> that the engineers could follow the Architect's development of the scheme while the drawings were under preparation. [. . .] The Architect explained that he could not allow any disturbance in the drawing office and it was necessary to work undisturbed during the development of his ideas and systems as the scheme could suffer by side-tracking at that stage.[14]

Ove decided to draft several pages of observations for Utzon's reflection:

> I wonder whether you really are master of the situation and can manage without help except from sycophantic admirers. I have often said that I think you are wonderful, but are you all that wonderful?
>
> You will probably dismiss my doubts with contempt. You have clearly indicated that our role is to do what we are told and leave you to manage your affairs. And believe me, that suits me . . .
>
> You have killed the joy of collaboration – but <u>I want to see the job finished all the same</u>.

In fact, Utzon had already bricked up the wall between his offices and those of the engineers: there was now no direct physical connection. While the press conceded that 'no artist can bear a critic looking over his shoulder', they also admitted that 'there seems to be a necessity under the circumstances, for someone to do it'.[15] Utzon's treatment of his own staff embarrassed both the engineers and the contractors. He informed his assistant Robert Maclurcan in November 1965:

> it is necessary for me from now on to ask you cut off any connection you have with the Opera House when it comes to my office, the Client, the Minister for Public Works, the Committee, the Trust, the Technical Advisory panel, all other panels, the Consultants and Contractors.

The offence? Maclurcan had officially attended meetings on Utzon's behalf and, naturally, talked to the Client. By then, however, Utzon was writing intemperate letters to almost everyone: he instructed Lewis to 'please refer the

Clients directly to me on all matters'. To the Chairman of the Opera House Trust he insisted, in November:

> I would like to inform you that any question of design or alterations to the programme can only be correctly answered by me or my office, and the questions directed to the Consultants or Contractors will not be correctly answered because none of these will have full knowledge of the functions involved.[16]

On the same day he wrote in the same vein to Willi Ulmer, and in a longer version to Walter Unruh, to neither of whom he had spoken for two months:

> the Client has, and might have in future, a tendency to ask questions of various Consultants instead of making them directly to me. As I am in charge of this building, there is only one place where the Client can direct his questions and that is to me and my office.

Utzon now forcefully insisted that his Client, a Minister of the Crown, to whom he was wholly accountable, should ask questions of no one, consult no one, speak to no one about the project – except to Utzon himself. On 12 July 1965 he had informed the Minister: 'I cannot in any way be blamed for any delay at any time.' Moreover, 'I have shown personally a perfect administration of those items I have administered':

> After a long period, I succeeded in convincing the Engineers that the first scheme was absolutely hopeless, and that together we had not been able to achieve a [sic] honest structure at the same time as we had not been able to fulfil the expectations of [deleted] the competition scheme had promised. My new scheme, which I developed in my office as the last of a whole series of schemes, was brilliant enough to stand up to any criticism the structural engineers could bring forward and this scheme of mine, which, as a scheme for a complex of this kind should do, covers all the different basic requirements in a perfect way.
>
> You might have been misled by Arup's recent report [. . .] on the shells, to the extent that you do not really understand that every detail in the existing work carried out, and in the whole scheme down to the last dimension and shape, has been formed by me.[17]

Impervious to the fact that any official could consult the records available to all parties, including the Architect and Engineer, Utzon elaborated upon this imaginative reconstruction of events, sinking ever further into self-deception:

It was mutually agreed with the Client that, any time a better solution was evolved on one point or another, it was necessary to incorporate the better solution. I have not compromised with either my previous Client or the consultants in my search for perfection. [. . .]. I wanted to make it quite clear that I should be in complete control of every detail.

Towards the end of August Hughes informed Utzon:

I do not believe that I have yet been successful in having your acceptance of some basic principles which must govern the construction of this project [. . .]. Your reference, both in your letter and other times, to your wish to build the 'perfect' Opera House is understood, but it must be accepted that all proposals must be considered in relation to cost.[18]

On 16 September Hughes stated that 'I, Minister for Public Works, am your client and accept as your responsibility the obligations to meet my reasonable requirements in respect of the work.' Moreover, it had become clear in the previous week that 'as yet there are not available any architectural drawings which can be classified as completed working drawings, nor are there available specifications, completed schedules and quantities, etc. such as will be required for the purpose of calling tenders'. Utzon responded by admonishing the Minister, on 1 November: 'I remind you that it is not professionally correct for you to seek advice direct from any of my Consultants.' The hectoring continued and naturally included London, to whom he insisted that 'all questions are referred directly to me and my office, and the whole of the administration is controlled by my office'.

Meanwhile, Michael Lewis sent Ove a confidential report on a meeting with the Minister: he had had virtually no professional contact with any of Utzon's staff for six months, and had met Utzon on only eight occasions. The government showed him documents proving that Utzon had been consulting other engineers in Sydney, and that this was 'doing us irreparable harm'. In response, Ove reiterated his thoughts of a year before, 'It seems now that we have come to the end of the road.' 'Probably our resignation would not be accepted, and I cannot see what the result ultimately would be, but at least it would bring the matter into the open.' By early 1966 absurdity was evolving into tragedy. On 17 February the acoustic consultant Cremer again insisted:

Any addition of further seats would acoustically overload the hall. If you increase the number of seats in a volume given it is similar to the increasing of a barrel of vine [sic] by adding some water. You may fill more glasses but then everybody gets a worse vine.

Around this time Utzon was making direct appeals to Ove about 'the development of the ceilings of the halls and also later on with the glass walls, as I have not received the correct assistance from your office here'.[19] Naturally he had 'a perfect and ingenious scheme which takes care of every aspect of the problems in building the ceilings of the halls'. But: 'the behaviour of your partners here is not professional. They are dealing directly with my Client behind my back in spite of my telling them not to do so.' Ove 'as a friend' warned him against resignation:

> if you resign, all is lost. It would be a most dangerous thing even to think of it. If you want just to use it as a threat, you must first be quite sure that it will not be accepted. And can you be so absolutely sure? [...] You can blame others as much as you like, your reputation will stand and fall with this building. [...] Can't you see that the only way to get over any trouble which you may have with the Client is for us to stand together. United we are strong. But we must also be just and see the Clients [sic] point of view. [...] You [have been] insulting my trusted friends and collaborators. . . . I have absolute faith in Mick and Co. . . . But let's scrap this nonsense about 'Dear Sir' and 'Yours faithfully' and secrecy and suspicion. We are too old for that. Let's think about the job and pull it through.

Michael Lewis sent another confidential report, which crossed with Ove's pleas: he had tried to placate Utzon, but 'his attitude was, as usual, autocratic and decidedly unrepentant': 'Do you think we are perjuring our engineering souls? How do you think Neville Chamberlain felt at Munich?'

By now, however, Utzon had 'three or four times' threatened the Minister that he would resign, and when he lodged a proposal with the words, carefully recorded in the government minutes, 'If you don't do it, I resign', Hughes replied: 'I accept your resignation. Thank you very much. Goodbye.'

In the immediately following exchange of letters, dated 28 February, Utzon declared that Hughes had 'forced me to leave the job', to which Hughes replied: 'I have received your letter of resignation which I deeply regret.' Ashworth had been active all the previous days and nights, together with several others, to dissuade Utzon from behaving foolishly. But by the evening of 28 February the press had learned that Utzon had dismissed his staff, and Hughes had published the exchange of letters.

Ove learned about all this by telephone and wrote to Utzon at once, expressing his shock, advising him to be very careful about what he said or did, and offering to help as much as possible: 'Your large following the world over could be lost if you do not show yourself understanding and generous.' The

following week Utzon's assistant Wheatland sent what turned out to be his last letter, to Wood, Director or Public Works: work on the wall cladding 'exceeds 90%'; work done 'exceeds 60%' on almost everything else. What the percentages meant, in the absence of evidence, and what 'work done' meant, was never to be clarified.

Michael Lewis had no doubt that Utzon orchestrated his resignation. Lacking any resolution of his difficulties, Utzon had only one challenge: the degree to which he could successfully blame others. Contrary to what he was alleging about Arup's, they had warned in March 1964 that Ralph Symonds's 'knowledge of the structural design stresses of plywood, was "extremely sketchy"', and the technical advice that they had been given was 'elementary to say the least and completely useless for our purposes': by August of that year Ralph Symonds Ltd was under receivership. Much of the argument had centred on whether the company could manufacture plywood sheets and beams of appropriate structural capacity to satisfy the acoustic needs of the auditorium interiors, the design for which was still inchoate. Plywood was also proposed for the mullions, ceilings and, first of all, for expensive full-scale mock-ups. Contrary to his strident claims, there was nothing innovative about Utzon's idea of maximising prefabrication: Ove had advocated the idea for more than thirty years, and never claimed it was his own invention. But time and money were needed to convince the engineers and the government of the reliability, safety and efficacy of the proposals. The impetus of other events, however, allowed no time for such cautious investigation.

At the beginning of March 1966 the Sydney press was once more in full flight. On 1 March the *Daily Mirror* reported that: 'Mrs Utzon refused to believe her husband had resigned when a *Daily Mirror* reporter broke the news at his house this morning.' On the following day the *Sydney Morning Herald* carried a first leader on the subject:

> The real issue concerns the architect-client relationship and its obligations. [. . .] No architect in the world has enjoyed greater freedom than Mr Utzon. Few clients have been more patient or more generous than the people and Government of NSW. One would not like history to record that this part-nership was brought to an end by a fit of temper on the one side or by a fit of meanness on the other.

Michael Lewis, following his daily long-distance telephone calls at A $2.50 a minute, sent a further confidential report on 3 March, which Ove distributed to all Partners:

Utzon for a long time has been insisting on a blank cheque from the Government on absolutely every aspect of design. The Government, on the other hand, have been extremely tolerant in their desire to see this building completed as something extraordinary. [. . .] Utzon could easily have attained his objectives by a variation of technique. [. . .]

It is not possible for us to go through a rational process attempting to understand his behaviour. By definition, his behaviour is irrational and we must simply accept it as one of his artistic foibles.

Reports [. . .] seem to indicate that he is becoming more autocratic and increasing his demands rather than reducing them. In the light of all this, it seems hardly likely that the Government will retain his services under any circumstances. [. . .]

I think he has done everything he possibly could to have us removed from the job. It has been extremely difficult for him because of the magnitude and quality of the work we have done. [. . .]

It is our responsibility to the Government and, for that matter, to the people of New South Wales, that if we do make a statement, it must be carefully considered and must contain full information on everything which we have been concerned with.

Five days later Lewis sent a long report of a meeting with the Minister at which he had explained what Arup's had achieved throughout the project, and how. He defined the only useful sense of 'working drawings' for a project of such complexity, and stated that for Stage III preliminary working drawings existed for the cladding, but nothing else: sketch plans were complete for the auditorium of the Minor Hall, but only preliminary sketch plans existed for everything else. Lewis suggested that the breakdown in co-operation occurred between November 1962 and May 1963, when Utzon departed on one of many long trips away on holiday – that is, from just before the freezing Boxing Day meeting at Heathrow.

Political debate, raging in Parliament, indulged in re-writing history. Former Minister Ryan, well aware that the current Minister would be unable to reveal certain facets of the whole saga, claimed on 9 March 1966 that when his own government had been in office, up to 1964,

there was a very serious division of opinion between the architect [. . .] and the head organization in London on methods of procedure. [. . .] His marvellous solution for the construction of the arches and the mechanical problems involved in their erection will be ever remembered. It was not the consulting engineer who did it, it was the architect.

This was entirely false, and was asserted for Ryan's own local political gains: it merely parroted one of Utzon's recent fabrications. Hectic and secret meetings took place over the next ten days, in private houses, the Lane Cove Motel and at Hughes's office. Hughes offered Utzon the chance of returning as leader of a team of prominent architects and consultants directly answerable to the Minister, and Utzon indicated that he would work 'with' but never 'under' them: the plan was very close to the one proposed by Lewis in August 1964. Lewis had 'the feeling that Utzon wanted to accept their terms but was too proud to say it directly': the government minutes recorded the impression on 10 March that Utzon 'accepted the conditions' subject to certain verifications, not least because he had affirmed by letter two days earlier that he accepted what he regarded as 'the major proportion' of the Minister's requirements. Utzon's immensely long letters of self-justification of 7 and 8 March are the hysterical outbursts of a sick man: officials were scrupulous in their professional annotation of them.

A public meeting of Utzon supporters was held at Sydney Town Hall on 14 March. More than half of the 1200 people who attended the noisy meeting were students; they listened to personal vilification of everyone except Utzon by Harry Seidler, a forceful young architect who had arrived in London from Vienna in 1938, and subsequently set up in Australia. He also attacked the President of the Royal Australian Institute of Architects, R. A. Gilling, who had in fact been tirelessly active behind the scenes, although he did not make public his own participation until thirty years later. Seidler's noise carried abroad, such that his former colleague in London Maxwell Fry cabled the Minister to say that he wished to 'associate with the world protest of architects'. The wild assertions made by the Utzon campaign were described by one neutral observer as 'quasi-Stalinist'. Fifty years later it would be unlikely for individuals, commercial firms and professional bodies not to engage legal representatives to defend them. Self-righteousness, and an adamant refusal ever to admit moral wrong-doing, is commonplace among professions, in architecture no less than in education, medicine or law, and is not unknown among religious leaders or politicians.

On 17 March the *Sydney Morning Herald* put a case for Utzon:

It was not his fault that a succession of Governments and the Opera House Trust should so signally have failed to impose any control or order on the project or even to discover what was going on. He can be blamed, if at all, only because his concept was so daring that he himself could solve its problems only step by step and because his insistence on perfection led him to alter his design as he went along. He has built the Opera House like a sculp-

tor working in clay rather than an architect with steel and concrete. It has been a costly experiment.

None of the participants most closely involved with the project, such as Ashworth, Ove or the government itself, published any remarks or documents to the disadvantage of Utzon, although there was a mountain of documentary evidence already recorded in minutes. And apart from Utzon himself, architects did not criticise or seek to vilify Arup's. But the 'Pro-Utzon' campaign became so noisy that it warranted overt rebuttal, rather than silent and professional loyalty to the principals and the project; those who broke silence thirty and more years after the event, if noticed at all, have been dismissed by those who hold firm to well-entrenched myths. None of the guided public tours, which have daily explored many areas of the Opera House since the mid-1970s, record anything other than Utzon's 'enforced departure' or 'political sacking': and the name of the engineers has never been mentioned. Silence has always been an effective means to expunge the truth.

Ove himself was emotionally and physically exhausted, and after starting to write to everybody from London, went to Portugal, to rest: and continued to write to everybody. He told Gilling that since Utzon 'moved to Australia three years ago there has hardly been any fruitful collaboration between our two firms'. Before departing for Sydney at the end of April, he also engaged in an intense correspondence with Steen Eiler Rasmussen, in the hope that he might be accepted by Utzon as a trusted intermediary. He rebuked Rasmussen for an article in *Politiken*, in which he had merely repeated a series of unjustified accusations by Utzon: and assured him that 'it is Jørn who inexplicably has withdrawn from cooperation with me. I am deeply saddened and bitter over what has happened.' He enclosed 'copies of the last letters and telegrams'. But during his Sydney visit, Ove learned of many further assertions that had to be rebutted: 'it was not Utzon who told us how to "solve" the superstructure.'

From London he also wrote to Lis Utzon, to reassure her, and through her, Utzon himself – who refused to answer letters or telegrams – that he was desperate to help. Was Jørn ill? Did he seriously wish to sabotage his dream? Did he not want Ove's team to try to rescue the project and make the best of it?

Her icy reply of 23 March heralded what was to come: Ove's offer of help was deemed offensively disingenuous, contradicting the firm's manifest lack of will to co-operate in recent years. Not only had Ove ignored Jørn's request not to contact the client, but the whole 'train of thought' in his letter revealed a person whom she did 'not want to answer'. Her letter preceded the arrival of one from Utzon himself, terminating Ove's contract, enclosing a copy of

his own long letter and Appendices to the Minister of Public Works, and a request 'not to answer any approaches made to you by my Client until you are notified by me of the results of the current negotiations'. Utzon asserted that a major reason had been 'Mr Lewis's unprofessional behaviour', but there were 'other stages' in which the firm 'to a great extent destroyed the architect's position'. The letter was a litany of accusations about 'your lack of support and misleading information'. In spite of happier days, he closed by declaring that he 'would not care to work with Ove Arup and Partners again in the way your firm has behaved in the last period here in Sydney'.

Ruth was extremely anxious about this letter, and did not open it, as she would normally do: she forwarded it directly to Ove: 'I didn't tell Jack it was here, because I didn't think it should be opened, and if it were not opened and he knew it had come he would have spent a good few neurotic days wondering what was in it.'[20] Twenty years later, Li told Ruth that while she and Ove understood Lis Utzon's dutiful support of her husband, her uncritical denial of his failure helped neither of them. Ove held that the burden of failure was primarily Utzon's to solve, although countless others were ready and willing to help him.

Ove sent a long reply to Utzon on 20 April:

I don't know whether this will reach you, or whether you will read it if it does. [. . .]

I realise that nothing I can say will alter your distrust of me or my motives. Lis's letter shattered me, and showed me how completely you have misunderstood me. But forget about me. . . .

How can you leave this child of yours to be messed up by other people? Can't you see, that in the long run this will harm you immensely? It is a disservice to Architecture and it will always be held against you. [. . .]

I feel that I am the man who is in the best position to bring about a compromise solution which will at least prevent that the Opera House is spoilt by others, even if it does not satisfy you entirely . . .

Is it not the most important thing, that the opera house be saved? Is that not more important than what happens to you and me? You used to say at the beginning of our collaboration, that architects should be anonymous, that it did not matter who did it as long as it was done rightly. I realise that you have moved a long way from this attitude – but there was something very fine in it. It is not given many to reach such a state of humility. But a little humility is no barrier to the production of great art. And I am afraid a little humility is needed on your part in this case if there shall be any hope of moving the Government from their position. [. . .]

I do not want to humiliate you, but humility coming from within, from respect for Architecture, for your mission, and from gratefulness for the divine spark in you – such humility will do you no harm.

Ove suggested that they meet in Sydney during his visit the following week: and a letter awaited him, in which Utzon reasserted that 'I do not dare to take the enormous responsibilities of being attached to the scheme without being in charge as the sole architect.'

Ruth reported a week later that the London office was still being bombarded by calls from journalists after Utzon's address or Ove's whereabouts: 'I gather from Li that the Danish press is at last getting a bit less emotional about their golden boy. Poor blighter – I suppose it is only a matter of time before they are all dead against him for letting down the Danish architects.'[21] Li was much more communicative over the telephone than Ove was in letters, and at the beginning of May, Ruth complained:

It looks slightly as if the only person Utzon hasn't attacked yet is himself. He must be in a very disturbed and unhappy state, or possibly not unhappy, because he is probably borne along on this belief that it is only a question of time before he is begged to go back on any terms at all.[22]

A newly elected British Labour Government had rapidly introduced new taxes, and this prompted Ruth to observe: 'I hope you realize that you pay less for women, and even less for girls. The interesting thing is when a girl becomes a woman.' Three months later, Ove sent Ruth an *ex gratia* cheque to spend on a holiday: she bought a sofa.

Ashworth, like everyone else, was distressed by what Lis Utzon appeared to be saying. As he put it:

I must say that, after all these years of working together and the continued support I have given the project, I find it very difficult indeed to accept that you should in any way think that I have been remiss in supporting you recently.

The minutes of the Technical Advisory Panel, chaired by Cobden Parkes on 5 May 1966, record Ove's rebuttal of accusations made by the Utzon campaign: the measured tone of the minutes do not disguise Ove's frame of mind – oscillating between rage at what seemed like betrayal, pride at achievements so strenuously won, and despair at opportunities irrevocably lost. His generosity, given several years of increasing tension, greatly impressed the government officials. His main concern was that the firm of Ove Arup & Partners had been accused 'of non-collaboration with the Architect on various aspects of planning', and he wished to refute these accusations:

Mr Arup said he was pleased to record that until the last eighteen months or so the relationship between Architect and Engineer was all that could be desired. Unfortunately the position commenced to deteriorate about that time particularly in connection with the work on Stage III and a deal of friction became evident. He stated that he himself realised it was very difficult to deal with Mr Utzon because Mr Utzon's whole consideration was perfection in every respect notwithstanding the immense and complex problems that were involved and his firm had done everything possible to meet these demands. Mr Ove Arup stated that whilst the requirements needed the utmost collaboration the position reached a stage where Mr Utzon had been unavailable for necessary meetings and discussions with his Engineers. Mr Arup went so far as to mention that during his last visit to Sydney some eighteen months ago he had informed Mr Utzon of his firm's intention to resign from Stage III contract because of lack of collaboration but on Mr Utzon's request and after considerable discussion with him had decided against this course. Mr Arup said this position had been kept to Architect-Engineer relationship in the interest of the project. [. . .]

Mr Arup stressed that the successful completion of the project was fully recognised and this firm's disassociation with the work could not be contemplated.[23]

Both in public and in private Davis Hughes warmly commended the dedication of Ove himself, and of the team on the ground: Jack Zunz, Michael Lewis and John Nutt. The Opera House 'could never have been built without their persistence and fabulous contribution'. Arup's themselves were unstinting in their praise of Corbett Gore, the self-effacing construction manager of Hornibrook's who undertook Stage II from 1962 onwards, and who was seemingly fazed by nothing. He had started on site at the same time as Lewis and Utzon, in the spring of 1963, and he and Lewis would share a bottle of claret off site when tensions mounted. Gore, like Ove and many others, always held that 'Utzon was probably, conceptually, one of the greatest architects I've ever had anything to do with. [. . .] As a practical producer of drawings, he was one of the worst.' One of the Hornibrook firm's principal innovations was the design and construction of the erection arch, which could move in any plane at any time and which 'could be made to conform exactly to the geometry of the rib by extending and twisting and moving the base forward'. The construction tasks were complex. Hornibrook's made concrete to the strength of 8500 lbs per square inch for the shells, stronger than was used anywhere else at the time; since it had to be placed in the heavily reinforced sections of the ribs which in places were only inches thick,

a suitable additive was necessary to ensure sufficient plasticity for it to fill small corners.

A week later the *Sydney Morning Herald* quoted Ove as saying that 'we never had, and never will have, the slightest interest in taking over the leadership of this very serious job'. He added: 'The Opera House was like an extension of Utzon himself. His artistic conscience or sense of responsibility demanded that every part of his job should be determined by him. It was therefore very difficult for him to delegate.' Finally: 'I think what is needed is tact, understanding, and the subjugation of personal pride to the needs of the job.' The *Sydney Daily Telegraph* sought Utzon's response to such remarks, and reported his claim: 'At no stage was it my job to handle the financial side.' Furthermore,

> he had received only one letter from his clients and it said only 'Make the most beautiful building in the world'. He had never been given a budget ceiling. He had never been ordered to finish by a given date. He had had to work for two masters [. . .] who had issued conflicting instructions.

During April and May Utzon was involved in litigation for sums unpaid and a range of claims. A senior government official recorded that Utzon had not been

> able to satisfy the Minister for Public Works that he was proceeding properly to fulfillment [. . .] nor that he could keep within any estimate of cost nor any completion date when he practically demanded complete control without constraint under threat of resignation.

Utzon continued to make personal attacks on Ove to any journalist willing to report them. On 10 May in Hawaii, where he had established his own company, he replied to Ove's letter:

> I see no point in meeting you or talking to you. You have shown an incredible lack of understanding of what an architect and the work of an architect is, not only in your personal letters to Lis and myself, but also and more seriously through your own and your firm's behaviour. [. . .]
>
> You have thoroughly revealed your unlimited over-estimation of your own – the engineer's – part in this case, an over-estimation which causes your deliberate destruction of my – the architect's – position. [. . .]
>
> How can a consulting structural engineer dare to encroach on the architect's work in such a fantastic damaging way? This is unheard of and completely unprofessional.

At the end of April Jack Zunz prepared a report on the saga, underlining the fact that Utzon's young and irresponsible supporters had achieved the opposite of their goal. The government's proposals to Utzon may have been unfortunately phrased, but the central questions concerned the motives of the parties involved, and why things happened as they did. Utzon's 'outrageous' allegations about Arup's were both untrue and damaging. The firm believed in 'Utzon's creative genius', but egos must be 'subjugated to the needs of the job': 'political and personal issues must not concern us'. What is the way forward, when heart and reason are in conflict?

Ove used these reflections in his own proposals, dated 2 May 1966. He insisted that Utzon was a great architect hampered, no doubt, by 'genius, charm and perhaps conceit'. The building would not 'remain a masterpiece' if completed by another hand; to destroy a work of genius would be cultural vandalism. But Utzon's irrational actions 'suggested that he believed himself able even to overthrow the Government'. The government itself knew 'nothing about opera or about this kind of construction' and 'their remedies, their restraints and delays' had made matters worse. Nevertheless, 'they have really been remarkably patient, friendly and understanding'. Certainly, Utzon himself had 'been subjected to intolerable and often unnecessary and avoidable strains' – the indefensibly early start, completely misleading initial estimates, intermittent Client decision making, unforeseen structural delays, pressures from consultants for directives. The crucial point, however, was 'the Architect's insistence on making every decision himself and refusing to delegate'. His heightened feeling of responsibility aimed at – and could result in – a marvellous work of art, of aesthetic perfection. Ove proposed that Utzon be brought back as Architect, working with a full-time Programme Panel, representing the Client. These were among the last attempts to support a troubled dreamer for whom reality constantly threatened to destroy the magic of the ineffable.

In early June Utzon attacked Ove again in the Copenhagen newspaper *Berlingske Aftenavis*, to which Ove responded: 'I think Jørn Utzon is a really outstanding architect but what he is saying now is pure nonsense. [. . .] I have never wanted to be the architect for the Sydney House project. [. . .] But the kind of statements he is now making about me, makes it still more difficult for him to return.'

Naturally the Sydney papers quoted much of this acrimonious debate, the primarily political dimensions of which are now hard to detect. Aside from local, state and national political animosities, often reflecting urban and country interests, there were professional rivalries and jealousies within the

camps of architects, engineers and builders, disputes within the theatrical and musical worlds, and conflict between the Australian Broadcasting Commission and newspapers. It is fifty years since the saga began, and the volume of hostile criticism towards the decisions of the then government has been directly proportional to ignorance of the facts. Like disciples of large egos in other realms – Wagnerites, Wittgensteinians – Utzon supporters cannot endure thoughts of error, failure, or bad faith.

On 14 June 1966 Jack Zunz decided that he, too, must write plainly to Utzon: 'For some time now – at least since you went to Sydney – you have, from time to time, written letters to us which at first hurt and offended then provoked and angered. However we have desisted from replying to you in similar vein.' He wondered whether, in a moment of calm, Utzon might not agree that logic and reason had given way to passions and anger. His attacks on individuals and the firm had more recently extended to 'nearly everyone who has faithfully supported you and the Opera House for many years and in some cases since the whole job started':

> is it not an almost impossible coincidence for all these people [...] who have helped you, who in some cases have even considered you a close and trusted friend, to suddenly become rogues and liars who turn against you? Can you not see reason and stop for just one moment to study your own attitudes? Perhaps a little understanding and humility from you would go a long way to save the situation even at this late stage. [. . .]
>
> [. . .] there is one thing we have not done. We have never been disloyal to you personally or to your ideal of the Opera House. Right from the beginning our imagination, like that of so many others, was fired by your conception and in order to help you achieve this ideal we have, at times, torn this firm apart to see that you get what you want. If we have erred on this particular score it is only that we have gone too far. Do you really think that the support this firm has given you privately and in public in the past eight years is an empty gesture?

Zunz then addressed and rejected each of Utzon's public allegations, and emphasised that 'the correspondence emanating from Mr Ryan and his office as well as our replies [. . .] is open for your or anyone else's inspection'.

> The whole Opera House centres around your conception. Whether you like it or not its trials and tribulations are your trials and tribulations. You cannot avoid this responsibility and rather than go over the things you say point by point we would like to plead with you to look at yourself, your actions and your attitudes. The essence of the problem is that no-one has

denied you the right to design the Opera House in accordance with your creative gifts and no-one will stand in your way to see that your designs are faithfully executed. If you take your stand on this issue support for you would be overwhelming. All connected with the job would stand shoulder to shoulder with you. [. . .]

One wonders whether you really want to finish the job – whether you've lost faith in your own ability to meet the high standards you have set and whether you have built up the wall of half truths and fantasies to make excuses for your withdrawal. [. . .]

Lastly a word about Ove. For 30 years or more he has worked for the improvement of understanding and constructive collaboration between our professions and to strive for a common goal – better building. When he met and worked with you he realised that you were the architect he had been looking for all his working life. Moreover, quite apart from his immense professional admiration, Ove has a deep and personal affection for you. Your recent attitudes, statements and letters have been a savage blow to him personally and as a consequence to the profession as a whole and the ideals for which he has been working.

I wish that you would stop and reconsider and look at the damage which has been done. Is it really too late to plead reason?

Outside the architectural profession, most people believed that Utzon could see no way to resolve the problems that had mounted up, and that escape was for him the only relief: he could then trumpet his frustrated ideal. Eminent engineers such as Nervi, Torroja and Candela openly criticised the architect for ignoring the required functions of the building. And before very long, members of the Arup team and Opera House staff who had to make it work regretted that the building had not been left as a mere sculpture when Utzon resigned. Why not build a properly functioning Opera House elsewhere? In the late 1950s acoustics was an extremely inexact science, and several new concert halls of the day had to be entirely reconstructed to meet elementary needs; in addition, fashions in performance of both music and theatre were about to change extensively. The Opera House had never been designed with the flexibility to satisfy such changes.

To many among the admiring and capacity audiences, however, such thoughts and criticisms are sacrilegious. To them the mesmeric sculptural forms outweigh any functional failings, as they do for many much-loved cathedrals and palaces. Moreover, icons become immune from disinterested assessment, and few enquire into the truths behind them. 'Originality', in the strictest sense, can rarely be attributed even to the most famous historical

figures, and some historians have noted that little is original about the design of the Opera House. Like everyone else, Utzon derived inspiration from many sources, although he invariably pre-dated his findings. To a majority, none of this matters – the character and behaviour of the architect, the sources of his ideas, the sacrifices or contributions of others, the casualties on the wayside: what exists, and transcends all such transient and trivial issues, is a building of universal magnificence. Cicero sardonically observed that the gods must be credited with whatever is creditable: all other questions are distasteful. Utzon's name is unassailably associated with the Opera House, and since he resigned from the project he has been awarded every major architectural prize in the world.

Betrayal and philosophical crusade

What happened after Utzon left?

After a gap of almost a year, during which the newly appointed architect Peter Hall had to establish what had been done, what was needed, and whether he could secure any help from what Utzon had left behind, construction of the cladding, the interior and of the exterior 'glass walls' began. Once again Arup's were involved in virtuoso calculations and techniques.

The general public, although excited by the media to be politically outraged, were not overly upset by events. But for many of those most closely involved, the atmosphere had been soured and the magic had disappeared from the project. Nevertheless, the overriding necessity to finish it and get the building open, concentrated minds and discouraged mutual recriminations. The President of the RAIA, Ronald Gilling, wisely warned the Minister that when future problems emerged, as they undoubtedly would, blame would unfairly be laid at the feet of the government and Peter Hall: the view would be loudly canvassed that 'This would not have happened if Utzon had stayed': Gilling insisted that 'this is absolute nonsense'.[1] He was right on both counts. Con-

cerned for the integrity of the profession, everyone associated with architecture was writing to someone; local and government architects contacted colleagues overseas, such as Sir Robert Matthew, then President of the International Union of Architects. No one was critical of the engineers; indeed, the Arup team were warmly complimented on their largely unsung triumphs.

Utzon's isolation from all about him became evident to most people only after he had left. He had succeeded in dramatically muddying the waters; but he failed to sow dissension among any of the huge team of consultants, contractors and advisers committed to the project. Some loyal colleagues felt betrayed, as by Bonnie Prince Charlie: fortunately, there was no Cumberland on the scene. As parties to the dispute pored over documents, the Crown Solicitor informed the Minister in December 1967 that Utzon had not been, and was not now, in any position 'to provide full working drawings for a tenderer, nor in fact to inform the client of his proposals for completing the construction of the building according to the terms of his engagement': this merely confirmed a formal examination of the drawings Utzon released in June 1966, none of which was a working drawing.

A year after Utzon had gone, the press tried to establish whether attitudes had changed. On 28 February 1967 Utzon gave an 'exclusive' interview from his home to *The Australian*: 'I would now be prepared to meet the Minister's demands for detailed cost estimates, and firm work schedule, and a panel of architects to examine any item in the plans and report on its cost, feasibility and timing.' The following day Hughes told the *Sydney Morning Herald* that 'There has been no approach to me by Mr Utzon and the question of his return does not arise.' By the time the international media took up the story, further ambiguity informed comment, although some writers were now overtly saddened. An architectural journalist asserted, five months later:

> Interior and exterior, inside and outside, are now divorced and can never make architecture. The halls where we will hear music will always be haunted, overshadowed, by this thing of gigantic irrelevance: this series of figuratively and almost literally empty shells.[2]

On 15 January 1968 Ove had replied to a letter from Utzon's former colleague Elias Duek-Coehn:

> You are still under the spell of Utzon's genius and charm. You believe him and you believe in him. To destroy that faith has no attraction for me and I will not attempt it. But it is necessary to explain to you and your friends that all these appeals to make it up with Utzon are beside the point. For my faith has been destroyed. Believe me, it has needed some very hard

knocks to do so and it has been a very bitter experience for me, but has been done thoroughly and all the king's horses and all the king's men cannot alter that.

The following September Utzon himself wrote to Duek-Coehn, in a way that could easily have been predicted:

> I have seen some of the work the new architects have done on the Major Hall and I can assure you that their project completely destroys the beautiful and logical development of spaces and inter-play between geometrical systems in my project. [. . .] It is now clear to me that no one can finish the Sydney Opera House better than I, cheaper than I or faster than I![3]

Ove felt free to speak more openly than before, and was in great demand for both informal and technical versions of what had happened. He alluded to the saga on almost every occasion he discussed the needs for collaboration, as was evident, for example, in his Gold Medal address to the RIBA in 1966, when insisting that the architect 'must shed some of his habits to make him team-worthy'.

In the short term, Ove was most irritated by the 'architectural students' of the 'Utzon Only' movement, whose incitement to 'blackmail' he found repulsive. They claimed that Arup's ought to have resigned when Utzon did. His own teaching experience spanned more than thirty years, beginning at the Architectural Association before the war, and he had recently returned from Harvard: he loved the enthusiasm, ambition and iconoclasm of keen students. But, to him, the gang mentality of frenetic activists too closely echoed political frenzy of the 1930s. Above all, however, Arup's had no need to defend themselves, since they were not party to the dispute; and they also held that the proper professional response was to refrain from publishing any correspondence involving Utzon. After exhausting his considerable patience, Ove walked out of a 'rather stormy' meeting with campaigners, looming over a particularly loutish and (from Ove's standpoint) regrettably bearded youth: 'You are a very disagreeable young man.' Student behaviour of this kind was about to sweep the campuses of Western Europe and the USA, and to Ove it was incomprehensible. He hated sycophancy, even deference; and he applauded youthful passion and conviction. But he never understood why left-wing teachers did not alert their students to the dangers of fanaticism and intolerance. And like many continental intellectuals of his age, who had lived through far more traumas than their students ever dreamed of, he was deeply hurt to find his views dismissed as those of an irrelevant old man.

Ove described the 'Utzon Only' group as engaged in a battle 'for Architecture with a capital A':

> He is a genius, with all the faults which this implies. Only he can finish the Opera House as it should be finished. It doesn't matter whether Utzon is right or wrong; it doesn't matter about him, even, or you or any of us – but this masterpiece must be saved for humanity.[4]

Few of his listeners knew that Ove was signalling his lifelong hostility towards ideologies and totalitarian groups which aimed to impose their will on others. As always, he insisted on starting with the empirical facts, as he understood them: nothing should be built 'on a lie'. Utzon was a genius, and no one else could finish the building; but 'Utzon can't finish it either'. By 'genius', he was referring to 'the aesthetics of architecture, the effect of space, forms, texture, colour and light on human sensibility'. Utzon had refused the Arup firm's offer to resign after Stage II, and Ove had agreed to continue: in retrospect, he judged this to have been a profound mistake. His resignation at that stage would have cleared the air, whether or not it would have been accepted by the Client. Ove now also thought it had been a mistake to have kept the Client in ignorance of the technical challenges they had faced and of their scepticism about the estimates. The emerging conflict with Utzon, and his obsession with 'his public image', should have been brought into the open; alongside Utzon's 'recurrent leitmotif' that 'everything was solved', Arup's realised 'with a growing sense of foreboding, of doom' that no drawings were forthcoming.

Ove repeated his basic premise that 'the engineer is not responsible for *what* should be built': 'in all matters of form or function, the engineer receives his instructions from the architect, whose job it is to interpret the client's wishes'. Aesthetics is the domain of the architect, again with the client's approval; and 'the particular kind of synthesis which produces a work of art must take place in one brain, at least in all but the most exceptional cases'. This last qualification was perhaps not strong enough to encompass the vast tradition of craft works from the past and in different cultures, about which much less is known than about modern work. In fact, Ove often failed to see when he had himself unwittingly adopted the Romantic concept of an artist.

Nevertheless, collaboration between architect and engineer had been essential in the case of the roof shells, because the designer of the sculpture could not make it stand up, and the engineer could make stand up only what ceased to be mere sculpture. They both had to work together on the design: preceded by mutual education. Collaboration of the participating teams took place at many levels. The ultimate cause of the final drama was precisely the failure

of such a partnership: Utzon 'did not and does not want any partners or even assistants who are indispensable to him, it must be "Utzon Only".' Ove was adamant: 'if you insist on having your head in the clouds, you must keep your feet on the ground, otherwise you're blown away.'[5]

After the form of the Opera House roofs had been determined, Ove took almost no part in detailed engineering or architectural discussions. But he still engaged in correspondence, warning the Minister, for example, in 1970, that a proposal to incorporate an escalator in the ceremonial staircase would be an act of 'vandalism' – and that the functional requirements of the brief must always come first. The Minister replied that there was 'almost universal complaint and surprise' about visitor access. In fact, nothing was done: but when he encountered inaccessible staircases himself, Ove grumbled loudly.

The scale and the complexity of the project transformed Ove's firm in many ways; but he was personally affected far more fundamentally. The Opera House had occupied his mind and secured his absolute commitment from February 1957 until it was opened by Queen Elizabeth in October 1973 – from his own mid-sixties to his late seventies. He was not merely thirty years senior to Utzon, but from an entirely different generation and background: in the judgment of his family and closest colleagues, he never regained his uninhibited enthusiasm for architects, nor did he risk complete trust in any one of them outside his own team.

Of course, neither he, nor any other sane observer, thought that there was a single explanation of the tragedy, nor that only one individual or decision or political circumstance was its sole cause. Such childlike yearnings, canvassed by interested parties, struck him as intellectually irresponsible, and thereby immoral. But if the protracted and Byzantine epic established the firm, it effectively destroyed its founder. Ove had put the firm on the line, and risked its financial future; the best people had been working on the scheme, which jeopardised the quality of other projects and threatened to generate a feeling of first and second teams. Understandable tensions developed in London. Dismay that he had condoned pursuit of a merely sculptural form, and rage at his own misjudgment mingled with disgust at his young friend's betrayal; his own idealism, commitment to excellence, and lifelong ambition to unify architecture and engineering had found the perfect commission in the Opera House. Or so it had seemed. But, as he sadly reflected in May 1966: 'The goal was in sight – and then this!' Utzon had 'failed . . . He confused flattery with friendship, truth with treason.'

But something of outstanding aesthetic appeal and public esteem did emerge, albeit an iconic sculpture rather than a truly effective concert hall. By

1965 Ove had already revised and enlarged the concept of what was being delivered, and urged readers of the *Architects' Journal* to wait some time before judging 'the success of the whole venture as an Art Centre, a public resort, a civic symbol, as monumental Architecture'. In his own eyes, however, his experiment had not succeeded; his thesis had not been proved; mutual trust and co-operation between architect and engineer had not been securely anchored. To someone buoyed up for so long by such ideals, the glass was half empty, not half full. The harmony that he sought entailed an understanding without which no satisfactory synthesis or compromise could be reached. And only then would it be accepted by normally self-absorbed individuals 'that half a cake is better than no cake at all'.

If, with an apparently ideal commission, the partnership failed, did it not follow that Ove's lifelong goal must itself have been flawed or unattainable? Of course not: because the particular context determined everything, above all the people involved and the nature of the bonds between them. But Ove did not fully grasp what he required of reformed architects: a fundamental change of beliefs, attitudes and procedures – a different *mentalité*. The unfamiliar bitterness of the saga – he was not inclined to bitterness – released him from the professional proprieties which, to a degree, had always muzzled him. From now on, he trumpeted his message: *reform* of the whole construction industry, and of the participating professions.

The gap to be bridged had been dramatically revealed in one of Utzon's last communications with Davis Hughes. There, he underlined the premise of his open attack on Arup & Partners, a premise which had dominated architectural thinking since the eighteenth century:

> As Architect of the house, I write from my ability to make a synthesis of the various consultants interested. I must be able to act as the captain of the team because if not the architecture will suffer and be one-sided and lean too much, for instance, to the structural side. [. . .]
>
> Also, an engineer does not have any hope of acting as an architect – he simply does not understand it. All his work can be calculated: none of an architect's work can be calculated. An engineer's whole life then is related to calculation and the architect has done the opposite.[6]

By an extraordinary coincidence, the *Sydney Morning Herald*, two days earlier, had carried a first leader on a noisy debate in Cambridge about 'The two cultures'. The arguments revived Ove's interest as a student in the issues, and his impassioned pleas to the British Association in the early 1940s.

During the 1930s, prominent writers such as Aldous and Julian Huxley had sought to counteract the cultural consequences of a widening gap between the arts and the sciences, noisily promoted by literary specialists. Just when Ove was struggling to advise Utzon on his inspiring but inchoate designs, the debate had erupted again. In the autumn of 1959, C. P. Snow delivered the Rede Lecture in Cambridge, under the title 'The two cultures and the scientific revolution'. Snow had already canvassed his views on this topic in the *New Statesman* and the *TLS*,[7] and debate was promoted in *Encounter*. Ove read all these discussions. Snow's lecture provoked a fiercely polemical reply by F. R. Leavis, who reiterated his own core belief that a properly constituted university school of English 'trains, in a way no other discipline can, intelligence and sensibility together'.[8]

Leavis deplored the intellectual, social and political influence, as he thought, of those who, unlike himself, had scientific and technological interests. By contrast, Snow had studied under the Nobel Laureates J. J. Thomson and Ernest Rutherford in the Cavendish Laboratory in the 1930s; by 1942, he was director of technical personnel at the Ministry of Labour, under Ernest Bevin, at precisely the moment when Ove began his correspondence with Miss Wilkinson. Snow believed that so-called 'cultivated' British society neither understood nor appreciated scientific endeavour and success; and that Britain's relatively poor economic record in the first half of the twentieth century reflected scientific and technological ignorance, if not hostility, among those in power. There were no first-class scientists in Parliament, and no Civil Servants had any first-hand knowledge of any advanced scientific endeavours. In his own novels about university politics, Snow also argued, like a number of philosophers of science, that the imaginative, speculative, aesthetic aspects of scientific thought were central, although methods within the sciences varied: such remarks were entirely ignored by the literary brigade. Snow claimed that failure to recognise the roles of technology and scientific enquiry throughout even our own history had fostered not only misunderstandings of the past, but inability to identify elements and central tasks in the present. Over-specialisation within the English educational system had merely exacerbated the problem, by enlarging the population of intellectual and practical Luddites, and generating new snobbisms: only the second-rate, for instance, turned to applied science.

With all of this Ove signalled his complete agreement by dramatic textual underlinings and marginal exclamation remarks: indeed, he had said almost all of this himself, in the presence of Huxley and Bernal, Blackett and Cripps, Born and Needham. The Utzon-Arup debate, such as it was, alarmingly mirrored the Snow-Leavis debate.

Historically, the modern separation of 'the arts and the sciences' emerged from efforts in France, and then England, to distinguish between practices where measurement and repeatability could authorise predictable results, and those in which they could not.[9] By the end of the eighteenth century the mathematics required for much scientific work were incomprehensible to all but experts. With the dramatic increase in literary publication for an ever more literate and leisured general public, throughout the nineteenth century, the view insensibly developed that the inaccessible sciences occupied an entirely different domain of human thought. Darwin's chief promoter, T. H. Huxley, sought to combat precisely such developments in the 1860s, in ferocious debates with bishops and professors of poetry such as Matthew Arnold. And yet, one hundred years later still, it was almost official British doctrine that a properly 'educated and rounded' individual would have been trained in the classics and in history. The contrast between Britain and best practice on the continent could hardly have been starker, and Ove was acutely conscious of it throughout his life: the key, as he quickly discovered in the 1920s, was the deeply ingrained class structure of British society, the snobbery and prejudices of which he found repellent.

This was the context in both Britain and Australia, when Utzon announced that an engineer could not possibly understand the architect. But whereas politicians could not be expected to take an interest in the myths and 'tribal loyalties' – Ove's phrase – of rival professions, nor in the niceties of cultural evolution, they not unreasonably did expect architects and engineers to look for common ground: this, after all, had been Ove's defining goal. One step, about which engineers were always explicit, and which continental scholars in all spheres in the 1930s had eagerly embraced, was to characterise human action in terms of problem solving. The task was then to explain what that meant. Everything in his own education directed Ove to complete agreement with this view – his philosophical and engineering training, his later friendship with Bauhaus intellectuals, from whom he differed mainly in his own emphasis on contexts, and his central emphasis on 'design'. Three major features of 'problems' were typically emphasised: first, the formulation of any problem revealed, or betrayed the limits of, present understanding; second, it limited the range of responses that would count as solutions; third, the solution of one problem often indicated where the next ones would arise, because our understanding is always incomplete and is evolving.

The scientific notion of 'problem' was intended to be entirely value-neutral, with no negative implications. For laymen, a better term might have been 'task', since everyone understands the importance of asking: what is the task,

and how are we going to tackle it? But emphasis on problem solving unintentionally resurrected questions about responsibility. When not oscillating vaguely between extremes, or trying to hold both views, thoughtful people adopt one of two positions. Some hold that credit belongs not to what actually happens, but rather to the motives and intentions behind it. Others hold that responsibility attaches to what actually occurs, and the consequences thereafter. This debate often reduced to one between processes and products or, in more acute cases, between ends and means. Since time immemorial, artists and craftsmen have confronted this dilemma. Ove respected the idealism of intentions, but resolutely held that what ultimately counted was what you did.

Successful propaganda during the late eighteenth century convinced many spectators that true artistic genius lay in the mind: implementation of ideas inevitably distorted them. Material expression, at best, only echoed the pure forms behind it. Those who rejected such Platonic idealism argued that expression was necessary not only as evidence to others, but to the very existence and character of otherwise inchoate and indeterminate ideas. 'How can I tell what I think, until I see what I say?' In the late 1750s Adam Smith castigated architects – with Robert Adam in mind – for claiming that the true work of architecture existed fully and finally in the drawings, not in what was built. This view has enjoyed periodic popularity ever since, especially among those who lack the moral fibre to put their ideas to the test. As Ove and his team discovered, such persons easily delude themselves in claiming to have fully solved problems in the mind, and in rejecting demands for evidence as insults to their integrity.

But if both credit and responsibility depended on what actually happens, further questions seemed to emerge: were credit and blame to be assigned always to individuals, or could there be team achievement, or even accidental success? Need reference to 'creativity' be confined to individual effort? On these matters architects and engineers tended to take diametrically opposite views, and the resulting tensions were rarely beneficial. One reason for argument arose because some architects described the ever-present constraints upon problem solving as inhibiting the absolute freedoms of creative thought. But there is no such absolute freedom, and every craftsman and artist in history has grappled with the constraints of medium, time, cost and personal energy, quite apart from other factors such as legal, client or other contextual demands.

Ideas of this kind had been at the forefront of Ove's mind, when in October 1958 he submitted a paper to the Institution of Civil Engineers on 'The archi-

tect and the engineer', for delivery in the spring and publication the follow-ing August.[10] It encapsulated thirty years of reflection, but it had far greater implications, for he was already deeply involved in the construction of the Sydney Opera House.

He began by defining his notion of 'design' as 'all the instructions in the form of drawings or other documents necessary to enable a skilled contrac-tor to erect the structure'. He knew he had often used a much richer notion, and he smuggled some of his normal assumptions into the present discussion. He also knew that a vast literature, deriving implicitly from Alberti and explic-itly from Vasari, had been generated around interpretations of *disegno* – a term which could signal both technical and very general concerns – although, as usual, he made no attempt to locate his views within that continuing tradition.[11]

The goal of both the engineer and the architect should be to find 'the right compromise solution' between the typically conflicting claims of function, sta-bility, appearance, practicability and economy. Up to the nineteenth century, the trial-and-error methods underpinning inherited traditions had largely sufficed in the building industry: no longer. But the specialised knowledge now necessary did not imply 'design by committee': on the contrary. Reflection upon the merits of diverse possibilities 'must take place in one brain [. . .] with authority to make the final decision'. Unfortunately, Ove described such a process as 'intuitive', albeit he had associated it with the brain. It was a term with a long history of mystification, and which properly only announced a problem, not its solution. Of course, Ove did not mean that decision making, by architects or engineers, lacked forethought or justification, least of all that they derived from any transcendental source.

Ove argued that the traditional allocation of spatial and aesthetic decisions to architects, and all other functional requirements to engineers, was no longer rationally defensible. Nevertheless, for all practical purposes it was 'desirable to adhere to the principle of undisputed leadership', by one or the other; and clients should not be permitted to meddle in the details of the design. This was because any selected 'expert' should have the final say on technical matters. Often the client either does not know what he wants, or wants the wrong thing; and in a worse scenario there may be no clearly identifiable client, as often happens with a large teaching hospital, or factory. Moreover, at the outset of a project the client 'cannot see what he is buying, he has to buy the "cat in the bag" '. Ideally, an architect should also be a good engi-neer. But in any case, engineering advice should enhance the architect's understanding, much as a musical accompanist contributes to the perform-

ance of a soloist. Ove then subtly transformed a familiar criticism of *architects*, into a challenge for *engineers*:

> Architecture, being a particular kind of art, suffers from, or glories in, being subject to fashion, changing taste, theories, ideologies, or personal idiosyncrasies, and it can be difficult for the engineer to follow suit. Some architects believe in a sculptural, classical, or formalistic approach to architecture.

Ove never understood how meaningless prattle, in any sphere, gained a hearing: in his world, at least, if a particular structure 'works', it did not matter what anyone said, unless deception resulted.

In a supplement on Coventry Cathedral, published in *The Times* on 25 May 1962, Ove once more insisted on the need for collaboration between architect and engineer, suggesting that 'the merit of the structure is not judged by its fulfilment of its main purpose – which is taken for granted – but by its economy and by its contribution to the solution of the architect's own functional and aesthetic problems'.[12] He did not reveal, at this stage, that Spence had consulted no engineer when he submitted the competition drawings – whereas Ronald Jenkins, for Arups, had discussed the Smithsons' submission with them. He once more repudiated the fashionable claim of architectural critics that the design of a cathedral should grow out of structural necessity: 'the atmosphere the architect is striving for, is not a matter to be settled by criteria of structural economy.' In the case of Coventry there were the usual mundane matters to consider, beginning with 671 bored piles to carry the loads down to the sandstone.

Spence separated the actual roof from the vault. The roofs, spanning a nave of about ninety feet, were conceived as a series of shell structures, which meant that thin walled structures carried the loads to the supports through compressive forces in the shells, rather than through the bending behaviour of beams. The roof canopy is a network of concrete beams stretching from wall to wall, supported on fourteen slender columns. Initially there were four rows of columns supporting a concrete vault; then two rows near the walls were omitted, and the positions of the two rows converging towards the altar were calculated by a series of grid lines which also fixed the position of ribs in the canopy. Then, partly for acoustic reasons, the spaces between the ribs were filled with shallow concrete pyramids; these were subsequently first pierced, and finally replaced altogether by timber slats.

To Ove a more interesting problem concerned the roof above the baptistery. It is essentially a composite shell of eight flat triangles, each stiffened by ribs: the shell is held together at the sides by ties. The roof supports the 78-

foot-high manganese bronze space frame, and part of the large bronze and glass screen. The latter is hung from the roof, which improved its appearance of lightness. Ove did not think the complicated angular course of the ribs was entirely satisfactory, but he succeeded in persuading Basil Spence to simplify several other unnecessary complications in his design. Spence reported that Ove had been 'very critical' of some design aspects, although overall 'absolutely in sympathy with what I was doing'. One new procedure that proved effective was used again in Sydney Opera House, and became commonplace for segmentally cast concrete bridges. This was the use of epoxy resin glue to bond thin joints of pre-cast concrete units.

The Partner responsible for the cathedral was Povl Ahm and, as so often, after extensive initial discussions with the architect, Ove contributed little to the detailed decisions. A minor feature was clarified only years later. On 7 June 1994 Ruth Winawer wrote to *The Times*: one evening, while working on the cathedral, Ove said to her: 'Oh, by the way, Basil Spence is designing the official clothes for the Bishop of Coventry, and he wants a narwhal horn for the crozier – he seemed to think I could get him one because I was Danish – I don't know why. See what you can do . . .' Ruth approached the Danish Embassy, and as Canon Paul Oestreicher confirmed, the crozier was made from the whale's extended tooth. There was also another minor detail: designing the cantilevered curved stair to the manganese pulpit 'was one of those personal intimate challenges that Ove relished', not least because the consequences of an ascending, but overweight, bishop could be alarming. Discussion started with a 10-inch roll of tracing paper, and Ove 'just went on talking and doodling. He generated a mode of thought that was for ever exploratory.'

A long interview in 1964 intended for the BBC programme *People Today* enabled Ove, in his seventieth year, to elaborate on his early life.[13] He chose Highpoint and his own Durham footbridge of 1963 as the two works that had given him most satisfaction: 'both are rather perfect examples of the complete integration of architecture, structure and method of construction.' Of all his other jobs, the Sydney Opera House was by 'far the most difficult and almost too exciting'. The interviewer cannot have known that Ove's answer to a question about 'the meaning of life' had barely changed from that in his student notebook of fifty years before: 'I don't think there is any Truth about Life with a capital T. No absolute truth, not one which is available to human beings with their limited understanding.'

Every individual is different, is unique – a fact which is sometimes forgotten by scientists and organisers who would like to treat human characteristics as material to feed into a computer. Therefore there is not one truth,

not one kind of goodness. It seems to me that one should savour and try to understand, in an artistic way, if you like, the richness and variety of life.

Ove conceded that his uncertainties encouraged 'too great a tendency to be merely contemplative':

I hate in a way to commit myself until I have investigated every possible course of action or line of thought. It makes me see the other man's point of view, which can be a good thing if it does not stifle action altogether, but it is mostly infuriating and a source of weakness.

As on other occasions, his insight here was muddled by hastily moving to another point: seeing various possibilities is not the same as seeing another's point of view, and seeing another's point of view is not necessarily a source of weakness. Did such a confusion contribute to misunderstandings with Utzon? Ove continued:

The possibilities are so endless, what sort of excellence should one pursue? [. . .] Should one have great humility, be meek – to inherit the earth – mild, charitable, tolerant, kind, self-effacing, or should one be intolerant of stupidity and prejudice and be ruthless in the pursuit of some idea or ideology? It is very difficult to choose. It is very difficult to be dogmatic about what one should do – it depends of course on what sort of person one is – and if one thinks too much about what sort of person one is one is quite likely to make a mess of things. I can appreciate almost any kind of excellence, even if it contains a certain amount of wickedness. For me it is almost easier to say what I don't like. Cruelty to children, greed – in others – pompousness, cocksureness, injustice, as I see it, lack of consideration for others in others, well I don't like to see people or animals suffer – all the usual things, for that matter. And, come to think of it, the reason you have to become involved in life is really the existence of other people. We are in this together, a fact which one, or I, sometimes lose sight of. You cannot shut yourself off completely from other people – there would hardly be much life left. And therefore human relations are really the most important thing in life. Hunger, illness and all kind of human suffering can be terrible, but the cruelty of one human being towards another is surely worse. And in human relations are also found the greatest possible happiness which can be felt. But – the most important? Creative thought or activity is of course also important, and for some the most important – so here we go again – sorry.[14]

Among their close neighbours in Virginia Water during the war had been the recently abdicated ruler of Thailand, King Prachatipok, and his son Prince

Subha Svasti. Ove and Li became close friends of the Svastis. Although he had been educated in Britain and lived there for more than thirty years, 'Chin', as he was called, decided to retire to his homeland, although many of his grandsons remained overseas. He wrote to ask Ove to be 'guardian' to his nephew, whom he proposed to send to Britain but who then spoke only Siamese. Flattered as he was, Ove was also appalled: 'he may be a model boy', but if anything went wrong 'it would be very difficult for me to find time to rush down to Cambridge even now and then, to put his affairs in order'. Such a reply was received with the utmost courtesy: why, then, should not the next generation take the boy on? Surely Jens and his wife Sheila could take him in, coach him in English and guide him? Luckily for Ove, the next letter reported that the boy had found a girlfriend and wanted to look after himself.

In the spring of 1964 Ove and Li returned to some of their favourite haunts in Portugal, with their daughter Karin and son-in-law Brian Perry. Ove's confidence in his sense of direction remained undented by the overwhelming evidence to the contrary. Unable to find 'Saide' on the map, although many signs announced it, he asserted that since it was not their intended destination anyway, they should turn round and go back to their starting point. 'Saide' is Portuguese for 'Exit'. His passengers quickly learned the virtues of resignation, or had to choose other transport. Ove covered one eye with his right hand, while driving along, because he was blinded by car lights reflecting off the wet road: 'I can see perfectly well now: if I use both eyes I see everything double.'

Pressure of work no doubt contributed to possible explanations, but Ove's encounters on the British highways continued to excite commentary by officials. And his insurance company received regular reports:

> At the junction of North Circular Road and Edgware Road I was waiting for a Green light and then crossed to the other side of the road when I was hit by the Army lorry coming from behind. . . . I cannot explain why this accident happened. I saw the lorry drawing near and tried to go to the left as far as possible, and was very surprised when the lorry proceeded in the direction of my car and dented it.
>
> At 3.00 p.m. I backed into another car . . . His radiator was damaged and there was also some damage to the front bumper on my car – the rear bumper was severely damaged and the exhaust was pushed in.

A junior colleague anxiously reported to Ruth Winawer that for twenty minutes the unattended Daimler had been sitting outside the office, with the engine running. Ove had gone to a meeting and then to lunch. He almost

never travelled by bus or tube, but on the rare occasions that it was unavoidable he always insisted he knew the route: and didn't.

Invitations to lend his name to worthy bodies increased with his own fame. Joseph Needham, then Master of Gonville and Caius College, Cambridge, invited Ove to be a sponsor of the Society for Anglo-Chinese Understanding, along with such notables as J. B. Priestley, Herbert Read and C. H. Waddington – all known to Ove. He agreed. Among the charities he supported was the Society for Autistic Children. He was extremely fond of children, and took great interest in the young families of his colleagues, often sending small presents and receiving drawings in return – all of which he kept. He would, of course, also receive unusual requests for support: he sent 5 guineas towards the legal defence costs of an artist arrested for trying to draw a continuous chalk line from London to Amsterdam, in protest at atomic bombs. An invitation to an ambassadorial 'Scandinavian Midsummer Celebration' suggested to Ruth 'a lot of solid prosperous Scandinavians engaged in pre-Christian fertility rites and folk-lorism'. She and her son had appropriated the office term 'pre-stressed' for 'anyone who is possibly admirable as a husband, father and engineer, but a dead loss as an ordinary dinner table companion or for the ordinary social occasion'. To Ove's complaint about some Danish workmen, Peter Dunican retorted that he normally had 'half a dozen people cushioning him from the full impact of the frightfulness of workmen'. Ruth and Dunican were among the very few who could push that far, but Ove did not much like it. He preferred Ruth's retort to his commendation of a masterly letter by Philip Dowson: she would 'like to do something masterly. "Mistressy" is quite different, unfortunately.' His old Marxist colleague 'Bobby' Carter, librarian at the RIBA before the war and director of the Architectural Association in the early 1960s, had a celebratory lunch with Ove just before his birthday: 'I thoroughly enjoyed the luncheon with you and the exciting experience of hearing you scatter your thoughts, as it were, on the table to be gathered together as particles, according to some law of thermodynamics, into crystalline patterns.' Ove replied that he would 'undoubtedly vote Labour, I generally do, because I think it is by far the least of two evils. Politics is far too complicated for me, party politics far too simplified and doctrinaire.'[15]

Around this time he read Richard Crossman's *Plato Today*, first published in 1937 and recently revised. Ove was enthusiastic about the book and wrote to the author: 'I agree with all of it as far as I am able to judge about it.' He was worried by one area, however: was Crossman prepared to accept that 'human values will change', or did he 'want to make the human race hold onto certain values'?

Do your remarks about Christianity imply that you subscribe to Christian values? All of them? Also Christian dogma and 'noble lies'? [. . .] I am not trying to be difficult . . . it would be very interesting to know how you solve the problem of being a philosopher-king. But I realise that it hardly leaves you time to answer silly questions, and therefore I do not expect an answer. I will look for it in your latest book – your other books have whetted my appetite – and if I find it, I will tell you, if I may. To make it easier for you, I will address it to your wastepaper basket.[16]

Celebrations of Ove's seventieth birthday, in April 1965, as the Opera House saga reached its climax, were as complex as ten Christmas parties put together. The Partners decided to commission a spinet from the best-known English maker of the day, Arnold Dolmetsch. When he heard of this, Ove insisted on travelling down to discuss with Dolmetsch what he was doing and how he went about making the instrument. Entirely uninhibited about commenting on Dolmetsch's methods, he was keen to make suggestions of his own. The journey to Haslemere exhausted his colleagues in every respect: Ove had been advised that a first-class railway journey would be the most comfortable and convenient way of arriving: which he crossly rejected on grounds of cost. However, the second-class carriage was so uncomfortable that he complained bitterly to everyone about that for the rest of the day. The Partners also produced a *Festskrift for Ove Arup* edited by Rosemary Devine, and with a cover designed by Le Corbusier. The volume included spoofs, verbal sketches and illustrations, an interminable poem from Buckminster Fuller;[17] and brief remarks by architects with whom he had worked, including Lasdun, Spence and Goldfinger. Felix Candela described him as 'the only legitimate successor of Maillart, and in several respects he even excels his predecessor'. He added: 'When I saw the pictures of Ove's tiny footbridge at Durham University, not only I said "of course", but felt a pang of jealousy, because nothing makes me more jealous than seeing a true work of art.'[18] Maxwell Fry recalled 'a collection of all the bridges he'd thought of, but generally hadn't built' and his amazement 'at the beauty of their conception'. There were five lines from Utzon, and an encomium from Jane Drew:

I cannot forget my first meeting with Ove. In fact, I remember it very clearly. I had a white dress on and I sat in the back of his car on the way to a party at the Yerbury's. There were some strawberries on the back seat and I got them all over my dress. That was a very memorable beginning! . . .

We found, when we were in Arabia, that 'Ovie' meant 'the shapeless one'. This he didn't altogether like. But it also meant 'god'. And there is some-

thing of this very big outlook which makes you feel you're with an extraordinary character for whom one has as much respect as one can have for anybody.

Ruth Winawer observed that Ove's open mind irritated colleagues:

When there is a complaint from outside he never automatically assumes that his people are in the right. He says that he will investigate. To people who have worked in an organisation where the practice is to preserve a solid front to the world this can be upsetting, because it seems to indicate a lack of faith in his colleagues. In fact this attitude is strictly rational – if we are in the right, the investigation will prove it. If we are not, then the sooner we find out and make things right, the better.[19]

And Ove's lunches, initially cooked over a boiling ring in 8 Fitzroy Street, and later in the private kitchen in no. 13, generated endless stories about the idiosyncratic ambience which never failed to impress potential clients. One interviewer rashly said that he too enjoyed cooking, and found himself buying the food and cooking it: this surprised no one in the office. Philip Dowson had been rebuked for replying that he would take his omelette 'just as it comes': 'No, no, that is not good enough at all. You cannot say that, you must have a view.'

While Ove was on a month's visit to Arup offices and sites in a troubled South Africa and a politically tense Rhodesia, his house in Highgate was burgled. Neighbours foiled the attempt, and Ruth strongly hinted that an appreciative letter would be in place – which she would draft, as usual. She added that 'Mrs Wancke will for ever afterwards be able to say to Mr Wancke "Well, perhaps you'll agree it was a good thing you listened to me that time when the Arups were burgled".'

In a talk to the Westminster Chamber of Commerce Ove insisted on the importance of

the psychological impact of space, colours, texture, light and shade – all these matters which long-haired artists spend all their energies talking about without ever agreeing about what they really want, and which would drive sober and practical men of affairs up the pole if they were ever to take any notice of it.[20]

He urged that very high priority should be given to such artistic effects, not least because 'beauty, character, poetry or environment [. . .] is something which has to be fought for': they call for sacrifices. It is significant that space, colour, texture and light, famously prominent themes in Alberti, were central

to Steen Eiler Rasmussen's lectures, which Utzon attended as a student, and which were later published in his influential book *Experiencing Architecture*.[21] Ove added, clearly echoing his statements in 1942, that people involved in the construction industries

> are not really collaborating in a spontaneous desire to create new and better buildings. [. . .] What they are thinking of, what drives them on, is probably how to improve their status and their share of the common cake. Anybody who would try to eliminate want by organizing the necessary collaboration of many people on a more rational basis is at once up against old customs, established trades and professions and vested interests, and the whole thing moves into a sphere of social organization and politics.

In seeking the best possible design one cannot omit politics: 'design must take account of purpose – and purpose is politics, if you like.' Because it is the key to the realisation of a project, Ove again underlined his broad conception of 'design': it includes all information about what should be built '*and how it should be built*' [italics in original]. The quality of the result ultimately depended on the quality of three different viewpoints – which rarely converged: those of the client, the builder and the artist. Each of these had different primary interests, namely, function, resources and environmental effects. And of these, the artistic dimensions are arguably the most problematic:

> artistic discipline is a very personal thing. Art can only be judged by acquiring understanding of artistic culture in general and of the personality of the artist in particular. Art can be criticised, perhaps, but it cannot really be taught. There are no rules – the artist makes his own rules.

Regrettably, Ove had no space to explain this last claim, which was almost certainly absorbed by his audience as a mere cliché. He merely added that in the context of building, the necessary synthesis for which he was pleading cannot be achieved by one mind alone, and

> the situation is sometimes aggravated by an attitude of mind which is frequently found amongst architects. He is a superior being, his main concern is to keep alive the flame of true art, and the objects of his attention receive a kind of reflected glory and are raised to a higher category, that of works of art.

These remarks were written at the height of problems with Utzon, and the allusion is indubitable.

As arbiter of taste he really thinks that he should dictate to the client what he is allowed to have. [. . .] His attitude to technology is that of a husband when it comes to sewing on buttons. Such arrogance may well produce works of art which are praised in the technical papers and excite architectural students all over the world. [. . .] The architects must stop shielding behind quantity surveyors to avoid contact with the mundane world of building, building costs and building invention.

The lecture also included two further characteristic comments: 'Delight is produced by imposing some kind of organization on the building structure, and you cannot organize something you don't know anything about.' 'Generally speaking the answer is team-work', requiring mutual understanding and respect, under a leader who makes the decisions.[22]

In October 1966, and simply because he was asked, Ove delivered his first school speech-day address, to Dixie Grammar School, Market Bosworth.[23] The young pupils had no idea what to expect from this tall, stooping, smiling, foreign, grandfatherly figure: parents and staff were intrigued by the whole event. 'Success in life', he said, had little to do with material things. In thinking about the future, one had to acknowledge that the astonishing technical progress made during his own lifetime had generated an entirely new set of problems. By the mid-1960s, the environmental writings of Rachel Carson, Barbara Ward and Ritchie Calder were gaining some hearing, but Ove was rare among business people in joining their ranks. He listed six challenges: population explosion, conservation of the world's resources, spoliation of nature, division of the world into rich and poor, adverse effects of new inventions on traditions and civilisations, challenges set by developments in medicine, automation, computers. At the core of all these problems were human beings, and their essential 'cussedness'.

But any fatalist response was entirely indefensible: 'You may hold that your decisions are determined by previous events and are not yours at all – but this won't wash in practice.' Many decisions, indeed, 'are more or less automatic reflexes', but most are 'a mixture of reasoning and inborn mental dispositions'. Too many, however, are taken 'without much judgment or thinking at all'. Whenever such views were canvassed in the seventeenth or eighteenth century, they were fiercely rejected by theologians and philosophers alike, indeed by anyone who subscribed to an abstract ideology. Although they had become commonplace in the Western world by the end of the twentieth century, they were not when Ove began to advocate them eighty or so years before: indeed they clashed with many political and religious doctrines, and even seemed to cast a slur on many professional traditions and practices.

Architects, engineers, politicians did not like being told that, on the evidence available, they had not thought out their positions.

A few weeks later Ove addressed the Institution of Municipal Engineers. He chose as his title 'Aesthetics and the engineer', knowing that his Oxford audience would regard this as a contradiction.[24] The main part of his argument had been written, and then laid aside in 1961, at the height of difficulties about the Opera House roof. His first task was still to make engineers '*want* to create [. . .] more beautiful structures'. But he then needed to dispose of the myth that 'beauty' is a matter of taste, and that one man's taste is as good as another, encapsulated in the saying: 'I don't know anything about art, but I know what I like.' He was adamant: 'Now this is a most dangerous view and it is most definitely wrong. One man's taste is *not* as good as another's.'

From the early 1960s onwards, as the adverse effects of cheaply made modern buildings impinged on public consciousness, Ove urged engineers to cultivate aesthetic awareness. The need

> to create beauty, to give aesthetic satisfaction, to impart character, unity or integrity, to our physical environment, to express our civilization or our cultural values, to satisfy certain psychological needs for symbolism, monumentality, humanity, inspiration, calm – call it what you like, there is still a spiritual need to attend to.

Ove's frequent restatement, in many lectures, of his empirical method was easily overlooked – it was too simply expressed and, in one sense, too familiar. And yet in many professions, including architecture, it was and remained commonplace to proclaim value judgments as universal absolutes, detectable perhaps by intuition but certainly immune from rational discussion. Ove accepted that:

> ethical and aesthetic pronouncements are not capable of logical proof – if anything is – they can only have a relative validity inside a certain cultural circle. This circle can embrace a large portion of homo sapiens in space and time or it may consist of an esoteric coterie – but only with reference to such a framework do they carry weight.[25]

Such cultural anchorage, as we might call it, secures value judgments against the extreme penalties of absolute subjectivity – the view that everybody's value judgments are of equal 'validity' because they are uniquely private to each individual. This last view is ultimately solipsistic. Ove held, on the contrary, that cultural anchorage not only gives value judgments 'weight' but, more crucially, is the only way that they have meaning and can be understood. One

fully understands that 'one man's *taste* is not as good as another's' only if one grasps how judgments of taste are learned and practised:

> as with other skills, the latent ability of people to acquire good taste, to become good judges of aesthetic quality, vary widely, but latent ability is not enough. It has to be brought out by application to the subject. Ability plus hard work is the formula.

Ove conceded that 'a kind of critique of architectural philosophy [. . .] ought to be done', to help readers respond appropriately to disagreements between architectural critics. He himself had 'learnt to be very skeptical about the various architectural or aesthetic maxims put forward to justify particular decisions. There is very often no compelling connection between the two.' Above all, he had seen good and bad architecture 'produced without recourse to any principles at all'. He concluded with a confession that he often found it difficult to justify aesthetic solutions: this was unfortunate, because it deterred his audience from thinking through his arguments. He had forgotten that, to many of his audience, any admission that it was *difficult* to justify aesthetic judgments was tantamount to conceding that there was *no* justification.

Throughout his life, Ove objected to the profligate misuse of the term 'theory' by many writers. For him, theories are temporary explanations of identifiable problems and practices: they are always provisional, and subject to revision and replacement. As constituents in continuous enquiry, theories enable us to identify successive generations of problems and routes towards their resolution: theories can be simple or complex, can be used singly or in combination, can be expressed symbolically or in other ways, and can vary in scope – but they are only tools or devices of our own making, and they can become both obsolescent and obstructive.

Scepticism about the presence of theory behind practice has a long history, of which Ove was well aware. Guild craftsmen had long resisted the imputation to them of theories and in his French translation of Vitruvius in 1688, Claude Perrault doubted that architectural works resulted from theories. Prominent painters and musicians over the next century tried to resist the imputation to them of theories, and philosophers such as Hume argued that few actions resulted from them. Why, then, had they seemed so attractive? One reason was that, since the early eighteenth century, critics who lacked firsthand practical experience in the arts wished to claim special insight into creativity, for the benefit of ignorant readers. Ove himself held that good design can be taught 'when it is emerging on the drawing board':

if we could follow the emergence of the idea, its development and purifi-
cation, study the rejects and compare them with chosen solutions, and if
possible hear the designer's own explanation of his preferences – then we
might learn something.[26]

Ove's view of how good design might be taught derived from two sources:
the Beaux Arts traditions which were still influential in Denmark when he was
a student, and his knowledge of musical master-classes, from which many of
his closest student friends had benefited. His discussion is about process, and
has echoes in all fields where skills are imparted by *showing* as much as by
talking – the ploughman, tailor, sailor or surgeon must essentially show an
apprentice how to do things, although the amount and propriety of accom-
panying commentary varies. As he says: 'Examples are more convincing than
talk.' Ove readily conceded that decisions by an experienced designer often
seem to lack self-conscious reflection, but they are in fact deeply grounded in
previous knowledge, and reflection upon comparative examples. In retrospect
the nature of the design problem to be solved, and its appropriate solution,
often seem to have evolved and emerged in tandem: certainly Ove was happy
to view his early collaboration with Utzon in this light – and, as he had said
a few months earlier, 'progress in engineering has always depended on inge-
nuity and invention, it is a creative thing'.[27]

Ove had no need to acknowledge the historical roots of his views – such
references might well have hardened opposition to what he was saying. In any
case, he always disliked the demands of 'scholarship', which he thought
drained the fun from enquiry, and too often distracted attention from inno-
vative solutions to the problems in hand: and any sniff of pedantry was out
of the question. But he misjudged the scale of the intellectual gap he had to
close, and failure to lay out his premises was a serious error of judgment.

Ove accepted that all human beings are fundamentally social beings: as
such, they learn a vast range of responses from other people, among whom
they must practise their behaviour in a context of rewards and constraints.
We all have basic sensory responses – animal likes and dislikes. But what we
do has to conform to the behaviour of others in our group, however large or
small, and to what they expect of us. This includes making the same kinds of
value judgment. We learn from others in our community – family, friends,
teachers – what counts as good or bad in any realm, what is acceptable,
proper, required; and we need reassurance, when outside help is missing, that
our responses will meet with social agreement. The reason for all this is that
judgments are made in the public domain, where rules, conventions and
traditions ensure some degree of mutual understanding and co-operative

endeavour. By contrast, private feelings and sensations may well be peculiar to ourselves, and represent, as it were, part of our inner life – albeit powerful, valuable and cherished.

Discussions about art and beauty, therefore, are public discussions about matters that can be resolved within a given cultural context. Early writers had regretted an increasing use of the word 'taste', associated, of course, with the idiosyncratic behaviour of the tongue. The new, popular usage generated a distinction between reports of sensations of taste, which were of little interest except to cooks and physicians; and *judgments* of taste, which were not about sensations at all. They reported justifiable responses to something publicly observable – responses, moreover, that had been arrived at through learning. The crucial preposition 'to' – responses *to* a publicly observable object – signalled that the mind was involved. Wherever thought was engaged, there was opportunity for learning, practice, correction and improvement.

Understandably, Ove spared his audiences any such disquisition: the context seemed inappropriate. But he never attempted to create an appropriate context, and never faced the task: as a result, to many readers his reflections seemed groundless and were too often dismissed as the vague ramblings of an old man. When he arrived in London in 1923, as noted above, Ove had been shocked at the anti-intellectualism of his young British engineering colleagues. As years went by, he never ceased to be shocked at the prevalence of the attitude, and persistently forgot that his audience would neither discern nor search for the logical foundations of his thinking. For almost two hundred years, a majority of spectators had come to believe that the realm of values was entirely personal; art, indeed, was a matter of the shivers.

Finally, however, at the age of seventy, Ove refused to dissemble further: 'the danger of this view that taste is a purely personal matter is that it absolves one from trying to improve one's taste'; 'ability plus hard work is the formula'.[28] The reference to hard work underlined his increasing frustration about the educational programmes he witnessed in Britain, and about an alarming tendency to stop thinking hard about issues. Ove wanted to underline the difficulties in his proposed approach to teaching, because of its unfamiliarity and the need to alert his audience to the scale of change required.

To the end of his life, he complained that he never received a serious, sustained or challenging response to any of his philosophical pronouncements, however provocative: and he was right. In 1971, reflecting on his wartime writings, which he had re-read, he concluded that 'reason has hardly any persuasive power. [. . .] What matters is not what is said, but who says it.' The following year, 1972, he declared that 'In all my years of campaigning I have

never found anyone who disagreed. [. . .] But *talking* about [collaboration] doesn't seem to have had much effect.' And the year after that, he stated that 'it isn't just a matter of what you say. It also depends on whom you say it to and when.' Any new ideas 'take time to sink in, and still more time to produce practical results'.[29]

A partial explanation of his failure, as he saw it, to convince more people, lay in a perennial pedagogical dilemma: audiences dismissed as banal what seemed transparently obvious, and dismissed as incomprehensible what was merely unfamiliar. When obscure, he did not seem profound; when clear, he did not seem interesting. Effective communication presupposes harnessing an audience's knowledge and interests. Striking the proper note between trivial-ising simplicity and paralysing difficulty calls for judgment about each precise context, and many thinkers over history have held that a certain degree of difficulty or stickiness is necessary to motivate anyone to think and reason.

Failure by others to do our bidding does not mean they did not understand what we said, nor that our core ideas are mistaken: thought and action, moti-vation and delivery are different animals. Ove had maintained this very point to Professor Høffding. But Ove reacted to such failure with incredulity, and by adopting an extremely risky device: he simplified his arguments, and con-centrated only on their conclusion. These were, indeed, more likely to secure instant acceptance or rejection: but their very simplicity deterred both the con-vinced and the unconvinced from really thinking through his position. Apart from sufficient 'challenge' to secure and sustain a reader's thoughtful response, a critical mass of supporters does much to popularise an approach: hence the fashionability of architectural 'jargon' to which he so much objected. Apart from his own team, who increasingly proclaimed the message themselves, Ove had few flag bearers. But, as time was to prove, he was mistaken about the impact of his ideas and the influence of his practice.

As an empiricist for whom the primary goal of thought is action, Ove never claimed that his ideas were original. But he failed to grasp that, to outsiders, the prominent success of the firm seemed to be independent of philosophy. Moreover, even if such ideas could be detected at some level of the firm's prac-tice or decision making, were they not so general as to contribute little that was distinctive? Only in retirement did Ove fully acknowledge that his first objective was to cultivate an environment in which his thinking would be addressed, and could be implemented: what had too often remained riskily implicit, now needed to be spelled out. That environment was the firm itself.

Sensitive as he was to time and context, Ove readily accepted that the mean-ings and uses of ideas change in response to many factors, and have histories

of their own. Like most of us, he was slow to review how his own 'core' beliefs had evolved in ever-changing contexts. Nor did he answer the question of how to sustain individual motivation by relentless critical enquiry. He trusted his chosen colleagues to recognise the need and the duty, and to be sufficiently self-motivated: but in a very large firm was such an assumption reasonable? Could everyone justifiably be expected even to have the temperament, since many people find little need for, and less reward in, sceptical reflection? Ove had lived long enough to know that many people find the undemanding dogmas of fanatics to be psychologically more reassuring than the doubts and warnings of empirical enquirers. He liked to defend his own outspokenness by quoting from the then recently discovered foreword to *Animal Farm*: 'Liberty means the right to tell people what they do not want to know.' But he was generous in also citing Ruth's cynical addition: 'Stupidity is expecting that they will listen.'

How could anyone disagree with his basic tenets: that a creative designer who aims at excellence must be committed to the last detail of his tasks; that he cares, for example, about what happens to the back of buildings. The success of British-designed cricket bats, tennis racquets, saddles and golf clubs was 'not the application of an aesthetic theory'. It derived from the closest attention to detail: 'perfection of function. The aesthetic perfection follows from this personal involvement.' Such careless asides – precisely the arguments about 'structural honesty' that he had rightly castigated for years – resulted from the numbing silence of his audiences: no one challenged him.

He cited a report to the Government of India about educational training in design, in which the ubiquitous spheroid brass pot in Hindu households, the *lota*, had been singled out for discussion. The evolution of these pots, their form and scale and detail, had resulted from innumerable decisions of innumerable individuals over innumerable generations: that is what evolution is – in this case, of the form, scale and detail of pots. Nevertheless, the writer insisted, the number of those decisions is infinitesimally small by comparison to the constituents of the simplest environmental problem.[30] Ove drew a sharp conclusion which, then as now, struck some listeners as shockingly retrograde and romantic: 'we have abandoned the craft method of working' and, by relying on machines, fail to lavish 'all the care which the good craftsman used to lavish on his work'.

Ove realised that the scale of his ambition, involving total reform of thought and action, would terrify most of his audiences. And yet he could not disguise that the aesthetic responsibilities he was urging engineers to face simply mirrored those placed on every other citizen: 'any citizen has this duty –

because in the end it is the general level of aesthetic awareness which determines the quality of an architectural epoch.'[31]

Ove's respect for craftsmanship was evident to all with eyes to see. Li kept a sharp eye on his public appearances, for which he wore expensively tailored suits and shirts, in contrast to his casual dress at home; ties were chosen with the utmost care and coats worn with self-consciousness – on occasion he wilfully chose scruffy old ones because 'they were back in fashion'. The fact that, to many, he ruined it all by wearing a Parisian beret – because Le Corbusier did? – was neither here nor there. At home, too, Li's dinner tables were famous for their fastidious detail, and their seemingly artless simplicity: every polished glass and silver implement announced a theatrical offering which complemented the equally balanced colour, texture, taste and form of the food. In the late 1960s Ove had proudly told Ruth Winawer during her only visit to Denmark of the still compulsory study of housewifery by girls in their final school year: she remarked on her own 'good fortune in having had an alternative'.

Pictures, cultural objects, furniture were carefully placed and lit for the delectation of the connoisseur. They attended most of the fashionable gallery and museum openings, especially for modern artists such as Nicolas de Staël, Marino Marini, Le Corbusier and others. Ove bought and commissioned decorative objects and works of art throughout his life, and quietly traded through his émigré colleague Paul Wengraf from the late 1930s. Alongside twentieth-century paintings, including several by his brother-in-law Gerald Davis, were earlier Dutch and French genre paintings, some of which turned out to have been bargains: a fine portrait of a poet by the Danish painter Jens Juel was donated to a Danish museum after Ove's death.[32] As time went on, many of the pieces were located in the office, and smuggling them home was not easy: Li insisted he 'didn't need them' and pronounced the house already full. Accordingly, paintings were stacked against walls, and cupboards were jammed with sculptures, masks, pottery and even silver.

Aside from office Christmas parties and the summer picnics, which Li attended assiduously, Ove kept his family life entirely separate from the firm, as was quite normal in the profession. A small number of colleagues or old friends were taken to the theatre or to the opera, but his own cultural interests mirrored more those of architects than of engineers. The continental and largely bohemian intelligentsia in London did not behave in a narrowly conservative British fashion. Some of the British professions did, of course, patronise the arts: their members went to the opera, concerts, plays and gallery openings – even, sometimes, the cinema – but they rarely thought hard about

such cultural events in the continental way to which he was accustomed. Ove himself had few kindred spirits with whom to discuss the paintings he bought, the furniture and pottery he commissioned, the music he continued to play throughout his life or heard at his annual pilgrimages to Glyndebourne and Aldeburgh. While at university, and later in Hamburg, he had attended concerts and plays every week, and was ever keen to see, hear and argue about contemporary work: he became entirely familiar with the works of Ibsen and Thomas Mann, Hermann Hesse and Bernard Shaw, all of whom were still alive in his youth. But in London, although he dutifully took the family to the cinema, he chose only the lightest of films; and except when convalescing, he rarely read fiction or history. At home he read *The Times*, the *New Statesman, Encounter* – and articles in the *TLS* that Li recommended. Danish papers and journals were sent over by the family: the technical journals stayed mostly in the office. From the 1950s onwards, however, he began to concentrate on environmental and other global issues; besides Rachel Carson et al., he avidly read E. F. Schumacher's *Small is Beautiful* and admired the writings of Buckminster Fuller. He made notes, scribbled down quotations, and held forth about them at dinner parties – to the delight of attractive female guests flattered by his attention, and the invariable irritation of their male escorts.

Ove's frustration about professional proprieties finally overflowed. As he told an Australian broadcaster in February 1968: 'I have had enough of Utzon now. [. . .] What I cannot stand any longer is the injustice of it: the suffering caused to so many people who have given so much.' So 'I will talk because nobody else apparently dares to do so. [. . .] I have been shackled by these constraints for so long that I must speak out or burst.'[33] And in autumn that year he wrote 'A fairy tale' in which 'a poet', 'who said he was an architect', had been asked to design an Opera House for the people of Sydney.' But he had never built anything before, and he needed some engineers to tell him how to build such a thing.' However, whenever the poet was asked a question, or challenged, he became angry, and said his spell would be broken. And one day he became so angry, he just walked away and accused the engineers of breaking the spell. But the engineers were very sad, because they were still under the spell: and everyone wondered what was going to be inside the building, under the beautiful roof.[34]

In November 1968 Ove delivered the Maitland Lecture to the Institution of Structural Engineers, of which he had been a member since 1940. The title was 'The world of the structural engineer', and it was immediately recognised as an *apologia pro vita sua*. Ove appeared under the guise of Ernest, and the

audience preened itself on detecting a reference to *The Importance of Being Earnest*. They were wrong. Ove was in fact alluding to Oscar Wilde's profound philosophical essays 'The critic as artist'.[35]

Ove knew that many engineers still found some of his ideas very odd indeed. So he alerted the audience:

> Engineering is not a science. Science studies particular events to find general laws. Engineering design makes use of these laws to solve particular practical problems. In this it is more closely related to art or craft; as in art its problems are underdefined, there are many solutions, good, bad and indifferent.[36]

Two asides in his speech were revealing. Ove conceded that in the 1930s when he set up with his cousin, he was not immediately successful because he was 'trying to ride three horses at the same time' – as plain contractor, designer-contractor carrying out structural work to his own design, and consulting engineer for the design only of structures. Moreover, such a strategy was perceived, correctly, 'as an act of defiance' by 'an outsider'. Among the deeply conservative members of the building and engineering worlds, he was an outsider: foreign, eccentric, always talking about things that were really not their concern, but also, it was to be hoped, often quite incomprehensible. Yet it could be quite convenient to be an outsider and thus exempt from certain expectations. Ove confessed that from the first days of starting his own firm he left much of the 'dirty work' to colleagues – that is, the tedious financial and administrative details: in so doing 'he laid the seeds of his own disgruntlement over losing touch with the details of the firm's activities'.

A few months earlier, and sponsored by Professor A. J. Pippard, Ove's candidacy for Fellowship of the Royal Society had been considered; he was unsuccessful, and when Pippard died, Sir (later Baron) John Baker became his seconder.[37] Baker had begun his professional life thirty years earlier as Pippard's assistant, and Ove had come to know him and his pioneering work on the plastic theory of structures, both through the Institution of Civil Engineers in the 1930s and, of course, for his work on Morrison shelters and other aspects of air-raid protection. Ove was to remain disappointed in his candidacy, however, and Baker returned all his papers when the ten-year candidacy rule expired. On 16 November 1968 Ove read an article in *The Times*, by the Provost of King's College, Cambridge, the anthropologist E. R. Leach. The article was entitled 'When scientists play the role of God', and Ove fired off an excited reply: 'I agree with every word of it.'[38] Leach had argued, *inter alia*, that 'our idea of God is a product of history. What I now believe is derived

from what I was taught by my parents, and what they taught me was derived from what they were taught, and so on.' And he had concluded: 'unless we teach those of the next generation that they can afford to be atheists only if they assume the moral responsibilities of God, the prospects for the human race are decidedly bleak.' In his typically long letter to Leach, Ove outlined his view that since no agreement can be reached on principles of behaviour, it is impossible to 'compare short term and long term consequences': we have only imperfect knowledge of consequences, and no moral yardstick for their measurement. He need hardly have added, to Leach, that he had no intention of turning back to belief in God in order to resolve such matters since he was 'unable to *believe* in something which means nothing' to him.

11

'The key speech'

Ove witnessed the growth of the firm with dismay, delight, and distress at his own increasing exclusion from central decision making – some of which was entirely accidental, resulting from respect for his privacy. In 1960 he was to reach the firm's retirement age of sixty-five – in his case, however, he was awarded the honorary permanent age of sixty-four, to enable him to continue as the Founding Partner. He was not alone, however, in worrying what his future role might be in the evolving corporate forms of the business.

In late 1963, during the middle of the Opera House difficulties in Australia and shortly before Ove Arup & Partners Australia was formed, the Building Group of Ove Arup & Partners became Arup Asssociates: this itself, together with Ove Arup & Partners, was subordinated to the parent firm of Ove Arup Partnership in 1970. That parent firm incorporated Ove Arup & Partners, Ove Arup & Partners Scotland and Arup Associates as companies with unlimited liability in 1977.

By a series of steps beginning in 1966 the Partners of the day gave away all the equity of the firm for no consideration, other than that they would be re-employed as directors with reasonable pension rights. Special arrangements were made for Ove himself and for Geoffrey Wood. By 1977 employee and

charitable trusts owned all the equity of the firm. Although he did not like the idea when first proposed, Ove became a strong advocate of the new scheme, whereby professionals enjoyed the maximum freedom to exercise their skills, unhampered by equity ownership.

Ancient thinkers held that the proper scale of any given activity can be judged only after the event: we can optimistically aim at it, but it is indeterminate, and even the colloquial phrase 'overdoing it' signals that limits have already been passed. Nevertheless, there is a moral duty to discover the boundaries within which we may each justifiably proceed – 'moral', because the boundaries are defined by customs, practices, values and beliefs. What were the 'proper' boundaries of Ove's firm; what constituted its identity; and could its identity evolve without betrayal of its core values? The original Arup team functioned as an extended family; whether the ethos of the late 1940s could evolve in tandem with unplanned enlargement of the firm was not discussed until it happened.

Ove always proclaimed that the identity and character of the firm depended entirely on its people. They implement or amend the tenets and values of the operation, but there are no guarantees of success. In his RIBA Gold Medal speech (1966) he stated that the firm's managers were 'trying to eliminate the psychological barriers to teamwork, to create a kind of composite brain for each job', but future organisational patterns could not be predicted. Moreover, an ethos of enthusiastic enquiry and mutual support throughout a firm can be equally well sustained in different contexts by different means. Ove, unlike many of his contemporaries, foresaw emphasis on research and development as necessary steps towards successful evolution (this was before that commercial activity became known as R&D), and he also predicted increased specialisation as necessary for tackling increasing complexities. Both developments were corollaries of his lifelong views that no individual knows enough even to formulate some problems; and that multiple viewpoints are required for the resolution of any complex issue.

Even in 1947 Peter Dunican had reprimanded Ove for substituting 'I' for 'we' when discussing the firm's activities. As the firm got bigger this tendency irritated several Partners, especially when he had never discussed or seen a project. In 1963 Dunican used the very same words – 'there is far too much concerned with "I" and not enough with "we".'[1] But Ove's personal contributions to mathematical calculations, or engineering detail, are not what secure his reputation in the annals of engineering and architecture, although they were steps to establishing it. What secures his place are the people he chose and inspired to develop and carry out his ideas, and the ethos created

for them and by them: there was nothing inevitable about the successes that have followed. Indeed, it is the very contingency of the right people, with the right approaches, in the right places at the right time that has ensured fame and fortune. Recognition of such contingency, and inescapable vulnerability to adverse change, has been a major strength of the firm since its middle years: the modern fashion for 'risk analysis and management' covers only some of these issues, but the regularity with which the right horses for courses have emerged is exceptional.

By their own lights, Ove's empirical claims are themselves open to constant re-examination: general notions such as loyalty, mutual respect, creative thought do not prescribe particular decisions. Although many generations of Arup employees have read what became known as 'The key speech', he did not claim its immunity from evolving interpretation: quite the contrary.

Management, nevertheless, did not always run smoothly. From the early 1960s Ruth regularly reported on sloppy organisation and delivery at senior staff meetings. In 1964, at precisely the moment Ove was telling a BBC interviewer that human relations were the most important thing in life, Ruth was once again worried about the atmosphere at headquarters: were there endemic flaws?

> It's not the Partners who are different, it's the Associates and others who are fighting their way up, and my God, as far as I can see, you have to fight or go under [. . .] we might be doing some good and original work instead of trampling each other down on the way. Sorry to go on like this, I no doubt exaggerate, as always, and you must remember that when you get back I won't have a chance to say anything to depress you, because you will be talking hard all the time, but I do feel strongly that something is very wrong with this place, and I know that new people coming in don't get the same feeling of suddenly coming alive the way people used to. I think you should DO SOMETHING. It is after all you who started it all, and you were the dynamo and I think you really have the best qualities to see what is wrong, because you must be able to feel what is not in accordance with your feelings or standards or principles or whatever you call it.[2]

And a management report, commissioned from 'experts', prompted her immediate enthusiasm:

> As clear as mud, as they say. I feel very strongly that people don't try hard enough to make what they have to convey intelligible. They seem to think that because they have a sort of jargon among themselves they can go on using it when they try to speak to people who are not in their profession,

which seems to me wrong. It is a case of my latest hobbyhorse – the present-day failure to communicate, which I think is at the root of a lot of trouble of one kind or another. I think that whatever you are to explain, whether it is how to boil an egg, or draw up an agreement, or cook a balance sheet, or plan a hospital, you should take pains to see that the non-professional audience should understand within the limits of their mental equipment – that they shouldn't be shut out also because you are only pre-pared to use jargon which is designed in the first place as shorthand for experts.[3]

Salary matters were often ineptly handled. Ruth was clumsily told she would not get a rise, and everyone else merely learned their fate from a noticeboard:

A frightful announcement was put on the board all full of words about a yard long, written by Peter, showing the splitting up of the various depart-ments, and who was responsible for what, with no clear announcement that so and so had been made an Associate, and so and so been made a Group Engineer. It really was inept. Still, I suppose I shouldn't be moaning about it. It's not my business. But it seems a bit silly to spend weeks and weeks thinking up ways of making the chaps feel that they had a future in the firm and so on, and that they were being guided by some sort of organization or system, and then spoiling it all by not taking the trouble to make the announcement or spreading the news in a proper way, but allowing it to leak out through various channels, so that the whole place was apparently seething with rumours and half-knowledge, and some people drew wrong conclusions, and altogether there was a lot of hard feeling. I think the way you do things is not as important as what you do, but it is still very impor-tant, and I think it is a complete failure to communicate if you have to go back and explain things.[4]

Almost a year later, in March 1968, Ruth reported another unsatisfactory Partners' meeting, and an amateurish mishandling of the librarian's wish to leave. To cheer Ove up, she enclosed a cutting from *The Times* announcing Buckminster Fuller's Gold Medal at the RIBA:

he enjoys dressing up as Father Christmas, capering around the dance-floor and declaiming scientific propositions in the form of home-made doggerel. But dignity returns in full when he performs in public. He is a fluent – though some complain interminably long – speaker. Students, however – by whom he is almost worshipped – merely say that the first two hours are the worst.[5]

What was wrong with everybody? She tried to get Buckminster Fuller's address from the RIBA, and 'their information department assured me they had never heard of him'. Comments on management practice increased. A meeting of Arup Associates for senior staff 'went off like a damp squib':

> You see I have thought that relations between ARAS [Arup Associates] and OA & P [Ove Arup & Partners] would be improved if ARAS really made an effort to explain themselves to OA & P who admittedly contain a lot of boneheads who simply sit around making snide remarks about ARAS, and if the more intelligent and receptive OA & P characters made an effort to understand why ARAS are so prickly and to appreciate them IN PUBLIC so that their appreciation can be observed. [. . .]
>
> Well, evidently no one had reached the point I had reached, or if they had, the execution went a bit wrong [. . .] one had also the impression that no one had taken any trouble to consider the audience, the effect, or in short what I had hoped was the purpose of the show. It was a pity, in my opinion. I think it was an opportunity wasted.[6]

In fact the Partners had already hired management consultants to look into matters, but this did not impress Ruth at all. Secretaries had been circulated with forms to complete 'about how their boss's time is spent':

> Not very sensible in a place like this, where you don't sit in the same room as your boss. The only thing would be to hand it over to him to fill in himself. I am rather sorry that there isn't one for you to fill in, for if it were to be done truthfully the chart would have to show you having meetings with two different people and a telephone message with a third, all at the same time. That would fox them. Actually I get sick with all these management people who spend weeks investigating and then tell us what is wrong with us, without producing some magic formula to tell us how to put it right. We all know what is wrong. If you paid me £2,000 or whatever it is, I would write a report to tell you what is wrong with us. In fact I frequently do it free, only quite naturally nobody listens, because all engineers know that all women are fools, so they think.[7]

Lectures and addresses by Ove and other Partners such as Peter Dunican, Jack Zunz, Povl Ahm and Philip Dowson naturally acquainted a growing audience with aspects of the 'Arup philosophy'; but many senior members of the firm felt, nevertheless, that Ove himself should set down his ideas about the firm before it was too late. Up to then, ideas and attitudes had been absorbed by osmosis rather than digestion: an explicit statement could prove

both illuminating and helpful. And then he learned, during a meeting with Sir Maurice Laing in 1968, that the latter's firm 'worked out and distributed to their members a kind of manual of labour'.[8]

Towards the end of 1969 Ove published the first part of his reflections on the 'Aims and means' of the firm, as he saw them after the first twenty-five years.[9] Over the next six months he prepared and delivered two of his most influential lectures. Few members of Arup's knew much about Ove's writings: but in these three presentations, his reflective character could not be missed. Indeed his reflections spilled over into more than a dozen papers and lectures given at this time, each one adding both substantial and historical elements to its predecessor.

The values of the firm, he asserted, derived from, and were anchored to a rejection of ideologies and narrow nationalisms – they reflected a frame of mind often called 'Western humanism'. The firm, as a team, pursued the same aims as its individual members: money; interesting and satisfying work; pleasant atmosphere and surroundings; the moral attraction and prestige attached to doing useful and good work. Nevertheless, such aims cannot be satisfied *in toto* because they conflict. But a criterion of priority itself presupposes answers to two other questions: 'what roles can, or should, the firm play in society?' The firm, in other words, is inextricably embroiled in issues of social responsibility.

The firm is committed to 'total design': this determines what is being built, the environment, and the lives lived. Visually, functionally, spiritually, the firm's work affects everything. The satisfaction of these aims, however, presupposes the fulfilling of some fundamental duties: to justify the trust of clients, to honour obligations to the professional institutions with which the firm is associated, to 'break down barriers', to evolve appropriately, and to properly respect the human beings who constitute the firm:

> But there is more to it than that. By creating a model fraternity, so to speak, we make a contribution to what is almost the central problem of our time: how to overcome the social friction and strife which threatens to overwhelm mankind. We could become a small scale experiment in how to live and work happily together.[10]

Ove then explained these generalities by reference to quality of work, quality of behaviour, improving professional efficiency and learning to work happily together. The primary aim of the organisation is 'the relentless pursuit of quality'. The realisation of this aim secures satisfied clients, increased reputation, more work and financial reward. Above all, it enhances self-respect. Ove then embarked on a speculative anthropology of architecture, for which he

claimed 'no historical accuracy' – an unfortunate confession: 'when a man built with his own hands', 'the result was a direct, if imperfect, expression of his aspiration, a synthesis of ends and means, of the desirable and the possible, of dream and action'. Only when

> this synthesis was lost, when the activity of building was split between a number of separate professions and businesses, when it was not any more a way to satisfy human aspirations for a better life, but a way to make money for various sectarian interests – it was then, and to that extent, that building came to lose its humanity and even to be a menace to man.

Ove increasingly objected to 'architectural reputations built on art', with complete disregard for whether the buildings work. He was not interested in architecture 'which is only sculpture or aesthetic self-expression' – those remarks date from 1969, with the Opera House several years away from completion. He foresaw that, through their own architectural wing, Arup's would become increasingly concerned with briefing, 'because the right decision on what to build is usually more important than how we build it'. Nevertheless, if we disapprove of a Client's intentions 'we should probably not undertake the job'. This remark generated heated personal correspondence on the moral justification of working in South Africa, stained as it was by apartheid; and within a few years equally heated debate within the firm about working on a military site which housed nuclear weapons.

The second part of Ove's reflections did not appear in the *Newsletter* for another three years; meanwhile he tinkered with their presentation, but two big challenges occupied much of his time. He gave the Alfred Bossom Lecture to the Royal Society Arts in March 1970, a year after his friend Maxwell Fry had enjoyed the honour. Ove's title was 'Architects, engineers and builders'.[11] However unfamiliar the ideas might have been to some of his audience, Ove welcomed the public platform to set out three of his basic premises: first, our grasp of anything is necessarily incomplete, mainly because of the interconnection of all things; second, all the tools or concepts we use to make sense of things are obsolescent – because the things they apply to are constantly changing; and third, the goals by which we wish to guide our lives emerge only in the process of searching for them. Later, at the age of ninety, he insisted: 'I am aware that aesthetic values change, that moral values change, the way people act or re-act, the kind of institutions they create, the way they educate their children, the way they play – all change.'

In the Alfred Bossom Lecture he described the 'total design' which should be the shared goal of both architects and engineers. It is the synthesis of three

relationships: those of the part to the whole; those of means and ends; and the spiritual or 'aesthetic' relationship between inanimate objects. But there is a problem:

> We are faced with the paradox that the pursuit of value of some kind or other is undoubtedly the mainspring of action, and yet if people really went about thinking about the ultimate purpose of all they did nothing would ever get done, there would only be a glorious fight about what ought to be done.

Regrettably, in most cases people 'don't think at all': 'means have a habit of becoming ends in themselves. This saves thinking, and encourages action. But, seen in a wider context, it could be the wrong action.'

What, then, is involved in the mental activity of designing? His answer was indistinguishable from schoolbook accounts of scientific experimentation: 'intuition, invention, ingenuity spring into action, tentative solutions emerge, are developed, analysed, adopted as working hypotheses, new relevant data collected, practical decisions made, etc.' The designer's aim is to produce a structure that functions, looks and lasts well, and costs little. As a 'fine' art, architecture had been historically concerned with the design of important buildings 'according to varying principles or theories which had more to do with forms, spaces and proportions than with strains and stresses'. Historically, engineering structures such as bridges and harbours 'did not have anything to do with architecture'. Indeed, when he first arrived in London, 'the two professions [. . .] didn't even speak the same language'. But the modern movement 'discovered that the work of bygone engineers was in fact architecture' – Le Corbusier's claims of 1922 – and Ove endorsed that claim: 'everything built is architecture.'

If that is the case, teamwork is essential to integrate all the specialist design decisions: the aim should be something with 'the wholeness of a work of art, and the inevitability of a tool'. He confessed that the 'composite mind' he advocated was precisely what he had urged on the British Association in 1942. He then incorporated an idea which had been much discussed in the 1930s:[12]

> The various ideas are emotionally charged. Even the most rational engineering solution is only one out of many possible solutions, and is preferred by its author on the basis of some intuitive feeling which he would find it difficult to explain. Designing is not a science, it is an art – but an art confined by the nature of its medium and the aims to be achieved.

Ove ventured a definition of architecture: 'A way of building which delights the heart.' But there was an important clarification:

> Delight is not only aesthetic delight. There is delight in economy of means, in the recognition of inventive simplicity, of directness and clarity of structure, in the appropriateness of the spiritual quality expressed in the combination of forms and spaces.

He agreed that failures in architecture can frequently be explained more readily than successes – its bombast rather than its modesty; often we cannot say why something 'is just right'. Moreover, if there are equally good solutions to a particular problem – as is usually the case – each of them may warrant the verdict of 'just right', since that judgment implies neither necessity nor uniqueness. As he had said four years earlier in his RIBA Gold Medal address, 'anything is right which leads to the right result'. Pride, in all its manifold forms, is one of the greatest obstacles facing a team. An effective and collaborating team, like a choir, must have a leader, and it must not 'degenerate into a talking shop'; but, equally, it must temper enthusiasm with relentless critical analysis and realism. The date of the Bossom Lecture, it should be recalled, is 1970: the Opera House saga was not over, and the firm of Arup was getting very large. Ove could not avoid the question of scale. The 'ideal' organisation

> would be a relatively small closely knit team, working in the same place and having a continuity of work on a few jobs at a time, so that the members could really learn to appreciate each other's qualities, or if necessary shed those members who didn't fit.

However, jobs were getting bigger, and technically more complex, and 'top level men' in the specialised fields needed could not give their full time to work on a small team. There must be individuals with power to get things done: 'The power to initiate action rests mainly with a small minority wielding political or financial power. Their main preoccupation is, however, with the maintenance and extension of this power.'

What were the obstacles to environmental improvement? How could people be motivated to confront those obstacles? Was a form of utopian vision necessary to fuel such motivation? For such tasks, was self-respect or even egotistical impetus to implement one's own agenda more important than approval by others? Ove multiplied the questions. His central point remained: 'it is motives which beget action, and it is action guided by deliberate choice we are seeking.' The moral task of the firm was the same as that of any individ-

ual – to discern the right motives, and to foster the strength of will to implement them. A measure of self-respect about one's motives would be necessary to sustain the enthusiasm needed for the journey.

One of Ove's lifelong irritations was the system of quantity surveying which enabled construction to start before the design has been completed: 'It encourages architects in their besetting sin, the delusion that they can create original masterpieces without soiling their hands with such mundane matters as how the pieces are put together.'[13] When he revised his ideas for 'The key speech',[14] he adopted Walter Gropius's phrase to signal the firm's ideal: 'total architecture'. The philosophical force of that phrase involved treating human beings as ends, not only as means – a Kantian notion that derived from his earliest undergraduate studies. Several matters troubled him, however. First, he could 'not see the point in having such a large firm' unless there was something that bound everyone together, unless they felt they had 'a special contribution to make'. On the other hand he disliked 'hard principles, ideologies and the like. They can do more harm than good.' Principles 'in some way have to be flexible, to be adaptable to changing circumstances'.

Abstract notions such as 'goodness, beauty, justice' have been proclaimed as goals throughout history, but 'they are created by a mental fog': they are 'illusions' and of little 'practical use as guide-lines'. The crucial fact is that 'they are man-made', like all our concepts; when trumpeted, they properly 'belong to the ideal world of Plato – which is fixed for ever. Rigid ideologies feed on them.' By contrast, the aims of the firm are 'not nearly so remote', and are not grasped 'out of the sky or wilfully imposed': 'they are natural and obvious'. Ove knew well that this last claim, although it represented his empirical approach to all things, itself needed some elaboration, but decided his audience needed respite. Moreover, he was well aware that the ancient debate about the application of principles to particular cases – casuistry – was not entirely familiar to his listeners.

Almost twenty-five years after starting the firm, Ove still believed that recruitment 'must be on a personal level', if the best people were to be hired: 'when we come across a really good man, grab him, even if we have no immediate use for him, and then see to it that he stays with us.' There remained a challenge: 'a fundamental contradiction between organisation and freedom' – or, in the words of the classical writers, 'liberty and authority'. Decision making should be 'spread downwards as far as possible, and the whole pattern should be flexible and open to revision'. He reflected on ways in which the Partnership arrangements might be adjusted to guard against possible future misbehaviour and made more 'democratic'. He also expressed his personal

anxieties about 'trying to gain a foothold in various exotic places', or risking 'long-distance architecture'. Staff matters must be taken seriously. Just as a multitude of daily jobs are dull, but necessary, 'it is no good pretending that all are equal – they aren't': necessity, importance and equality are different notions. The pronoun 'we' should embrace as many people as possible. Improvement in communication must never cease, because local growth overseas was likely to weaken the ties that bind the firm together. He also made some observations about not having more Partners, but Ruth warned him that his stated reasons were 'not valid and are disingenuous': he ignored her.

A few brave and thoughtful colleagues challenged Ove on the correlation between the high-minded moral stance of 'The key speech', and what actually happened in the field. One writer, who was keen to emphasise criticism only of 'opinions, policies, actions', challenged Ove to justify the firm's operation in South Africa: there did not seem to be equal pay, welfare facilities or job opportunities for all, irrespective of race or colour.[15] Moreover, there was little evidence of non-white participation in the endless discussions of apartheid which, Ove asserted, occupied Partners in their visits to South Africa. If, as Ove stated, the goals of the firm were moral and not financial profit, how could he apparently condone apartheid with such complacency? Would he have condoned such behaviour in Nazi Germany? Ove did not like the question, or the comparison: they rankled. Had their position really been one of commercial expediency; or had they adopted a morally defensible pragmatism, which in the long run would benefit the dispossessed? Although strengthened by Dunican's vehement hostility towards apartheid, Ove was also concerned for the safety of staff who were outspoken critics of the regime.

Before finalising the second part of his thoughts about aims of the firm, he read a paper at the Royal Society in November 1971, under the title 'Future problems facing the designer'.[16] He made multiple copies of this paper and distributed them widely among relatives, friends and professional colleagues. His aim was to associate his special sense of 'design' with a widely accepted concept of 'scientific enquiry':

> Both are complex mental activities, set in motion by a stated objective, and based on a stock in trade of knowledge and experience, augmented by fact-finding, classification, interpretation, analysis and synthesis in various proportions – a process where imagination, intuition and invention are of vital importance.

The crucial difference, Ove maintained, was in their objectives: 'the scientist wants to explore nature . . . the designer wants to change [it]' – the

Marxist echo cannot have been missed. Moreover, because the designer's practical problem is underdefined, there are many solutions between which he must choose. He misleadingly claimed that 'the shaping of the question is part of the answer' for an artist; he should have said, and perhaps meant to say, that the shape of the question influences the eventual shape of the answer.

While he immersed himself in such thought, Ruth underwent a long-postponed private operation to straighten a toe. She wrote to Li and Ove from hospital, and noted that colleagues came to visit her, drink her Madeira, and reprimand her for going private: 'In principle I agree with them, but in practice I must say that I am not sufficiently a socialist to sacrifice my comfort, or privacy' – she very well knew what Ove's position was. She had always known she 'wasn't cut out to be a martyr'. Her surgeon had surveyed her toe with the satisfaction she enjoyed after creating a perfect soufflé, and she had felt she 'ought to make deprecatory remarks like "Oh well, I just saw it and thought of you – I'm so glad you like it – if it's not the right size I can change it".'

In thinking about what to write for his firm's silver jubilee in 1971, Ove confessed to feeling like 'the Sorcerer's Apprentice' over Arup's 'spectacular growth'. In twenty years the number of permanent staff had increased thirty times. The growth certainly strengthened the pursuit of quality. Indeed, 'the proliferation of our multi-disciplinary activities' enabled more than improvement: 'it aims ultimately at a reform of the whole building industry.'

This unequivocal declaration, in 1971, is significant. Ove asserted that anyone fundamentally interested in their work would have to be a reformer, committed to the removal of barriers: this was ultimately 'a matter of conscience', because 'we are citizens of the world' and must think beyond 'our own convenience'. In this solemn sense, the members of the firm are working 'for other human beings inside a legal and economic framework'. He was fearful of being misunderstood: 'There is nothing more nauseating and dangerous than fixed ideologies derived from books or theoretical speculations and pushed down people's throats without regard for the manifold and diverse needs of human beings.'

The justification for change requires evidence: we must be convinced that the needs and wants of both clients and of the society in which we live can be met only by doing things differently. Writing and talking are often completely ineffective in bringing about appropriate change. A better way, to some extent authorised by history itself, is 'persuasion by example, by showing what can be done in practice'. Indeed, Arup Associates had been established in part

to demonstrate what preaching had failed to effect: and it succeeded. On the general moral question of expediency, Ove defended it only as a 'temporary deviation', like tacking in a head wind to reach your goal when it is 'both justified and necessary'. Might that dispose of challenges about their South African work? At least the battle to enrich the lives of future generations is a battle against an identifiable enemy: the universal human weaknesses of indifference, inertia, greed, laziness – and ignorance.

Ove prepared the second part of his reflections on 'Aims and means' as an addendum to 'The key speech' and outlined the firm's current organisation.[17] At that date, June 1972, a small group of Senior Partners controlled overall policy and decided on organizational matters; they appointed a series of divisions, each under a Senior Partner, and each consisting of not more than one hundred people. Initially the firm had been owned and financed by one man; then leading assistants, called 'Partners', were offered a share of the profit on top of their salary. A few were selected on merit to be Partners, who then owned a share of the firm. But the idea of ownership seemed to be wrong, since what defined the firm was not shared property, but shared ideals. A capital gain of £100,000 was secured by selling the lease of 13 Fitzroy Street, and renting back the premises. A fund was established for each of the eight Partners, to whom the windfall resulting from the capital gain was distributed. The equity of the firm itself was assigned to two discretionary trusts, although the precise value of the firm was not established. From that point Partners controlled the firm only so long as they held office. This made it difficult to dissolve the firm, but provided funds for widows, dependants, shareholders of the Partnership and other worthy causes. In essence, the firm was led by a self-perpetuating oligarchy, whose new members were chosen by the existing eight Partners. New Partners received a full share of profits after five years. The veto available to each member was never used, and subsequent to the firm's incorporation in 1977 no formal vote was taken on any issue. Despite inevitable disagreements the Partners accepted collective and individual responsibility for the decisions they reached.

The Partners functioned as engineers or architects, designing and sometimes managing projects, although extensive delegation was necessary as the firm expanded. Administration, as such, was further 'downline'. The divisions differed in terms of their functions, locations, services and professions concerned, although Ove emphasised that, as in the history of any firm, 'accident, principles and expediency each play a significant role'. Expansion overseas, to Dublin, Gold Coast, Nigeria, Rhodesia, South Africa and elsewhere

had not been the 'result of deliberate policy' and possibly had happened too quickly. Legal and financial reasons contributed to their transformation into separate partnerships. In Britain, the civil engineer generally acted as prime agent, with the structural engineer subservient to the whims of the architect; accordingly, a civil engineer had more opportunities to contribute to structural solutions. This was inevitably more rewarding, because the right solution to structural problems is generally the right solution for the job as a whole. The firm thus aimed to secure civil engineering contracts, not least because 'sound engineering is the only way to make architectural excellence competitive'.

The creation of Arup Associates and the Building Engineering Division also happened by chance. Philip Dowson had joined the firm in 1953, to assist with jobs such as factories on which the client did not want to employ an architect. He became a Partner of Arup Associates when it was formed in 1963, by which time he was working on a post-graduate extension for Somerville College, Oxford. Dowson refused Ove's suggestion that he leave to start a private practice, and would accept the commission only if Arup's were the engineers. Might it not now be possible to pursue the firm's goal of 'total architecture' as something more than aesthetics? Would sympathetic architects lend support? In fact, the RIBA was initially hostile to the idea, and some of Ove's closest friends were enraged, especially Maxwell Fry and some former members of Tecton, such as Denys Lasdun. Over the years, most accepted the outcome.

Arup's had forced the issue: 'architects could not possibly tolerate that they should be employed by engineers, whereas they found it quite in order that architects should employ engineers.' These were the very architects who trumpeted collaboration and integration. Their attitude, of course, served to exhibit the deep prejudices which at that time, and in every profession, also blocked equal rights, pay and prospects for 52 per cent of the population – women. Ove's absolute trust in Dowson's architectural abilities and leadership was rewarded, and the Associates soon acquired an independent reputation, with numerous prizes to its credit. The Associates were embedded in a large engineering organisation which was able to supply both specialist knowledge when needed, as well as venture capital. After this, a complete service was developed by the heating and electrical engineers, and the Building Engineering Division came to exist alongside Arup Associates.

In such ways did the firm's commitment to integration strengthen decisions to step outside professional borders and offer multi-professional services, but

there was always a caveat: any team, however multi-disciplinary, must remain alert to its limitations.

Ove's analyses were the last large-scale documents that Ruth arranged, because she had dropped a bombshell: and Ove could not believe it. It was time for her to leave: depart: go: resign: exit.

There remained time, however, for her to remind him of a few practicalities: 'Please remember on Thursday that you are going to OXFORD. If you change at Didcot and ask someone at the station which platform the Cambridge train goes from you may get into difficulties.' And not for the first time, she remarked: 'I know you are not remotely interested in my holiday, so I won't bore you with recounting my plans, never fear.' Amazingly, a year earlier, Ove had responded to that season's rebuke:

> You may have some justification for your bitterness about my not caring for where you go, but you are not quite right, all the same. I would like to know, and certainly Li would – she has asked me several times, already in London, and I have meant to ask you – but always only remembered when you weren't there. There are too many things to think about, or I _am_ too scatter-brained. But perhaps there is also something fundamentally wrong with me – I always suspected so. But then I manage to explain it away somehow. One does. One almost has to.[18]

Ruth awaited Ove's reports of Britten's _Death in Venice_, premièred in Snape in June 1973, declaring her own allegiance to the music by Mahler that had been featured in Visconti's film version. But, as she was leaving towards the end of August, she was beginning to have 'Hail and Farewell' drinks with old colleagues. Sydney Opera House was still not open – the ceremony was planned for 20 October, a week after Ove's Gold Medal speech to the Institution of Structural Engineers. As dramatic photographs appeared months in advance, at least Ove was beginning to receive cheering letters. In June Clough Williams-Ellis thanked Ove for a book on the whole saga:

> What ever can I say in response to your most generously sent book – except GOSH! – and of course a humble thank you! My main feeling being that if a human being can achieve a thing like this – is there _any_ limit? An encouraging thought in itself if only such terrific technical expertise is exercised to human and civilized ends – such as yours. Were I – in a nightmare – to find that I was responsible for the outcome of such an intimidating job I should immediately react by cutting my throat before I could be lynched for incompetence! I know my limitations![19]

Ruth chose her final anecdote with consummate care. She recounted Olivier's 'simply tremendous' performance in O'Neill's *Long Day's Journey into Night* at the Old Vic. But she was handing over to her successor on that day:

Everything is now in fantastic order, with a card index of where to find everything that might be difficult, such as where to order oil and who your tailor is, and so on. So you are the only problem left to solve.[20]

Cultivating 'the art of the impossible'

Layman associate civil engineers with roads and bridges: and a bridge was the structure of which Ove was most proud.

In 1959 he had flown to St John's, Newfoundland, where the firm was involved in constructing bridges for a harsh climate: the following year equally harsh climatic conditions had to be considered. President Nkrumah of Ghana was interested in a Transafrican EastWest road: this involved the design of several bridges, and Ove explored the ideas of building one on the banks of the Ankobra and swivelling it out towards the middle. Geoffrey Wood argued that this required technology not then available in Africa, but Ove insisted, and by September 1963, the bridge had been 'designed down to the last detail', together with models. Shortly afterwards, however, Nkrumah lost power and the project was abandoned. The extent to which Ove looked for precedents elsewhere is unclear, but there are similarities between the ideas for his African bridge, which he later published,[1] and what he was about to do in England.

In November 1961 he was approached to build a bridge across the River Wear in Durham, to provide a link between two parts of the university.[2] The

sum available was £35,000. This was thought to be barely enough for a short bridge at the foot of the steep valley, spanning 120 feet. Ove proposed building a bridge three times longer, and at the top of the 56-foot banks: 'a thin, taut, white band stretching horizontally across the valley, resting on a pair of slender tapered fingers, in a V shape, rising from each side of the river.' All falsework and scaffolding on the river was eliminated by casting the bridge in two separate halves, one on each bank, and then swivelling each half through 90 degrees to meet in the middle. Each footing was founded on bored piles on each bank, and consisted of revolving cones enabling the halves to be pivoted, after the 150-ton half bridges had been positioned and the bearings grouted. Elegant bronze expansion joints mark the centre of the bridge.

Ove told Yuzo Mikami in 1969 that he had come to realise that he was 'much more interested in Architecture than in engineering, unless engineering is considered as architecture'. He added: 'I am full of ideas or dreams of an architectural nature – but it is of course people that matter, and there are many more important things than architecture.'[3] In his seventies, as mentioned above, he began to claim credit in the form of 'I' rather than 'we': to the irritation of colleagues. He did not always fully credit Yuzo Mikami and John Martin, for example, who worked hard on details of the bridge. Povl Ahm declared later that, however beautiful, the Durham Bridge would never have passed the criteria of design upheld by the Bridges office in Arup's: it could have been built more cheaply and more easily, but the contractor was an admirer, and lost about 30 per cent on building it. Even Kylesku Bridge, opened in 1984–5, and in which Ove himself had no hand, was not built at minimum cost. Ove insisted to Povl Ahm and other colleagues that his major criterion of aesthetic quality must be given top priority.

Ove wisely confined his now ritual moans to close colleagues who, with equal wisdom, associated them with the frustrations of old age. The majority inside and outside the firm warmed to his enthusiasm, and cherished his role as a guide or guru. To Povl Ahm, Philip Dowson and Jack Zunz, he acted more like a father or guardian than the boss. One of Mikami's affectionate letters is significant:

> In six years of working with you, you have given us such a profound influence especially on our philosophical ideas, human as well as architectural. It is hard to say what it was in a sentence or two, but we feel that we have been enormously enriched and enlightened by it. Even the heartbreaking experience of the Opera House affair was, in human terms, a sort of priceless fertilizer to my mind, almost as important as the tragic memory of the World War II.[4]

Although he no longer had a direct hand in projects after his bridge, some of the firm's activities held a special affection for him. Benjamin Britten and Peter Pears had moved to Aldeburgh, Suffolk, in 1947, and the following year Pears had the idea of 'a few concerts given by friends'. The ten-day festival grew, and by 1967 lasted three weeks, by which time many of the world's most distinguished soloists and chamber groups had performed in the surrounding churches of the area and at the Jubilee Hall. In the autumn of 1965, after an initial enquiry to Ove, Arup's were given eighteen months to convert disused nineteenth-century malt houses at Snape into a concert hall, with some additional opera facilities wherever possible. The initial mistake that had been made in Sydney was self-consciously avoided: the brief was explicitly for a concert hall for seven hundred to eight hundred people, not a dual-purpose hall. It was, nevertheless, to be used as a recording studio, and the designers worked alongside the recording engineers to ensure that their technical needs were met. Derek Sugden, who headed the team, described the assignment as 'the sort of job one dreams about'.[5] But the dream suddenly became a nightmare. The building burned down on the first night of the 1969 Festival, only two years after Queen Elizabeth had inaugurated it. It was entirely rebuilt in forty-two weeks: and she reopened it in June 1970. It was not the only fire the firm had to contend with. Holy Trinity Church, Southwark, burned down in 1973 on the night before contractors were due to start conversion to London's first rehearsal hall. Arup Associates thereafter converted or refurbished a number of important theatres and concert halls, including Buxton Opera House and the Theatre Royal in Glasgow, home of Scottish Opera. Ove Arup and Partners were consulting engineers for refurbishment of the Royal Opera House, Covent Garden.[6]

Ove and Li attended Aldeburgh for thirty years and often took special guests: everything about the scale and the distinguished company appealed to Ove. Li became furious if he brought office papers with him, because she knew he would not get a much-needed break: on one occasion she burst out 'Wherever we go he brings all these things'; and on another 'I wish concrete had never been invented.' During the fevered debates over nuclear matters, they attended the controversial production of Wagner's *Ring* conducted by Colin Davis at Covent Garden. Conversation in the long interval inevitably turned to the topic, and Li exploded: 'Why did you start this awful firm, Ove? You do such terrible things.' 'We have lots of Partners all with different views . . .': whatever he intended to reply was curtailed by the bell.

The occasion of Ove's seventy-fifth birthday encouraged Derek Sugden to organise the first of three celebratory concerts held over the next fifteen years.

Benjamin Britten conducted the English Chamber Orchestra and chose the programme, which included Mozart's A major Symphony no. 29 and his own *Les Illuminations*, with Peter Pears as soloist. Britten had died by the time of the eightieth-birthday concert, which also celebrated Li's and Ove's Golden Wedding. On that occasion, the ECO was conducted by Philip Ledger and the programme included Britten's Serenade for Tenor, Horn and Strings, and ended with Haydn's Symphony no. 22 in E flat, 'The Philosopher'. The eighty-fifth-birthday concert, also given by the ECO, included songs by Nielsen, subtly evoking Ove's student days of long ago.

Throughout the 1970s Ove rehearsed his well-worn ideas to an ever wider audience, but his targets were no longer disguised, or his hostilities muted. In 1970 he told the Cambridge Conference on the Education of Architects that 'architectural theory' was invariably 'a collection of unverifiable statements of obscure meaning', resembling 'the relation of aesthetics to painting'.[7] Fundamentally, architecture 'is an art rather than a science. It seeks solutions to specific practical problems with the aid of scientific knowledge and research, but is not itself a scientific discipline, and none the worse for that.' Regrettably, architectural critics restricted the concept of architecture to the aesthetic aspects of structures, because 'the appearance, the sculptural quality of a structure, can be taken in at a glance'. One consequence is that 'the practical philistine' develops a very low opinion of architects, when he discovers that a great reputation can be achieved 'at great extra cost and a disregard for function'. But it is the type of function which determines whether a job is classified as architecture or civil engineering – shelters of most kinds being placed in the former category.

If, in 1970, Ove had Utzon still very much in mind when making such remarks, he was reaching further back to his colleagues of the 1930s and 1940s, such as Maxwell Fry, in asserting that it is not the architect's job to do sociology. Moreover, he was increasingly nervous that almost any reference to aesthetic 'intuition' would deter people from 'hard work', involving 'critical analysis, selection, and execution'.

A couple of years later he expanded on the theme.[8] Even when architects ceased to be master-builders, and were forced to listen to technological advice which was beyond them, they still 'wanted to remain master at all costs'. It was hardly surprising that many engineers suspected that the architect was 'simply pandering to his own ego at his client's expense'; when an architect is a visual artist he will typically 'allot too high a priority to sculptural or aesthetic quality', and fails to build for people.

In 1971 Ove was asked to write the obituary of Arne Jacobsen, although he denied knowing him well enough to 'penetrate the protective armour with

which he surrounded himself'.[9] He felt that Jacobsen disguised his intense shyness with an appearance of arrogance or rudeness, but he would never have made the kind of 'public announcements of a Wright or an Utzon'. On the other hand, he was entirely confident about his own objectives, taste and judgment, and in his belief that, in pursuit of perfection, the architect should control everything to the last detail.

But Ove had had his fill of this kind of architect; and the affectionate tone of correspondence with Gropius and Buckminster Fuller was in marked contrast. Ove always acknowledged his debts to Gropius, and the extent of their agreement is well illustrated in a letter that Gropius wrote in 1966. He said that he found it

> very difficult to interpret the differences between architects and engineers regarding the creative, inventive qualities involved in their contributions, particularly as I see – as you do – the conceptual process as a total entity, form, structure and economy being inseparable within it. To conceive the bones of a building rightly so that they fulfil the three requirements is an organic, creative act just as the architectural composition of the building masses. I fully agree with you that the emphasis should, therefore, be on the team. Education of architects, engineers and artists alike must then, first of all, be directed towards understanding and accepting the collaborative process, the 'composite mind', which by itself will make for more humility and mutual respect and – I believe – will be of benefit to 'art'. Within this process the final control will fall to that individual who has the broadest scope and is willing to accept from his teammates everything which can enrich the total conception.[10]

Later on, Buckminster Fuller sent Ove the first chapter of his new book *Critical Path*. Ove felt he could easily single out observations for commendation: 'But that would not be right. If I lay claim to be your friend – and that I do – then I must behave like a friend and speak the truth. You say yourself that it is the integrity of each individual human that is in final examination.'[11] Ove objected to the personalising of impersonal forces – the old 'pathetic fallacy' of which he had accused architects decades before – but above all to Fuller's unquenchable optimism. Ove held that 'the fight' must be on an altogether different front from Fuller's promotion of global technologies. In Ove's view: 'we must simplify our lives and forsake greed and the lust for power – we must try to understand one another and live in harmony.' He agreed that when they were both young everyone held that 'science would see us through' and, indeed, it did bring material prosperity to many. 'But we haven't con-

quered our human nature.' At the end of 1982 Fuller sent Ove the published book, and several months later Ove wrote a long appreciation.[12] After recounting his early philosophical studies he reiterated his view that most human troubles 'stem from the misuse of our sophisticated technology'. He repeated his firm's commitment to 'design efficiently for quality', and to avoid using irreplaceable resources. His notion of 'quality of design' involved 'fitness for purpose, inside a given budget' – it was not merely what one could get by buying a costly suit. The quality of a building – indeed any artefact – 'is always a composite quality': we need only to accept that the requirements of commodity, firmness and delight admit of considerable variety in their content, and a vast range of means to implement them. The central point, however, is that 'many-faceted quality requires the application of many skills which are rarely found in one person' – there normally needs to be a master-cook, but one of exceptional ability, and possessing rare human talents.

Ove insisted that recent history showed that human nature can be changed significantly – ancient tribal beliefs and customs had been replaced by material hedonism. Of course, legal and properly policed restraints were today necessary to ensure some forms of mutual agreement in a fundamentally interdependent world. But two popular notions, in his view, signalled the wrong route: 'competition and confrontation'. They increasingly dominated both professional and commercial transactions, and must be replaced by 'negotiation and collaboration'. Whereas Fuller optimistically held that yet more technology can resolve all the difficulties, by contrast, Ove held that technology only dealt with material things, not with 'our inner life, love, pride, nature, art, religion'. He concluded by recording that his 'values would not change. They have not changed much – but the human world around me has changed. A new generation has the right to choose their own values.' Fuller did not have time to reply: he died in the following year, at the age of eighty-eight.

On 11 June 1971 the firm held a summer party at St Katherine's Dock. At 4.00 o'clock that afternoon, rumour had spread on the sixth floor of 13 Fitzroy Street that a very significant telephone call had been received. Jack Zunz bearded Ove on the way out of the office: 'Is it true that you have been offered a knighthood?' Ove looked sheepish: 'I cannot lie to you, but it's true!' Grinning widely, he added: 'And it's about time too!' He was seventy-six. An official announcement was made at the party as the clocks struck midnight. Congratulations and affection flowed in from all quarters. Max Fry and Hugh Casson sent sketches of Ove in knightly armour.

And he received a typewritten expenses claim form: for travel, there were 'Second class return travelling expenses from your place of residence in the

United Kingdom to the place at which the investiture is held', together with subsistence expenses 'up to the following amounts':

(i) Where absence from home is 5 hours but not more than
 10 hours 33p
(ii) Where absence from home is 10 hours or more but does
 not involve a night's lodging 75p

Ove tried to work out what qualified him for a knighthood: longevity, good teachers, a good home and 'a devoted wife who would go through thick and thin for you, who looks after you and saves your life on numerous occasions'; Partners and colleagues 'who do all the work', an intelligent secretary who 'works with devotion'; children, grandchildren and friends. He really did appreciate these blessings: he simply forbore to tell the benefactors.

The following month, July 1971, Arup's were partners with Piano & Rogers, who won the competition set by the President of France to construct the Centre Beaubourg, or Centre Pompidou as it is also known. The architects were almost forty years younger than Ove, short of work and with a total staff in Genoa and London of eleven: they were virtually unknown. Arup's, regarded by one client as 'a model of the best sort of Danish-English liberalism', was by then a worldwide firm, with a concomitant reputation and a permanent staff of just under fifteen hundred. Povl Ahm was Senior Partner on the project; the Executive Partner was Edmund (Ted) Happold, one of the most successful younger members of the Arup 'family', who subsequently established his own practice. In addition, Peter Rice joined the team. He had been assistant resident engineer for the Sydney Opera House and was an outstanding structural engineer, publicly proclaiming the necessity for holistic design.

The governing concept of the Beaubourg design was flexibility, and the result deceptively simple: push everything outside to ensure an internal void – all equipment, machinery and visitor movement. Moreover, advanced technology, prefabrication and lightweight materials were to define the construction. Machinery, in any case, is almost always the first part of a modern building to need replacement, and internal uses could never be predicted: the practical requirements were for weather-resistant materials and construction.

Arup's chose not to align themselves with any French firms: this provoked obstruction in Paris, and generated tension within the team. The painful experience of contractual muddle and disagreement in Sydney had persuaded Arup's not to sign the contracts drafted for the Paris job: their aim was to keep clear of the bankruptcy threatened by the proposed penalty clauses,

and thereby save the architects in any future crisis. Many, including several participants, judged Arup's to have been mistaken. They antagonised the client, and yielded all decision making, responsibility and credit to the architects. Furthermore, not only did Arup's rely on quantity surveyors more than was commonplace in France, they intended to introduce a management contractor to supervise the job. This latter step eventually proved to be successful, but fee negotiations between Arup's and the architects foundered on attitudes too redolent of Sydney to be amusing: especially since the role of *prima donna* was virtually sanctioned by the contract. The architects did not like working with changing teams from Arup's; but the engineers thought the personal relationships and tensions within the very small architectural practice were dangerous. Fortunately for everyone involved, President Pompidou appointed as the project manager a brilliant public servant, Robert Bordaz, who had been head of Radiodiffusion-Télévision Française in 1962–4. His great experience and diplomacy resolved crises and forestalled major disasters. Nevertheless, fast-track construction of the project, undertaken for political reasons precisely echoing those in Sydney, benefited the detail and quality of the product in no single respect. Arup's also believed that proportional expenditures should have been more tightly controlled during the project, even though the overall cost fell within the 12 per cent contingency margin allowed on the contract: the total was approximately £30.5 million.[13]

Like many public monuments, the building had been mired in fierce local and national debate about urban and cultural resources, as well as political priorities and rivalries. Regrettably it endured a long period of poor management, and incompetent internal planning.

Ove could not believe that Ruth either wanted or needed to leave in 1973; but she was then sixty-three and it was more than forty years since she had first attempted to fulfil her yearning to master the arts of gourmet catering. She had been his invaluable prop, foil, guide and protector – unacknowledged. Her decision to go was courageous: she had been in love with him, in some sense, for years. But she must not hover on the margins of his life. Of course she continued to see the Arup family, sort out the firm's archives and engage in occasional correspondence.

And she penned her first letter two days into her new life, to thank Ove for 'making it easy to go before it's too late to experiment with some of the things I've always wanted to do'. She confessed to not having 'some of qualities which make a good secretary', because she was 'too much of an individualist', and resented not having the opportunity to exert herself. She added:

'Although I have never been what is known as "an Arup type" (and neither have you) I do appreciate the spirit of the firm up to now.' More importantly, and as she had been saying for twenty years, he

> should really get down to writing a book, explaining <u>why</u> you think <u>what</u> is important. Apart from everything else, you owe it to the people who have helped you to build the firm in accordance with your ideas, often giving up quite a lot in the way of recognition and financial reward to try out your ideas. I think you fail to appreciate, for obvious reasons, that team-work makes demands that not everyone, unless he is likely to be the leader, can accept happily. I know I couldn't and I know you couldn't.
>
> However, it is no longer my responsibility to lecture you and tell you unwelcome truths, which you brush off as my 'cynicism'. I can now, thank Goodness, join the mob who say only how marvellous you are![14]

Over four months later, and with equal force, she told him that first, the Partners should elect new Partners, and ask themselves why they were so dependent on Dunican; but second,

> it is time people stopped being so terribly superior, and standing afar off on a pedestal. It is not an attractive image. [. . .] A firm of your size should be making a constant contribution to the running of Institutions, providing officers who are directly concerned with real rather than administrative or academic engineering. It is a duty to your profession, and much more difficult than standing on the sidelines and telling everybody else they are stupid and unimaginative and pompous and all the things that they undoubtedly are. And it is not a good idea to concentrate on the Civils just because their fantastically British image gives those of you not born here a curious kind of <u>frisson</u>.[15]

Why did Partners 'shy away from the consideration of a problem which will involve you in looking at your organisation as a whole? [. . .] Anyway, you can tear this up and forget it, for I have now cleared my conscience – which for the last twenty years did double duty as your conscience too.' Ruth had to hit hard because arguing with him, let alone reprimanding him, was like boxing a sponge. Occasionally he protested, usually about something scarcely credible. When departing for Ingeborg's ninety-third birthday in 1976, he had absurdly objected to comment on his being Danish and 6 feet 3 inches tall: no one regarded him as anything other than Danish. He spoke Danish at home and with his extensive family, took a strong interest in Danish affairs in London, and together with Li seemed to be ever more Danish in later years.

Ruth continued to send witty rhymes at Christmas and on his birthday, and sharp reminders of her understanding:

> a tremendous number of people are scared stiff of you or at least find you very formidable, and would hesitate to make suggestions about anything for fear of being flattened. You and I thrive on the strength of our own opinions, however misguided, but a lot of people, specially the English, will do anything to avoid a confrontation.

After he died, a note from Ove was found 'on top of his bundle of letters from Ruth'. It read:

> Ruth was my secretary for 20 years. She knows what she is talking about. Or – perhaps – not quite. She knows the way she wants to guide me. She knows what she likes. I am not in that happy position. Not quite. And I don't particularly like being guided. But I will consider any proposition.

Three months later, as if to continue her conversations, Ruth typed a 'PROTEST': 'Only some one very stupid, and I insist this rules me out, would think after even a day in his company that she could "guide" O.A.'

October 1973 was a frantically busy month. Before flying out for the opening of the Opera House, he delivered his Gold Medal address to the Institution of Structural Engineers.[16] In it he wittily listed half a dozen tenets which might have warranted the award, although he had enjoyed 'scant success' with many of them. Even if a few colleagues and collaborators had been persuaded about some of them, that was clearly not the scale of influence he sought. He had often not 'made much headway with government departments or with official bodies':

> It isn't just a matter of what you say. It also depends on whom you say it to and when. You have to be fortunate enough to find people who will listen to you, so that concerted action can result. Ideas are powerful: that's why totalitarian states are afraid of them. But it's a delayed action.
>
> They take time to sink in, and still more time to produce practical results – and the latter depends on other people.

Moreover, his ideas were 'very simple', 'just common sense': unfortunately most mistakes by engineers – and 'other people too' – are 'due to lack of common sense'. He listed his core ideas:

1. design and construction are interdependent and must be adjusted to one another;
2. simplicity of design makes economic and aesthetic sense;

3. two parallel brick walls covered with reinforced concrete slab don't provide a good shelter against blast;

4. when many cooks make a dish, they had better agree amongst themselves about the recipe;

5. to start thinking about the cost of what you are designing after you have designed it, is a bit late;

6. it is a waste of time to base exact calculations on rough assumptions, or a strong building on weak foundations, or in general to pursue the means without defining the ends.

He also permitted himself to ride some of his 'old hobby horses': particularly the fact that 'a structure exists for a purpose and as part of an entity that also has its purpose; and that the efficiency of a structure can only be judged in the light of these various purposes great and small'. 'Totally integrated comprehensive architecture' requires great effort and dedication from the directing team. While it may *seem* impossible to reverse the apparent trends of materialism, humanity requires it: the goal should be to 'cultivate an art of the impossible'.

Almost the first thing Ove did after Ruth left was to elaborate on his earlier presentations, in another address to the Trustees of the Partnerships. He acknowledged that a range of problems had emerged within the firm, and warranted proper resolution by the Partners: he did not accept that failure to address them in their first form more than a decade earlier made things more difficult. The firm initially succeeded, he held, because they were structural engineers with a civil engineering outlook; their philosophy was based on acceptance that the whole is more important than the part. And their first challenge was to preserve flexibility while pursuing the aim of wholeness. The size of the firm is one factor: in small groups the limited experience available is bound to result in missed solutions, and will deter membership by ambitious specialists. On the other hand, specialist firms are likely to achieve co-ordination, but not synthesis or integration. Specialisation too often generates both limited vision in the investigators, and barriers to comprehension by others.

Ove predicted, in 1973, that few firms would even aim to resemble Arup's in its scale and diversity; but that as jobs got yet bigger and more complex, even Arup's could not expect to work only alone, covering all aspects and ever more specialised services. The size of the firm would probably double again, but new staff would have to be 'conditioned to our way of thinking'. He still believed, as he had always done, that mistakes should be admitted and redressed, typically by re-examining certain practices. For example, he

believed that some of the firm's decisions had been taken solely for reasons of expediency, and commitments made before they were ready – such as factories for Carlsberg beer and for John Player's tobacco, and the then incomplete Centre Pompidou project in Paris (opened January 1977). If the primary goal of the firm, as it should be, is quality, then both clients and architects needed to be closely checked before working with or for them. Ove failed to confront one implication of increasing size: the extent to which leaders should share their doubts and uncertainties, bearing in mind the commercial security of the firm, and the motivation of subordinates who, as the firm grew dramatically, inevitably knew few, if any, of the leaders personally: quite unlike the old days.

Ove decided that the opening of the Opera House would be the centrepiece of a world tour, on which he and Li duly embarked. As usual, something got lost or forgotten: if not the chopsticks, then a camera lens, or even a camera. Harrods became highly suspicious when his tropical suits were sent for cleaning, after their return. He suddenly remembered that there were seven £100 notes and one dollar bill in the pockets: Li calmed everyone down. But when he collected expensive new long-distance glasses, he found he saw two rival images, and could drive home only once he had taken them off altogether.

From the late 1960s onwards a steady stream of testimonials to Ove arrived from former members of the firm who wanted to celebrate their pride in its ethos. In 1973 Jock Harbison, Chairman of the Ove Arup Partnership in Dublin, had singled out the personality of the firm's leaders as a primary source of inspiration to the staff, and the following year he wrote:

It will be 20 years to the day on Monday July 1 that I joined the firm – and I would like simply to say thanks for taking me on and for making a career and an experience of which I can recall nothing but happy memories. [...] You yourself must have had many qualms when you decided to become a consultant and to take on the risks and hazards of 'being your own man'. All I can say is congratulations for having done so, for being the success you are – and for giving opportunity to the likes of me and my very long-standing friends and colleagues in practice here. [...]

We all have this in common – that you thought us worth association with you. We were your choice. Those who come after us will not enjoy that characteristic. [...] For all of us you were a 'happening'.

Another employee, who was about to be made redundant, felt impelled to write:

I am writing this note to you to tell you how much I have enjoyed working for you and how sad I am to have to go. [. . .] I write this note to you personally to thank you for having provided a unique firm in which I have enjoyed much happiness and job satisfaction. These years have enhanced my life and I am grateful for them.

It was entirely natural that, in 'semi-retirement', Ove broadened his reflections to embrace environmental issues and political agendas. During his earlier years of daily decision making, such writings could have been commercially counterproductive, and probably misunderstood – some of his reflections, in any case, were manifestly irrelevant to typical daily issues on site or in the drawing office.

He assigned his first inklings of 'the ecological consequences of technology' to childhood holidays with his maternal grandparents in Norway. He heard them deplore a proposal to harness the Rjukan waterfall for electric power, and had been much affected by their distress. He wanted to associate ecological concern with the humanistic aims of his firm: 'We must ask ourselves what would happen if everybody else did what we do. Would that serve humanity? – the Kantian criteria for ethical conduct.' Ove's daughter Anja, who had long been active in environmental campaigns, prompted him to join Friends of the Earth.

Environmental anxiety and hostility to nuclear proliferation were not the only political issues that exercised Ove from the 1970s onwards. He gladly joined Hugh Casson, Lionel Esher, William Holford and Basil Spence in writing to *The Times* in April 1974 about the plight of Jews in Russia, particularly architects and engineers. It was, after all, only thirty years since they had all witnessed what happened in Germany, although Ove's colleagues knew nothing of his wife's Jewish connections.

In 1975, to the surprise of outsiders who were unaware of his skill and lifelong interest in chess, Ove launched his new designs of chessmen, chess boards and boxes at the London Design Centre. In addition, he had designed a new notation. Six symbols, including a square, zig-zag, diagonal and circle, suggested the character of each piece and the way it moves. His son Jens undertook the initial craftsmanship in beautiful hardwoods imported from the East, but the high cost of these initial sets propelled the project into plastics. Ove spent considerable time and money researching and discussing possibilities with different manufacturers. But they sold very few, and sets were given away. He had solved the problems he had formulated for himself, to his satisfaction, and walked away: unlike Utzon, he had not been commissioned to undertake a specific task. Archesco Disc, Standard and Yo-Yo Sets are now collectors' pieces.

Less satisfactory, because they did not reach the production stage, were designs he worked on for cocktail plates which resembled a painter's palette: they were required to hold a wine glass securely, while providing a plane surface for canapés. Such items later became commonplace, but not in his lifetime, nor to his design.

Increasingly Ove would ask colleagues 'What then can I be used for?', and he wrote out for himself lists headed 'What I want'. Top of one list was 'No partaking in management', followed by salary arrangements, especially for people 'who are used by me for private affairs: secretary, chauffeur, Archesco, children's affairs'. He wanted to know how he could 'know about interesting jobs, do some travelling with wife'. In December 1974 he decided to talk to Peter Dunican, and characteristically wrote to him immediately afterwards – exactly as he had done in discussions with his cousin Arne, almost thirty years earlier: 'I was not too happy about our interview.'[17] His new list of wants, in sequence, was: a secretary, his room, a part-time chauffeur, 'the ordinary right of a partner to visit interesting jobs, conference meetings etc', payment 'for enjoying these advantages', 'leaving all the chores to my partners'. He also wanted 'the help of various members of the firm when needed' in connection with his own affairs and the Arup Chess Co. He then asked: 'What am I prepared to do in return? Not much. My claim must rest on what I <u>have</u> done for the firm.' He wondered whether his wants were reasonable, and whether the Partners would think so: he would be willing to discuss resigning if ill-feeling developed. Happily, his oldest colleagues recognised the usual degree of theatre in all this, alongside the parade of 'truth' and 'bluntness': they preferred to let things take their natural course. Ove did not resign: and did come to the office three times a week for the next fourteen years.

Indeed, he remained extraordinarily alert. For many years his more philosophical discussions had been confined to the Danish Club, or special friends. But his notion of a family firm entailed that talk about anything and everything should be encouraged. Colleagues embroiled in the urgencies of daily decision making, however, had little time to enjoy, or endure his global reflections. Saving the world was not top of their agenda, especially when he started listing the problems to be addressed:

> getting Ulster united with Ireland, throwing the Jews out of Palestine, ending apartheid in South Africa, making Iran a pure Islamic nation, dealing with those trying to convert the whole world to communism or Christianity, freeing the suppressed Baltic States from Russia, uniting West and East Germany, North and South Korea.

What had this to do with engineering consultancies? A scribbled note declares: 'I must give talk about what to do or not to do.'

One admirer with whom Ove conducted lengthy intellectual correspondence was Christian Brett, Lady Esher: this was usually prompted by dinner-party conversation or one of the books they sent each other. In 1977 he recalled Høffding's lectures and his 'belief that the universe was not indifferent to our noblest endeavours'. Ove still rejected Høffding's insistence on the necessity of such a belief, as he had done sixty years before:

> When I told him that I could not see the slightest reason for believing such a thing, and that wanting to believe it did not constitute a reason for believing it, I obviously touched a sensitive nerve, for he banged the table and said: One has to believe it!

Ove's Humean view was unshakeable: 'I know that my actions are seldom motivated by reason – certainly not by reason alone, and often against what I believe to be right.'[18] He noted that one author they had been reading, after propounding his revolutionary and unqualified scepticism, nevertheless still caught 'the 8.15 to the City'. Why was the author so certain in his scepticism?

From the mid-1970s Ruth was not on hand to temper his characteristic outspokenness. He told one correspondent that he was 'not particularly interested in Life Cycle Costing, I don't know what it is, and I don't particularly want to know'.[19] He told every correspondent who might be suspect that there was far too much philosophy around in architectural talk – indeed too much meaningless talk altogether.[20] But he did concede in 1987: 'I will gladly assume the mantle of a Philosopher (privately).'[21]

The freedom Ove now enjoyed to explore ideas also allowed him more time to participate in discussions. Outside the academic world, in which Ove took almost no part, intellectual debate in Britain was mainly confined to professional societies for elected members only. This did nothing to counteract narrowness of outlook – whether by civil or structural engineers, or by architects or philosophers. Indeed, such societies barely acknowledged what others were doing, and typically had little truck with the outside world – none of the communications media exercised influence comparable with that of television or the internet today. Ove was inevitably attracted, therefore, by opportunities to take part in serious discussion with leaders in their field.

In May 1977 he attended the first of a series of discussion dinners hosted by Edward de Bono in the Athenaeum and at the Albany, his chambers in Piccadilly. The aim was to establish a 'Centre for the Study of Thinking', and de Bono intended to involve only the great and the good. Lord Mountbatten

attended several, and among the distinguished participants, all of whose comments were recorded and circulated, were Ove's architectural friends Hugh Casson and Lionel Esher, politicians such as Keith Joseph and Denis Healey, scientists such as Sir John Cockerell, Sir George Porter and C. P. Snow, academics such as A. J. Ayer and Sir Michael Swan, and inventors such as Clive Sinclair and Alex Moulton. On one occasion Ove informed the company that he chose colleagues for his firm because he liked them, and they were enthusiastic: the kind of person was more important to him than the kind of thinking. Although he enjoyed these occasions, he came to agree with Esher's view that it was all talk; but insisted that 'thinking is not a separate category from feeling and doing – or indeed from living'. The dinners were only one of the means by which he tried to keep abreast of current thinking – albeit hardly any of the guests was under sixty.

For thirty years and more, Ove attended occasional lectures at the Royal Institute of Philosophy, held in Dr Williams's Library, Gordon Square: and he subscribed to the associated journal, *Philosophy*. The meetings enabled him to hear and to meet some of the big names on the intellectual scene (he was in any case familiar with the more artistically avant-garde among them through the Institute of Contemporary Arts) and to be surrounded by almost the whole gamut of philosophical convictions – from Hegelian metaphysicians to logical positivists, whose models of valid enquiry were confined to areas of mathematics and the natural sciences. In 1978 an article by Max Black, who taught at Cornell but was known to everyone in London, appeared in *Encounter*. Entitled 'Scientific neutrality', it castigated 'poor David Hume' for insisting on a logical gap between 'is' and 'ought'. This appalled Ove: and it depressed him even further that Black resorted to assertions in the absence of examples: what moral propositions have objective truth value, which ethical principles are fundamental to all human beings? To Ove, science was merely a tool, but "truth" is an abstraction [. . .] which transcends our understanding'; and 'scientists [. . .] are very careful not to claim any absolute truth for their theories'. The moral behaviour of scientists, as human beings, can certainly be criticised; but the discipline of science has its own methodology, and can be neither moral nor immoral. There are no grounds to regret that ethics is not a branch of science: 'all the things that matter most to us lie outside the world of science' – art, music, human relationships and so on.[22]

Ove's paper was not his best written – Ruth was no longer casting an eye: but for that very reason it exemplified why professional philosophers took no notice of what he said. First, English-speaking academics in the field from the 1930s onwards were arrogant, narcissistic in their interests, and dismissive of

almost everyone outside the academy: popularisers were ignored, and even former insiders who had been expelled, such as Bertrand Russell, were treated with cautious scepticism. The Royal Institute of Philosophy had always tried to resist and combat these recognised tendencies, but with only limited success. The second reason for Ove's treatment was that he had detected a feature of the 'analytic' philosophy of his day which its proponents were reluctant to admit. In spite of its loudly empiricist pretensions, its major tenets were essentially *a priori* and smacked of the ideologies that Ove most distrusted. Fortunately, he was not deterred in his reflections and found considerable support for his views in the writings of Karl Popper, who had been professor at the London School of Economics since 1949. Ove was especially delighted to learn that Denys Lasdun cited Karl Popper as one of his own gurus.

To be disdainfully dismissed as a bumbling amateur was painful, but it served to confirm Ove in the wisdom of rejecting an academic career after World War I. Nevertheless, he needed rigorous challengers to dissect his philosophical premises: and he had none. He was partly aware of this, and in a letter of 1985 thanking Lionel Esher for his autobiography *Ourselves Unknown*, he confessed: 'I could not help envying you also – I was hungry for people of my kind to talk to, being an outsider and very shy.' Certainly some cynical colleagues thought that he risked talking about architecture to engineers and engineering to architects only because neither profession knew much about the other. In fact, he was too often diverted into polishing a diminishing repertoire of ideas, instead of enriching and modifying them in the light of expanded enquiry: no one pushed him to augment or clarify what he wanted to say. For a hundred years or so the British have understood a 'philosopher' to be someone who contributes some new idea, interpretation, perspective or synthesis of established views; not to someone who merely adopts in detail a thoroughly standard position, and rests their thought and actions on it. Nevertheless, Ove regarded himself, as did his closest friends, as a philosopher; following continental traditions, however, they used the term to characterise his relentless concern to examine the nature, foundations and implications of any ideas which became the focus of attention. Talented and charismatic young colleagues, such as Peter Rice, were misled into stating that although 'he was very coherent, very astute' about individual subjects, Ove 'never developed a coherent philosophy. [...] Somehow you feel there was more, a complete philosophy which might have shed light on a larger part of the human predicament.'[23] Such a response was prompted by one undeniable fact. Ove did not gather together all his scattered reflections, and he neither claimed nor aimed to articulate an original, all-encompassing view of the

world: indeed, he had a lifelong antipathy towards all systems and ideologies, which is what some readers understood by 'philosophy'. He had examined and accepted entirely familiar empiricist views about the nature and acquisition of knowledge, and he adopted empirical methods of enquiry and practice; these explicitly influenced his moral and social views, as witnessed on the small scale by his ideas about the firm, and on the larger scale by his environmental concerns and his views on education. His empirical approach required and generated diverse practical outcomes and possibilities – unlike many ideologically based ideas. The necessity for action, and the conviction with which it must be carried through, on which Ove always insisted, did not require Platonic certainties.

In his eighties he openly talked of himself as 'a double outsider': a foreigner among the British and an engineer among architects – the confession was sometimes a relief and a help to his colleagues, especially in a context of the unconverted.

Ove's oldest colleagues and champions well knew that in the 1970s the chattering classes had not yet been convinced by, or even exposed to, his ideas. Povl Ahm, in a discussion of the Centre Pompidou, felt impelled to repeat observations that Ove had been making for fifty years:

> The fact that the competition was won by a combined team of engineers and architects, and also designed and implemented by that team, has never been fully understood and recognised by the public and the press, especially the architectural press who apparently cannot conceive that engineers can play any creative part in a project and that engineering is an art form, aiming at synthesis and only making use of scientific analysis and knowledge as tools.[24]

In October 1977 Dunican delivered his presidential address to the Institution of Structural Engineers. The professionalism required of structural engineers entailed 'total intellectual, emotional, political and social commitment'; this is because design, the core of engineering, is a social art, and one which itself demands 'imagination, inspiration, invention'. (It is significant that Ove himself had characterised scientific thought and experiment in terms of 'imagination, intuition, and invention', precisely to counteract the myth that only 'art' depended on these mental capacities.[25]) Dunican then cited R. H. Tawney's distinction between the rights which define industry, and the duties which define professions.[26] For Dunican, the essence of any professional relationship could be reduced to integrity, mutual trust, confidence and competence. Service to the community is a central task of structural engineers

alongside the conception of structural systems, their calculation, construction and stability; and in a social democracy, the community decides on objectives and the resources to be allocated to them.

Several of Ove's most senior and immediate successors also engaged in debates about the 'two cultures', and the inadequate education of architects and engineers. In all professions there is the constant challenge to avoid projecting yesterday's solutions onto tomorrow's problems. Philip Dowson and Derek Sugden, successive chairmen of Arup Associates, made this point on a number of occasions.[27] Sugden advocated for both architects and engineers a period of relevant training after a period of proper education. University graduates would move into apprenticeships before joining one of the professions. The former practice, still followed in some countries, of intending doctors and lawyers taking humanities courses before proceeding to their professional training, had much to recommend it: something was necessary to broaden the minds of young specialists whose expertise narrowed by the year. Little room is provided, as in past generations, for awakening social and political consciousness, historical and cultural sensitivities, or even multi-lingual access to unfamiliar traditions. As a result, awareness of the multiple contexts we all inhabit is undeveloped, and our multifold duties unrecognised. Above all, there is no recognition that the concepts and methods we use, the disciplines and tools familiar to us, have finite lifetimes, beyond which they become barriers.

Sugden and his colleagues also discussed a matter of central importance to clients, and which overtly challenged notions of architecture as concerned with purely aesthetic forms: flexibility. Both flexibility and adaptability of designs should be goals when designing building for indeterminate requirements.[28] A set of planning principles is flexible if it allows several possibilities; a building is adaptable only so far as fixed components can be removed without structural failure. The mechanical and electrical services are the most expensive parts of buildings, and the first to need maintenance, renewal or modification – in 1965, for example, no designs of urban office blocks incorporated air-conditioning, and many had no double glazing: ten years later those features were standard. Even more dramatic changes were needed to incorporate services for the electronic age. To meet such requirements, Arup's used grid networks in the design of buildings which allowed for growth, interchangeable parts and ease of alteration.

Although Ove had made his early reputation by promoting the virtues of reinforced concrete, other developments were to the fore in his later years. The complex shuttering and centring required for shell construction, for

example, and the difficulties of providing good insulation and waterproofing, all contributed to their declining popularity. Furthermore, over the twenty years separating the design of the Sydney Opera House and the Hong Kong and Shanghai Bank, steel technology far outstripped developments in concrete, largely because of research and development for the oil industry, and a thriving Japanese economy. Jack Zunz had drawn attention in 1987 to features of the Centre Pompidou: 'All the tension members are solid steel, all compression members are hollow tubes, while joints and nodes are cast steel. [. . . , which] meant using cast steel on a scale and of a quality not experienced in contemporary building technology.'

This led to several developments: performance prediction of large weldable castings was possible only because of fracture mechanics technology; omission of external fireproofing (except for the columns that were liquid-filled and could operate like kettles if heated) became possible through innovative analysis showing which structural members were expendable without catastrophic collapse; and there were innovations in the foundations of the main columns.

In poring over old papers Ove scribbled new versions of old self-analyses. At the age of ninety he wrote a short note under the heading 'My testament to the world! Coming clean!' It hardly varies from his student efforts of seventy years before:

Cursed by timidity, vexed by infinity. Hating blinkers, trying to be all-embracing, to see every point of view, fearing commitment, thus excusing laziness and self indulgence, duties neglected, lacking love, self-centred meanness.

As always, there was a self-defensive posturing in these theatrical confessions. It certainly did not help that Ove found old age 'disagreeable'. Li, too, was frail: characteristically, she never told Ove of her cancer, from which she died eighteen months after him. He drifted into and out of consciousness in his last months. On 5 February 1988 he suddenly awoke: sat up: looked around: and died.

13

Legacies

With only two exceptions, turnover and profits have increased every year since the founding of the firm in 1946: and there has never been a loss. In that first year a net profit of £1237 was made on a turnover of £3324. Within two years the turnover had risen to £23,000, with a net profit of over £6000. By 1949, when junior partners prompted serious discussion of their position, Ove's share of the net profit of nearly £7000 was ten times that of his colleagues. The following year the turnover reached £40,000 and Ove's personal share of the profit over £6000: this itself tripled over the next four years.

As the graphs show (see p. 325), turnover increased sharply, and divisible profits proportionately. The £50,000 mark was passed in 1952, £100,000 in 1955; it doubled again within two further years, and yet again over the next two. The first million pound mark was passed in 1964; this had doubled by 1968, reached £12 million by 1975, and £50 million ten years later. In the year of Ove's death, 1988, turnover had reached £100 million. By 1997 the £200 million turnover mark had passed, by 2001 the £300 million, and in the following year the £400 million mark.

The original twenty members of the firm were supplemented slowly at first: the one hundred mark was passed in 1956, five hundred in 1965. Numbers

increased from fifteen hundred in 1974 to three thousand in 1989, and by 2005 exceeded seven thousand. By that date the global Arup Group was working on projects for about four thousand clients in over a hundred countries, from seventy established offices. Overseas work made up more than half of the firm's work by 2003, a tripling in the fifteen years since Ove's death. Many of these projects were on a vast scale, including the construction of a new airport and transportation system in Hong Kong, the Kansai airport in Osaka, Japan, extensive work in Beijing for the 2008 Olympics, and in Shanghai for the New World Centre: closer to home the Channel Tunnel Rail Link, and the construction of a new St Pancras have attracted considerable interest, as have plans for Stratford City in east London and the 2012 Olympic facilities in the nearby Lea Valley. The British public was puzzled and amused in equal measure by the saga of the London Millennium Bridge, a suspension-span bridge which closed within a few hours of opening after hundreds of pedestrians had caused a marked wobble. The engineering concept for the bridge had emanated from Arup designers, as the architect acknowledged, and Arup's responded exactly as their founder would have insisted. To correct the 'lateral oscillation' viscous and tuned mass dampers were installed, and all the research was widely published in the technical and popular press, and made available on the internet. To reopen the bridge the firm commissioned Sir Peter Maxwell Davies to compose a new piece for instrumental ensemble, *Crossing Kings Reach*. In the last decade, museums and art galleries, concert halls and opera houses, libraries, train systems and stations, airports, university buildings, conference centres, corporate headquarters and bridges form part of a long list of projects throughout the world designed and constructed by the Arup Group. Even before the Sydney Opera House was completed, one of the newly appointed team of architects proclaimed: 'really good buildings of the future will certainly be done by engineers and probably not architects at all',[1] and Ove's firm has increasingly been associated with sensational structures. No one cavilled at allusions to Brunel or Paxton or Brunelleschi.

In recognition of such achievements, five knighthoods and numerous CBEs have been awarded to members of staff, which is unique for a single firm of this kind and size: the first CBE and knighthood, of course, were awarded to Ove himself.

What more did he want? The firm was triumphantly successful, and to a remarkable degree had implemented his ambitions to integrate architecture and engineering. In old age, as recounted above, he was happy to assume the mantle of a philosopher. This was not a substitute for daily decision making in the firm, nor a rejection of its goals and activities. It was because he now consid-

ered his fundamental goal to be a *moral* one, concerned with fellow human beings: a goal, the full character of which had only slowly dawned on him, and a goal which, at different stages of one's life, one would approach in different ways. The French would have known him at once: *un moraliste*, perhaps even *un philosophe*. Indeed, all of his more philosophical observations could have been written by any one of a dozen writers in the eighteenth century.

Over the months before he died, Ove wrote to his oldest Danish friends. He told Jorgen Varming:

> I have in the last two or three years changed my views on several matters, and in fact I am no longer the ENGINEER ingenious who created the famous Arup worldwide firm, but rather a Philosopher, philosophising about Art and Quality, Good and Bad, Existence and the Meaning of Life – all that cannot be understood by human beings. In my bright moments I have the illusion that
>> As my mental powers decline
>> So my wisdom starts to shine.

He was not lapsing into rejected ideologies. Kant had dominated continental philosophical education in his youth, and Ove's early rejection of the abstractions of both Plato and Kant – the only two names he usually mentioned – may well have hampered reception of his own ideas. For a century and more to reject Kant aloud was like loudly rejecting religion in polite English society: which he also did. And he was keen to find like-minded souls. He congratulated Conor Cruise O'Brien on an article in *The Observer*, in which he expressed Ove's own lifelong disgust at God's toleration of evil, and his indefensible behaviour towards Abraham. Ove recounted how he had always been told to have faith first, and belief would come later; but his study of philosophy had only confirmed his suspicions of this move. 'Science has no place for God.' What he could not understand, however, was what O'Brien meant by saying that he was 'unable <u>not</u> to believe in God'.[2]

In spite of such remarks, Ove gradually abandoned his few remaining certainties, including certainty about the absence of certainty. A year before he died he declared: 'I just know that I don't know anything.' His atheism insensibly drifted into agnosticism, although in 1985 he adamantly insisted in his Christmas message to staff: 'I cannot myself claim to understand what the word "God" means, for me it is just a convenient short-hand for all the things that I don't understand.'

Ove's publications spanned more than sixty years. For the first thirty years or so, virtually no other engineers or architects spoke or wrote about the issues

that concerned him most;[3] and to most of his audiences his matter was as exotic as his manner. Some architects, and planners in the mould of Patrick Geddes, were socially concerned, of course; but Ove differed from them all in his early education as a philosopher and a mathematician who was able to identify both the premises and the implications of the arguments he espoused. Propaganda about architecture had suppressed the ineliminable contribution of engineers: but redressing that injustice was not Ove's primary concern.

What, then, were his concerns, and did he succeed?

Two scales defined his thought from the 1920s onwards. On the smaller scale of his chosen profession, he wanted to establish frames of mind, attitudes and organisational structures that would enable architects and their engineers to co-operate from the very outset of a commission. Only by such harmony, he held, could the ancient goal of firmness, commodity and delight be achieved. The disciplines were, in any case, mutually reliant, and a fusion of thought and practice was likely to be economically, socially and politically beneficial. But if the goal could be very simply stated, the obstacles were great, and Ove soon found himself proposing radical changes in the education and training of architects and engineers alike.

As he became entangled in those tasks, however, his larger-scale ambition achieved focus: the removal of anything that might be a barrier to thought and practice – in any walk of life. He rightly observed that the terms 'architect' and 'engineer' were 'coined in an earlier age': and he insisted that they 'no longer fit' either what happens today or will happen in the future. This was not a petulant verbal protest. On the contrary, it announced that 'we must change our old ways of thinking'.[4] But multi- and cross-disciplinary thought and co-operation could take place only if each discipline itself was unhampered by constraints and internal barriers. Ove did not initially appreciate the magnitude of the task, and his audiences had no idea what he was talking about. His colleagues in engineering and architecture justifiably asked what relevance such concerns had for their daily, practical tasks.

What forced Ove to concede that the values would periodically need to be spelled out, re-examined and reaffirmed was precisely the incomprehension of his audiences. As he put it in a draft letter to staff in 1984: 'I do not know why it is that things which seem obvious to me are not obvious to everyone else.' By then, he had come to realise that the philosophical underpinning of his values would also need to be explained. But here, his colleagues seemed lamentably unaware that, if at all, they paid attention only to his conclusions; yet these rested on assumptions, and had implications, of extraordinary importance.

One insight derived from the Enlightenment itself. An understanding of the complex world around us required a division of intellectual labour, but the resulting specialisation generated barriers to mutual understanding which were ever harder to break. And that insight itself revealed the Sisyphean task: barriers removed from one place would re-emerge in another.

Ove was, indeed, a 'moralist' in the eighteenth-century sense: he was concerned with *mores*, that is, the beliefs, customs and practices of fellow human beings, as distinct from the forces of nature. For such thinkers, a central question was how the mind works, because in ignorance of that we would remain ignorant of all human behaviour. Empiricists held that although all beliefs are derived from interpretations of experience, our own firsthand experience is very limited – so we take over most of our beliefs, on trust, from others. However, we are not motivated by thought alone; on the contrary, our emotions not only colour our thoughts, but are the motive force to actions. There is another caveat: we are limited by our capacities of perception, memory and understanding. What we take to be knowledge is not only incomplete, but much of it will later be discarded and superseded.

Ove accepted all of this: it is the foundation of most modern scientific thinking. Opponents of such an approach, dismayed more by its psychological than its logical implications, dismissed it all as 'sceptical'. But to Ove such scepticism defines existence: it is not a justifiable reason for despair, but a spur to relentless enquiry. In 1954 Ove fully conceded that our over-developed intellects can 'inhibit completely the will to act', and a decade later that 'if people really went about thinking about the ultimate purpose of all they did nothing would ever get done'.[5] But no empiricist had ever denied that action must take place – indeed it is the goal, the point, the justification of prior thought, however inadequate that thought might have been. And we must act with energy, commitment and decisiveness: equally, we must never forget that we could turn out to have been mistaken.

There was another element in his thought with impeccable historical credentials. Sensory pleasures often elude verbal analysis or representation; many of them result from our responses to the small or subtle details which are the marks of quality. Such details result from human decisions: they were crafted by designers whose skills are rooted in learned traditions, and the standards by which the work is assessed derive from those traditions and their legacy. Ove was adamant that we *learn* to make judgments of 'taste'. Such judgments are not mysterious 'intuitions': they are the reward of hard work, and they refer to appropriateness to a context. Excellence always entails appropriateness. In a talk at the Athenaeum in 1967 to which he had given much thought

– he always sent such efforts over to Ingeborg – he declared: 'we need sensitivity to atmosphere [. . .] to what is appropriate.' But he also signalled the scale of the intellectual challenges few colleagues acknowledged: 'if we are going to discuss the shortcomings of the building and allied industries', we shall have to engage in 'a critique of our kind of society, our whole civilisation'.[6]

Such views were second nature to Ove: he was dismayed to discover that others had never encountered them, and accordingly did not share them. But to his great credit, in old age he never yearned for the certainties he had so vehemently denied throughout his life: he stood by the belief that there is no point at which a sceptical empiricist can terminate the relentless demands of thinking. There were puzzles, nevertheless. How was the impact of his writing to be gauged?

There were two obvious tests. Those who were convinced by his arguments might broadcast them in their own fashion: or they might simply change their practices in accordance with their new beliefs. Ove ritually, but mistakenly, believed that no one outside the family, as it were, broadcast his views. Accordingly, he inferred that he had not been heard, or not been understood, or had been rejected. No one could deny that what his own firm did in practice had far greater influence than speeches and proclamations: it was the proof of the pudding. But Ove was ever impatient about temporal and motivational gaps between thought and action, and his search for excellence fuelled irritated dissatisfaction when others did not follow suit.

In preparing 'The key speech' he had gestured towards even greater problems, of considerable antiquity. He explicitly held both that every case is unique, and that all things change – values, beliefs, meanings; that our grasp on things is incomplete, provisional, and often later shown to be mistaken. How, then, could he possibly proclaim a set of principles for the firm which would be applicable to unknown cases, in unknown contexts, by unknown individuals with diverse and changing perceptions? How could any one case be relevant to the particularity of another?

Ove's answer was clear: his 'principles' must be treated not as binding rules but flexible guides, as incapable of covering borderline cases and, above all, as subject to evolution. It followed that the criteria for satisfying his declared ethos would necessarily vary over time: advancing technologies would challenge the team to strive for excellence in new ways, with new skills; financial management would also vary according to legal, political and social changes. Even the criteria of desirable and effective teamwork, and of team leadership itself, would evolve to meet inevitable changes in the context. All of this meant

that no eternal methods could be formalised, no closed set of variables identified when devising strategies or programmes.

Ove wanted all his colleagues to understand – but it could sound so pompous – that the perpetual challenge of the firm mirrored the human predicament: the constantly changing contexts in which we live entails that we can neither predict nor fully understand anything. The practical engineer, like the mythical commonsense man, was supposed to reject such highfalutin' talk as pointlessly casting doubt on daily decision making: the differences of particular cases can be minimised to the point of insignificance, and our incomplete knowledge can be circumvented by relying on well-established practices. Surely, Ove's strictly logical conclusion could be pragmatically ducked?

Ove's reply was that, by definition, such a relaxed, not to say complacent attitude, was a recipe for disaster. Regular, if not continuous, reflection on the ethos was essential to ensure not just its strength and propriety under new conditions, but its very existence.

In a context of multi-dimensional change, the central questions about 'The key speech' are whether and how its general aims and aspirations can be made precise and meaningful. Moreover, although Ove was implacably opposed to any ideology or mantra, can his own general remarks escape from becoming exactly that? One answer lay in the emergence, in new contexts, of new terms to better describe old problems: 'sustainability', for example, embraces many of the broader issues that Ove incorporated in his notion of 'environment', and the pursuit of 'holism' today entails experts unheard of twenty years ago. The traditional requirements of motivation, flexibility and creativity in individuals can also be fostered in physical and virtual environments undreamed of during Ove's lifetime: what counts as flexibility and creativity differs over time. Just as Ove himself endorsed Wotton's Vitruvian criteria of 'commodity, firmness and delight', because these 'container-concepts' allowed for vast contextual variation, so his own key ideas were open to enrichment.

One question that Ove himself had often ignored was the nature of his intended audience. Although he became ever more outspoken and more wide-ranging in his discussions, he did not thereby secure the audiences he needed. For, if they had been almost ritually resistant to rational reflection, when he was young, their successors felt no need to heed the musings of a distinguished colleague, now old. Moreover, there were other social factors, which were equally hard for him to combat. By the mid-1970s a shared cultural background among young professionals no longer existed in Britain: they were not multi-lingual, they no longer all read the same journals and newspapers, nor

were they all familiar with the history, heritage and values of their own communities, let alone of the new contexts in which they worked. In tackling problems inherited from the past, the necessary anchorage of the present in the past was ignored and unintentionally suppressed. As a result, Ove sadly found his audience mainly among fellow pensioners, and this increased his frustration. He was by no means alone: within the more narrowly confined academic communities, continental scholars such as Isaiah Berlin, George Steiner, Jacob Bronowski were soon to be anathema to the new generation of proudly ignorant students, who had neither endured suffering nor contributed to their exemption from it. The community at large was the poorer for the rejection of such wise heads.

As everything in Ove's life had demonstrated, co-operation presupposes trust, and preferably mutual understanding. The layman-client is in constant danger of being stranded between layers and modes of communication, lacking access to the technical matters that must absorb the practitioners. The language professionals use with clients may only poorly mirror how they communicate with each other, and characterise their tasks and opportunities. Ove saw that if laymen needed education to understand the firm's multi-disciplinary approach, so might the professionals need to be educated to communicate intelligibly. Ideological barriers are often jealously defended by institutions which aim to preserve their influence and their myths, but the evolution of all professions is aided by integrating external ideas which modify inherited constraints. The impermanence of even the most cherished ideas must be underlined, but a critical mass is needed to generate sufficient ideas to sustain any innovative organisation.

The mandatory vision and mission statements required of most organisations since the 1980s emerged from perfectly sensible questions: what are you doing?; why?; for how much?; and so on. To their great benefit, Arup's already had Ove's 'key speech' to hand. Moreover, Ove and his successors were acutely aware of the danger of human habits which threaten all organisations – inflexibility, pride, ignorance. Partly to address such threats, the firm introduced the first of its five-year plans in 1995. The Partnership had already incorporated a large range of specialist activities, while continuing to establish partnerships with outside specialists where these were needed. Above all, the Arup Group proclaimed its commitment to holistic and environmentally sensitive resolution of their global projects. One anxiety was signalled at the same time.

On the positive side, increasingly knowledgeable clients have embraced Ove's commitment to informed co-operation at the outset of project planning; on the other side, explicit public auditing of many financial and professional

practices has replaced internal motivation by external incentives. Thus has the perennial conflict between the goals of liberty and authority been sustained. In fact, Enlightenment goals of individual freedom long ago yielded to its opposite, in the hands of radical thinkers who proclaimed larger social agendas. Repression of individualism was an explicit feature of Marxist regimes; but it also became an unintended consequence of liberal market economies, as institutions clawed control to the centre. As a result, 'trust and human relationships' disappeared from the ethos of many organisations. New practices and technologies introduced consistency; but they also prescribed, if they did not also constrain, the nature of everything that was done – or even permitted. The contrast could hardly be greater with the informal and barely predictable steps that Ove's original small team would take.

Respect and understanding are built on personal acquaintance; and only thus can a small team acquire the 'generosity of spirit' vital to its survival. Such generosity is the social dimension of the open-mindedness essential for the ceaseless refinement of thought and design. The larger the organisation, the greater the difficulty in establishing such an ethos: Ove's early concern with 'scale' was entirely justified.

All domains of enquiry require people whose distinction lies in breaking the boundaries of current thought and practice: the creative flexibility needed for success, destabilising as it can be, can be fostered by inter-disciplinary team-work. The Arup Group does not, and does not need to, claim uniqueness in its overall ideals; but pursuit and delivery of its proclaimed ideals does distinguish it from many rivals, because, like self-critical analysis and creative thinking, there are no resting places. When, as they do, the constituents of contexts multiply and evolve at different rates, any dogmatism is self-destructive. Ove himself belonged to a generation only beginning to respect and respond to cultural differences; but as the Arup Group recruits local staff to lead overseas projects, existing ideas will undergo scrutiny, and some will need revision. For example, the importation of Western brands of capitalism, management and politics to societies which find them all alien, will generate problems comparable with those invariably caused by dominant forces – whether Roman, Mongol, Christian or Islamic. In such varied contexts, it can be asked whether the philosophical content of 'The key speech' can appropriately define the distinctive character of Arup's; or be modified to embrace arrangements proper to the ethos of the differing branches of the firm. In fact, Ove had himself raised the question, in the spring of 1984, at the final meeting of Peter Dunican's chairmanship. Ove wondered whether consensual adherence to 'The key speech' could possibly survive a doubling of the present

93. Ove began working on bridges in 1922. This is a model of 1960 for a bridge across the River Ankobra, Ghana.

94. Runnymede Bridge, Staines, Berkshire, 1978. Its profile echoes designs for the Ankobra Bridge.

left 95. Construction of Kylesku Bridge, Sutherland, Scotland, 1978–84.

below 96. The Sapele Bridges span the Jamieson and Ethiope rivers in Nigeria, near their confluence with the Benin, 1963–7.

97. Model for the Kingsgate footbridge, Durham, 1961.

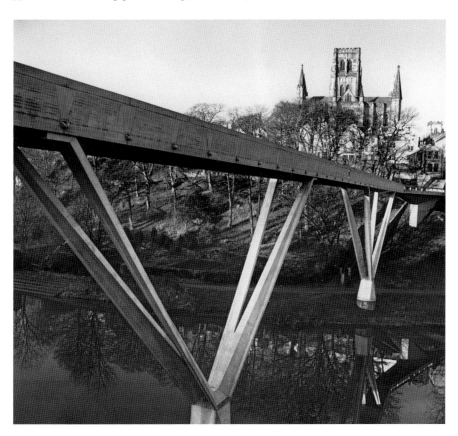

98. Kingsgate footbridge, 1964.

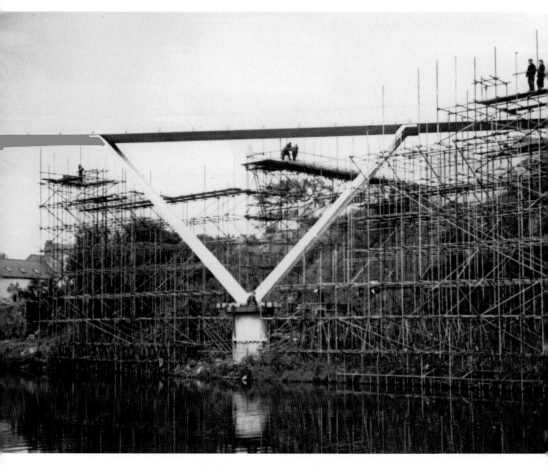

99. Constructing Kingsgate footbridge, 1963. The bridge was designed in two halves, one on each bank, which were swivelled to meet in the middle.

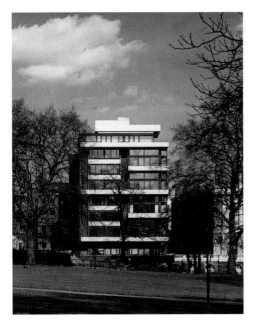

100. St James's Place, London, designed by Denys Lasdun, with Ove as consultant, 1961–5. For Ove the site was symbolic: a bomb site facing trench shelters in Green Park (foreground of the picture).

101. Buckminster Fuller, 1968.

102. Falmer House, University of Sussex, on which Ove advised Basil Spence, 1962.

103. Preliminary design for the Centre Pompidou, Paris, designed by Richard Rogers, 1971.

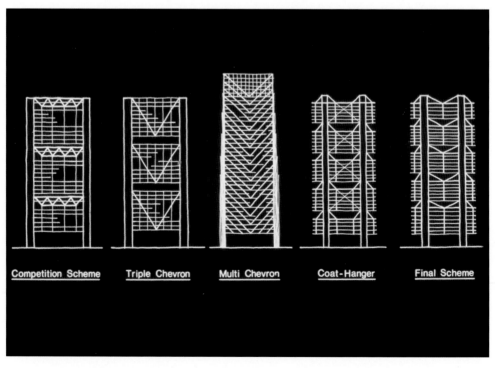

Competition Scheme Triple Chevron Multi Chevron Coat-Hanger Final Scheme

104. Evolving designs for construction of the Hong Kong and Shanghai Bank, by Norman Foster, 1980–81.

105. Ove with Peter Dunican and Ruth Winawer, 1955.

106. Annual summer outing on the Thames, 1958.

107. The Highgate House, 1965, before the garden achieved maturity.

108. Ove in the Highgate garden, 1973.

109. Ove and Li at Highgate, 1969.

110. Ove in his Highgate study: the bookcase hid yet more paper, 1969.

facing page top 111. Partnership Board Meeting in Highgate, 1963.

facing page middle 112. Ove at one of numerous parties in the Arup Library, 1975.

facing page bottom 113. Inaugurating the spinet by Arnold Dolmetsch, commissioned by the Partners for Ove's seventieth birthday, 16 April 1965.

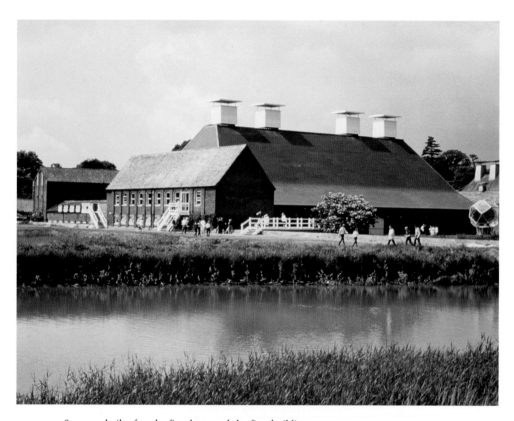

114. Snape, rebuilt after the fire destroyed the first building, 1971.

facing page 115. Channel Tunnel Rail Link, Medway bridges spanning the estuary in Kent, 2003.

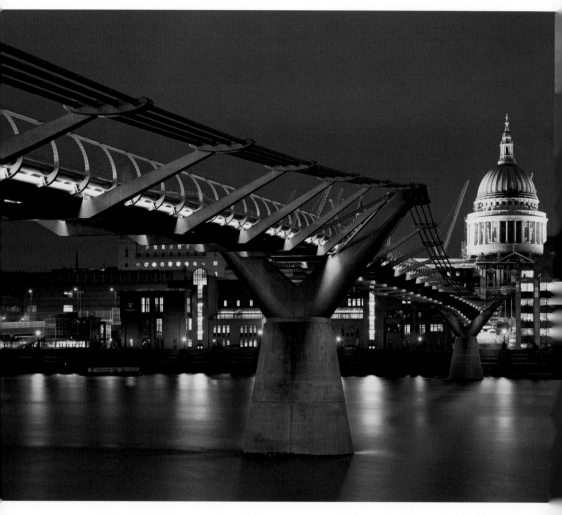

116. Millennium Bridge, London, 2000.

117. A corner of Ove's office, as he last saw it, 1988: sculptures, pottery, paintings, drawings, models and other *objets d'art* fill every inch. The painting of a mother and child is by the avant-garde French artist, Jean Souverbie (1891–1981).

118. Øresund Bridge linking Denmark and Sweden, 1996–2000.

left 119. Watercolour of Kingsgate footbridge, by Roger Rigby, 1985.

facing page bottom 120. Ove played chess for over seventy years and won numerous competitions at the Danish Club. He established the Arup Chess Company Ltd, and in 1975 launched his own design of Archesco sets, made in hardwoods, or plastic, and accompanied by his new chess notation. In the tower models, in the background, the board wraps round a column on which the pieces are suspended. Chopsticks in Ove's pocket remained a lifelong habit.

number of eight Partners. Moreover, present-day emphasis on competition seemed incompatible with the 'liberal idealism' of the speech.

Within months of that meeting, however, a sudden furore had developed, generated by work undertaken by the Edinburgh office. The job site was adjacent to a naval depot known to house nuclear armaments. Ove, of course, had been advocating for almost twenty years greater awareness of environmental issues, and his views were well known on nuclear matters. He had visited Dounreay five years earlier, but had declined to sign a letter to *The Times* in support of work there, on grounds that he did not know enough. And in an unpublished letter to *The Times* of June 1983, he deplored the stockpiling of atomic weapons and their sale 'to primitive tribes and gangsters', which he saw as a consequence of 'design for profit'.

In the autumn of 1983 Ove told his Partners that the firm was like everyone else: 'very backward in choosing the right things to do'; 'it may be necessary for me to resign from the Partnership to clear my name'.[7] This melodramatic threat was unfortunate. Some Partners understandably wondered whether he was not once again insisting that it was fundamentally his firm, because it was with his money that it started – he unwisely opened another missive by describing the firm as 'after all my child'.[8] Ove conceded that his remarks were political and about ends, not about the best means an engineer might adopt to solve a problem. He asked colleagues whether 'the firm should refrain from having any opinion about politics at all'. In the Edinburgh case it was eventually decided that the firm would honour its present contract, but subsequently alert staff if a proposed task was in a 'sensitive' area, politically or morally. But Ove had also asked colleagues about 'The key speech' of 1970: 'was it a remnant of a liberal tradition which is entirely unsuited to the present economic climate'?; had it been 'too unrealistic at birth' since a slide had already begun 'into an uninhibited dance round the golden calf, where everything is measured in money terms or profit'? Colleagues who had written directly to Ove about 'the nuclear crisis' overlooked the fact that 'The key speech' only suggested 'guidelines': these may need updating 'in view of the technological explosion and the erosion of moral standards'.

In his later years, and with time to indulge himself in thought, he could not avoid the pressures of close friends to review his life and to write his autobiography. He made several false starts. But, as usual, he came up with objections to the task: indeed, he revelled in them.

He readily conceded – how could he not – that he had 'drawers, shelves, and suitcases full of relevant material'; but he was concerned by the fact that

any story of a life consisted of both fact and fantasy ('Dichtung und Wahrheit'): moreover, memory is fallible, perceptions are deceptive, documents unreliable. 'What, then, is truth?' How was he to decide who did what, for whom, when, why, where and how? What were their aims and values, the costs and the consequences? How good were the ends and the means, the process and the product? What influenced who, and who was influenced by whom? Moreover, if insight depended on knowledge of the personalities involved, what were the criteria of insight, and how could it be conveyed? If one could not really know another person, could one even know oneself?[9] And might one not surrender to self-deception, and retrospectively assign to oneself problems, priorities and practices, let alone motives and ideas, of which one was unaware at the time? Of course one could. He had dealt with such sceptical challenges more than seventy years before. Why was he giving in, now?

Ove wrote a characteristically affectionate letter to Ruth Winawer after his own seventieth birthday, to congratulate her on her reminiscences in the recent *Newsletter*. He observed: 'you can't very well expect me to enumerate all the benefits your existence has bestowed on me – I haven't time to sit here all afternoon (*I left out: writing to you). [. . .] That is of course not the reason why I thank you for your 'piece' – there is reason, let that suffice.'

Ruth collected and cherished Ove's scribbles, especially those devised for birthdays or Christmas. In 1976 he sent her a piece he entitled 'The monument speaks: [shame!]'. She was thrilled: 'Gosh . . . You don't pull your punches do you? I am entirely in sympathy, and I agree with the content and applaud the means of expression. There is no end to the blindness of those who don't want to see.' The verses deplored the disregard shown to age, experience, memory, tradition, the past: because

> It's in the past we find the clue
> To our identity.

Since his schooldays, Ove had devised innumerable pieces of doggerel, often accompanied by 'doodles': the immediate models for these were to be found in Danish traditions, but the doggerel often captured insights in the manner of Rochefoucauld's maxims – and accordingly appealed to only a small circle of British colleagues. After his death, his daughter Anja edited and published a collection of these pieces.[10]

Inevitably Ove was predeceased by many friends and relatives. Henning died from a heart attack after running for a train in 1963; his beloved Ingeborg had turned ninety-three before her death in 1976. The frequency

increased with which yet another letter of sympathy, understanding and affection was called for. Ove told the widow of Clough Williams-Ellis: 'Like everyone else, we were captivated by his enthusiasm [. . .] we simply came to love you and felt privileged to be counted among your friends.' And after Lubetkin's wife died: 'I am very conscious that I owe you a great deal. You had a great influence on my life, even if I could not follow you all the way.'[11] Lubetkin replied:

> You generously acknowledge my influence upon you. What deserves somewhat more attention is the enormous debt I owe you for your skill, intelligence, gift of imagination and, not least of all, your patience in dealing with me when I struggled with my self-imposed limitations and constraints quite incomprehensible to all but you.
>
> [. . .] whereas I believed in the power of images to shape the destinies of me and societies, your approach was more analytical, generated by the desire to solve step by step the many conflicts as a precondition of change.
>
> We both believed in change, yet the ossified society required only a semblance of renewal and got plenty of it. [. . .]
>
> Both the cool analytical logic of gradualism and the abrasive dissent of subversion were swamped by a cloying sweetness of acceptance.
>
> I was wrong. But who was right?[12]

So, had Ove really expected to win his lifelong battle? He certainly did not win it in his lifetime, and a writer in 1995 strongly objected to the barriers obstructing progress in the building industry: 'the crumpled linen suits of the professional design office exist in unsullied and fashionable isolation from the horny-handed sons of toil who wrestle to put up their virtually unbuildable creations.'[13]

But, in the strictest sense, his own arguments had shown that the battle would never, could never be finally won – it would simply move to new territory. His mind battled relentlessly with the demons of philosophy. Yet had he not said that what mattered most was people? Not ideas, not money, not buildings, not reputation – but people, his family, friends, colleagues? And had he not repeatedly said that all 'ideas are emotionally charged'; and that 'emotional overtones [. . .] invariably interfere with any rational relationship with members of the opposite sex'.[14] Did this mean that one's emotional life defined one's personality? Was that the core of Buffon's observation: *le style c'est l'homme même . . .*?[15]

Envoi

'. . . si vieillesse pouvait'

Sceptical, empirical enquiry yields no certainties, no emotional assurances: focused practical activity alone keeps the furies of doubt at bay. Self-absorption can be cheated by confronting its dreams, and even uncertainties about oneself can be calmed by social activity, perhaps also by writing to others.

At the age of eighty Ove decided he must, in some way, recollect, revisit, restore, rekindle – he wasn't sure – his deepest feelings. He was quite unclear about what he wanted or expected to happen, or even what his motives were. But it was, after all, a small group of people to whom he was going to write. Everyone replied: and the resulting treasures were securely locked in a private drawer of his office desk.

In fact, no silence had enveloped the past. Ove had news of Else Lorenz from friends and her brother Erhard, who had worked with Ove in Dublin and designed his Highgate house. After several letters in the mid-1970s, Ove telephoned her in 1980 to discuss whether it would be a good idea to meet: she had no anxieties. In one of her replies she reported: 'it was such a kind and sweet letter, and I cried a lot when I read it.' She told how her mother had helped to destroy their relationship – 'we never managed to say a proper good-bye to each other' – and damaged her later marriage: but she would love

to see Ove again. On the other hand, they 'are no longer the same as back then': would there be any use? Shortly afterwards she wrote: 'I have to tell you that the best thing that has happened to me for a long time was when you sent me your love. I think of you in the most loving ways. Your old Else, who'll never forget you.'

But in November 1984 Ove forced himself to write to her brother:

It is too bad that I did not reply long ago to your letter about Else's death. I did know that it was drawing towards the end after receiving some very loving letters from her. Also I wrote to her not that long ago without getting a reply, and I had just decided to write to you to ask how things were. Perhaps it was for the best that everything happened the way it did.

. . . Yes, I am please that we talked to each other before she passed away.

What must one do? what should one say? Only months before Erhard's letter arrived, late one night he wrote to Ruth:

I was immediately filled with remorse and shame and there welled up in me so many thoughts, so many things that I wanted to explain to you, so many regrets about wasted opportunity, at having disappointed friends like you whose help I spurned – no, not spurned, for I always appreciated them and agreed with them but I was too weak or timid or self-indulgent to follow the good advice. Not that all the advice <u>was</u> good, what <u>was</u> good was that <u>something</u> needed to be done, but what was not quite so simple as it was supposed to be.

What echoes from the distant past still haunted him?

But there is something in me which I would like to say, also very much for my own sake. Something which I have not formulated yet and which I most likely never will be able to formulate, but there is a kind of thread which goes through my life and which has been lost and taken up again – I would like to know myself. Is it vanity? I do not know although I know the fatality of it. A quest for truth and intellectual honesty – it is that, but what does it mean. I would like to say what it means to me – but I don't really know. What is quality, integrity – quite apart from the fact that I don't have it. I am soft. A mixture of weakness and stubbornness – You see what you have to put up with. A shameless exposure of inner chaos. I don't like myself very much. I am like the curate's egg – good in parts.

With Elsebeth Juncker, too, Ove also stayed in touch. As with Else, he had done business with her brother since the 1930s – he was a flooring specialist

– and Ove occasionally visited her and her husband outside Copenhagen. And she visited the family at Highgate, and discussed his chess designs with him. A letter of April 1952 conveyed her feelings:

> The first parts of your letters are always amazing . . . they all look the same . . . starting by saying that you don't mean any of what you're about to write . . . or that it may just as well be something completely different . . . or that it may be put differently, which would make it something different again. You start, then, to put it briefly (no, it won't be that brief) by hiding yourself, by waving a whole lot of blankets, just in case anyone should think that this is actually serious. And besides, that is how you start on anything that you say. And afterwards you come out with things that are deadly serious . . .
>
> Actually, I don't know why we've never talked like this before . . . You are neurotic. And so am I. That's why I can tell you so calmly. How the two of us could ever consider getting married is beyond me, because in a way there is nothing to choose between us, and it is against nature that married people should be like that. On the contrary, they ought to complement each other, which I suppose both of us have managed to do in those marriages we have finally entered into . . .
>
> Your most obvious symptom is a kind of fear of taking responsibility. Thus all those innocent blankets that you wave about every time you say or write anything, and probably also when you take action . . . You're rather afraid of life (and believe me, you have a reason to be), and therefore you take refuge in your maths and all your wonderful abstract buildings. You push maths and logic in between yourself and life. You may suffer from 'le complexe de l'etranger' . . .
>
> I haven't even talked about your other great symptom, the one which spoiled so much for the two of us, and which we fought against so fiercely in Paris.

Elsebeth's recommendation of psychoanalysis did not appeal to Ove, but her comments, exactly thirty years after they had parted, struck home. Ove not only heard, and listened to, the half dozen friends during his lifetime who penetrated his defensive smoke screen: he fell in love with them. But then he had to handle an emotional relationship. It was safer to hold back: he might be wrong; they might be hurt; he would be.

At about the same time he was planning to meet Else, Ove also re-established contact with Olga Kaae – with the help of a mutual friend. He was eighty-one, and she was but eighty-five. She had led an interesting and inde-

pendent life as a missionary in India, and later as leader of a religious retreat in Denmark. She wondered at first whether it would be wise to meet, or indeed to resume any substantial correspondence: to her, he seemed still to be preoccupied with questions about the meaning of life, and it might be best to let the past be. Naturally, Ove also thought that this might well be right: but on the other hand, it might not be. Olga did not disappoint him: 'the image of yourself which you conjure up through the written word speaks its very own language to me. I recognise you as you were those many years ago, and this has pleased me and touched me very much.'

This is hardly surprising: his letter of April 1982 might well have been dated April 1914:

> I cannot manage all the things that I would like to do and all the things that I ought to do . . .
>
> I agree with you that things had to go the way they did, and that there is no reason whatsoever for us to break off our contact. . . . Yet it will be broken shortly anyway, whether we want it or not. Whether we 'understand each other entirely', as you're hoping, I am not quite sure of myself. And I have to admit that it bothers me somewhat, and has bothered me in the past. I would very much like to get the opportunity to really talk things through with you, to try to find out where each of us stands and how far we may go along together. . . .
>
> As you know, when we first met I was far too shy and constrained to be able to 'pour out my troubles to you'. I really was raving mad, as is clear from my diaries; I both detested myself and at other times displayed signs of a kind of megalomania, since I believed that at some point I would be able to find or solve the mystery of the world. Not that I have got anywhere on this, and now I don't believe that any person is able to do so.

And so on. He added a P.S.:

> Our contact is not broken off, as long as we live. But some doors are seldom used, even if they aren't locked. But now it is spring – and this will always be one of the wonders of god! But don't rejoice yet.
> So, then, love from Ove.

Could they meet in Denmark? There were obstacles: distance, age, infirmity. They did not. Or had they already, in the only way possible?

Ove agreed with Olga, that 'it was for the best that things went the way they did between us'. They had grown up 'in two completely different environments'; their lives and work had taken place 'at least externally in very

different worlds, where the distance between us was far too great to allow our acute young love to build a bridge across the gap which existed between us'. Were they not like the two children in Hans Andersen's *The Snow Queen?* They were not brother and sister, but 'loved each other just as much as if they had been'. In the hostile world beyond childhood they lost each other. But after 'running to the end of the world' in search of him, the girl found him: 'they could find only one difference, and that was in themselves, for they saw that they were now fully grown up.'

Olga worried about Ove's health, and the pressure under which he put himself, which deprived him of 'inner calm'. She nervously sent him verses and hymns, knowing he hated anything smacking of religion. But he was delighted, especially with Andersen's verses on choosing the right road in life. And, yes, he refused to condemn the ways in which others found peace of mind, even though his own goal was 'intellectual integrity':

I am not indifferent towards 'good' and 'evil', although I cannot define these concepts, and I'm intelligent enough to accept the limits of my intellect. Thus, I must try to help the good and fight the evil. But when the 'evil' is partly within oneself, it is very difficult to do so.

In 1986 Olga's sister sent Ove a note to say that Olga had suffered a stroke – she was ninety-five. She managed to sign the note herself. Exactly seventy years after they met in 1913, Olga had stated what Ove still could not, dared not, express:

I feel that in one way or the other there exists a deeper level of under-standing between us, and that this has something to do with love – and this has really never been any different.

A few months after her death, Ove drafted one of his last impassioned out-bursts to *The Independent*. It was imperative to illustrate his views about language:

to say or write 'I love you' means next to nothing. It is the way it is said which matters, it is the look in the eyes, the tone, the gestures, it is the emotion which streams out to be received or rejected.

Chronology

In order to convey the growth and scale of the firm's activities since 1946, the brief chronology below lists major organisational changes, the opening of overseas offices and most of the projects discussed in this book (names in parentheses are those of the architects). Some major projects since Ove's death are also listed. Ove himself never regarded Arup & Arup Ltd, Civil Engineers and Contractors, the firm he founded in 1938 with his cousin Arne, as being connected in any way with the firm he founded in 1946 as Ove N. Arup, Consulting Engineers.

1946 Practice opens in London, UK, 1 April, as Ove N. Arup, Consulting Engineers

Office opens in Dublin, Ireland

Bus Station, Dublin (Michael Scott)

1949 Ove Arup & Partners formed with Ove Arup, Ronald Jenkins, Geoffrey Wood and Andrew Young as Partners

1951 Office opens in Ibadan, Nigeria

Rubber factory, Brynmawr; Footbridge, Festival of Britain; beginning of design for Coventry Cathedral (Basil Spence)

1952 Office opens in Salisbury, Southern Rhodesia (now Harare, Zimbabwe)

1953 Ove Arup created Commander of the British Empire (CBE)

1954 Offices open in Lagos, Nigeria; Lusaka, Northern Rhodesia (now Zambia); Johannesburg, South Africa; and Bulawayo, Southern Rhodesia (now Zimbabwe)

Completion of Hunstanton Secondary Modern School, Norfolk (Alison and Peter Smithson)

Chronology

1955 Ove Arup & Partners West Africa formed

Office opens in Kano, Nigeria

1956 Peter Dunican appointed a Partner

Office opens in Accra, Ghana

Completion of Hallfield Primary School (Drake & Lasdun); Bank of England Printing Works, Debden, Essex

100 *permanent members of staff*

1957 Ove Arup & Partners South Africa formed

Offices open in Nairobi, Kenya; and Sheffield, UK

Completion of TUC Congress Memorial Building, London (David du R Aberdeen); beginning of design for Sydney Opera House (Jørn Utzon)

1958 Offices open in Durban, South Africa; and Manchester, UK

Beginning of design for St Catherine's College, Oxford (Arne Jacobsen); completion of St. James's Place, London (Denys Lasdun)

1959 Ove Arup Partners Rhodesia formed

Library established in London, UK

Completion of Aero Research, Duxford, Cambridge

1960 Ove Arup & Partners Scotland formed

Office opens in Edinburgh, UK

Completion of Falmer House, University of Sussex (Basil Spence); Royal College of Physicians, London (Denys Lasdun); designs for Volta River Bridges, Ghana

1961 Ronald Hobbs appointed a Partner

1962 Geotechnics Group established in London, UK

1963 Ove Arup & Partners Ireland and Ove Arup & Partners Sierra Leone formed

Office opens in Sydney, Australia

Arup Associates established

1964 Ove Arup & Partners Australia formed

Offices open in Kuala Lumpur, Malaysia; and Monrovia, Liberia

Computer Group and Research & Development Group established in London, UK

Completion of Kingsgate Footbridge, Durham

1965 Povl Ahm and Jack Zunz appointed Partners

Ove Arup & Partners West Africa dissolved

Ove Arup & Partners Nigeria and Ove Arup & Partners Ghana formed

Offices open in Cape Town, South Africa; and Windhoek, South West Africa (now Namibia)

Highways and Bridges Group established in London, UK

500 *permanent members of staff*

1965–70 Snape Concert Hall, Aldeburgh, Suffolk (built twice)

1966 Ove Arup & Partners Zambia and Ove Arup & Partners Malaysia formed

RIBA Gold Medal for Architecture awarded to Ove Arup

Beginning of restoration of York Minster

1967 UK Partnership re-formed as Ove Arup & Partners Consulting Engineers and Arup Associates

Offices open in Pretoria, South Africa; Glasgow, UK; and Newcastle, UK

Foundation Engineering Section and the Housing Division established in London, UK

1968 Ove Arup & Partners Jamaica formed

Offices open in Canberra, Australia; Singapore; and Birmingham, UK

Traffic Group established in London, UK

The Joughin Report on the organisation of Ove Arup & Partners received

Maitland Medal of the Institution of Structural Engineers awarded to Ove Arup

1969 Philip Dowson appointed a Partner

Office opens in Perth, Australia

Queen's Award for Technological Achievement made to Ove Arup & Partners

1970 Ove Arup Partnership becomes parent firm of Ove Arup & Partners and Arup Associates

Ove Arup delivers 'The key speech' at a meeting of the Arup Partnerships in Winchester, UK

Ove Arup & Partners Singapore formed

Ove Arup awarded a knighthood

1971 Offices open in Riyadh, Saudi Arabia; Cardiff, UK; and Dundee, UK

Building Engineering established in London, UK

Project Planning and Site Supervision group established in London, UK

Beginning of design for Centre Culturel Georges Pompidou, Paris (Piano and Rogers)

1972 Offices open in Melbourne, Australia; Waterford, Ireland; and Penang, Malaysia

Ronald Jenkins retires as a Partner

1973 The Gold Medal of the Institution of Structural Engineers awarded to Ove Arup

1500 *permanent members of staff*

1974 Offices open in Tehran, Iran; and Bristol, UK

Offshore Engineering and Fire

Engineering Groups established in London, UK

1975 Offices open in Paris, France; Port Moresby, Papua New Guinea; Kota Kinabalu, Sabah; Port Louis, Mauritius; and Doha, Qatar

1976 Offices open in Hong Kong; Benghazi, Libya; and Cork, Ireland

Mechanical and Electrical Development Group established in London

1977 Ove Arup Partnership reconstituted with Peter Dunican as Chairman and Jack Zunz as Chairman of Ove Arup & Partners; the firm's trust ownership established

Ove Arup dan Rakan Brunei and Ove Arup dan Rakan Sabah formed

Offices open in Brunei; Gaborone, Botswana; Lae, Papua New Guinea; and Abu Dhabi, UAE

Industrial Engineering and Arup Geotechnics established in London, UK

1978 Peter Dunican elected President of the Institution of Structural Engineers

Geoffrey Wood retires as a Partner

Runnymede Bridge, Staines; beginning of design for Kylesku Bridge, Sutherland

1979 Office opens in Aberdeen, UK

Offshore Engineering established in London, UK

1980 Office opens in Mmabatho, Bophuthatswana

Arup Acoustics established in London, UK

Philip Dowson awarded a knighthood

1981 RIBA Gold Medal awarded to Philip Dowson

Offices open in Baghdad, Iraq; Cairo, Egypt; and Kuching, Malaysia

Chronology

1982 Offices open in Brisbane, Australia; Limerick, Ireland; and Warwick, UK

1984 Queen's Award for Export Achievement made to Ove Arup & Partners

Peter Dunican retires as Chairman; Jack Zunz and Ronald Hobbs succeed as Co-Chairmen of Ove Arup Partnership; Povl Ahm becomes Chairman of Ove Arup & Partners

Offices open in Jakarta, Indonesia; Rabaul, Papua New Guinea; and Cambridge, UK

1985 Offices open in San Francisco, USA; and Auckland, New Zealand

1986 Offices open in Adelaide, Australia; Los Angeles, USA; Nottingham, UK; Wrexham, UK; Winchester, UK; and Horsham, UK

Ove Arup elected Honorary Royal Academician

Opening of the Hongkong Bank, Hong Kong (Norman Foster)

1987 Environmental Services Group and Arup Research & Development established in London, UK

Office closes in Riyadh, Saudi Arabia

1988 Ove Arup dies, 5 February, aged 92

Offices open in New York, USA; and Leeds, UK

The Gold Medal of the Institution of Structural Engineers awarded to Jack Zunz

1989 The Ove Arup Foundation, a charitable educational trust, established in memory of Ove Arup

Jack Zunz and Ronald Hobbs retire as Co-Chairmen and are succeeded by Povl Ahm as Chairman of Ove Arup Partnership; John Martin becomes Chairman of Ove Arup & Partners

Peter Dunican dies, 19 December

Offices open in Gold Coast, Australia; and Coventry, UK

Arup Facade Engineering established in Sydney, Australia

Communications & Information Technology Group established in London, UK

1990 Arup MMLS (Turkey) formed

Offices open in Manila, Philippines; East London, South Africa; Tokyo, Japan; Istanbul, Turkey; and Douglas, Isle of Man

Project Management Services Group established in London, UK

1991 Arup GmbH established

Offices open in Berlin, Leipzig and Düsseldorf, Germany

3500 permanent members of staff

1992 Ove Arup Partnership becomes a private unlimited liability company owned in trust for the benefit of the employees

Povl Ahm retires and is succeeded by John Martin as Chairman of Ove Arup Partnership; Duncan Michael becomes Chairman of Ove Arup & Partners

Michael Lewis retires as a Partner

Arup Facade Engineering and Controls & Commissioning groups established in London, UK

British Consultants Bureau Consultant of the Year Award, Class 2 given to Ove Arup & Partners as Joint Winner

1993 Offices open in Athens, Greece; Cairns, Australia; Copenhagen, Denmark; Madrid, Spain; Moscow, Russia; and Shenzhen, China

First Gold Medal of the Institution of Civil Engineers awarded to Povl Ahm

British Consultants Bureau Consultant of the Year Award Class 3: British Small Consultancy Firm Award given to Arup Economics & Planning

1994 Queen's Award for Export Achievement made to Ove Arup Partnership

Office in Rabaul, Papua New Guinea, closes due to volcanic eruption

British Consultants Bureau Consultancy Firm of the Year Award

Quality Assurance Certification awarded to offices in Birmingham, UK; Coventry, UK; Brisbane, Australia; Sydney, Australia; and Dublin, Ireland

1995 John Martin retires and is succeeded by Duncan Michael as Chairman of Ove Arup Partnership; Bob Emmerson becomes Chairman of Ove Arup & Partners

Office in Doha, Qatar closes

Queen's Award for Export Achievement made to Ove Arup Partnership

British Consultants Bureau Consultancy Firm of the Year Award given to Ove Arup & Partners

1996 Offices open in Darwin, Australia; Detroit, USA; and Shanghai, China

Office in Moscow, Russia, accredited and registered

1997 The Ove Arup initiative results in the new Board of Arup Partnerships

Office opens in Kokopo, Papua New Guinea

Launch of Arup Energy and Arup Transport as worldwide businesses

1998 RKL-Arup established as the firm's water engineering business following the merger with Rofe Kennard & Lapworth

Office opens in Toronto, Canada; Warsaw, Poland; and Westborough, Mass., USA

Formation of the Corporate Services Board

Quality Assurance Certification of Arup Communications

1999 Ove Arup Partnership becomes a limited company

Merger with Design Research Associates Ltd within the Advanced Technology Group to form DRAL-Arup, providing services in vehicle design and styling

Merger with BMP Communications to work with Arup Communications in providing strategic telecommunications services

Office opens in Boston, USA

2000 Bob Emmerson succeeds Duncan Michael as Chairman of Ove Arup Partnership Ltd; adoption of the singular name 'Arup'

Merger with NAPA to form Arup NAPA, providing services in the airports sector

Merger with Jolyon Drury Consultants to form Arup-JDC, providing materials handling and logistics services

Office opens in Houston, USA

Australasia Board established as the sixth operational board

Queen's Award for Export Achievement awarded to Ove Arup Partnership Ltd

Millenium Bridge, London (Norman Foster); completion of Øresund Bridge linking Denmark to Sweden

2001 Formal merger with Arup Australia; Ove Arup Partnership Ltd is renamed Arup Group Ltd

Europe & Building Division and Specialist Practices Division are formed from Building Engineering and Operations Divisions

Offices open in Amsterdam, Netherlands; Belfast, Northern Ireland and Liverpool, UK; and Milan, Italy

Transport Division is renamed Infrastructure Division

European Award for Steel Structures, for Øresund Bridge, and British

Construction Industry Award for Tate Modern, London, UK

4500 permanent members of staff

2002 Offices in Auckland, New Zealand; and Canberra, Australia, close

Offices open in Bangkok, Thailand; Seattle, USA; and Seoul, Korea

Several World Architecture awards for Druk White Lotus School, Leh, Ladakh, India; two ACEC Engineering Excellence awards for the International Arrivals Building at Kennedy Airport, New York, USA; and the Association of Consulting Engineers Australia's Silver Award for the National Museum, Canberra, Australia

2003 Office in Abu Dhabi, UAE, closes

Offices open in Beijing and Macau, China; Chicago, USA; Frankfurt, Germany; and Málaga, Spain

Several awards for the Millennium Bridge, London, UK

2003–4 Several awards, including the RIBA James Stirling Prize and the Emporis Skyscraper Award, for 30 St Mary Axe, London, UK

2004 Terry Hill succeeds Bob Emmerson as Chairman

The Divisional structure is replaced by four geographic Region Boards – Americas, Australasia, East Asia and Europe – and three Sector Boards – Buildings, Consulting and Infrastructure

RIBA Regional Award – Europe, for O'Connell Street Monument, Dublin, Ireland; also several awards for Selfridges Department Store, Birmingham, UK

2004–5 Several architectural and engineering awards for Seattle Library, Seattle, USA

2005 Povl Ahm dies

Office opens in Dubai, UAE

Special Award from HKIE Joint Structural Division, Hong Kong, for Langham Place, Kowloon, Hong Kong

2006 Ronald (Bob) Hobbs dies

Office opens in Doha, Qatar

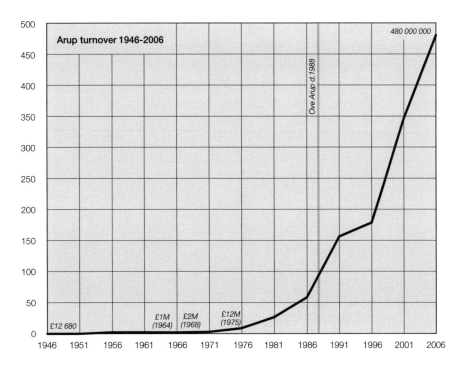

Arup turnover 1946-2006

£12 680

£1M (1964)

£2M (1968)

£12M (1975)

Ove Arup d.1988

480 000 000

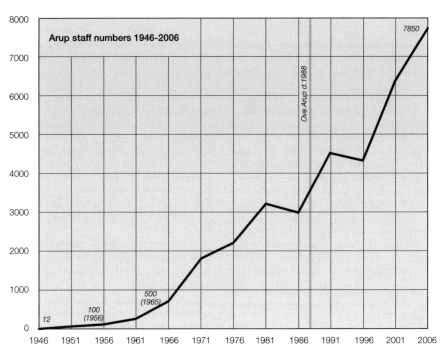

Arup staff numbers 1946-2006

12

100 (1956)

500 (1965)

Ove Arup d.1988

7850

Notes

Unless otherwise specified, all quotations are from letters, diaries, documents and typescripts in private hands. Some of the documents cited also exist in duplicate copy form in publicly accessible collections. The Arup Papers are held in the Churchill Archives Centre, Cambridge, as are the recordings for the Arup Oral History project. The large selection of material in the Arup Papers was initially made by Mrs Ruth Winawer and Dr Francis Walley. The Arup Library, London, holds both published material and confidential documents relating to the firm. Other sources include: the Utzon Papers in the Mitchell Library, Sydney; the Ashworth Papers in the National Library of Australia; the State Papers of New South Wales; and the Archive of the Sydney Opera House Trust. Apart from diary entries, the initials 'OA' indicate typescripts and published items cited in the list of writings below.

Chapter 1

1. Johannes Arup to Fru Sophie Nyquist, Grimstad, Norway, 16 April 1895.

2. Mathilde (1865–1931) came from a large family of ten children, in Norway: most of her siblings died in childhood. Johannes (1844–1911) was the son of Niels Christian Jensen Arup, and married Johanne Kirstine Cathrine Munk (1856–90). Johannes's three brothers Peter, Frederik and William all had children and Ove kept in touch with his cousins and their children. William's son Leif suggested to Ove that he might study engineering, and they started the engineering course together. Leif later emigrated to the United States. Frederik worked in London for forty years, and it was with his English-educated son Arne that Ove entered into Partnership in 1938.

3. Ove Arup to Mary Midgley, 20 Aug 1987, in response to her article 'The flight from blame' in the journal *Philosophy*, July 1987: Arup Papers, 2/99.

4. *Jubilaeumsskrift i anledning af Sorø Akademis Skoles 350-års jubilaeum*, Soransk Samfund, Sorø 1936.

5. Henning Arup to Ingeborg Arup, 20 Feb 1911. Ingeborg (1883–1976) was educated in

England, as were her two sisters Ellen (1885–1919) and Astrid (1881–1964).

6. Henry Krog-Meyer, 'Gymnasiet på Sorø Akademi 1909–11', in *Soraner Blad*, Sorø 1985.

7. John Coryell (1848–1924) was a successful American writer of detective stories and later of women's fiction: he wrote under several pseudonyms and even his publishers adopted false names.

8. OA, 'People today', BBC interview, 1964 (not broadcast).

9. August Baumann to Ove Arup, 13 June 1912, 14 Oct 1912, 24 Nov 1912, 23 Dec 1912, 23 March 1913, 24 April 1913.

10. Aage Bugge to Ove, 21 July 1913.

11. OA, BBC interview, 1964. He expanded a little on this in 'Philosophy and the art of building', 1974, trans. Jens Arup in *Ove Arup 1895–1988*, ed. Patrick Morreau, Institution of Civil Engineers, 1988.

12. *Karakterbog for Ove Nyquist Arup*, for the school years 1908–9, 1909–10, 1910–11, signed 30 Oct 1908, 24 Sept 1909, 1 April 1911, 20 Jan 1912.

13. Including those by Gottlob August Tittel (1786), Snell (1789), Heydenruch (1794) and Schaffler (1788); also Johann Christian Zwanziger's *Commentar über Herrn Professor Kants Kritik der praktischen Vernunft*, Leipzig 1794.

14. Ove Arup to Mary Midgley, 20 Aug 1987; see n. 3 above.

15. Interview in *Concrete Quarterly*, 144, 12 Feb 1985.

16. Ibid.

17. OA, 'Philosophy and the art of building', 1974.

18. Arthur Nikisch (1855–1922) was succeeded as director of the orchestras in both Berlin and Leipzig by Wilhelm Furtwängler.

19. Lauritz Melchior (1890–1973) was born in Copenhagen and adopted American citizenship in 1947. He began his career as a baritone but made a second début in the title role of Tannhäuser in 1918, soon becoming internationally renowned as a Wagnerian *Heldentenor*.

20. Olga Kaae to Ove Arup, 1 June 1915.

21. Ove Arup to Mary Midgley, 20 Aug 1987; see n. 3 above.

22. Olga Kaae to Ove, 4 Dec 1914.

23. Olga Kaae to Ove, 1 June 1915.

24. Olga Kaae to Ove, 29 Oct 1916.

25. Olga Kaae to Ove, 10 Nov 1918.

26. BBC interview, 1964.

27. BBC interview, 1964.

Chapter 2

1. Vitruvius, *Ten Books on Architecture*, trans. Ingrid D. Rowland, Cambridge 1999. In 1985 a concrete floor was excavated in southern Galilee, dated to 7000 BC; others of slightly later date were found in Yugoslavia and Egypt. For a study of the rival material, see James W. P. Campbell, *Brick: A world history*, London 2003. Fired bricks have been used as a building material for over five thousand years, and mud bricks for twice as long. Ove referred to Vitruvius, unusually, in 'An engineer looks at architecture', delivered to the Leicester University Arts Festival, 11 Feb 1969.

2. John Smeaton, *A Narrative of the Building, and a Description of the Construction of the Edystone Lighthouse with Stone: To which is subjoined, an appendix, giving some account of the lighthouse on Spurn Point, built upon a sand,* London 1791. Sir Robert Smirke (1780–1867), architect of the British Museum buildings of 1820, helped to popularise concrete; and in 1854 in the city of Ove's birth, William Wilkinson (1819–1902), who manufactured plaster of Paris and Roman cement, patented a shallow-arched floor-slab in which iron strips – actually barrel hoops, were set on edge to act as 'tension rods'. He later placed a grid of steel rods over the moulds before concrete was poured, thereby securing reinforcement.

3. Essential references are: A. J. Francis, *The Cement Industry 1796–1914: A history*, Newton Abbot 1977; Rowland J. Mainstone, *Developments in Structural Form*, London 2/1998; for mainly American references, Cecil D. Elliott, *Technics and Architecture: The development of materials and systems for buildings*, Cambridge, Mass., 1992. For historical background: John Fitchen, *Building Construction before Mechanization*, Cambridge, Mass., 1986; John Fitchen, *The Construction of Gothic Cathedrals: A study of medieval vault erection*, Oxford 1961; Walter C. Leedy, Jr., *Fan Vaulting: A study of form, technology and meaning*, Santa Monica, Ca.,

1980; Brian Cotterell and Johan Kamminga, *Mechanics of Pre-industrial Technology*, Cambridge 1990; Lyn T. Courtenay, ed., *The Engineering of Medieval Cathedrals*, Aldershot 1997.

4. See Gunnar M. Idorn, *Concrete Progress*, London 1997.

5. J. G. Forchhammer (1794–1865) had an extensive correspondence with Darwin.

6. Five years later this collection appeared in English: *Towards a New Architecture*, trans. Frederick Etchells, London 1927. On Charles Edouard Jeanneret (1887–1965) [Le Corbusier], see Michael Raeburn and Victoria Wilson, eds, *Le Corbusier: Architect of the century*, London 1987.

7. On Walter Gropius (1883–1969), see Jeannine Fiedler and Peter Feierabend, *Bauhaus*, Cologne 1999.

8. OA, BBC interview, 1964.

9. OA, 'The engineer looks back', *Architectural Review*, 166 (993), Nov 1979.

10. In January 1921 the Allies' Reparations Commission had ordered Germany to repay 1.32 billion gold marks, to be paid off at an annual rate of 6 per cent.

11. Quoted in Richard J. Evans, *The Coming of the Third Reich*, London 2003, p. 106. See also Michael Burleigh, *The Third Reich: A new history*, London 2000.

12. *Mein Kampf* was published in 1925, and sold extensively only after Hitler came to power. Hitler dictated most of it to Rudolf Hess, while he was in prison.

13. Elsebeth Juncker to Ove, 21 Dec 1923.

14. OA, 'The world of the structural engineer', Maitland Lecture to the Institution of Structural Engineers, Nov 1968, *Structural Engineer*, Jan 1969; reprinted in *Arup Journal*, 20 (1), spring 1985.

15. OA, BBC interview, 1964.

16. OA, 'The engineer looks back', 1979.

17. BBC interview, 1964.

18. Mother to Ove, 11 April 1924.

19. Mother to Ove, 14 April 1924.

20. Mother to Ove, 6 May 1924.

21. Mother to Ove, 6 June 1924.

22. Mother to Ove, 6 June 1924 (second letter).

23. Mother to Ove, 13 Feb 1924.

24. Lafcadio Hearn, *Kokoro: Hints and echoes of Japanese life*, London 1895; also Hugh Benson, *Initiation: A novel*, London

1914; and two historical books by the prolific T. F. Troels-Lund.

25. Elsebeth to Ove, 10 Sept 1924.

26. Grete to Ove, 12 Oct 1924, from Berlin.

27. Grete to Ove, 21 Oct 1924, from Berlin.

28. Grete to Ove, 4 Nov 1924.

29. Grete to Ove, 27 Nov 1924.

30. Mother to Ove, 14 Dec 1924.

31. Knud Rübner-Petersen to Ove, 26 Dec 1924, from New York.

32. Bengt to Ove, 2 Feb 1925, in response to a mislaid letter from Ove of 19 Jan 1924.

Chapter 3

1. Poul Sørensen (1873–1964) married Dagmar M. Samuel (1879–1973). Their daughter Ruth was born on 31 July 1902. After her divorce in 1919, Dagmar reverted to her maiden name until marrying Dr. Hahn in 1923.

2. Mother to Ove, 22 March 1925.

3. Henning to Ove, 20 Sept 1925, with receipt dated 20 Aug 1925.

4. Grete to Ove, 22 May 1925.

5. Mother to Ove, 23 May 1924.

6. Ole Haxen, in *Festskrift for Ove Arup on the Occasion of his Seventieth Birthday, 16 April 1965*, ed. Rosemary Devine, *London Newsletter*, 32. Haxen gained engineering experience on bridges in Turkey and elsewhere, before joining Christiani & Nielsen in Rio and, in 1953, the Arup office in Rhodesia (now Zimbabwe).

7. Li to Ove, 13 Oct 1925.

8. Gerald and Esther Davis to Mrs Ruth Arup, 8 Aug 1926.

9. Leif to Ove, 11 June 1926, from Bronxville.

10. Leif to Ove, 26 Sept 1927.

11. OA, 'Reinforced concrete in relation to present-day design', *Concrete and Constructional Engineering*, 21 (3), 1926.

12. OA, 'Strengthening existing bridges', *Concrete and Constructional Engineering*, 21 (8), 1926; OA, 'Dolphins with loose filling', ibid., 22 (1), 1927.

13. All citations from OA, BBC interview, 1964.

14. Ole Haxen to Ove, 23 April 1927.

15. Vesla Magnusson to Ove, 9 Nov 1929.

16. Henning to Ruth and Ove, 18 Feb 1931.

17. Astrid Arup to Ruth, 26 Aug 1928.

18. Anna Arup [Henning's wife] to Ove, 8 March 1931, plus note from Henning.

19. Henning to Ove, 22 Sept 1931.

20. Henning to Ove, 24 Oct 1931.

21. Four million of the six million dead were in Ukraine. Over two million villagers had already been deported, at gun point, to Siberia or Kazakstan, and the populations of Moscow and Leningrad had been swollen by more than 3.5 million peasants fleeing their villages. See Stéphane Courtois, Nicolas Werth, Jean-Louis Panné, Andrzej Paczkowski, Karel Bartošek and Jean-Louis Margolin, *The Black Book of Communism: Crimes, terror, repression*, Cambridge, Mass., 1999.

22. On Lubetkin (1901–90) see John Allan, *Berthold Lubetkin: Architecture and the tradition of progress*, London 1992, and his *Berthold Lubetkin*, London 2002. Ernö Goldfinger (1902–87) was born in Hungary and studied in Paris, where he was strongly influenced by Le Corbusier. As a contribution to solving housing needs after the Second World War, he designed several tower blocks.

23. Ingeborg to Ove and Ruth, 23 Jan 1932.

24. Henning to Ove, 13 Jan 1933.

25. Wells Coates (1895–1958) was born in Japan, and studied engineering in Canada; Maxwell Fry (1899–1987) was one of the few modernist architects of the day born and educated in Britain, also becoming one of the few with experience of building in the tropics.

26. OA, BBC interview, 1964. Cornelis Van Eesteren (1897–1988) was Chairman of CIAM from 1930 to 1947: he worked in Amsterdam for thirty years and was an influential town planner.

27. Henning had been anxious to find out who these two were, assuming Lodz to be Polish: he was relieved to find that they were Danish, and both listed as graduates from the Copenhagen Polytechnic; Lodz was born in 1894 and Kjaer in 1899. Henning to Ove, 8 Jan 1934.

28. OA, 'The world of the structural engineer', 1968.

29. Ibid.

30. Else Arup to Ove and Ruth, 20 Dec 1933.

31. Letter from Jorgen Varming to Sean Mulcahy, cited by him in Dublin Memorial Service to Ove, May 1988; forwarded to Ralph McGuckin.

32. An obituary in the *Journal of the Institute of Engineers of Ireland*, Sept 1996, states that Varming 'played chamber music with friends rather in the manner of Irish poker players – a last movement, like a round of ace-pots, for the road, standing up. The six Varming prizes for young Irish composers in the 70s and 80s honoured his music making.'

33. OA, 'Art and architecture', Royal Gold Medal address, 21 June 1966; *RIBA Journal*, Aug 1966.

34. Conrad Hal Waddington (1905–75) graduated in geology, but later became Professor of Genetics in the University of Edinburgh; John Desmond Bernal (1901–71), Professor of Physics at Birkbeck College, London, was regarded by colleagues such as Julian Huxley and Joseph Needham as the cleverest man they knew. Profoundly influenced by Marxism, especially by Engels, he formally left the CPGB in 1933; he shared the often utopian socialist views of many distinguished scientists, including Haldane and Blackett.

35. After the war Felix Samuely (1902–59) achieved fame as the engineer of the Skylon in the Festival of Britain (1951).

36. OA, 'A society for the built environment', inaugural speech to the Building Services Engineering Society, Institution of Civil Engineers, 26 Oct 1972; reprinted in *Arup Journal*, 20 (1), spring, 1985.

37. George Martin & Co. to O. N. Arup, Esq., 11 April 1940.

38. OA, 'Working-class flats in reinforced concrete', *National Builder*, for April 1935 (published 7 March).

39. Eugen Kaufmann (1892–1984) emigrated to Great Britain in 1933. An architect and town planner, he practised under the name of E. C. Kent, occasionally worked with Samuely, and specialised in small private and commercial buildings. Serge Chermayeff (1900–1996) emigrated to the USA in 1940 and subsequently became professor at Harvard, later at Yale.

40. Elizabeth Denby, 'The designs reviewed', *Architects' Journal*, 21 March 1935.

41. OA, 'Planning in reinforced concrete: An analysis of structure as well as a comprehensive treatise on the subject', *Architectural Design and Construction*, Part I, 5 (9), July 1935; Part II, 5 (10), Aug 1935.

42. See Fitchen 1961.

43. OA, 'Philosophy and the art of building', 1974.
44. OA, 'The engineer looks back', 1979.
45. Allan 2002, p. 27.
46. OA, 'The engineer looks back', 1979.
47. OA, [Biographical] 'Notes for DOMUS', 1983. Arup Papers, 2/99.
48. Ove to Malcolm Reading, 24 April 1985.
49. Ibid.
50. OA, 'The engineer looks back', 1979.
51. Cited by Allan 1992.
52. William Tatton-Brown revealed that the only detailed drawings ever prepared of High-point II – to Kier's distress – were 'as-built' drawings prepared after everything was finished: interview for the Arup Oral History project, March 1996, AROH/1.
53. See Andrew Saint, The Image of the Architect, London 1983.
54. Francis Skinner to Ove, 2 Feb 1936, enclosing 'Memorandum for discussion: Conway Hall 11 February 1935'.
55. Louis MacNeice, The Strings are False: An unfinished autobiography, London 1965, pp. 169, 166.
56. Henning to Ove, 3 Oct 1937.
57. Henning to Ove, 8 Dec 1937.
58. For Ronald Jenkins (1907–75), see obituaries by OA, Newsletter, 94, Jan-Feb 1976, and by John Henderson and Peter Smithson, Arup Journal, 1976.
59. Solomon Rosenblum to Ove, 7 Jan 1939; Jørgen Jørgensen to Ove, 8 May 1939.
60. Astrid to Ove, 14 April 1939.
61. Anja Liengaard, The Adventures of a Child in Search of the Truth, Llandysul 2002.
62. OA, 'Philosophy and the art of building', 1974, of which one draft version reads: 'I developed a certain scepticism towards adults in the way they express themselves. They would say things like: "Do not do what I do, do what I say".'
63. Paul Wengraf to Ove, Sept 1974.

Chapter 4

1. The Law Reports, The Public General Acts 1937–38, p. 16. For details of London tube shelters, see: Andrew Emmerson and Tony Beard, London's Secret Tubes, London 2004; John Gregg, The Shelter of the Tubes, London 2001; Mike Brown and Carol Harris, The Wartime House: Home life in wartime Britain 1939–1945, London 2001.
2. OA, BBC interview, 1964.
3. Ibid.
4. House of Commons, Official Report, 10 Nov 1932, Parliamentary Debates, 5th series, vol., 270, London 1932, col. 632.
5. J. B. S. Haldane (1892–1964) came from a philosophical background and upheld a form of Kantian idealism up to 1928, as he thought it best encompassed Einsteinian science – as opposed to a form of materialism appropriate to Newtonianism. Like his colleague J. D. Bernal, he was greatly influenced by Engels.
6. Reported to the Association of Architects, Surveyors and Technical Assistants, & National ARP Coordinating Committee, 'Conference on ARP', 2 Feb 1941. Paris metro stations had been gasproofed in 1938 at a cost, including gas locks and plant, of £2 per person sheltered.
7. Cyril Helsby, 'Air raids, structures, and A.R.P. in Barcelona today', Structural Engineer, Jan 1939. J. B. S. Haldane, 'Mathematics of air raid protection', Nature, 142 (3600), 29 Oct 1938. The Cement and Concrete Association had already issued three reports in October and December 1937 on 'The case for small private shelters', 'Pre-cast concrete tube splinter-proof air raid shelters' and 'Paris air raid shelters'.
8. Ove to F. J. Sander (Honorary Secretary of the ARP Co-ordinating Committee), 23 Jan 1941: that same day Ove circulated copies of his letter of resignation to the Daily Herald, Glasgow Herald, Manchester Guardian, Yorkshire Herald, News Chronicle, Daily Telegraph and The Times.
9. Ronald W. Clark, J. B. S.: The life and work of J. B. S. Haldane, London 1968, p. 165.
10. Ove to K. Hajnal-Konyi, 25 Jan 1939.
11. House of Commons, Official Report, 12 June 1940, Parliamentary Debates, Fifth series, vol. 361, London 1940, col. 1295.
12. OA, 'Report on indoor shelters', 30 Dec 1940. See F. Walley, 'From bomb shelters to postwar buildings', Structural Engineer, 79 (4), 20 Feb 2001.
13. Ove to Lubetkin, 9 Jan 1939. Ove retained his correspondence with Lubetkin among his private papers.

14. OA, 'Jubilee foreword', 8 March 1971. B. Lubetkin, *Planned A.R.P.*, London 1939.

15. Herbert Morrison opened the exhibition at the Finsbury Town Hall on 6 February 1939 and the *News Chronicle*, *Daily Telegraph* and *Evening Standard* reported on the following day. Haldane's provocative remarks accompanied his article of 8 February in the *News Chronicle*.

16. OA, 'Introduction' to *Air Raid Precautions: Report to the Finsbury Borough Council, by Messrs. Tecton, Architects on the Structural Protection for the People of the Borough against Aerial Bombardment*, 6 Feb 1939, p. 2. Copies of the reports, and some of the correspondence, are also in the Arup Papers.

17. Martin Gilbert, *Winston S. Churchill*, vol. 5: *The Coming of War, 1922–1939*, London 1972, *Documents 1936–1939*, 1982, pp. 1398–9. I owe the reference to John Allan.

18. OA, 'Value for money', in *Air Raid Precautions*, 1939, pp. 5–6.

19. OA, 'Construction of shelters', ibid., p. 23.

20. The two best-known spiral staircases were in Dover and in Orvieto. The 26-foot diameter triple Grand Shaft Staircase in the Western Heights defences of Dover was constructed between 1806 and 1809 for defence against attack by Napoleon. In Orvieto, the double helix spiral staircases of the Pozzo di S. Patrizio, constructed between 1527 and 1537, are 175 feet deep and 45 feet wide. In addition, the ramped or stepped wells in India were very well known to Haldane. For India, see Morna Livingston, *Steps to Water: The ancient stepwells of India*, New York 2002.

21. Esther to Ruth and Ove, 6 Sept 1939.

22. Esther to Ruth and Ove, 12 Dec 1939.

23. Esther to Ruth, 16 Dec 1939.

24. Ove to Henning and Anna, 9 Nov 1939.

25. For background on the war in Denmark, and the Molotov-Ribbentrop Pact, see I. C. B. Dear, ed., *The Oxford Companion to the Second World War*, Oxford 1995; also Burleigh 2000.

26. Esther to Ruth, 10 April 1940.

27. Esther to Ruth, 14 April 1940.

28. Gerald to Ruth and Ove, 19 April 1940.

29. Esther to Ruth, 26 April, 3 and 8 May 1940.

30. Esther to Ruth, 26 May 1940, aboard S.S. *Washington*.

31. Esther to Ruth, 6, 7, 27 July and 1, 7, 16 Aug 1940.

32. *Home Front Handbook*, Ministry of Information, London 1943.

33. Martin Gilbert, *Winston S. Churchill*, vol. 6: *Finest Hour 1939–41*, London 1983, pp. 778–9.

34. *The Times*, 22 June 1941.

35. OA, *London Shelter Problem*, D. Gestetner Ltd, 15 Oct 1940, p. 4.

36. Ibid., p. 10.

37. Ibid., p. 20.

38. Ibid., pp. 24ff.

39. Jane Drew (1911–96) married Maxwell Fry in 1942; they established Fry, Drew & Partners in 1946. Ove got to know them both as members of MARS in the 1930s.

40. Ove to Dowager Marchioness of Reading, 30 June 1939.

41. OA, 'Dispersion', Appendix II to *Safe Housing in Wartime*, D. Gestetner Ltd, Oct 1940, pp. 34, 40.

42. Ove to T. D. W. Reid, 28 Nov 1974, about an article being prepared on Ellen Wilkinson (1891–1947) for *The Dictionary of Labour Biography*, ed. Joyce M. Bellamy and John Saville, 10 vols, Basingstoke and London 1972–2000. She visited India in 1932 with a parliamentary delegation and went to Spain during the Civil War. Her many pamphlets and books include *The Terror in Germany*, London 1933, and *Why War? (A handbook for those who will take part in the second world war)*, London 1934. See Betty D. Vernon, *Ellen Wilkinson*, London 1982.

43. Ove to Miss Ellen Wilkinson, MP, Ministry of Home Security, 13 Dec 1940.

44. Ellen Wilkinson to Ove, 1 Jan 1941.

45. Ove to Ellen Wilkinson, 6 Jan 1941.

46. OA, BBC interview, 1964.

47. H. L. Childe, Concrete Publications Ltd, to Ove, 15 Jan 1941.

Chapter 5

1. Esther to Ruth, 1 Aug 1940.

2. Esther to Ruth, 20 Sept 1940.

3. OA, Diary, 16 March 1951.

4. Esther to Ruth, note on envelope of forwarded letter from their mother, 13 Oct 1940.

5. Esther to Ruth, 12 Nov 1940.

6. Esther to Ruth, 7 Feb 1941.

7. Esther to Ruth, 9 May 1941.

8. Ove to Dartington Hall School, 15 July 1941.

9. National Employers' Insurance Association Ltd to Ove, 16 April 1941.

10. Ove to Tolec [B. Lubetkin], 29 Nov 1941.

11. Ove to Tolec, 29 Dec 1941.

12. *The Market Square*, Ministry of Food, March 1944; reprinted by the Imperial War Museum, London 2003.

13. Esther to Ruth, 14, 28 Oct 1941 and 6, 18, 28 Jan 1942.

14. Kokoschka's portrait of Ivan Maisky [*b* Jan Lachowiecki] (1884–1975), painted in 1942–3 and presented shortly thereafter to the Tate, London, includes a statue of Lenin in the background and a globe featuring the USSR. An English translation of Maisky's diaries is in preparation (Yale University Press).

15. OA, 'Prefabrication', 8 Jan 1936, Arup Papers, 7/35.

16. OA, 'Elimination of waste by planning and standardisation', British Association for the Advancement of Science, 27 Sept 1941. He virtually repeated this sentiment in 'Science and world planning', another British Association meeting, June 1942; reprinted in *Arup Journal*, 20 (1), spring 1985.

17. Max Born (1882–1970) was a German-born physicist who won the Nobel Prize for Physics, 1954. Julian Huxley (1887–1975) was a biologist and professor of zoology; his grandfather was T. H. Huxley, Darwin's most distinguished contemporary champion. Joseph Needham (1900–1995) was a biochemist and eminent sinologist. All were humanists, with strong socialist sympathies.

18. Five volumes appeared (1942–4), in English and French, edited by Jacques Metadier, and with the title *Solidarity: A platform for all those who can help to plan a better world*.

19. Circular from the Association of Scientific Workers, received by Ove, 29 Jan 1942: Arup Papers, 2/9.

20. OA, 'Opening remarks' for the Association of Scientific Workers Conference 'Science and the war effort', 10 Jan 1942: Arup Papers, 5/1.

21. John Wilmers to Jens Arup, 29 April 1993.

22. Esther to Ruth, 14 Aug 1942.

23. An apparently spontaneous general strike took place soon after D-Day in June 1944, probably planned by the Freedom Council nine months earlier. This group of underground leaders was publishing 254 illegal newspapers by 1944, with an annual circulation of 11 million copies. Ove's student friend Niels Bohr (1885–1962) – who famously rebuffed his friend Werner Heisenberg (1901–76) at a secret meeting organised by the Nazis – was active in this group, and significantly assisted in the escape of five thousand Jews to Sweden. There, a group of five thousand refugees eventually formed the Danish Brigade, to intervene in the event of either an Allied invasion or German capitulation. But when that occurred, the resistance movement in Denmark already numbered around forty thousand and, indeed, took control the day after the formal German surrender on 4 May. In the final days of the war, however, a low-level precision bombing raid by the RAF on the Gestapo Headquarters in Copenhagen enabled thirty-two out of thirty-three condemned resistance workers to escape: one of them accidentally found the list of all Danish collaborators. After the war, thirty-four thousand collaborators were arrested and punished: a matter of great significance.

24. Esther to Ruth, 5 Oct 1943.

25. 'Short report of conference, January 1943', *Scientific Worker*, journal of the Association of Scientific Workers: Arup Papers, 2/9.

26. OA, 'Denmark and the "cultural" invasion attempt', given at the Association of Scientific Workers Conference 'Scientists of the United Nations and the war effort', 6 Dec 1942: Arup Papers, 5/1.

27. *Frit Danmark* to Ove, 14 Dec 1942.

28. As recorded under the heading 'Norwegian ministers' in OA's Diary, 13 Feb 1943.

29. Cyril Sjøstrøm (Mardall), in *Festskrift for Ove Arup*, 1965.

30. Ove's application for a petrol increase, 15 June 1942.

31. OA, 'Address to Association of Supervisory Staffs and Engineering Technicians', 7 April 1943: Arup Papers, 5/1.

32. Jenkins accompanied Ove to an interview with Major Pavry.

33. For Mulberry Harbour, see: W. J. Hodge, 'The Mulberry invasion harbours', *Structural Engineer*, 24 (3), March 1946; Guy

Hartcup, *Code Name Mulberry: The planning, building and operation of the Normandy harbours*, Newton Abbot 1977; Alan Harris, 'Mulberry harbours', *Transactions of the Newcomen Society*, 1989-90, vol. 61. On security, an extraordinary story is told by Mark Seaman in the introduction to his *Garbo: The spy who saved D-Day*, Richmond, Surrey, 2004.

34. Ove's CV for the War Office, 3 Feb 1944.

35. OA [with Jenkins], 'Design of pierhead fenders', 8 March 1944.

36. Lt Clive Entwistle to Ove, 1 Aug 1944.

37. OA, letter to *RIBA Journal*, 14 Nov 1943.

38. OA, 'The need of a simple vocabulary of planning', letter to *Architects' Journal*, 17 May 1943.

39. OA, Diary, 25 Jan and 4 Feb 1944: Ove was working on demountable houses. These and his two-storey designs resulted from his membership of the Government's Prefabrication Committee. By the summer of 1944 over five hundred V2 rockets had created half a million more homeless citizens in London. An emergency Temporary Housing Programme was established in May, and a prototype temporary bungalow was shown at the Tate Gallery: design proposals and tenders were invited from private firms, and Ove submitted three designs to one of the several manufacturing companies, Arcon. The government plan was to construct 150,000 houses, with a life of up to fifteen years: the last house was delivered in 1964, and some are still in use. Asbestos cement panels were fixed to a steel frame; inside the walls and ceiling were covered with plaster board panels. The dimensions of the sheds Ove designed were approximately $24\frac{1}{2}$ by $23\frac{1}{2}$ feet.

40. Draft of pamphlet headed 'Easter manifesto – April 1st'. Ove reprinted copies of his 'Memorandum on box-frame construction for terrace houses and flats', May 1944, and distributed it to influential colleagues, such as Professor P. M. S. Blackett. Ove prepared numerous versions of his paper 'Can "Prefabrication" help to solve our postwar housing problem?' for the Directorate Committee, starting on 16 Dec 1942: 18 Feb, 28 April, 13 Oct, 16 Nov, 1 Dec 1943; 5 Jan 1944.

41. Ove to Professor Blackett, 29 May 1945.

42. Guy Morgan to Ove, 22 Aug 1944.

Chapter 6

1. W. G. Holford, 'A profile of Bethnal Green', Report 39, Association for Planning and Regional Reconstruction, Feb 1946. At that date Jaqueline Tyrwhitt (1905-83), landscape architect and planner, was secretary, under the directorship of Lord Forrester, but in 1949 she became Director of Research there; she was also secretary of CIAM, under Sigfried Giedion, in its later years.

2. Maxwell Fry to Ove, 19 Oct 1944. Like several references in Ove's correspondence, the implications of Fry's remarks are today easily missed. His fundamental questions are: what are the relations between political ideology and aesthetic integrity? can the purity of art be justifiably defended by ignoring the political and social context in which it is being celebrated? Willem Mengelberg (1871-1951) was appointed in 1895, at the age of twenty-four, to be principal conductor of the Concertgebouw Orchestra in Amsterdam, a position he held until his death. A Nazi sympathiser, he was reviled for handing Jewish musicians over to the Nazis. The reference to the Berlin Philharmonic is even more pointed. Wilhelm Furtwängler (1886-1954) had succeeded Nikisch as director of the Berlin Philharmonic in 1922 and at the outbreak of war was also director of the Bayreuth Festival. He stayed in Germany, but under Gestapo pressure at the very end of the war he fled in February 1945: he was cleared of all allegations of collaboration with the Nazis at the end of the following year. However, Herbert von Karajan (1908-89), an ambitious young rival of Furtwängler (whom he succeeded in 1955), never dissociated himself from the National Socialist party, which he joined in 1933. Finally, Benjamin Britten (1913-76), like a number of other artists, had left Britain for the United States immediately before the war: but he returned to London during the darkest days of 1942, and registered as a conscientious objector. Other musicians, such as Richard Strauss (1864-1949) and Karl Böhm (1894-1981) also chose to stay and perform in Nazi Germany throughout the war.

3. Ove to Maxwell Fry, 2 Nov and 30 Dec 1944.

4. Ove to Max, 21 Jan 1945.

5. Ove to Brig. Sir Bruce White, 6 Dec 1944.

6. Ove to Max and Jane, 20 April 1945.

7. Ove to Esther and Gerald, 20 May 1945.

8. Ove to Leif and Edith, 20 May 1945.

9. George Orwell, 'The freedom of the press', preface to *Animal Farm*, in *The Complete Works of George Orwell*, ed. P. Davison, 20 vols, vol. 17: *I Belong to the Left*, London 1998, pp. 253 ff. Both Ruth Winawer and Ove talked about this preface, when it re-emerged: OA, 'A society for the built environment', 1972; Ruth to Ove, 19 Sept 1972.

10. Max to Ove, 5 June 1945.

11. Ove to Max, 15 June 1945.

12. Jane to Ove, 17 July 1945.

13. Jane to Ove, 19 Sept 1945.

14. Henning to Ove, 15, 20 and 28 Aug 1945, with PPS of 23 and 25 Aug.

15. Ove to Max and Jane, 21 Oct 1945.

16. Ibid.

17. Lubetkin to Ove, 19 March 1945.

18. Ove to Lubetkin, 4 June 1945.

19. Lubetkin to Ove, 10 June 1945.

20. Ove to Lubetkin, 14 June 1945.

21. John Henderson to Ove, 27 Aug 1945: OA, 'The need of a simple vocabulary of planning', 1943.

22. Ove to Max, 30 May 1946.

23. Ove to Max, 22 May 1946.

24. See John Blanchard and Peter Ross, '1946 and all that', supplement to *Arup Bulletin*, 132, Dec 1993; 137, May 1994; 140, Dec 1994.

25. OA, 'Science and world planning', 1942.

26. Ibid.

27. OA, 'Shell construction', *Architectural Design*, 17 (11), 1947; reprinted in *Arup Journal*, 20 (1), spring 1985.

28. Geoffrey Wood, interview for the Arup Oral History project, 1995: AROH/1.

29. OA, After-dinner speech to the Society of Danish Civil Engineers in Great Britain and Ireland, Savoy Hotel, London, 13 May 1955.

30. Cited by John Summerson in his introduction to Trevor Dannatt, *Modern Architecture in Britain*, London 1959.

31. Allan 1992, p. 322: personal communications to Allan from Fry and Lubetkin.

32. OA, 'The engineer looks back', 1979.

33. Lubetkin to unidentified correspondent on dissolution of Tecton, 17 July 1947.

34. Sir Robert Matthew (1906–1975) was Architect to the LCC and became the first Professor of Architecture at Edinburgh; Sir Leslie Martin (1908–2000) was Matthew's deputy,

succeeding him at the LCC in 1953. He became the first Professor of Architecture at Cambridge. Together with Peter Moro and others at the LCC he designed the Festival Hall, London, the first of the complex of buildings to be completed for the Festival of Britain in May 1951. Martin became a close and much valued friend of Ove's.

35. OA, Diary, 9 May 1951.

36. Ove to Automobile Association, 3 Dec 1946.

37. OA, 'Report on Kuwait': Arup Papers, 7/45.

38. OA, 'Mechanical draughtsmanship', talk at ICA, 1949.

39. OA, After-dinner speech to the Society of Danish Civil Engineers in Great Britain and Ireland, 1957.

40. Adam Smith, *The Theory of Moral Sentiments* (1759), ed. D. D. Raphael and A. L. Macfie, Oxford 1975, II.ii.2.2. The common influence on both Ove and Smith was Cicero, but Ove probably knew of Smith only via the work of Hegel and Marx.

41. Ove to Raymond McGrath, 3 Nov 1949.

42. Monica Beardsley to Ove, 17 Aug 1950.

43. OA, Diary, 3–24 April 1949.

44. Dora Mylius to Li, 15 Dec 1948. They had met up again at the 35th Anniversary Dinner of the London office of Christiani & Nielsen.

45. Sir Bertram Clough Williams-Ellis (1883–1978) was a self-taught architect and decorated soldier from the First World War. He was an early exponent of environmentally friendly architecture and built the village of Portmeirion in Snowdonia between 1926 and 1939; work on this was resumed in 1954 and continued until 1972. He travelled to the Soviet Union with John Summerson in the early 1930s.

46. OA, 'Works in progress', Feb 1950: Arup Papers, 2/37.

47. OA, 'Draft list', ibid.

48. OA, 'Areas covered by reinforced concrete shells', 7 Sept 1951: Arup Papers, 2/45.

49. OA [with Jenkins], 'The design of a reinforced-concrete factory at Brynmawr, South Wales', *Proceedings of the Institution of Civil Engineers*, Part III, Dec 1953.

50. Ove to Clive Entwistle, 12 April 1951.

51. Ove to Entwistle, 24 Aug 1964.

Chapter 7

1. 'Memo. For meeting of Partners, Oct 1949', following meeting with Jenkins, 21 Oct 1949.

2. Poynton Taylor to Jane Drew, cited by Leonie Cohn, *Jane Drew: Architect*, Bristol Centre for the Advancement of Architecture, 1986, p. 16.

3. Personal communication.

4. Personal communication.

5. Peter Dunican to Ove, 24 Sept 1951.

6. OA, Diary, 15 Nov and 19 Dec 1950. There is dispute over whether Fry invited Le Corbusier to be Partners in the project or whether the invitation was the other way around. Le Corbusier, Perret and Freysinnet were the only 'unqualified' architects permitted to practise in France by the Vichy Government during the Nazi occupation: this affiliation upset other CIAM members.

7. Max to Ove, 25 Feb 1951.

8. Max to Ove, 1 July 1951.

9. Jane to Ove, 4 Oct 1951.

10. Max to Ove, 5 March 1952.

11. Jane to Ove, 24 June 1952.

12. OA, Diary, 15 Nov 1951. But also 11 Oct 1950: 'Trouble in the office . . . Practically everyone gave notice.'

13. OA, Diary, 17 Nov 1951.

14. Ove to Geoffrey Jellicoe, 6 Nov 1952.

15. Kate Champkin to Ove, 15 Aug 1951.

16. Ove to Spence, 28 Aug 1951; OA, Diary, 1 June 1951. Basil Spence (1907–1976), who was knighted in 1960, had designed the Sea and Ships Pavilion for the Festival of Britain, and during the war had worked at the Camouflage Training and Development Centre, at Farnham. Peter Smithson (1923–2003) had married Alison Smithson [née Gill] (1928–93) in 1949: Ove declared that the fact that their 'elegant and sophisticated design [. . .] did not even get a mention was unforgivable': *Newsletter*, 94, Jan–Feb 1976.

17. OA, Diary, 8 Oct 1951. By January 1952 Ove Arup & Partners had submitted preliminary foundation plans to the architect: the Associate in charge was the newly appointed Povl Ahm. Ove was still taking an active part in direct discussions with Spence two years later: ibid., 22 April, 6 May, 9 June 1954. See Povl Ahm, 'The structural design of the new Coventry Cathedral', *Ingeniøren-International Edition*, 6 (2), March 1962; OA, 'Coventry Cathedral: How the plan took shape', *The Times*, supplement, 25 May 1962, reprinted in *Arup Journal*, 20 (1), spring 1985; Povl Ahm, 'Design and structure', in *To Build a Cathedral*, ed. Louise Campbell, Warwick 1987; Basil Spence, *Phoenix at Coventry*, London 1962; Louise Campbell, *Coventry Cathedral: Art and architecture in post-war Britain*, Oxford 1996.

18. Eero Saarinen (1910–61), the son of an architect, achieved fame for his domes and vaults, particularly the TWA building at Kennedy Airport, New York (1962), and the stainless steel Gateway Arch in St Louis (1964).

19. On 21 January 1949 Ove sent Paul Elek a bill for £10 10s. for assessing Leonard Michael's manuscript 'Contemporary structure in architecture'. Elek replied: 'I am afraid we have to disappoint you about the fee. This is practically standardised as between publishers and readers and is usually one and a half or two guineas but never more than the latter.' Twenty-five years later, in ignorance of the owner, Elek wrote to Ove in Highgate to ask if he was thinking of selling his house.

20. Olaf Kier to Ove, 29 Sept 1953; Ove to Kier, 1 Oct 1953.

21. OA, Diary, 30 May 1953.

22. Ove to Edvard Heiberg, 10 Jan 1947. Sigfried Giedion (1888–1968) was a pupil of the art historian Heinrich Wölfflin, and saw himself primarily as a journalist campaigning for modern architecture under the influence of Gropius and Le Corbusier. He wrote and lectured extensively, particularly in the United States. Ove first came across him through his book *Bauen in Frankreich, Bauen in Eisen, Bauen in Esenbeton*, Leipzig 1928, not least because Giedion's discussion of 'ferroconcrete' essentially embraces Ove's notion of 'reinforced concrete': Sigfried Giedion, *Buildings in France, Buildings in Iron, Buildings in Ferroconcrete*, trans. J. Duncan Berry, Santa Monica, Ca., 1995.

23. The Italian architect, critic and publisher Ernesto Nathan Rogers (1909–69) was a cousin of the British architect (Lord) Richard Rogers (*b* 1933), with whom Arup worked on the Centre Pompidou.

24. OA, Diary, 10 July 1951.

25. CIAM Commission 3, 'Report on architectural education', presented at RIBA, 14 July 1951.

26. CIAM Commission 2, 'Reunion of the

arts at the core', presented at RIBA, 11 July 1951.

27. CIAM circular to delegates, July 1951.

28. CIAM 9, Aix-en-Provence, July 1953.

29. OA, 'The engineer looks back', 1979.

30. Max to Ove, 26 Feb 1953.

31. Max to Ove, 18 June 1953.

32. Jane to Ove, 10 Dec 1953.

33. Ruth Winawer, in *Festskrift for Ove Arup*, 1965.

34. Ruth to Ove, 27 Oct 1953.

35. Ruth to Ove, 6 Nov 1953.

36. Ruth to Ove, 9 Nov 1953.

37. Ruth to Ove, 12 and 17 Nov 1953.

38. Ruth to Ove, 13 Sept 1954.

39. Ruth to Ove, 4 Oct 1954.

40. John Cordwell to Ove, 24 April 1950.

41. OA, 'Structural honesty', talk to the Architectural Association of Ireland, 9 Feb, and in London, 25 March 1954: *Irish Architect and Contractor*, 4 (9), 1954.

42. Ibid. Vitruvius's terms [1.1] were *firmitas, utilitas* and *venustas*; some have translated *venustas* as 'harmony', primarily because they take Vitruvius's second list [1.2] to be only an elaboration of it. That list was *ordinatio, dispositio, eurythmia, symmetria, decor* and *distributio*. In fact, Latin scholars deny that the terms have clear definitions, possibly because of Vitruvius's idiosyncratic use of the language. Ove's own reference was to the opening lines of Sir Henry Wotton's *The Elements of Architecture* (1624), which set out to establish rules for judging architecture. Wotton (1568–1639) had studied most of the existing ancient and modern treatises, and his own work remained popular throughout the seventeenth and eighteenth centuries. Until Ruth began to edit his English, Ove followed the German practice of capitalising 'Architect' and 'Architecture', but his references to 'engineer' were always lower case.

43. Ibid.

44. Ibid.

45. Leon Battista Alberti, *On the Art of Building in Ten Books* (c. 1450), trans. Joseph Rykwert, Neil Leach and Robert Tavernor, Cambridge, Mass., and London 1988; Claude Perrault, *Les Dix livres d'architecture de Vitruve*, Paris 2/1684; William Chambers, *A Treatise on Civil Architecture*, London 1759; Geoffrey Scott, *The Architecture of Humanism*, London 1914; Steen Eiler Rasmussen,

Experiencing Architecture, Cambridge, Mass., 1959. Aside from Ove's dislike of scholarly pedantry, which he saw as a substitute for active thought, he avoided such references because of the largely anti-historical attitude among modern architects. He repeatedly warned them, however, that the prevailing ideologies were *a priori* and foolishly ignored empirical data from the past: indeed, ideologies were typically formulated precisely to be exempt from the messy and endlessly changing particularities of daily life.

46. OA, 'Structural honesty', 1954.

47. Ibid.

48. Ruth to Ove, 7 Feb 1955.

49. Ruth to Ove, 2 Feb 1955.

50. Ruth to Ove, 5 and 10 Feb 1955.

51. Ruth to Ove, 18 Feb 1955.

52. Ruth to Ove, 24 Feb 1955.

53. Ove to Ruth, 3 March 1955.

54. In April 1941 Kauffman signed a treaty giving control of the Danish colony of Greenland to the USA.

55. OA, 'The integration of structure and architecture', lecture given at Harvard University and at the Illinois Institute of Technology, Chicago, March 1955.

56. OA, Diary, 13 April 1955. Spence invited Ove to be consultant on the Nottingham project.

57. OA, 'Modern architecture: The structural fallacy', *The Listener*, 7 July 1955.

58. OA, Address to the Concrete Society 4th Annual Convention, Bristol, 1971.

59. Ove had extensive discussion with Spence about this, and several other central matters: see Chapter 10.

60. OA, 'Post graduate education of civil engineers', Belfast Conference, Sept 1958.

61. The Symphony no. 40 in G minor by Mozart; and his Requiem, with Lisa della Casa, Ira Malaniuk, Anton Dermota and Cesare Siepe.

62. Ove to John Cordwell, 8 Aug 1958.

63. Speech opening an exhibition of pottery by Lucie Rie and Hans Coper, Berkeley Galleries, London, 15 Oct 1956. Ove laid particular stress on these remarks, and copied them in a letter to J. M. Richards, 19 Oct 1956.

64. Ruth to Ove, 24 Oct 1956.

65. Ove to Wanda Rosa, 8 July 1952.

66. Ruth to Ove, 25 and 26 Oct 1956.

67. Throughout his life Ove's English

spelling and grammar were eccentric, especially when he was writing in a hurry. He frequently asked Ruth to correct his mistakes, which she had always silently done: he often lapsed into Danish – 'jo', 'så'; unchecked, he would double his consonants – 'litterally', 'alltogether', 'untill'.

68. Nikolaus Pevsner to Ove, 17 Jan, 12 Feb 1957: Ove added and then deleted a final candidate – his own design of 1952, for the diving board at Bryanston School.

Chapter 8

In this chapter I have drawn extensively on papers held privately and on personal interviews with many people who took part in the project. I have consulted papers in the Arup Group Head Office; the Mitchell Library, Sydney; the State Records of New South Wales; the National Library of Australia; the Archive of the Sydney Opera House Trust; the Australian Broadcasting Corporation; and the Powerhouse Museum, Sydney.

1. *The Times*, 30 Jan 1957. The details about Utzon were not strictly accurate: he had received a 'minor' medal, not the Gold Medal, for a competition for a concert hall, music school and practice rooms. Almost no detail had been provided in the drawings. A standard reference for the evolution of opera houses and concert halls since the seventeenth century is Michael Forsyth, *Buildings for Music*, Cambridge 1985; see also Derek Sugden, 'The Opera House: Complexities and contradictions', The Prince of Hesse Memorial Lecture, Aldeburgh, 1992.

2. Although an unauthorised biography, Philip Drew's *The Masterpiece: Jørn Utzon, a secret life*, Melbourne 1999, documents many details of Utzon's life and work. The following works discuss the Opera House: Michael Baume, *The Sydney Opera House Affair*, Sydney 1967; Harry Sowden, ed., *Sydney Opera House Glass Walls*, Sydney 1972; Vincent Smith, *The Sydney Opera House*, Sydney 1974; Philip Drew, *Sydney Opera House: Jørn Utzon*, London 1995; David Messent, *Opera House Act One*, Sydney 1997; Françoise Fromonot, *Jørn Utzon: Architect of the Sydney Opera House*, London 1998; Philip

Drew, *Utzon and the Sydney Opera House*, Sydney 2000; Yuzo Mikami, *Utzon's Sphere: Sydney Opera House – how it was designed and built*, Tokyo 2001; Peter Murray, *The Saga of Sydney Opera House*, London 2003.

3. Alvar Aalto (1898–1976) was a much admired Finnish architect, whom Ove got to know at the early CIAM meetings in the 1930s: like Ove, he was an explicitly sceptical humanist, hostile towards Lutheranism, and to the burgeoning ideologies of the day. He received the RIBA Gold Medal in 1957. See Nicholas Ray, *Alvar Aalto*, London 2005.

4. Ove to John Mark Johansen, 26 Feb 1957.

5. It transpired that Ashworth himself had drafted the conditions of the competition, in accordance with the rules of the UIA, the Royal Australian Institute of Architects (RAIA) and the Government of New South Wales; the jury had been appointed by the State Government of NSW, who were the Promoters, on the advice of RAIA. Over seven hundred expressions of interest were logged, but 223 competition entries were eventually received (this number oscillated in records, between 233, 223 and 222). Goossens had advised on the relative size of the halls required. The overall cost of the competition had been £13,825, of which just under half, £6000, was dedicated to travel and honoraria for the jury members.

6. See Hilde de Haan and Ids Haagsma, *Architects in Competition: International architectural competitions of the last 200 years*, London 1988. Albeit with the benefit of accumulated experiences, in 1990 the Trustees of the National Museum of Scotland studied new museums throughout the world for a year before formulating their brief for a new Museum of Scotland: initial requirements were sharply refined as the design process got under way, and as the large number of contributing experts clarified everyone's ideas. The jury of eight analysed each of the 371 competition entries with an intensity that enhanced mutual understanding of various viewpoints and discouraged professional claptrap. All of this eased and encouraged communication within and outside the teams associated with the project during the long process of building. It is commonplace for some Assessors of prestigious competitions to doubt whether any of the entries matches up to their usually inchoate

dreams: this happened in Coventry and Edinburgh, for example.

7. Leslie Martin to H. Ingram Ashworth, 12 Feb 1957.

8. Cited in Messent 1997, p. 141. Felix Candela (1910–97) was born in Spain and emigrated to Mexico in 1939: Ove greatly admired his innovative shell constructions. Messent cites in part or full many of the central documents of the saga.

9. Anon., 'House at Highgate. Architect: Erhard Lorenz', *Architectural Design*, 28 (9), Sept 1958: 'the plans were much altered under the impact of the client's requirements.'

10. Ashworth to Utzon, 26 April 1957.

11. Ove to Ashworth, 24 June and 17 July 1958.

12. Geoffrey Scott, whose *Architecture of Humanism* (1914) Ove often cited, had been the editor of Boswell and a former member of Bernard Berenson's set in Florence.

13. OA [with Ronald Jenkins], 'The evolution and design of the Concourse at the Sydney Opera House', *Proceedings of the Institution of Civil Engineers*, April 1968; reprinted in *Arup Journal*, 8 (3), Oct 1973.

14. Ashworth to Martin, 8 July 1957; Martin to Ashworth, 17 July 1957.

15. Ashworth to Haviland, 9 July 1957.

16. Ashworth to Utzon, 24 Oct 1957.

17. Ashworth, 'Report on the architect's final proposals for the stage machinery', 29 Sept 1960.

18. Ruth to Ove, 7 Jan 1958.

19. Ruth to Ove, 1 April 1958.

20. Utzon to Ashworth, 5 Aug 1959.

21. OA [with G. J. Zunz], 'Sydney Opera House', in *Structural Engineer*, 47 (3), March 1969; reprinted in *Arup Journal*, 8 (3), Oct 1973. I have followed this account closely in what follows.

22. Ronald Jenkins to Ove, 14 Sept 1961.

23. Ruth to Jack Zunz, 24 Feb 1959. Ove was working with Spence on both Coventry Cathedral and the Hampstead Civic Centre when Spence was appointed in January 1959 to design the new University of Sussex. Spence immediately asked Ove to be the structural engineer for the project.

24. Jenkins [over OA's signature] to SOHEC, 25 Nov 1959.

25. Ove to Ashworth, 14 Dec 1960.

26. Ove to Richard Sheppard, 20 Aug 1959; Sheppard to Ove, 9 Sept 1959.

27. Jack Zunz to Ove, 31 March 1960.

28. *Moisasurs Zauberfluch* (1827), with text by Ferdinand Raimund (1790–1836) and music by Philipp Jakob Riotte (1776–1856), was long popular in Vienna; only the songs survive. The story is typical of Viennese entertainment of the time: the demon Moisasur avenges the destruction of his temple by turning everyone into stone.

29. Utzon to Ashworth, 2 Nov 1960.

30. Ashworth, abridged minutes of meetings in Hellebaek, 5–8 Sept 1960.

31. Vitruvius, X.16.4. Archaeologists in the Middle and Far East, as well as in Europe, have established that some of the pottery and clay models found in their ancient sites functioned as guidelines to the builders and patrons of the day; even pieces previously classified as votive offerings or toys may have served a similar function.

32. Alberti, trans. 1988, II.i.

33. Ronald Jenkins, 1953: Arup Papers, 2/44.

34. See Henry A. Millon and Vittorio Magnago Lampugnani, eds, *The Renaissance from Brunelleschi to Michelangelo: The representation of architecture*, London 1994; Henry A. Millon, *The Triumph of the Baroque: Architecture in Europe 1600–1750*, London 1999.

35. H. Ingram Ashworth, 'The Sydney Opera House', 1 June 1961.

36. Ralph Goddard to Utzon, 11 Oct 1960: Utzon Papers, Mitchell Library, Sydney, MS 2362/18.

37. Ralph Goddard to Utzon, 18 Nov 1960: ibid.

38. Alan Harris to Ove, 20 Dec 1960; further endorsed, 13 Nov 1980.

39. Walter Unruh to Ashworth, 12 June 1961.

40. OA, 'Presentation of the Royal Gold Medal for 1960 to Professor Pier Luigi Nervi', *RIBA Journal*, May 1960. Buildings by Nervi (1891–1979) include the UNESCO headquarters in Paris (1950) and the Olympic Stadium in Rome (1960).

41. Ibid.

42. Ibid.

43. OA, 'Discussion on ethics and conduct in the building industry', Joint Building Group meeting with Sir Maurice Laing, 21 Feb 1968.

Ove omitted this paragraph from the version he delivered, and Ruth thought he was mistaken to have done so: presumably, he was once again trying to avoid frightening the horses.

44. OA, 'Contribution to discussion of Nervi's paper at UIA Conference', 1961.

45. Ibid.

46. Ralph Goddard to Ashworth, 20 Sept 1961.

47. Ralph Goddard to Ashworth, 3 Oct 1961.

48. Rider Hunt [Goddard] to Utzon, 27 Nov 1961.

49. Ashworth to Ove, 5 Jan 1962.

50. Ashworth to Utzon, 22 Dec 1961.

51. Utzon to Ashworth, 15 Jan 1962.

52. Ove to Ashworth, drafted 30 Sept, re-dated 21 Nov 1961.

53. Ashworth to Ove, 4 Dec 1961.

54. Jack Zunz to Ove, 9 Feb 1962.

55. Knowledge of the records kept during the construction (begun 1421), later adaptations and nineteenth-century mutilation of the Cà d'Oro in Venice, for example, enhances everyone's appreciation of the building: Richard J. Goy, *The House of Gold*, Cambridge 1992.

56. On 17 January 1958 Ove discussed the making of models for the shell with Edouardo Torroja (1899–1961), the Spanish architect and engineer who had constructed his first concrete shell buildings in the early 1930s.

57. Utzon to Secretary of SOHEC, 3 April 1962.

58. Haviland to Utzon, 7 June 1962.

59. R. J. Thomson to the Minister for Public Works (Ryan) 'Confidential report on Opera House estimates', 14 Sept 1962.

60. Ryan to Haviland, 11 Oct 1962.

Chapter 9

1. Messrs Ove Arup & Partners, statement, 26 March 1963.

2. Ibid.

3. Minutes of Site Meeting 54, 27 Nov 1963.

4. Lewis to Ove and Zunz, 'O. A. & P.'s position for Stage III', memorandum, 13 May 1963.

5. Utzon to Zunz, 17 Sept 1963, in reply to his letter of 26 Aug 1963.

6. OA, interview in *Berlingske Tidende*, 6 Dec 1963.

7. Notes made by the Department of Public Works of the meeting between Utzon and the Minister [Ryan], 16 June 1964: Utzon Papers, Mitchell Library, Sydney, MS 2362/23.

8. Patricia Rolfe, 'The Unfinished Symphony', *The Bulletin*, 18 July 1964.

9. Lewis to Zunz, 24 March 1964.

10. Ove to Lewis, 18 Aug 1964.

11. Nikita Khrushchev (1894–1971) was Premier of the Soviet Union from 1958 until dismissed in October 1964, just two years after the Cuban Missile crisis had created dangerous tension between the United States and the Soviet Union.

12. Secretary to the Minister of Public Works to Utzon, 15 Jan 1965.

13. Sigfried Giedion, 'Jørn Utzon and the third operation' and 'The relation to the past', trans. Jaqueline Tyrwhitt, typescript 1964.

14. Minute of 1 July 1965; Utzon Papers, Mitchell Library, Sydney, MS 2362/12.

15. *The Australian*, 18 Sept 1965.

16. Utzon to Chairman of the SOH Trust, 1 Nov 1965.

17. Utzon to Minister [Davis Hughes], 12 July 1965.

18. Hughes to Utzon, 25 Aug 1965.

19. Utzon to Ove, 10 Feb 1966.

20. Ruth to Ove, 31 March 1966.

21. Ruth to Ove, 29 April 1966.

22. Ruth to Ove, 5 May 1966.

23. Minutes of Technical Advisory Panel to the SOHEC, 5 May 1966: Papers of H. Ingram Ashworth, National Library of Australia, MS 4500, Box 6.

Chapter 10

1. Ronald A. Gilling, 'Utzon, the Institute and the Sydney Opera House', 1996; Ove made exactly the same point in a letter to Peter Hall, 18 May 1978.

2. Robin Boyd, *Life*, 24 July 1967.

3. Utzon to Elias Duek-Coehn, 2 Sept 1968.

4. OA, 'The Sydney Opera House Affair: Comment by Ove Arup', confidential note to Partners, Sept–Oct 1967, based on several earlier drafts.

5. Ibid.

6. Utzon to Davis Hughes, 7 March 1966.

7. *New Statesman*, 6 Oct 1956, and *TLS*, 15 Aug 1958: Ove's heavy pencil marks conjure up his passionate reactions.

8. F. R. Leavis, *Education and the University*, London 1943, p. 34.

9. See Paul O. Kristeller, 'The modern system of the arts', *Journal of the History of Ideas*, 22–3, 1951–2; Peter Jones, 'Introduction' to Part V, *The Enlightenment World*, ed. Martin Fitzpatrick, Peter Jones *et al.*, London 2004.

10. OA, 'The engineer and the architect', *Proceedings of the Institution of Civil Engineers*, 13, Aug 1959.

11 The notion of *disegno* is implicit throughout Alberti; for an introduction to Vasari's usage, see Patricia Lee Rubin, *Giorgio Vasari: Art and history*, New Haven and London, 1995.

12. See also Chapter 7, n. 17.

13. OA, BBC interview, 1964.

14. Ibid.

15. Ove to Edward [Bobby] Carter, 13 Jan 1968.

16. Ove to Richard Crossman MP, Minister of Housing and Local Government, 22 March 1965. He replied: 'As for the problems of the philosopher-king, I tried to deal with them in a book which has just come out, *Planning for Freedom*. As you say, it is the key question we have to face': Crossman to Ove, 31 March 1965.

17. The architect and inventor Buckminster Fuller (1895–1983) was best known for his geodesic domes.

18. Felix Candela, in *Festskrift for Ove Arup*, 1965.

19. Ruth Winawer, in ibid.

20. OA, 'The problem of producing quality in building', talk to the Westminster Chamber of Commerce, 1965; reprinted in *Arup Journal*, 20 (1), spring 1985.

21. Rasmussen 1959.

22. At exactly the same time he gave a series of taped interviews, which were later summarised by Peter Rawstorne in the *RIBA Journal*, 72 (4), 1965. On tape Ove had said: 'Prima donna architecture can be both good and bad. [. . .] If the prima donna is not a very serious, deep-thinking, deep-seeking, humble artist, but is full of himself, wants to make an impression, wants to do something which hasn't been done before, wants to make a splash just for the sake of it, then, in that sense, prima donna architecture is bad.'

23. OA, 'Speech to Dixie Grammar School, Market Bosworth, 20 Oct 1966.

24. OA, 'Aesthetics and the engineer', address to the Institution of Municipal Engineers, *Surveyor and Municipal Engineer*, 3 Dec 1966. Most of the lecture replicates Ove's unpublished submission of August 1961 to the Institution of Civil Engineers entitled 'Engineers lack training in the aesthetic aspects of design'.

25. Ibid.

26. Ibid.

27. OA, 'The problem of producing quality in building', 1965.

28. OA, 'Aesthetics and the engineer', 1966.

29. OA, 'Jubilee Foreword', 1971; OA, 'A society for the built environment', 1972; OA, Gold Medal Address to the Institution of Structural Engineers, Oct 1973, reprinted in *Arup Journal*, 20 (1), spring 1985.

30. OA, 'Aesthetics and the engineer', 1966. In 1958 the eminent American designer and architect Charles Eames (1907–78), a close friend of Eero Saarinen, in a report for the Government of India on the training of designers, had recommended the establishment of a National Institute of Design. Eames had written: 'Of all the objects we have seen and admired during our visit to India, the Lota, that simple vessel of everyday use, stands out as perhaps the greatest, the most beautiful.' He then listed twenty considerations that might contribute to its design. Ove admired Eames's practical experiments with new materials, such as plywood and fibreglass, in the design and construction of houses and furniture.

31. Ibid.

32. Jens Juel (1745–1802) was a successful society portrait painter. Having studied in Hamburg, he then worked in Dresden, Rome, Paris and Geneva. From 1795 until his death he was Director of the Royal Danish Academy of Arts.

33. OA, 'This day to-night', ABC interview, broadcast 28 Feb 1968.

34. OA, 'A fairy tale', 1968.

35. Oscar Wilde, 'The critic as artist', in *Intentions*, London 1891. Wilde, like Ove, had been bitterly disappointed not to secure a philosophy appointment after graduation: in his case, at Oxford. This essay, and the group with

which it was published, explored aesthetic ideas of Plato, Hegel and Wilde's friend Walter Pater – but in such a disguised and flippant way that most readers entirely missed their seriousness.

36. OA, 'The world of the structural engineer', 1968.

37. Baron Baker (1901–85) reformed the teaching of engineering at the University of Cambridge, where he was Professor of Mechanical Sciences from 1943 to 1968. Among his numerous awards was the Royal Medal of the Royal Society in 1970.

38. Ove to E. R. Leach, 18 Nov 1968. Leach replied at length, 21 Nov 1968, and mentioned that *The Times* article had been extracted from an earlier contribution to the *Saturday Evening Post*.

Chapter 11

1. Partners' Memorandum, Peter Dunican to Ove, 22 Jan 1963.

2. Ruth to Ove, 30 Oct 1964.

3. Ruth to Ove, 30 Aug 1966.

4. Ruth to Ove, 10 April 1967.

5. Ruth to Ove, 1 March 1968.

6. Ruth to Ove, 7 March 1968.

7. Ruth to Ove, 21 March 1968.

8. OA, 'Discussion on ethics and conduct in the building industry', 1968.

9. OA, 'Aims and means: Part I', *Newsletter*, 37, Nov 1969.

10. Ibid.

11. OA, 'Architects, engineers and builders', Alfred Bossom Lecture, Royal Society of Arts, 11 March 1970; reprinted in *Arup Journal*, 20 (1), spring 1985.

12. Particularly by R. G. Collingwood, then a Professor of Philosophy at Oxford, for example in his *Principles of Art*, Oxford 1938.

13. OA, 'Architects, engineers and builders', 1970.

14. OA, 'The key speech', Arup Organisation Meeting, 9 July 1970; reprinted in *Arup Journal*, 20 (1), spring 1985.

15. To Ove, 24 May 1971, requesting also anonymity.

16. OA, 'Future problems facing the designer', Paper 5 at the Royal Society Discussion Meeting 'Building Technology in the 1980s', 4 Nov 1971.

17. OA, 'Aims and means continued', June 1972.

18. Ove to Ruth, 23 Sept 1972.

19. Clough Williams-Ellis to Ove, 2 June 1973.

20. Ruth to Ove, 23 Aug 1973. She officially retired at the end of August but took a week's leave entitlement.

Chapter 12

1. OA, 'Trois Projects de ponts', *L'Architecture d'aujourd'hui*, 10, 1963.

2. *Arup Newsletter*, 9, 1963; 22, 1964.

3. Ove to Yuzo Mikami, 11 Oct 1969.

4. Yuzo Mikami to Ove, 30 June 1968.

5. Derek Sugden, 'Snape Concert Hall', *Arup Journal*, June 1967.

6. Derek Sugden, 'The Maltings Concert Hall, Buxton Opera House and York Minster: A reconstruction and two restorations', *Conference: Construction: A challenge for steel*, Luxembourg, Sept 1980; 'Scottish Opera', *TABS* (*Stage Lighting International*), 34 (2), summer 1976.

7. OA, 'Notes for the follow-up meeting 2 Oct 1970, after Cambridge Conference on the Education of Architects 2–4 April, 1970', Sept 1970.

8. OA, 'A society for the built environment', 1972.

9. OA, 'Obituary on Arne Jacobsen for RIBA Journal', 5 April 1971.

10. Ove to Walter Gropius, 5 Aug 1966.

11. Ove to Buckminster Fuller, 26 Feb 1980.

12. Ove to Buckminster Fuller, 16 May 1983.

13. P. B. Ahm *et al.*, 'Design and construction of the Centre National d'Art et de Culture Georges Pompidou', *Proceedings of the Institution of Civil Engineers*, Part 1, 66, Nov 1979. Nathan Silver, *The Making of Beaubourg*, Cambridge, Mass., 1994.

14. Ruth to Ove, 2 Sept 1973.

15. Ruth to Ove, 25 Jan 1974.

16. Gold Medal Address, 1973.

17. Ove to Peter Dunican, 3 Dec 1974.

18. Ove to Christian, Lady Esher, 30 Aug 1977.

19. Ove to Department of Building, University of Aston, 13 April 1976.

20. Ove to Chairman of UNESCO Council

on Tall Buildings and Urban Habitat, 21 June 1977: 'there is far too much philosophy and methodology floating about now.' Ove to David Watkin, 31 Jan 1978: 'most of what is paraded as "Architectural Theory" is a load of nonsense.' Ove to Philip Johnson, 8 May 1979: 'I dislike preconceived ideas or theories about architecture.' Ove to W. S. Gauldie, 9 April 1980: 'we should beware paper-design.'

21. Ove to Mary Midgley, 20 Aug 1987; see Chapter 1, n. 3.

22. OA, Comments on Professor Max Black's essay 'Scientific neutrality' in the current issue of *Encounter*, Aug 1978.

23. Peter Rice, 'A celebration of the life and work of Ove Arup', *RSA Journal*, June 1989.

24. P. B. Ahm *et al.*, 1979; see n. 13 above.

25. OA, 'Future problems facing the designer', 1971.

26. Peter Dunican, 'Structural engineering: Some social and political implications', presidential address to the Institution of Structural Engineers, 6 Oct 1977; R. H. Tawney, *The Acquisitive Society*, London 1923.

27. Philip Dowson, 'Integration-disintegration', Junior Liaison Organisation Conference, Sept 1973.

28. Derek Sugden, 'The Office man's view of the new graduate Architect', *Architects' Journal*, 140 (6), Aug 1964; Derek Sugden, 'Planning for the unknown', British Constructional Steelwork Association Conference on Steel in Architecture, Nov 1969.

Chapter 13

1. David Littlemore, SOH Oral History Collection, State Archive of New South Wales.

2. Ove to Conor Cruise O'Brien, Nov 1982.

3. Among the few who proclaimed ideas in the Arup mould were Michael Fores and K. P. Foggo. Michael Fores, 'All one culture – or three'; 'Science v. engineering'; 'What is technology', in *New Scientist*, vols 42, 45, 47, 1967, 1970, 1972; and K. P. Foggo, 'Teamwork in design', *Irish Engineers Journal*, May 1969.

4. OA, 'A society for the built environment', 1972.

5. OA, Lecture to the Pre-stressed Concrete Development Group and the South African Concrete Association, Oct 1954; and OA, Lecture to the South Africa Pre-stressed Concrete Development Group, 28 Oct 1965.

6. OA, 'Architecture is sick. Should it be revived?', talk at the Athenaeum, London, 2 Jan 1967.

7. Ove to Partners, 26 Sept 1983.

8. Ove to Partners, 9 July 1984.

9. In a brief seventieth-birthday message to Peter Dunican (1983) Ove wrote: 'What if Nanny – as Nannies tend to do – insisted that ordinary politeness and good manners ordained that you must be assumed to be perfection itself in human disguise, with no shortcomings or blemishes of any kind – then I would recoil in horror. You would be reduced to a bloodless phantom, the "real" Peter would simply evaporate. Of course I do not pretend to know the full "Truth" about you, the "real" Peter. Nobody does that, not even you.'

10. OA, *Doodles and Doggerel*, ed. Anja Liengaard, Aylesbury, n.d.

11. Ove to Lubetkin, 28 March 1978.

12. Lubetkin to Ove, 4 April 1978.

13. Ben Derbyshire, *Architects' Journal*, 23 Feb 1995.

14. OA, 'Architects, engineers and builders, 1970; OA, Speech to Alma Mater, Copenhagen, 1964: Arup Papers, 5/4.

15. Georges-Louis Leclerc, Comte de Buffon (1707–88), 'Discours sur le style', on the day of his admission to L'Académie Française, 25 Aug 1753.

Bibliography

Ove Nyquist Arup's writings: selective list

All the items below are unpublished type-scripts or draft texts unless otherwise indicated.

1926 'Reinforced concrete in relation to present-day design', *Concrete and Constructional Engineering*, 21 (3)

1926 'Strengthening existing bridges', ibid., 21 (8)

1927 'Dolphins with loose filling', ibid., 22 (1)

1929 'Subsidence under the tidal pressures', letter to the *Structural Engineer*, 7 (12), Dec

1934 'A café at Canvey Island', *Architect & Building News*, 137, Feb

1934 'Design of piled jetties and piers', *Concrete and Constructional Engineering*, 29

1935 'Design of piled jetties and piers', ibid., 30

1935 'Working-class flats in reinforced concrete', *National Builder*, for April (published 7 March)

1935 'Assessors report', ibid.

1935 'Planning in reinforced concrete: An analysis of structure as well as a comprehensive treatise on the subject', *Architectural Design and Construction*, Part I, 5 (9), July

1935 Part II, ibid., 5 (10), Aug

1936 'Prefabrication', 8 Jan: Arup Papers, 7/35

1939 'A.R.P. – The Finsbury Scheme', *Architect & Building News*, 157, Feb

1939 *Air Raid Precautions: Report to the Finsbury Borough Council by Messrs. Tecton, Architects on the Structural Protection for the People of the Borough against Aerial Bombardment*, 6 Feb

1939 *Design, Cost, Construction, and Relative Safety of Trench, Surface,*

Bomb-proof and other Air-raid Shelters, Concrete Publications Ltd

1940 *London Shelter Problem*, D. Gestetner Ltd, 15 Oct

1940 *Safe Housing in War Time*, D. Gestetner Ltd, Oct

1940 'Report on indoor shelters', 30 Dec

1941 'Elimination of waste by planning and standardisation', British Association for the Advancement of Science, 27 Sept

1942 'Opening remarks' for the Association of Scientific Workers Conference 'Science and the war effort', 10 Jan: Arup Papers, 5/1

1942 'Science and world planning', June; reprinted in *Arup Journal*, 20 (1), spring 1985

1942 'Denmark and the "cultural" invasion attempt', given at the Association of Scientific Workers Conference 'Scientists of the United Nations and the war effort', 6 Dec: Arup Papers, 5/1

1942 'Can "Prefabrication" help to solve our postwar housing problem?', begun 16 Dec

1943 'Short report of conference, January 1943', *Scientific Worker*, journal of the Association of Scientific Workers: Arup Papers, 2/9

1943 Paper read at conference on 'Planning of Science – in War and in Peace', Jan

1943 Address to the Association of Supervisory Staffs and Engineering Technicians, April: Arup Papers, 5/1

1943 'The need of a simple vocabulary of planning', letter to *Architects' Journal*, 17 May

1943 Letter to *RIBA Journal*, 14 Nov

1944 [with R. S. Jenkins], 'Design of pierhead fenders', 8 March

1944 'Easter manifesto – April 1st'

1944 'Memorandum on box-frame con-

struction for terrace houses and flats', May

1945 'Reinforced concrete', *Architects' Year Book*, no. 1

1946 'Reflections on architectural competitions'

1946 'Competitions'

1946 'Final report on Kuwait', Dec

1947 'Crystal Palace Competition', *Architects' Yearbook*, no. 2

1947 'Shell construction', *Architectural Design*, 17 (11), Nov; reprinted in *Arup Journal*, 20 (1), spring 1985

1948 'Discussion of new trends in building technique: Prefabrication, standardisation, slab construction'

1948 'Building and architecture: General trends'

?1949 'Mechanical draughtsmanship', talk at ICA

1949 'The architectural possibilities and limitations of reinforced concrete construction'

1949 'Reinforced concrete construction'

1950 'Works in progress' and 'Draft list', Feb: Arup Papers, 2/37

1950 'The inter-relation of structure and architecture'

1951 'Areas covered by reinforced concrete shells', 7 Sept: Arup Papers, 2/45

1952 'Long-span roofs'

1953 'New building techniques in the tropics'

1953 'Memorandum on the structure and economics of multi-storey flats'

1953 'Report on multi-storey housing for the London County Council'

1953 'Various types of roof construction'

1953 'Interim report on Picton Street'

1953 [with R. S. Jenkins], 'The design of a reinforced-concrete factory at Brynmawr, South Wales', *Proceedings of the Institution of Civil Engineers*, Part III, Dec

1953 'The Brynmawr rubber factory'

1954 'Structural honesty', talk to the Architectural Association of Ireland, 9 Feb, and in London, 25 March: *Irish Architect and Contractor*, 4 (9)

1954 Lecture to the Pre-stressed Concrete Development Group and the South African Concrete Association, Oct

1955 'The integration of structure and architecture', lecture given at Harvard University and at the Illinois Institute of Technology, Chicago, March

1955 'Modern architecture: The structural fallacy', *The Listener*, 7 July

1955 'The structure of high buildings', *Transactions of the Institution of Civil Engineers of Ireland*, 82 (1)

1956 [with Sir Howard Robertson, R. S. Jenkins and H. F. Rosevear], 'Design and construction of the printing works at Debden', *Structural Engineer*, April

1956 Speech opening an exhibition of pottery by Lucie Rie and Hans Coper, Berkeley Galleries, London, 15 Oct

1957 'A discussion about future developments in building techniques', *Architectural Design*, 27 (11)

1957 'Some recent notable shell structure designs', Second Symposium on Concrete Shell Roof Construction', Oslo, July

1958 'Post graduate education of civil engineers', Belfast Conference, Sept

1959 'Form and structure in R[einforced] C[oncrete]' [with special reference to Coventry Cathedral]

1959 'The architect and the engineer', *Proceedings of the Institution of Civil Engineers*, 13, Aug

1960 'Presentation of the Royal Gold Medal for 1960 to Professor Pier Luigi Nervi', *RIBA Journal*, May

1961 'Contribution to discussion of Nervi's paper at UIA Conference'

1961 'Engineers lack training in the aesthetic aspects of design', submitted to the Institution of Civil Engineers, Aug

1961 'Reinforced concrete: An account of progress in reinforced concrete design' [for *Financial Times* survey, 13 Nov]

1962 'Coventry Cathedral: How the plan took shape', *The Times*, supplement, 25 May; reprinted in *Arup Journal*, 20 (1), spring 1985

1963 'Trois Projets de ponts', *L'Architecture d'aujourd'hui*, 10

1963 Interview in *Berlingske Tidende*, 6 Dec

1964 Speech to Alma Mater, Copenhagen: Arup Papers, 5/4

1964 'People today', BBC interview (not broadcast)

1964 'Discussion of form and structure in engineering', *Proceedings of the Institution of Civil Engineers*, 29, Oct

1965 'Sydney Opera House [Prestressed Concrete Development Group]'

1965 Transcripts and final interview report, 'Ove Arup talks to Peter Rawstorne', *RIBA Journal*, April

1965 'The problem of producing quality in building', talk to the Westminster Chamber of Commerce; reprinted in *Arup Journal*, 20 (1), spring 1985

1965 Lecture to the South Africa Prestressed Concrete Development Group, 28 Oct

1966 'Art and architecture', Royal Gold Medal address, 21 June; *RIBA Journal*, Aug

1966 Speech to Dixie Grammar School, Market Bosworth, 20 Oct

1966 'Aesthetics and the engineer', address to the Institution of Municipal Engineers, *Surveyor and Municipal Engineer*, 3 Dec

1967 'Architecture is sick. Should it be revived?', talk at the Athenaeum, London, 2 Jan

1967 'Advances in engineering', *Financial Times*, supplement, 11 July; reprinted in *Arup Journal*, 20(1), spring 1985

1967 'The Sydney Opera House Affair: Comment by Ove Arup', confidential note to Partners, Sept–Oct, based on several earlier drafts

1968 'Discussion on ethics and conduct in the building industry', Joint Building Group meeting with Sir Maurice Laing, 21 Feb

1968 'This day tonight', ABC interview, broadcast 28 Feb

1968 [with Ronald Jenkins], 'The evolution and design of the Concourse at the Sydney Opera House', *Proceedings of the Institution of Civil Engineers,* April; reprinted in *Arup Journal*, 8 (3), Oct 1973

1968 'Teams for total design', *The Times*, supplement, 15 July

1968 'A fairy tale'

1968 'The world of the structural engineer', Maitland Lecture to the Institution of Structural Engineers, Nov; *Structural Engineer*, Jan 1969; reprinted in *Arup Journal*, 20 (1), spring 1985

1969 'An engineer looks at architecture', delivered to the Leicester University Arts Festival, 11 Feb

1969 [with G. J. Zunz], 'Sydney Opera House', *Structural Engineer*, 47 (3), March; reprinted in *Arup Journal*, 8(3), Oct 1973

1969 [with G. J. Zunz], 'Sydney Opera House', *Structural Engineer*, 47 (10), Oct

1969 'Aims and means: Part 1', *Newsletter*, no. 37, Nov

1970 'Architects, engineers and builders', Alfred Bossom Lecture, Royal Society of Arts, 11 March; reprinted in *Arup Journal*, 20 (1), spring 1985

1970 'The potential of prestressed concrete', *Concrete*, 4 (6)

1970 'I am not a prophet', *Contract Journal*, 4761

1970 'Notes for the follow-up meeting 2 Oct 1970, after Cambridge Conference on the Education of Architects, 2–4 April 1970', Sept

1970 'The key speech', Arup Organisation Meeting, 9 July; reprinted in *Arup Journal*, 20 (1), spring 1985

1971 'Jubilee Foreword', 8 March

1971 'Obituary on Arne Jacobsen for RIBA Journal', 5 April

1971 [with G. J. Zunz], 'Sydney Opera House', *Civil Engineering*, 12

1971 'Future problems facing the designer', Paper 5 at the Royal Society Discussion Meeting 'Building Technology in the 1980s', 4 Nov

1971 Address to the Concrete Society 4th Annual Convention, Bristol

1972 'Aims and means continued', June

1972 'A society for the built environment', inaugural speech to the Building Services Engineering Society, Institution of Civil Engineers, 26 Oct; reprinted in *Arup Journal*, 20 (1), spring 1985

1973 Gold Medal Address to the Institution of Structural Engineers, Oct; reprinted in *Arup Journal*, 20 (1), spring 1985

1973 'What's our line', Arup Partnerships: Trustees Meeting no. 3, Oct

1974 'Philosophy and the art of building', trans. Jens Arup in *Ove Arup 1895–1988*, ed. Patrick Morreau, Institution of Civil Engineers, London 1988

1975 'Built environment professions: What's in a name?', *Built Environment*, March

1975 'I only used ordinary, plain common sense', *New Civil Engineer*, April

1976 Obituary of R. S. Jenkins, *Newsletter*, 94, Jan–Feb

1978 'The Danish Embassy', *Arup Journal*, 13 (2), June

1978 Comments on Professor Max Black's essay 'Scientific neutrality' in the current issue of *Encounter*, Aug

1979 'Development of English architecture', *Erhvervs Bladet* (Copenhagen), June

1979 'The engineer looks back', *Architectural Review*, 166 (993), Nov

1980 'My architectural theory', *RIBA Journal*, 87 (11), Nov

1981 'Thinking and getting things done', *Newsletter*, April [contribution to an Edward de Bono after-dinner discussion]

1983 [Biographical] 'Notes for DOMUS': Arup Papers, 2/99

1983 Statement to the Fellowship of Engineering, Sept

1984 'Chess'

1985 Interview in *Concrete Quarterly*, 144, 12 Feb

1985 'Frei Otto and his work', March

[1989] *Doodles and Doggerel*, ed. Anja Liengaard, Aylesbury, n.d. [limited edition, privately published by Ove Arup Partnership]

In–house publications

London Newsletter, 1st series, 1962–5
Newsletter, 2nd series, 1966–84
Arup Journal, 1966–
[Arup] *Bulletin*, 1983–
Ove Arup & Partners 1946–1986, London 1986

Books

Alberti, Leon Battista, *On the Art of Building in Ten Books* (c. 1450), trans. Joseph Rykwert, Neil Leach and Robert Tavernor, Cambridge, Mass., and London 1988

Allan, John, *Berthold Lubetkin: Architecture and the tradition of progress*, London 1992

Allan, John, *Berthold Lubetkin*, London 2002

Baume, Michael, *The Sydney Opera House Affair*, Sydney 1967

Blake, Peter, *The Master Builders*, London 1960

Brown, Mike, and Carol Harris, *The Wartime House: Home life in wartime Britain 1939–1945*, London 2001

Burleigh, Michael, *The Third Reich: A new history*, London 2000

Campbell, Louise, ed., *To Build a Cathedral*, Warwick 1987

Campbell, Louise, *Coventry Cathedral: Art and architecture in post-war Britain*, Oxford 1996

Campbell, James W. P., *Brick: A world history*, London 2003

Chambers, William, *A Treatise on Civil Architecture*, London 1759

Clark, Ronald W., *J. B. S.: The life and work of J. B. S. Haldane*, London 1968

Cohn, Leonie, ed., *Jane Drew: Architect*, Bristol Centre for the Advancement of Architecture 1986

Colvin, Howard, *A Biographical Dictionary of British Architects 1600–1840*, London 3/1995

Collingwood, R. G., *The Principles of Art*, Oxford 1938

Cotterell, Brian, and Johan Kamminga, *Mechanics of Pre-industrial Technology*, Cambridge 1990

Courtenay, Lyn T., ed., *The Engineering of Medieval Cathedrals*, Aldershot 1997

Courtois, Stéphane, Nicolas Werth, Jean-Louis Panné, Andrzej Paczkowski, Karel Bartošek and Jean-Louis Margolin, *The Black Book of Communism: Crimes, terror, repression*, Cambridge, Mass., 1999

Dannatt, Trevor, *Modern Architecture in Britain*, with introduction by John Summerson, London 1959

Dear, I. C. B., ed., *The Oxford Companion to the Second World War*, Oxford 1995

Drew, Philip, *Sydney Opera House: Jørn Utzon*, London 1995

Drew, Philip, *The Masterpiece: Jørn Utzon, a secret life*, Melbourne 1999

Drew, Philip, *Utzon and the Sydney Opera House*, Sydney 2000

Elliott, Cecil D., *Technics and Architecture: The development of materials and systems for buildings*, Cambridge, Mass., 1992

Emmerson, Andrew, and Tony Beard, *London's Secret Tubes*, London 2004

Evans, Richard J., *The Coming of the Third Reich*, London 2003

Festskrift for Ove Arup on the Occasion of his Seventieth Birthday, 16 April 1965, Devine, Rosemary, ed., London Newsletter, 32 [32 contributions under the heading 'This Ove Arup']

Fiedler, Jeannine, and Peter Feierabend, *Bauhaus*, Cologne 1999

Fitchen, John, *The Construction of Gothic Cathedrals: A study of medieval vault erection*, Oxford 1961

Fitchen, John, *Building Construction before Mechanization*, Cambridge, Mass., 1986

Fitzpatrick, Martin, Peter Jones *et al.*, eds, *The Enlightenment World*, London 2004

Ford, Edward R., *The Details of Modern Architecture*, London 1990

Forsyth, Michael, *Buildings for Music*, Cambridge 1985

Francis, A. J., *The Cement Industry 1796–1914: A history*, Newton Abbot 1977

Fromonot, Françoise, *Jørn Utzon: Architect of the Sydney Opera House*, London 1998

Giedion, Sigfried, *Buildings in France, Buildings in Iron, Buildings in Ferroconcrete* (1928), trans. J. Duncan Berry, Santa Monica, Ca., 1995

Gilbert, Martin, *Winston S. Churchill*, 8 biographical vols [first two by Randolph Churchill], London 1971–88; companion documentary vols, 1972–2000; vol. 5: *The Coming of War, 1922–1939*, 1972 [*Documents, 1936–1939*, 1982]; vol. 6: *Finest Hour, 1939–1941* [*Churchill War Papers, 1939–1941*, 3 vols, 1993–2000]

Goldthwaite, Richard A., *The Building of Renaissance Florence*, London 1980

Goy, Richard J., *The House of Gold*, Cambridge 1992

Gregg, John, *The Shelter of the Tubes*, London 2001

Haan, Hilde de, and Ids Haagsma, *Architects in Competition: International architectural competitions of the last 200 years*, London 1988

Harrington, Kevin, *Changing Ideas on Architecture in the Encyclopédie, 1750–1776*, Ann Arbor 1985

Harris, Eileen, *British Architectural Books and Writers 1556–1785*, Cambridge 1990

Hartcup, Guy, *Code Name Mulberry: The planning, building and operation of the Normandy harbours*, Newton Abbot 1977

Home Front Handbook, Ministry of Information, London 1943

Idorn, Gunnar M., *Concrete Progress*, London 1997

Jeanneret, Charles Edouard [Le Corbusier], *Towards a New Architecture*, trans. Frederick Etchells, London 1927

Joedicke, Jürgen, *Architecture since 1945*, London 1969

Jubilaeumsskrift i anledning af Sorø Akademis Skoles 350-års jubilaeum, Soransk Samfund, Sorø 1936

Lasdun, Denys, *Architecture in an Age of Scepticism*, New York 1984

Leedy, Jr., Walter C., *Fan Vaulting: A study of form, technology and meaning*, Santa Monica, Ca., 1980

Leavis, F. R., *Education and the University*, London 1943

Liengaard, Anja, *The Adventures of a Child in Search of the Truth*, Llandysul 2002

Livingston, Morna, *Steps to Water: The ancient stepwells of India*, New York 2002

Lubetkin, B., *Planned A. R. P.*, London 1939

Lutyens, Mary, *Edwin Lutyens*, London 1980

MacNeice, Louis, *The Strings are False: An unfinished autobiography*, London 1965

Mainstone, Rowland J., *Developments in Structural Form*, London 2/1998

Margolius, Ivan, *Architects + Engineers = Structures*, Chichester 2002

Mark, Robert, ed., *Architectural Technology up to the Scientific Revolution*, London 1993

The Market Square, Ministry of Food, 1944; reprinted by the Imperial War Museum, London 2003

Messent, David, *Opera House Act One*, Sydney 1997

Middleton, Robin, ed., *The Beaux Arts and Nineteenth-century French Architecture*, London 1982

Mikami, Yuzo, *Utzon's Sphere: Sydney Opera House – how it was designed and built*, Tokyo 2001

Millon, Henry A., and Vittorio Magnago Lampugnani, eds, *The Renaissance from Brunelleschi to Michelangelo: The representation of architecture*, London 1994

Millon, Henry A., *The Triumph of the Baroque: Architecture in Europe 1600–1750*, London 1999

Morreau, Patrick, ed., *Ove Arup 1895–1988*, Institution of Civil Engineers, London 1988

Murray, Peter, and Mary Anne Stevens, *Living Bridges*, London 1996

Murray, Peter, *The Saga of Sydney Opera House*, London 2003

Orwell, George, *The Complete Works of George Orwell*, ed. P. Davison, 20 vols, vol. 17: *I Belong to the Left*, London 1998

Perrault, Claude, ed., *Les Dix Livres d'architecture de Vitruve*, Paris 2/1684

Picon, Antoine, *French Architects and Engineers in the Age of Enlightenment*, Cambridge 1992

Raeburn, Michael, and Victoria Wilson, eds, *Le Corbusier: Architect of the century*, London 1987

Rasmussen, Steen Eiler, *Experiencing Architecture*, Cambridge, Mass., 1959

Ray, Nicholas, *Alvar Aalto*, London 2005

Rubin, Patricia Lee, *Giorgio Vasari: Art and history*, New Haven and London 1995

Rykwert, Joseph, *The First Moderns: The architects of the eighteenth century*, London 1980

Saint, Andrew, *The Image of the Architect*, London 1983

Scott, Geoffrey, *The Architecture of Humanism*, London 1914

Seaman, Mark, *Garbo: The spy who saved D-Day*, Richmond, Surrey, 2004

Silver, Nathan, *The Making of Beaubourg*, Cambridge, Mass., 1994

Skempton, A. W., ed., *Biographical Dictionary of Civil Engineers*, vol. 1: *1500 to 1830*, London 2002

Smith, Adam, *The Theory of Moral Sentiments* (1759), ed. D. D. Raphael and A. L. Macfie, Oxford 1975

Smith, Vincent, *The Sydney Opera House*, Sydney 1974

Sommer, Degenhard, Herbert Stöcher and Lutz Weisser, *Ove Arup & Partners*, Basel 1994

Sowden, Harry, ed., *Sydney Opera House Glass Walls*, Sydney 1972

Spence, Basil, *Phoenix at Coventry*, London 1962

Steiner, Zara, *The Lights that Failed. European International History 1919–1933*, Oxford 2005

Tawney, R. H., *The Acquisitive Society*, London 1923

Bibliography

Vitruvius, *Ten Books on Architecture*, trans. Ingrid D. Rowland, Cambridge 1999

Watkin, David, *Morality and Architecture*, Oxford 1977

Wilde, Oscar, *Intentions*, London 1891

Williams, Stephanie, *Hongkong Bank: The building of Norman Foster's masterpiece*, London 1989

Wotton, Henry, *The Elements of Architecture*, 1624

Index